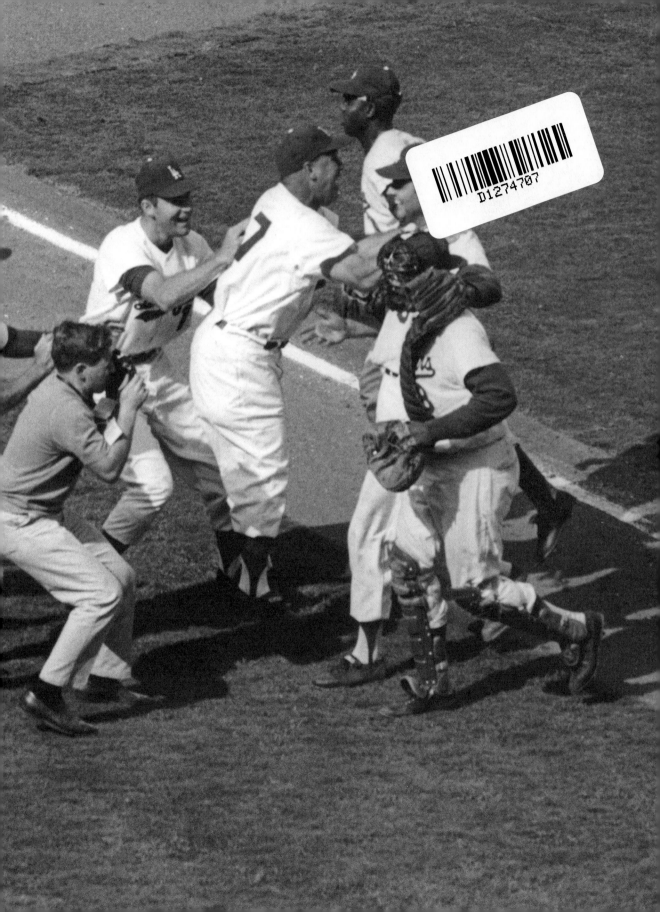

RELENTLESS

FOCUS ON AMERICAN HISTORY SERIES
The Dolph Briscoe Center for American History
University of Texas at Austin
Don Carleton, Editor

NEIL LEIFER

RELENTLESS

THE STORIES BEHIND THE PHOTOGRAPHS

with
Diane K. Shah

UNIVERSITY OF TEXAS PRESS ⩔ AUSTIN

Requests for permission to reproduce material
from this work should be sent to:
 Permissions
 University of Texas Press
 P.O. Box 7819
 Austin, TX 78713-7819
 http://utpress.utexas.edu/index.php/rp-form

∞ The paper used in this book meets the minimum
requirements of ANSI/NISO Z39.48-1992 (R1997)
(Permanence of Paper).

LIBRARY OF CONGRESS
CATALOGING-IN-PUBLICATION DATA

Leifer, Neil, author, photographer.
 Relentless : the stories behind the photographs /
Neil Leifer with Diane K. Shah. — First edition.
 pages cm — (Focus on American History
series)
 Includes index.
 ISBN 978-1-4773-0948-3 (cloth : alk. paper)
1. Leifer, Neil. 2. Photojournalists—United States—
Biography. 3. Photographers—United States—
Biography. 4. Photojournalism. 5. Photography
of sports. 6. Celebrities. 7. Celebrities—Pictorial
works. I. Shah, Diane K., author. II. Title.
III. Series: Focus on American history series.
 TR140.L445A3 2016
 770.92—dc23
 [B]
 2015031821

For Mom, Dad, and Howie

CONTENTS

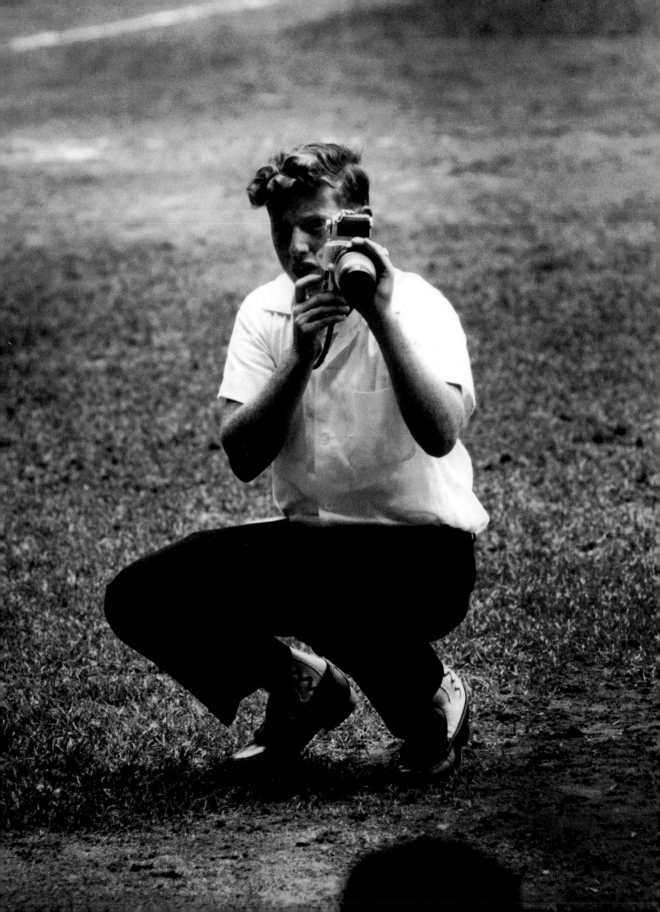

INTRODUCTION

"The dictum that one picture is worth more than a thousand words is one of those glib generalities that grows fuzzy when regarded closely, like the image on a television screen. Which picture compared with whose words? . . . The fact is, the camera can tell a story with smashing impact, and it can deceive."

So wrote the legendary columnist Red Smith in an introduction to my first book, *Sports* (Abrams, 1978). I have no idea how many words a picture is worth, but I do know it can tell a whole story about its subject, tell it vividly and with tremendous economy—in a snap. There is also something a photograph—even a great photograph—can't show: the story behind the picture, the people and the circumstances that came together in that $\frac{1}{500}$th of a second when the shutter was snapped and an image was frozen for all time. These are the stories you never hear, and they're often worth at least a thousand words. I've been telling these stories over dinner tables for forty years and now I'd like to share them with you.

Photojournalism has changed dramatically since I was a kid taking pictures with my Brownie Hawkeye on New York's Lower East Side. It was just a hobby until I joined a photo club at the Henry Street Settlement House, which offered all sorts of activities to keep kids off the streets and out of trouble. I quickly got hooked on shooting pictures, developing and printing them, watching the images magically appear in the swirl of the

WITH MY CAMERA, CIRCA 1961. PHOTO BY WALTER IOOSS SR.

developer. I thought I had a knack for it. It never occurred to me that this could be a career. Getting paid to take pictures? At sporting events? You've got to be kidding me! But once I started getting published, I realized that a camera could be my ticket to everywhere. A kind of magic carpet, you could say, to anyplace I wanted to go.

And go I did. I started out shooting sports and, before I knew it, I was taking pictures of many of the greatest athletes of the past half century. Not only that, but my career also took unexpected turns that sent me off to distant locales I couldn't have even imagined. I ended up taking pictures of everyone from presidents and popes to movie stars and murderers—some of the most famous and infamous people on the planet.

And almost every one of those pictures comes with a story.

Some of the stories recall the changing world of photojournalism. When I started out, we used film, and there were two absolutely crucial things to worry about every time I snapped a picture: focus and exposure. There were no electronics in the camera, no auto-focus or auto-exposure. Photoshop hadn't been invented to correct errors or remove unfortunate elements in the composition, be it an obnoxious fan waving a crude sign or a blemish on a celebrity's face. When shooting sports, you usually had only one chance to get the picture. And because sports are shot mostly with long lenses, eye-hand coordination was absolutely essential. So you always worried: Did I get it in focus? Also, because the margin of error of the highest-quality film was quite small, you always wondered: Did I get my exposure right? You never knew—until the film was developed.

In time, lenses got smaller, faster, and lighter in weight. Then, many years later, came the digital camera, which does pretty much everything for you. Still, I'm convinced that the photographer, not the camera, makes the difference. Many of today's top photographers were the best in the business long before the digital era. My colleague Walter Iooss is doing his finest work today, and he's been great for more than fifty years. Annie Leibovitz, too, and Douglas Kirkland, who is in his eighties. Also Gregory Heisler, whose photographs today are every bit as good as they were thirty years ago, maybe better.

Even in today's digital world, some things don't change. Photography is still all about lighting and composition and how you put them together to make a compelling picture. After all these years and all these technological advances, I am absolutely convinced that the most gifted and skillful photographers still take the best pictures.

When I began shooting, I doubt that anyone would have looked at my

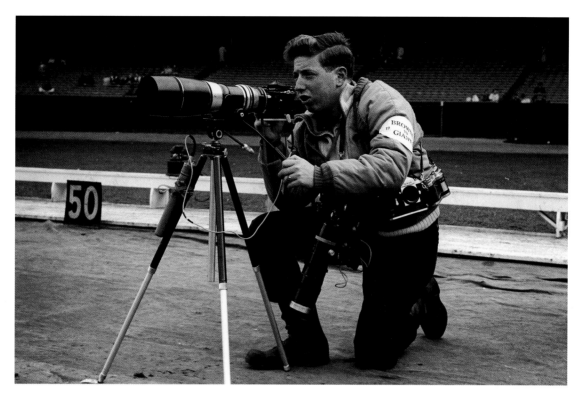

AT CLEVELAND MUNICIPAL STADIUM, 1961. PHOTO BY JOHNNY IACONO.

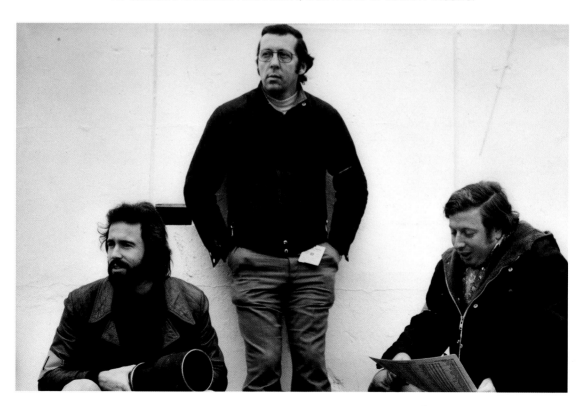

WITH WALTER IOOSS JR. (LEFT) AND JIM DRAKE (MIDDLE), 1974.

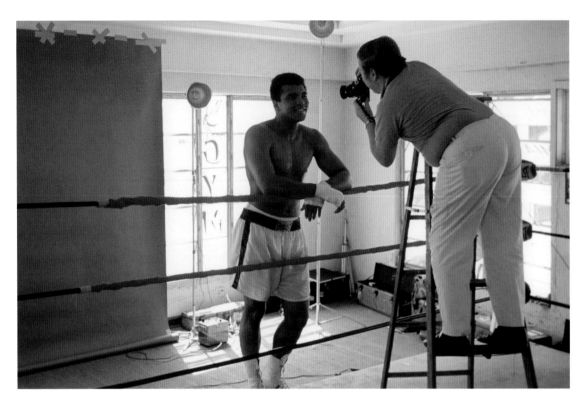

ALI POSING FOR ME AT MIAMI BEACH'S 5TH STREET GYM, 1970.

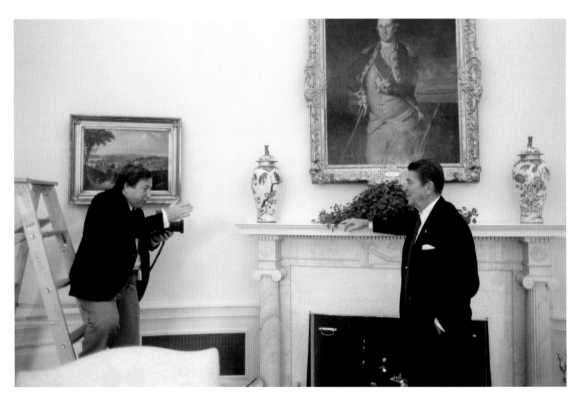

PRESIDENT REAGAN POSING FOR ME IN THE OVAL OFFICE, 1983.

photos and thought, Aha! Here's a kid who's going to go far. I never even won a photo contest. More than my photos, it was my determination, ambition, street smarts, and some corned beef sandwiches (we'll come back to those sandwiches later) that got me in the door at Time Inc.

And my timing was perfect. As Time Inc. grew into the largest magazine company in the world, I got to work for some of the most successful magazines in history—*Life*, *Sports Illustrated*, *Time*, and *People*. Over the next thirty or forty years, *SI* and *Time* went from using color photography on the cover, but only sparingly inside, to being famous for late-closing color throughout. Money was no object. If I had needed a camel, Time Inc. would have paid for one. (No, wait! I actually did have to rent four giraffes for an Olympic photo spread in Kenya, and in Washington, D.C., I leased a donkey that the subject, a prominent political figure, refused to sit on.) Looking back, I believe this surely was the Golden Age of magazines, a time of great prosperity and opportunity for photographers and journalists. We had the freedom to travel the world, to take big chances, and to make them pay off.

But this business of photography was hardly a cakewalk. True, getting an assignment was easier back then. There were many more magazines and far fewer photographers competing for assignments. Today, the number of photographers shooting at big events—be they Super Bowls, Academy Awards, presidential visits, or natural disasters—is in the hundreds (and often in the thousands if you count all those citizen journalists with camera phones). Take *SI*. Years ago, the magazine would send three, maybe four photographers to a Super Bowl; now it sends ten or twelve. Three or four would be assigned to the Olympics; now it's eight or ten.

Photography always was, and still is, an intensely competitive, sharp-elbows business, marked by constant fighting—even with colleagues and close friends—for position, credentials, and display space. Photographers keep careful score, and the final tally is expressed in terms of pages and, most important of all, covers. You did almost anything necessary to get the assignments you wanted and the shots you needed—but I always stopped short of pulling some of the dirty tricks I witnessed all the time. One photographer of note had the clout and the connections to prevent a competitor from getting credentials, or landing a good photo position, and he used that power freely.

I knew this game well. As a kid trying to break into sports photography, I had to battle the photographers who ruled the press box at Yankee Stadium like tribal warlords. I knew early on that I never wanted to become

one of them. What I am proudest of is that, even though I am extremely competitive, I always cared about my integrity. I never wanted to beat the other guy by screwing him. I wanted to beat him by taking the best picture. The result is that my two biggest competitors at *SI*—Walter Iooss and Jim Drake—are still good friends to this day.

In time, the Golden Age of magazines began to tarnish. Budgets shrank, along with advertising revenue, and the ground began shifting under the feet of even the best photographers and writers. Suddenly, there were fewer magazines and far fewer opportunities. *Life*, once every photographer's mecca, was gone and so were *Look* and *Saturday Evening Post*, replaced by ESPN and the power of TV. Long ago, an *SI* photographer, John Zimmerman, came up with the idea of planting a camera in a hockey net. He also was the first to put a camera behind the glass backboard of a basket. I shot the 1966 Muhammad Ali-Cleveland Williams fight at the Houston Astrodome by affixing a remote-controlled camera to a lighting rig eighty feet above the ring. Today, these angles are routinely seen in every single sporting event on TV. What used to be the exclusive domain of pioneering *SI* or *Life* photographers is now an everyday occurrence.

Also changing dramatically were the people we were assigned to shoot, as subjects became less approachable and increasingly stingy with their time. Athletes and politicians began to do what movie stars and celebrities have always done: control access and stage-manage image with teams of agents, publicists, and lawyers, all of whom we have to deal with. This made our photo assignments even more demanding, and it forced photographers to work harder and be more creative.

I remember a photo shoot with Magic Johnson before the 1992 Summer Olympics. Magic was always a delight to work with, but when I asked him to put on the official Team USA warm-up jacket, he shook his head. "I'm sorry, Neil," he said. "But I can't be seen wearing the Reebok logo on a magazine cover. I'm under contract to Converse."

Roadblocks often produce creative solutions, and the shot I took of Magic, from behind, as he glanced over his shoulder, turned out to be better than the straight-on shot I had planned. There are plenty of stories like this one.

Are you ready?

Neil Leifer
New York City
October 2015

RELENTLESS

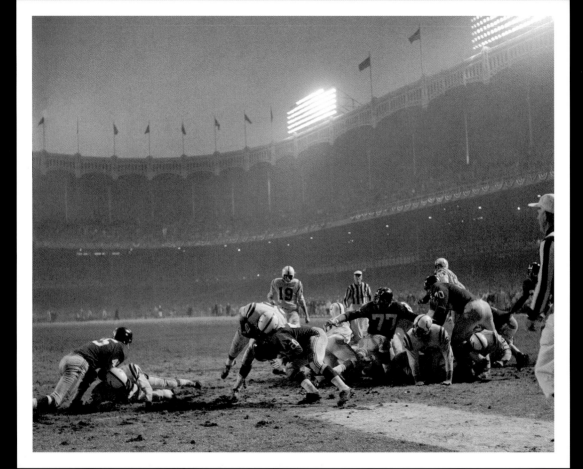

GREATEST GAME EVER PLAYED

> **"** *Some people call me a pretty aggressive kid. I used to mind the tag a lot more than I do right now because I realize it's just the way I'm made. In my business, a fellow has to be aggressive if he wants to succeed. One of these days I'd like to be the greatest sports photographer in the world.*
>
> —NEIL LEIFER, age 19, as quoted in *Boys' Life*, September 1962

It is a cold December day—December 28, in fact—and the air in the Bronx is electric. Long before kickoff, a bundled-up crowd that would swell to 64,185 is streaming into Yankee Stadium to watch my New York Giants battle the Baltimore Colts. Since the Super Bowl hadn't been invented yet, the teams will be playing for football's highest honor, the NFL championship.

Now, if you look to the left of the farthest goalpost—behind what in summer is the visitors' bullpen—a ramp used for truck deliveries to the stadium goes up from the field. It opens onto the street where a half-dozen buses carrying wheelchair-bound veterans from the local army hospital roll up to the curb. Immediately, several volunteers spring into action. They wheel the men through those huge doors into the stadium and line them up against the outfield wall from left field around to the monuments in center.

From the stands, you might even notice me, there by the wheelchairs.

See, after six Giants home games this season, I have mastered this routine. Not having the money to buy a ticket—nor the clout to secure a press pass—I discovered before the first game that I could enter the stadium by wheeling in veterans. And once inside? Oh, man. When most of the volunteers disappear into the stands to get a better view of the game, I stay where I am, right here on the field, my trusty Yashica-Mat camera tucked under my jacket.

The end zone is the worst possible spot for a fan, but it's great for a photographer. My Yashica, though, is far from an ideal piece of equipment. It has a fixed lens, for one thing, so I can't come in close—as I would with a telephoto lens—and fill the frame with the action. Maybe it is perfect for sitting under the basket at Madison Square Garden or on the sidelines of a football game, when the action is fifteen feet away. But the minute the action is thirty, forty feet away, I can't capture the play very well, and I am not yet technically savvy enough to know how to take advantage of the camera's shortcomings.

And there is another problem: security. At the moment, teams use four rent-a-cops, two on each sideline, mainly to guard against drunken fans spilling onto the field. But some of these men are the same guards who work Knicks games at Madison Square Garden, and by now they know me. How many times have they chased me out of the Garden? Even worse, the credentialed newspaper photographers keep a sharp eye peeled for me and try to shoo me away from their sacrosanct turf. But here, I have an entire field, instead of a basketball court, on which to play hide-and-seek with the news guys and the rent-a-cops. When they aren't looking, I will creep up maybe twenty or thirty feet and hope that a pass or a running play will sail by close to me. If only I had a 135mm lens—a medium telephoto. But that I cannot afford, not even close.

As the season wore on, I became a fixture at the stadium, and hoping to ensure the favor of the four security men, I would fetch hot coffee from an urn placed on a table near the vets and cheerfully deliver the brimming cups to the chilled rent-a-cops. In time, they'd look the other way when I stole over to take pictures of the players huddled on the bench—or crept in for a close-up of the action.

And man, this game will have plenty of it. A tie game at the end of regulation, it is about to go down as the only championship game in NFL history to be decided in sudden-death overtime. I watch as the Giants win the subsequent coin toss and go three-and-out on the first series. Then Johnny Unitas masterfully maneuvers the Colts to the Giants' one-yard

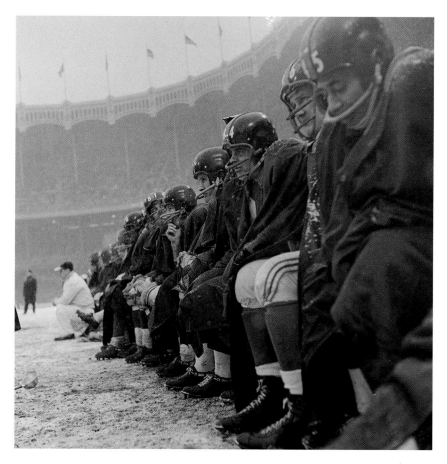

GIANTS PLAYERS ON BENCH AT YANKEE STADIUM, 1958.

line. On the next play, running back Alan Ameche falls across the goal line, giving the Colts a 23–17 victory in what would become known as the "Greatest Game Ever Played."

As it happens—and, of course, not purely by accident—I am standing ten yards behind that goal line, directly in front of Ameche and, with the stadium darkening and fog swirling across the field, I snap one shot and capture Ameche cradling the ball as he tumbles into the end zone.

Little could I have imagined that blustery day that this black-and-white photo would become one of the iconic sports pictures of the twentieth century.

Nor could I have given myself a better birthday present. Did I mention? December 28, 1958, was my sixteenth birthday.

FOLLOWING PAGES: CONTACT SHEET OF NFL CHAMPIONSHIP BETWEEN THE COLTS AND GIANTS, 1958.

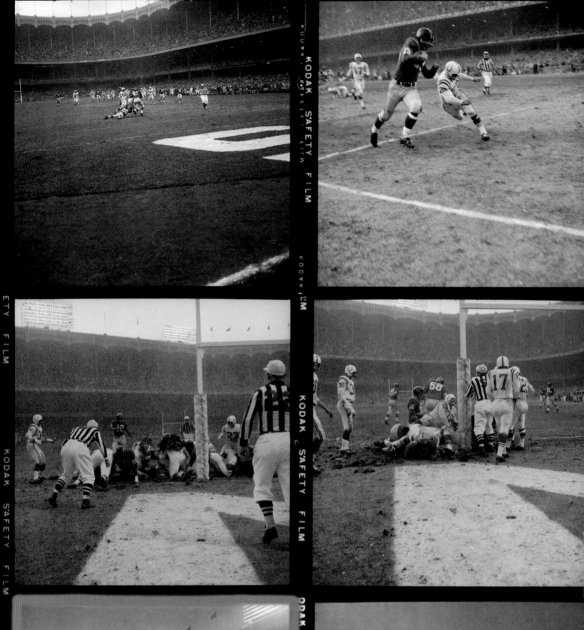
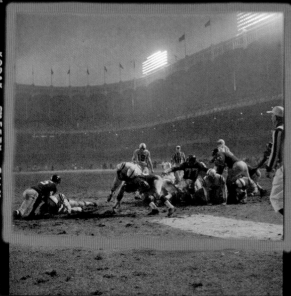

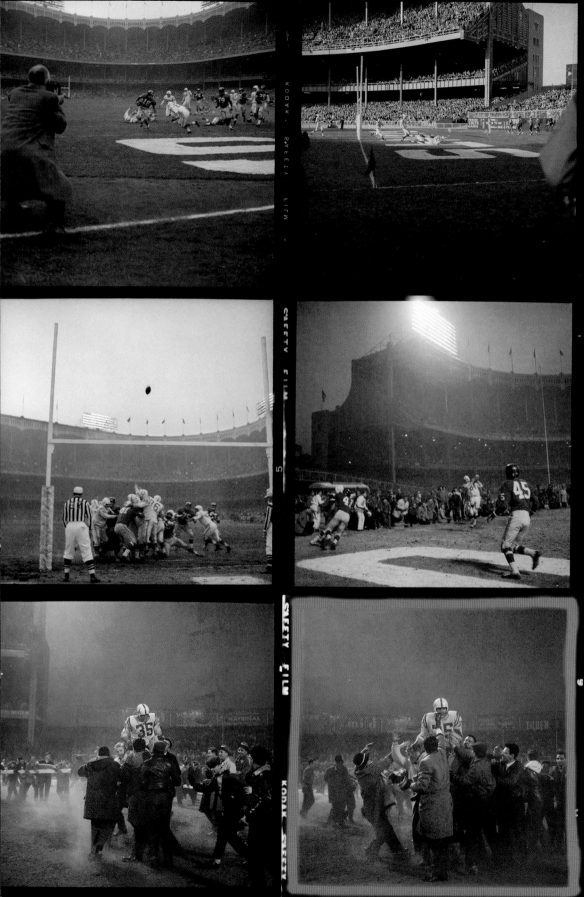

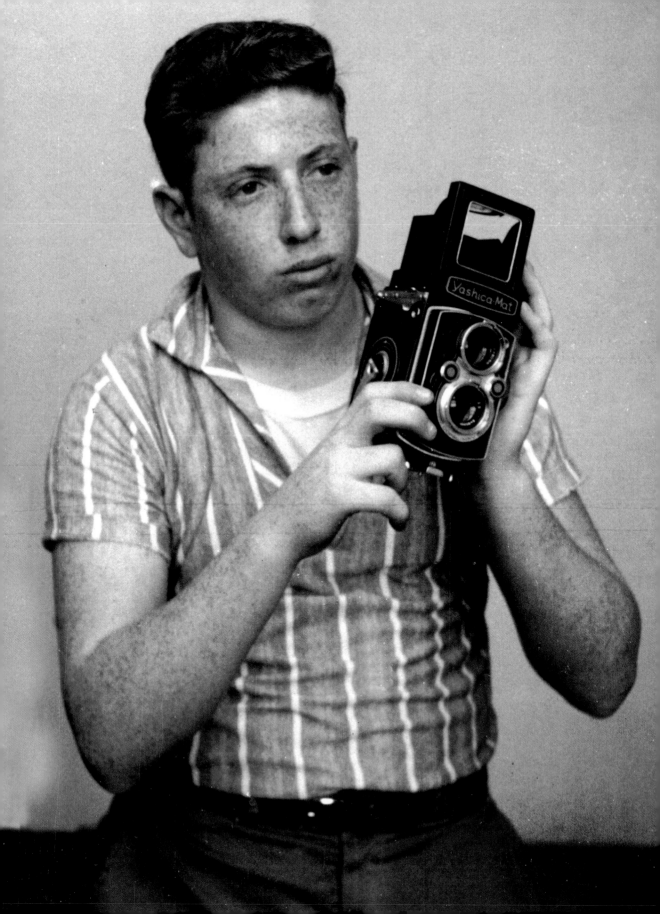

PHOTO BY NEIL LEIFER

> " *If there was one Neil picture I wish I had shot, it would have been the Ameche photo, hands down. It was one of the most defining moments in the history of sport. What's so amazing is it showed what he had at such a young age. I think so many of the great pictures he took as a teenager and in his early twenties, with this perception of the bigger scene—what I never could even have imagined—are remarkable. It shows this magic moment in one of the great events in the history of sport, the single greatest event in football history.*
>
> —**WALTER IOOSS**, *Sports Illustrated* photographer

The Alan Ameche picture did not make me a success overnight. Although I was sixteen, I still looked twelve, or possibly eleven. And I had yet to sell a single photo; in fact, I hadn't even tried to. It had never occurred to me that you could actually make a living this way. All I knew was how happy I felt when one of my pictures ran in my high school paper over the words: PHOTO BY NEIL LEIFER.

That was my first season shooting football. I had made my mark at the Garden, getting thrown out repeatedly by those rent-a-cops. But football meant the Giants, and I loved the Giants—the Frank Gifford, Charlie Conerly, Sam Huff, Alex Webster Giants. Tickets were always available on game day—half the stands would be empty—but I couldn't afford to buy one. So when I saw they needed volunteers to wheel in the disabled veterans, I figured, that's for me. Someone once asked if I ever thought

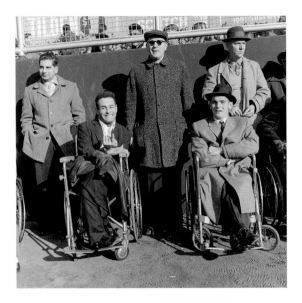

WHEELCHAIR-BOUND VETERANS,
YANKEE STADIUM, 1958.

of entering the stadium in a wheelchair myself. Maybe I wasn't that clever, but given what I wanted to do, my cover would have been blown the minute I got out of the chair. "Look, a miracle! He can walk!"

Although I hardly studied for school, I did study photographers. *Life* and *Sports Illustrated* were my bibles. I had long dreamed of having my pictures appear in both magazines, and I knew on that December day in 1958 that I had something good to show them.

But wait, I'm getting ahead of myself.

--

Work, hard work, was nothing new to me. I always understood that if I wanted to have money in my pocket, I needed to work. As a twelve-year-old, I was down at City Hall with a little shoeshine box my father had made for me, waiting for men in suits who wanted a shine. I was probably the only little Jewish boy shining shoes; most of the kids (and grown men) working that job in those days were black, and besides, I was terrible at shining shoes. Invariably, I would get more polish on the socks than on the shoes.

Then I got my second job, at Jay Rose's Corset Store, a famous shop on Clinton Street, near Delancey. My mother worked there. She specialized in fitting corsets for a clientele of mostly old Jewish, Irish, and Italian ladies. Among my mother's customers was Ethel Rosenberg. Till the day she and her husband Julius were electrocuted for treason, my mother couldn't understand how "such a nice lady" could be a spy. I'm guessing Ethel tipped well.

My job was to deliver the bras and girdles. I worked only for tips. Sometimes I would hike up five or six flights of stairs, some old zaftig woman would open the door, and I would hand her a box that was long and flat, like those used to deliver flowers. I knew I would get a quarter, but I hoped to get fifty cents. Usually they would take the box and say, "Eh, boychik, you mind vaiting a few minutes? I gotta try it on and you'll help to pull the strings?" (The girdles were made with strings in the back that you had to pull to cinch them up nice and tight.) Then they'd go look in the

mirror—not exactly a Victoria's Secret moment—and they'd still only give me a quarter!

Soon I moved on to a more lucrative gig—scalping tickets. I would go to Yankee Stadium with my cousin Normie, who had dropped out of school and become the real criminal of the family. Scalping was different back then. You could stand in front of the box seat entrance and say, "Anybody got an extra ticket?" Same thing at Madison Square Garden. You had to watch out for the cops, but you'd be amazed how many people had season tickets—maybe four seats—only a friend bows out at the last minute, so they'd give you the ticket. Immediately you'd sell it. A box seat cost three dollars or three-fifty. I was a very cute thirteen-year-old redhead and I could make a really sad face. Often I'd go home with ten or twenty dollars in my pocket; many times I made off with fifty. I did that for two or three years. I was really good at it.

A short walk from our apartment stood the Henry Street Settlement House. It had numerous programs—boxing, basketball, piano lessons, sewing classes—all designed to keep kids off the streets, where gangs roamed and drugs were a problem, especially heroin. I joined the Settlement House to play basketball, but they only let you do that two nights a week, so I also signed up for the camera club. My parents had given me a Brownie Hawkeye, and I could walk five minutes to the East River and shoot pictures of the ships moving in and out of the Brooklyn Navy Yard across the river. I started shooting pictures of navy ships in about 1955. I was particularly fond of aircraft carriers and battleships.

The list of legendary people who came out of my little camera club includes Vinny Nanfra and Mickey Palmer (Michael Palmieri in those days), both of whom went on to distinguish themselves at *Look*. Mickey is also one of only three living photographers who have covered every Super Bowl. Johnny Iacono and Manny Millan, also camera club vets, became *Sports Illustrated* photographers.

Nelly Peissachowitz, a wonderful Polish woman with a love of photography, taught the photo group, which consisted of two sections of six to eight kids. The club provided each of us with one roll of film a week, donated by Kodak. DeJur, an American camera company, donated cameras. But we had to pay for the paper for prints—I think it was a dime a sheet—and you used two sheets a week. So, twice a week, instead of buying ice cream, I bought paper.

I really looked at camera club as a way to kill time on Tuesday and Thursday nights when I wasn't where I would rather have been—playing

basketball in the gym. But Nelly had a way of making photography fun. Every Thursday, she would give us an assignment to shoot over the weekend. Having only one roll of film—twelve shots—really teaches you discipline. Then, on Tuesday, you brought your film in and developed it, and Nelly would discuss it with you and help pick the best frame. She also taught us how to make a print. She showed us how to burn in areas that were too light or dodge areas that were too dark, and she would critique the prints. I still think there's nothing as exciting as taking the paper out of the enlarger, putting it in the first chemical, and, suddenly, a picture appears.

Every December, Nelly held a contest to see who could take the best picture of the Christmas tree in Rockefeller Center. One kid would take a straight-on, boring shot; another would stand on Fifth Avenue and take a picture through the iron angels that lined the path to the tree. One year, I shot the tree reflected in a puddle. I never won the contest, though—never even came close. But it really got me thinking creatively, wondering as I looked at the winning picture, "Why didn't I see that?"

HIGH SCHOOL PRESS
CREDENTIAL, 1958–1959.

The next thing I knew, I was buying a cheap enlarger. I took another step into the world of photography when I became photo editor for the Seward Park High School paper, the *Seward World*. My good friend Johnny Iacono was my staff photographer, and I assigned him all the dances and what he called "the girlie stuff"—obligatory pictures of things like the school orchestra and glee club—while I, naturally, gave myself all the sports photo shoots. I had so much fun doing this that when my family moved to Queens, I stayed at Johnny's house during the week so I wouldn't have to switch schools. I was a senior, having skipped a grade, and I had no real interest in school. But I could usually bluff my way through and pass tests with an eighty, rather than making an effort and shooting for a ninety. I had no interest in college either, although I thought I might try to get into Annapolis and make it as a navy pilot.

Meanwhile, I was moving from a life of crime (scalping tickets) to an honest living as a delivery boy. I began working at the Stage Deli. I could not have imagined how many doors this job would open for me; it gave me an opportunity to develop practical skills that would be useful for years to come.

The Stage Deli would charge people seventy-five cents for a taxi to make deliveries. But if they were within a few blocks, I would run, or if I had to go farther, I would take the subway for fifteen cents and pocket the taxi money in addition to the tips—and I'd get the food there even faster than if I'd used a taxi. At lunchtime, I would balance four bags on each arm and race off. Often, the building doorman wanted to take the order up, give me a quarter, and collect a bigger tip for himself. But I would insist on delivering the food, and this worked about 90 percent of the time. So instead of the doorman handing me a quarter, I could make fifty cents, a dollar, sometimes even two. My favorite customers were Jackie Gleason and Ed Sullivan, who did their shows nearby. If I could hand the food to them personally instead of dropping it off with someone at the stage door, I'd get a really big tip, maybe five bucks.

Another place I knew well from my deliveries was the *Life* Studios on West Fifty-Fourth Street, on the fourth floor, just a three-minute walk from

MY FIRST MAGAZINE COVER, 1960.

the deli. When photographers were shooting assignments there, they always ordered lunch from the Stage, and I would jump to do those deliveries because they let me hang around the studio. *Life* magazine's Ralph Morse, a big star, would be shooting some wonderful picture, I'd walk in and ask if I could watch, and he'd say, "Yeah, sure." So I would stay and ask questions, and Ralph would stop what he was doing to explain to this kid, this delivery boy, how he worked his magic. The two studio assistants, instead of tipping me fifty cents, would give me three or four rolls of Tri-X film, which was like getting a three-dollar tip.

After the NFL championship game, I rode the subway home and raced down to the basement, where my father had grudgingly given up space to build me a darkroom. I developed the roll of film, and as I looked at the negatives—the film was still wet—I realized how lucky I had been: first, because the Colts ended up going in my direction for sudden death and second, because of the way the final series played out. Johnny Unitas

engineered what has always been considered one of the all-time great drives. But no one could figure out why the Colts ran for a touchdown when all it would've taken was a chip shot field goal to win the game. There was speculation that team owner Carroll Rosenbloom, who was known as a big-time bettor, had put his money on the Colts. I think they were 3.5-point favorites, meaning a field goal that would've won the game would not have won the bet. There was never any evidence of this, but, whatever the reason, here came the Colts, running the ball toward me. And it wasn't just them. A few hundred drunken Baltimore fans poured out of the stands and onto the field. (In those days, you brought a bottle with you, and by overtime, people were pretty well hammered.) So now the four rent-a-cops had their hands full and the last thing they were worried about was some kid with a camera. As the Colts came down the field, I didn't wait until they were close. I moved into position exactly ten yards back from the goal line.

I was lucky to have the action coming in my direction and lucky to have the rent-a-cops thoroughly distracted by the drunken Colts fans they were trying to keep off the field. But a third bit of luck also broke in my favor: the touchdown could have been a pass to the left or the right. In fact, Unitas did pass on the second down, which put the Colts on the one-yard line. I was shooting with my Yashica-Mat—not a motor-driven camera like the big boys had—and my one roll of film had only twelve shots. Unitas handed the ball off to Alan Ameche and this huge hole opened up. For the guys with the telephoto lenses, it turned out to be a fairly ordinary picture of Ameche, his head down, clutching the ball, bulling through that hole. I clicked the button just as Ameche went over the goal line. The picture has all the line play at the bottom, including Emlen Tunnell, the Giants defensive back, who was blocked on the left side, and all the Colts blocking on the right. Ameche had eight feet to run through. There was nobody near him except one Giant (Jimmy Patton). I had no idea what I'd taken, but, lucky for me, because of the limitations of the Yashica-Mat's lens, the picture captured the whole scene on the field woven into the mood of Yankee Stadium.

It was as if the Colts had conspired to hand me a perfect picture. But then, good fortune struck again. Pandemonium broke out. Today I probably wouldn't follow Ameche, because Unitas was the big hero and he was just trying to get off the field. The Baltimore fans, meanwhile, were tearing down the goalpost, and in the shot I took of Ameche being carried off the field by the crowd, you can see the goalpost as it's toppling—it's halfway to the ground in my picture. But more important, as the fans hoisted Ameche

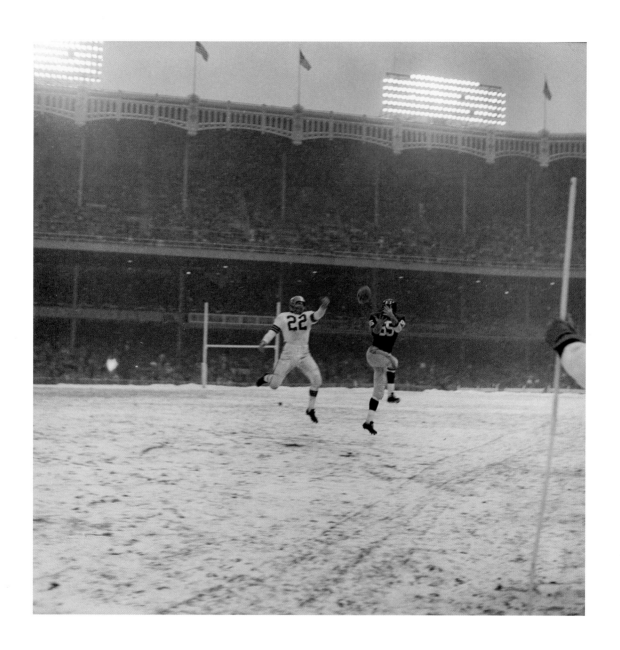

GIANTS' BOB SCHNELKER MAKING A CATCH OVER KEN KONZ (#22), 1958.

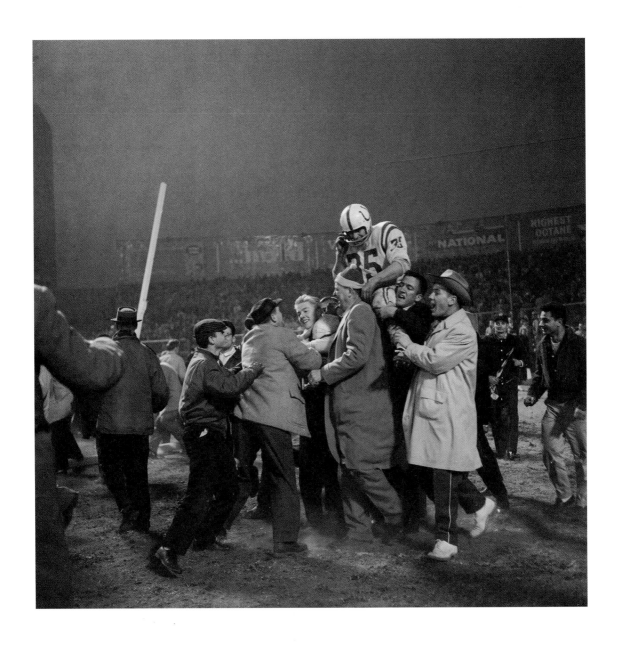

ALAN AMECHE CELEBRATES THE COLTS' NFL CHAMPIONSHIP WIN WITH FANS, 1958.

on their shoulders, I was right in front of him. I've never seen another picture like that and, to be honest, I thought it was my best shot of the day. I figured, *I really got something great.*

In my darkroom, I looked at the roll of film I had processed. I was never very good at printing pictures, but one thing I knew was that full pages in magazines were vertical and so were cover photos. I cropped the picture with Ameche on the left side and all the Giant linemen on the right, looking helpless and defeated. The stadium lights and the darkening sky made the picture very dramatic.

On Monday, I could hardly wait to bring my pictures to *Sports Illustrated.*

In the Hollywood version of this story, the ambitious kid photographer bolts past security and dashes into the *SI* offices. He dazzles the tough, experienced photo editors at the nation's premier sports magazine, who dump their best photographers' pictures and run the kid's Ameche shot on the cover. It would be like a rookie making his first plate appearance and hitting a walk-off grand slam.

What did happen, of course, was not nearly so dramatic. For one thing, in those days, there was no building security, so pretty much anyone could walk into any office and ask to see whomever. More importantly, I had already met—on my deli runs—the people I needed to see.

So, with my Ameche picture in hand, I rode the elevator to the fourth floor of the Time & Life Building and asked to see Ted Stephany. After a photographer finished an assignment, he would give the film to Ted, who logged it into the system. When I gave Ted my Ameche picture, he shook his head. "You should have come last night," he said. "It's too late. We've closed the magazine. But I like this picture. Let me get a print made and we'll show it to the editors for maybe another use."

Ted sent my picture up to the lab. They did no cropping; they printed the entire square frame. I studied the print and thought, "Wow! This really looks good." More important, it was the first professional print I ever had. And it wasn't even ready to be engraved; it was just a down-and-dirty print, and it was beautiful.

In the end, nothing happened at *SI*. Nobody seemed to care about my Ameche picture.

So I went to Plan B.

By the time I was fourteen or fifteen, I had become aware of what were then called "one-shot" magazines. Before the football season, these magazines ran photos from the previous year and stories that looked ahead. There were *Street & Smith*, *Argosy*, *True*, and *Dell*. So after I got nowhere at *Sports Illustrated* with my Ameche print, I started showing my Giants pictures to the editors of all the one-shots.

My first stop was *Dell Sports* to see the editor, Bob Markel. His assistant was a young Irish kid from the Bronx named Ken Regan who would become one of my best friends for more than fifty years. Markel liked my photos and said he wanted to hold on to a bunch. And, lo and behold, the following August, they used my Ameche touchdown, full page, on the inside cover of the magazine. This meant it was the glossy cover stock—not the cheaper paper used inside the magazine—and it really looked nice. Inside, they used other pictures I had taken of the Giants on the sidelines in the snow. I can't remember how much I got paid—twenty-five or maybe fifty dollars per picture—but I was thrilled.

Markel became my hero. He even gave me a credit line, but more important, the other photographers in that magazine were all the stars of the business. The biggest, perhaps, was Marvin Newman, who practically owned the cover.

Oh boy, I thought. Now I'm in the business, too.

CONTENTS:

DELL SPORTS MAGAZINE

VOLUME 1, NUMBER 10: NOVEMBER 1959

SPECIAL ISSUE: PRO FOOTBALL

CONTRIBUTING EDITORS:

JOHN STEADMAN, Baltimore News-Post
CHUCK HEATON, Cleveland Plain Dealer
TOMMY DEVINE, Detroit Free Press
CAL WHORTON, Los Angeles Times
CHUCK JOHNSON, Milwaukee Journal
HERB GOOD, Philadelphia Inquirer
JIMMY MILLER, Pittsburgh Sun-Telegram
DARRELL WILSON, San Francisco Chronicle
LEW ATCHISON, Washington Star
GORD HUNTER, Calgary Herald
TOM HARRIS, Edmonton Journal
DICK CARROLL, Montreal Gazette
JIM KEARNEY, Vancouver Province
GORD WALKER, Toronto Globe and Mail

editor, dell sports: Bob Markel art editor: Angelo Greene
associate editors: Joe Sheehan, Stanley Woodward art director, special projects: Bill Chevalier
issued monthly: Ken Rogan cover photo by Rush & Walker from Frank Clillone
art director: Fernando Texidor editorial director: Richard L. Williams

DELL SPORTS MAGAZINE is published six times a year by Dell Publishing Co., Inc., Washington and South Avenues, Dunellen, New Jersey—Special Issue: BASEBALL issued in January, Special Issue: BASEBALL STARS issued in February. Special Issue: WHO'S WHO IN THE BIG LEAGUES issued in June. Special Issue: PRO FOOTBALL issued in August. Special Issue: STANLEY WOODWARD'S FOOTBALL issued in September. Special Issue: BASKETBALL issued in November. DELL SPORTS MAGAZINE, Vol. 1, No. 10, November 1959. Copyright 1959 by Dell Publishing Co., Inc. Executive and editorial offices, 750 Third Avenue, New York 17, N. Y. Albert Delacorte, Publisher; Helen Meyer, President; Paul R. Lilly, Executive Vice President; Harold Clark, Vice President-Advertising Director. Published simultaneously in the Dominion of Canada. International copyright secured under provisions of Revised Convention for Protection of Literary and Artistic Works. All rights reserved under Buenos Aires Convention. Printed in U.S.A. Chicago advertising office, 221 North LaSalle Street, Chicago 1, Illinois. DELL SUBSCRIPTION SERVICE, 321 West 44th Street, New York 36, N. Y. Single copy price 25c in U.S.A. and Canada. Subscriptions in U.S.A. and possessions and Canada, $2 per year. Pan American and foreign, $2.50 per year. Application for second-class entry is pending at Dunellen, N. J. POSTMASTER: Send notice on Form 3579 to 321 West 44th Street, New York 36, N. Y.

THIS WAS THE END: Alan Ameche (left) of the Colts blasts through Jim Patton—and the Giants' goal line—to score the title-winning touchdown of 1958, in the sport's first overtime finish.

BALTIMORE COLTS AT A GLANCE

RUSHING—Stronger inside than out
PASSING—Great with Unitas
KICKING—Punting below par
DEFENSE—Strong lines, fair backs
ROOKIES—Not outstanding

(For schedule and statistics see Form Chart.)

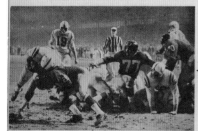

FINAL SCORE: Unitas (19) handed off to Ameche who crashed over for the score that gave the Colts the pro title in a spectacular sudden-death overtime, 24-17. Here Jim Patton (20) tries vainly to halt Ameche's touchdown dive.

THE OTHER CLUBS ARE OUT TO KEEP ⟵ THIS ⟶ FROM HAPPENING AGAIN...

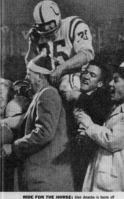

RIDE FOR THE HORSE: Alan Ameche is borne off the field by jubilant Colts fans who had waited years and years for their moment of triumph.

continued

fact the rest of the conference is gunning for them, the Colts, with their proven performers, appear likely to surmount the stiffest opposition.

Depend on it, some of this opposition will be dirty. They'll tear in on Unitas, for instance, under full heads of steam to keep him from throwing touchdown passes. They'll clash him after he's thrown the ball. Some of them will be out to re-crack his ribs if they can—knowing that Baltimore without Unitas wouldn't be the same team.

Offensively, the Colts boast standout blocking bulk and mobility (Jim Parker and Art Spinney) in the line, lightning speed (Lenny Moore) and thunder (Alan Ameche) in the backfield, a pair of sure-handed ends (Ray Berry and Jim Mutscheller). And at the throttle, the coolest Colt of all, the TD-flinging Unitas.

Defensively, Baltimore has a rough four-man crew up front, led by Marchetti and Gene (Big Daddy) Lipscomb, a keen, roving trio of line-backers and an alert quartet of pass guardians, headed by Carl Taseff and Andy Nelson.

However, one discordant note has cropped up on the rosy-hued Baltimore landscape. George Shaw, No. 2 quarterback, has grown restless on the bench and has publicly broadcast his desire to be traded.

Shaw, after making an admirable showing in his rookie season in 1955, was sidetracked by a knee injury the next year, the accident opening the way for Unitas. Shaw hasn't been able to get his job back since.

The Colts made a few stabs at complying with Shaw's wishes but with what degree of earnest-ness it's hard to tell. Of the teams contacted felt that the asking price for Shaw was unrealis-tically high. No deal has resulted as yet and it would not be surprising if Shaw remains a Colt.

The remainder of the Colts' offensive cast is well set. It's fleet Moore and clever L. G. Dupre at the halfback posts and Ameche The Horse at fullback.

Moore, Baltimore's deep threat, is so fast that it's virtually impossible to cover him with only

one defender. The former Penn State flash raced for a team-high total of 938 yards after catching 50 passes last year. On the ground he went for 598 yards on 82 carries.

Ameche is the old-fashioned type of plunging fullback. He was Baltimore's leading rusher again in 1958 with 791 yards and the 220-pound battering ram hiked his four-year total to 3,103 yards.

Slated for more offensive action in his sopho-more season is Leonard Lyles, once described as "the fastest man in football." Moore adherents take issue with that statement. Lyles broke in mostly on the kickoff return platoon and had a 103-yard scoring sprint as one of the gems of the season.

Berry and Mutscheller are two dependable pass-clutchers who, though not fast, can "hook" their way into the clear for short yardage. Berry, one of the heroes in the Colts' drive to the tying field goal against the Giants, caught more passes (56) than anyone else in the league last year, and

gained 794 yards.

Tackles are Parker, 270-pound All-Pro, and George Press (245). The capable guards are Spinney (250) and Alex Sandusky (235) with Buzz Nutter (235) at center.

Marchetti, a 6-4, 240-pound quarterback-rush-ing terror who has been All-Pro many times and the veteran, Don Joyce (6-3, 255), are the wing-men in the toughest defensive line around. With tackles Art Donovan (270) and the gigantic Lips-comb (288), they limited the enemy to a league-low 1,291 yards and spilled passers for losses totaling 256 yards.

The backers-up are Bill Pellington, Don Shin-nick and Leo Sanford. Dick Szymanski, on the injured reserve list last year, returns as the 36th veteran and will battle for a starting spot here against Sanford.

Baltimore's once porous secondary was solid-ified to such an extent that its roving defenders compiled the best theft record in the NFL, 35 interceptions. Halfback Taseff and safetyman Nelson were joined by sophomore Ray Brown and Milt Davis as the right cornerman. With greater experience working together, they should be even more deadly on the opposition's aerial attempts.

Another long-time Baltimore headache was ap-parently cured when Brown became the regular punter late in the season. He finished with a satisfactory 39.9 average on 41 kicks.

The Colts have a unique two-way field goal threat. Bert Rechichar, utility defenseman, boots the long ones (he holds the league record of 56 yards) and Myhra, sub offensive guard, the "chip-pies."

Hanson Churchwell, a 250-pounder from Mississippi, is rated the rookie with the best chance of making the club at offensive guard.

If there is a gleam of hope for the other West-ern clubs to derail Baltimore from a second straight title, it rests on the fact that several of the important Colts, especially defensively, are on the acid side of 30 with long service in back of them. In this group are Donovan, a 10-year man at 34; sub defensive tackle Ray Krouse, ninth year at 32; Sanford, ninth year at 30; Taseff, eighth at 31; Marchetti, eighth at 32 and Spinney, eighth at 32.

If some of these older Colts fade it will slow down Baltimore's offensive and defensive power-houses. But if they don't falter, Johnny Unitas & Co. are heading for another title roundup.

COLTS SPREADS FROM PRO FOOTBALL ISSUE, *DELL SPORTS*, 1959.

LIFE ROCKEFELLER CENTER, NEW YORK 20, N. Y.

Memo to Neil Leifer

Sorry, Neil, but the answer from
our Miscellany page editor was
no thanks.

Thanks a lot.

128-07 234th St.
Laurelton 22, New York

Ruth Lester

CONTRIBUTIONS DEPARTMENT

MISS LEEN AND ANNE BANCROFT

> " *Neil Leifer is a genius. How do I know? His mother told me.*
>
> —ED KOCH, former New York City mayor

Ruth Lester was a charming woman who was the contributions editor at *Life* magazine during the 1950s. Her job, essentially, was to keep the editors and the photo department from having to talk to every crackpot or amateur—or deli delivery boy—who thought he was good enough to shoot for the magazine. In other words, people like me. I would come into the *Life* offices with pictures that weren't remotely good enough but I thought might end up on a "Miscellany" page or maybe a "Speaking of Pictures" spread. Ruth's job was to be as nice as possible while keeping the editors from having to waste time with nobodies like me.

"Neil, these are really good," she would say. "But the story isn't something that's going to work in the magazine." Or, "Neil, I showed it to the editor"—which she may or may not have done—"and it just doesn't work." Or, "We have something similar that we're going with this week."

At the time, *Life* had the world's greatest photo staff ever assembled—people like Alfred Eisenstaedt, Carl Mydans, Margaret Bourke-White, Dmitri Kessel, Ralph Morse, and George Silk. Trying to break into that group was like shooting for the moon. But one day in 1959, when I was delivering sandwiches from the deli, I showed some pictures to Ruth and she said, "Listen, there may be an opportunity here that I think you'll really like. One of the staff photographers is looking for an assistant. Nina Leen. I think you know her work."

What I knew was that Nina often did fashion, among other things,

including, years later, a great *Life* essay on bats—actual bats, the kind that fly around at night and maybe suck your blood. Who in their right mind . . . ? But Nina was very talented—and very difficult. I didn't realize that's why nobody lasted very long as her assistant, which must have been why she was looking for a new assistant every few months. All I did know was that she was a *Life* photographer and I would have paid her (not that I could have afforded it) to hire me. And it was a full-time job. "When she works, you'll be with her as her assistant," Ruth Lester said. "When she isn't working, she'll still pay you, but you're going to be available full-time."

I immediately called Nina and met with her, and she hired me on the spot. It all sounded perfect—too good, in fact, to be true.

A week or two later, Nina phoned me. "We have an assignment. I am photographing Anne Bancroft, who is about to open on Broadway in *The Miracle Worker*. We're going to spend the day with her in Wildwood, New Jersey, where she is preparing for the play."

Nina added, "I live in Tudor City and I want you to meet me there. We'll leave at seven in the morning, and you should be dressed properly for this. I'd like you in a jacket and tie."

It was summer, hot and muggy, but I wore my wool jacket—the only one I owned—and put on my tie. When I arrived at Tudor City, I said, "Good morning, Nina."

"You will refer to me as *Miss Leen*," she said darkly.

I was a little taken aback because at Time, Inc., Henry Luce would correct you if you addressed him as Mr. Luce. "It's Henry," he'd say. Andre Laguerre, the legendary *SI* managing editor, was feared by everyone but known to all as Andre.

Miss Leen handed me the camera bag, which was heavy, but in those days I was in great shape. Then she said, "We're going to drive across town to pick up the writer."

She had a convertible and she directed me to the back seat, where I sat in my jacket and tie. I noticed that she was dressed for a day at the beach, wearing a halter top. I was afraid to ask if I might take off my jacket. The writer got into the car, and we headed out on the Garden State Parkway. Before long, the writer said she had to go the ladies' room. Miss Leen immediately pulled into the first rest stop. I soon learned that I could be peeing in my pants and she wasn't pulling into any rest stops for me. But the minute the writer asked, "Can we stop for coffee?" Boom! Right into another rest stop.

Miss Leen also made it clear to me, "You only talk when I've asked you a question." But nobody said a word to me, though they gabbed nonstop all

the way to Wildwood. Meantime, the writer asked Miss Leen to put down the top, and they sat comfortably up front in their halters and shorts while I was in the back sweating in my wool jacket and holding on to my hair because Miss Leen was going seventy-five miles an hour.

We finally arrived at a hotel in Wildwood, and Miss Leen ordered me to take the camera bags, adding, "You are not to speak to Miss Bancroft."

We went inside, and she showed me the lenses and explained what each one was for—which I already knew—and it was only then that I found out what the assignment was about. Anne Bancroft wanted to know what it was like to be blind—she felt this was important when she played Annie Sullivan, Helen Keller's tutor—and so she wore gauze over her eyes and sunglasses over the gauze. She had invited *Life* magazine to spend the entire day. Miss Leen never introduced me to Anne Bancroft. It was as though I wasn't there. I thought, "I can't believe this is happening."

She started shooting in the actress's hotel room, and we later drove to a series of locations. She shot Anne Bancroft on a swing, then on the beach. At each new location, Miss Leen would get out of the car to check the light and decide if it was a good time of day to shoot there. The writer would get out, too, leaving me alone with Anne Bancroft. We were both in the back seat, and she was frightened because she couldn't see. The first time this happened, Miss Bancroft said, "So what's your name, young man?" I said, "Neil," although I wanted to say I wasn't supposed to talk to her. Then she asked where I lived and did I work with Miss Leen all the time? I explained this was my first day, and she said, "I've seen some of Nina's pictures. She's a wonderful photographer." I said, "Oh, she's one of the great *Life* photographers," and we kept talking until Miss Leen came back to the car. Anne got out of the car and walked ahead with the writer while Miss Leen turned back to me and launched into a lecture. "I told you not to speak to Miss Bancroft! It's important that you don't talk to her!"

"Miss Leen," I said, "she talked to me. What do you want me to do? Not answer her?"

"Yes!" snapped Miss Leen. "Don't answer her!"

Toward the end of the shoot, Miss Bancroft gave me her phone number and asked me to call her. She said, "You're a very nice young man. Would you like to see the play?"

I had never been to a Broadway play. I said, "I'd love to," and she ended up sending me two tickets.

Although no words were ever exchanged, or explanations offered, I never worked for Nina—sorry!—*Miss Leen* again.

LEARNING THE ROPES

" *One day this kid rings me up and says, "I'm Neil Leifer. Can I talk to you about sports photography?" He came to see me, and we talked. Sometime later, I got another call from Neil. He was having great difficulties up at Yankee Stadium with the news photographers, who were ostracizing him and preventing him from working there. I tried to give him some advice, but it was not within my power to help him because the newspaper photographers controlled what was going on. I would say maybe he was a little raw. People expected a young man to have a little more respect.*

—MARVIN NEWMAN,
Sports Illustrated photographer

In 1959, I was still trying to sell my pictures as best I could. No editor was going to hire a sixteen-year-old and no team was going to give me a credential. Often I would go to Madison Square Garden or Yankee Stadium and hope to snap some good photos before I was spotted and thrown out.

I had better luck with the Giants. Jack Mara, co-owner of the football team, frequently dropped by the Stage Deli. He got an earful from Max Asnas, who owned the deli, and immediately ordered the team's publicist to give me a season credential.

The Yankees were another story. There weren't that many regular shooters on the beat in those days, but the old press photographers ruled

the press box, jealously guarding their turf and doing everything they could to keep the young guys out. Besides the press box, there were two places you were allowed to work in the stadium; nobody was allowed to roam the stands. One spot was the first base end of the Yankee dugout, where there was one seat for a photographer. I had recently bought a Pentax 35mm camera and I had a little telephoto lens, both of which were perfect for shooting from the dugout area. I would also have taken the one seat next to the visitors' dugout. Both were usually available because those seats could be brutally hot during day games, so most of the newspaper photographers sat up in the mezzanine press box. This was controlled by the New York Press Photographers Association, and especially Charlie Hoff, who worked for the *New York Daily News* and happened to be the premier newspaper sports photographer of his day. I never understood how he could take so many good pictures while he spent most of his time looking to see if I was in an aisle at Yankee Stadium or Madison Square Garden. These newspaper guys would sit up in the press box with their cold beers and sodas and shoot the games with Big Bertha cameras. They rarely used the first- and third-base positions; in fact, only the wire services, AP and UPI, would shoot down there.

But whenever I requested either of those seats, the press photographers would automatically make the same request in order to keep me out. They convinced the Yankees that I didn't belong. "The press box," they insisted, "we control that!" Even though *Dell Sports* was willing to get a credential for me, I still couldn't get in. The old guys made the rules, and no one challenged them.

Marvin Newman couldn't help when I asked him to intervene for me, but I figured there had to be a way to cover baseball. Dell could get me passes for Connie Mack Stadium in Philadelphia, so I started taking the bus there. A round trip train ticket from Penn Station cost around eight dollars, but the Trailways bus cost six. I needed those two extra dollars to buy film, so I took the bus and then the subway to the stadium. There I could shoot from the aisles, and I got some pretty nice pictures for the baseball issues of the one-shot magazines.

Soon I discovered that I could shoot the Yankees on the road. The Baltimore Orioles not only gave me a credential, they were also the nicest people in the world. They were one of only four teams that let photographers work on the field, which was a great place to shoot from. As I began having more of my pictures published, I decided to force the issue at Yankee Stadium.

Someone from Dell told the Yankees that if I couldn't be in the press box or anywhere else in Yankee Stadium, the team could be looking at a lawsuit and that Dell intended to support me. The Yankees finally relented, and I got a credential for the press box. The next year, 1960, I got full credentials for the World Series to shoot for Dell, which meant a roving credential to work in the aisles and a dressing room credential, too.

I was on my way.

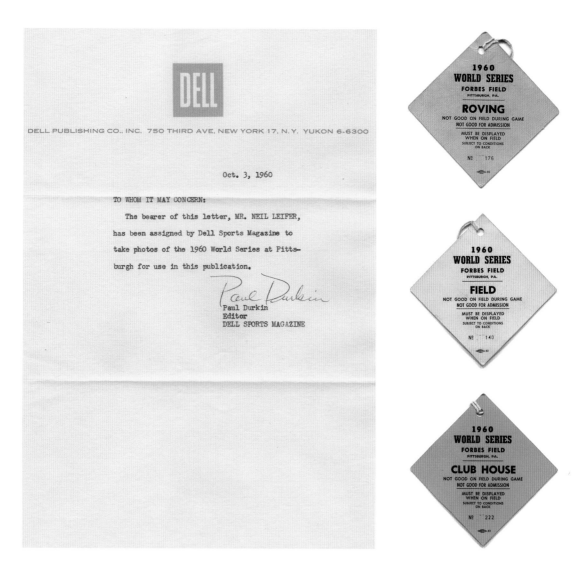

DELL SPORTS LETTER ASSIGNING ME TO THE WORLD SERIES AND PHOTO CREDENTIALS, 1960.

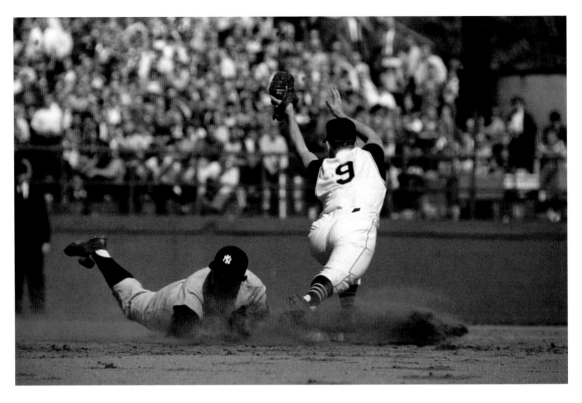

YOGI BERRA GETS PICKED OFF BY THE PIRATES' BILL MAZEROSKI, 1960.

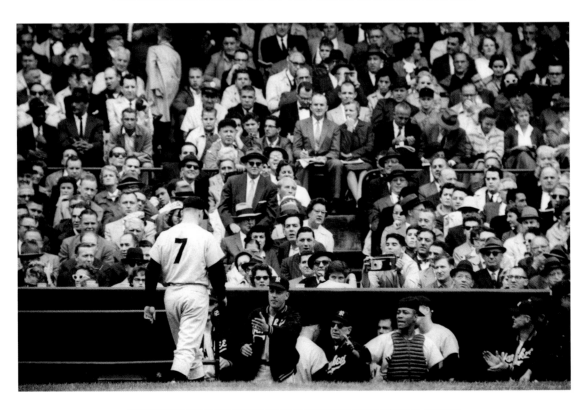

MICKEY MANTLE RETURNS TO THE DUGOUT, 1960 WORLD SERIES.

The Yankees-Pirates World Series opened in Pittsburgh.

Now what I really needed was a Nikon F camera with a motor drive so I could compete with the big boys. It was the state-of-the-art camera and it cost three hundred dollars, plus another one hundred and fifty for the motor drive. I didn't have that kind of money, so I went to my father. I didn't get very far into my pitch before my father became livid, insisting that photography was a "rich man's hobby" and that a fancy camera was a waste of money. Money, by the way, that he didn't have, as he emphatically explained. But being persistent even then, I kept after him, wore him down, and finally talked him into going to Olden Cameras and buying it for me on time, which I wasn't old enough to do by myself. He had never before bought anything he couldn't pay for up front, and he didn't want to start now—certainly not for a rich man's toy. I promised I would make the money to pay for it, and three or four days before the World Series, he grudgingly agreed to the time payment plan. Then I went to *Sports Illustrated* and asked Gerry Astor, the photo editor, if he would give me enough film to cover the series. He agreed. The deal was this: I would be shooting on spec—I'd only get paid for what they published—but *SI* would provide all my film and process it. (Dell would get the pictures in plenty of time for their publication schedule.) "Send your film back each day with our guys," Gerry added.

By "our guys," he meant my heroes—the three stars of *Sports Illustrated*—John Zimmerman, Hy Peskin, and Marvin Newman. I now had exactly the same camera that they were shooting with, along with a 300mm lens and a 150mm lens. In Pittsburgh, a roving credential allowed you to go right up to the front row of the field-level box seats and crouch in the aisle. I was set.

And I had figured out a game plan. The World Series started on Wednesday. Game 2 was Thursday, then came a travel day before games on Saturday, Sunday, and Monday at Yankee Stadium. So coverage of the first four games would appear in the next issue of *SI*, which closed Monday, but only Game 1 would be shot in color. So, naturally, I shot it in color, as did the other *SI* shooters, and I gave my film to John Zimmerman to send back with his. One of my shots

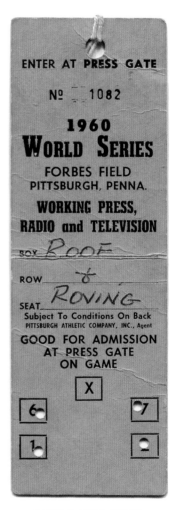

FORBES FIELD PRESS CREDENTIAL, 1960.

was of Yogi Berra getting picked off second base in the second or third inning. And that shot would become the only color page from the World Series in *SI* that week.

Then, in Game 2, Mickey Mantle hit a home run, and I got a nice picture of him from behind, returning to the dugout. This ran as nearly a full page, but black and white.

In those days, *Sports Illustrated* paid three hundred dollars for a color page, one hundred and fifty for a black-and-white page. So in two games I had made enough money to pay for the camera and the motor drive. When the four hundred and fifty-dollar check arrived, I went down to Olden with my father and paid up in full. My father never called photography a rich man's hobby again.

A final note: everyone was fine with my success except Marvin Newman, who was really pissed off. He thought it was unprofessional to work on spec. But I was seventeen years old and nobody was going to hire me. I like and respect Marvin and we're good friends now, but at the time he was quite upset. He'd been very nice when I called him for advice, but I'm sure he never expected me to be a competitor one day.

Five games later, his mood would change dramatically because he's the guy who shot Bill Mazeroski's famous home run that beat the Yankees in Game 7, one of the greatest and most famous photographs in World Series history.

--

Having proven that I could hold my own with the best photographers in the game, I was feeling pretty good about myself and thought I really knew what I was doing. That is, until nine months later when Marvin taught me one of the tricks of the trade. It was December 31, 1961, and we were shooting the NFL championship game between the Giants and the Packers in Green Bay. Marvin—who was, in my opinion, the best football photographer working—and I were the only photographers *SI* had assigned. We were shooting in black and white for what would be the lead story in the magazine.

Five minutes before the kickoff, Marvin asked if I planned to go into the locker room after the game.

"Why wouldn't I?" I said. He asked me which locker room, and I said the Giants'. You always want to shoot the winners' locker room, and both Marvin and I were certain the Giants would beat the Packers.

Marvin, who has quite a healthy ego, said somewhat smugly, "Then you

left a camera in there, didn't you?" I had no idea what he was talking about. He said, "I did. Frank Gifford's holding it for me in his locker."

"Why?" I asked.

"Because it's so cold outside that when you go into the locker room, the camera sweats and the lens fogs up, and it takes a long while for it to clear up."

It was too late for me to run back and leave a camera. "Dammit!" I thought. "That's one picture I'm not going to get."

Except the Packers beat the daylights out of the Giants, 37–0. I'll never forget seeing Marvin in the hall outside the Giants' locker room, pleading with the guards to let him in so he could collect his warm, dry camera from Frank Gifford's locker. The press is always allowed into the winners' locker room first, and, sure enough, when they let us in, my cameras sweated up and I could barely shoot. I was trying madly to wipe the condensation off the lens, but nothing worked.

SPORTS ILLUSTRATED, JANUARY 8, 1962.

When my camera finally cleared up, I snapped Paul Hornung. My shots were a little foggy, which made them atmospheric and all the more effective. Meanwhile, Marvin was still out in the hall, banging on the Giants' locker room door. He finally made it into the Packers' locker room and took a picture of Hornung, the only shot from Marvin that *SI* ran on the six-page spread. I got space on all six pages, including a closing double truck (a full two-page spread).

But I'd learned my lesson. It's nice to know the old tricks of the trade, but you also need to know that they can backfire.

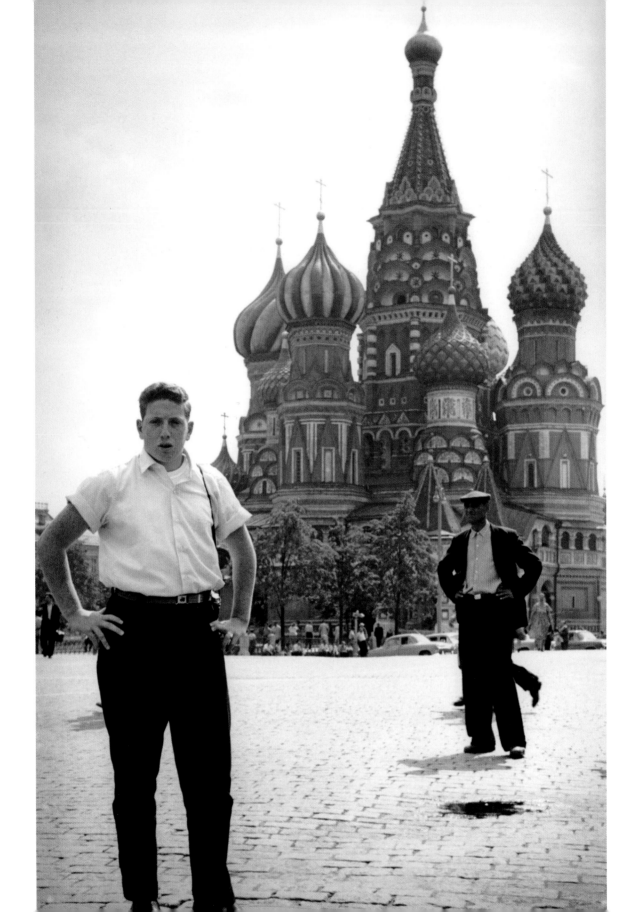

OF ARMBANDS AND ARMPITS

> " *You've got to remember that this is a guy who got his start by wheeling veterans in wheelchairs into Yankee Stadium.*
>
> —FRANK DEFORD, *Sports Illustrated* writer

U nderstand, I had never been west of Kansas City. I had never been out of the country, not even to Canada or Mexico. And yet, there I was, brand new passport in hand, bound for Moscow, where *Dell Sports* had arranged to get me a credential to photograph the 1961 Russian-American track meet.

Sports Illustrated was sending Marvin Newman and Jerry Cooke, two of its best photographers, to cover the meet and had agreed to look at my film on spec. This whole trip was a big deal because it was the height of the Cold War and visas to the Soviet Union were hard to get. Stalin hadn't yet fallen out of favor; in fact, his body was still in the mausoleum in Red Square. It was the last year before they moved him out, and I was able to see him there. (He'd been dead nine years, but he looked great. His mustache was fantastic!) The Leifer Theory about why they removed Stalin from the mausoleum is that he was showing up Lenin. Anyone who's ever seen Lenin knows he's a shriveled-up ball of wax. I will confess, I spent three days trying to get up the nerve to take Stalin's picture—no photography was permitted—but I finally decided not to risk it.

My trip would take me to AAU track meets in Russia, Poland, Germany, and England. Russia was first. And, remember, track and field was big then. Credentials were hard to come by, especially for non-Russians. I couldn't wait to get mine because I had collected every credential I ever had and this would be my first in a foreign language. It was going straight to the Leifer Hall of Fame.

To pick up that credential, you had to go to Lenin Stadium, the site of the competition. Now, back home, nobody cares what you do with your credential after a sports event, but I would soon discover that the Russians had a different system. We walked down the stairs into the bowels of Lenin Stadium. Seated behind a desk was Mr. Clean, a big bald guy who looked like a former weightlifter. He was right out of some bad Cold War movie and would have been perfectly cast as commandant of a Russian prison. You presented this guy with your letter confirming that you were to get a field credential. He checked your name against a typed list.

Behind him were shelves filled with thick folders, all neatly arranged. I handed Mr. Clean my letter, which included my name and Dell affiliation. An English-speaking translator conferred with Mr. Clean, who, after checking his list, handed me an armband with a number and something written in Cyrillic. Then he opened a book and pointed to my number, indicating where I was to sign. Apparently, they used the same armbands for every event held in Lenin Stadium, from sports to concerts. I was told in no uncertain terms that I had to return the armband when the meet was over.

I thought, fat chance! This armband is never going back. And when the meet ended, I left Russia, my armband tucked away in my camera bag.

The following year, 1962, the U.S.-Russia meet was held in Palo Alto, and it turned out to be a kind of turning point for me. This time I was there for *SI* with Hy Peskin, a veteran at the magazine and one of its best shooters. He was also one of my heroes. The magazine had allotted six pages just for photos—the only text would be captions—and I got all six pages, shutting out Hy Peskin. I was finally convinced I could work with the big boys.

In 1963, the meet was again held in Moscow, and I was the only *SI* photographer assigned to shoot it this time. I'd covered about a hundred events in the past couple of years, so I was feeling confident about the work ahead of me. Hell, I even knew the drill for picking up credentials at Lenin Stadium. So I went to the stadium again, and there was my old friend, Mr. Clean, as menacing as ever. As soon as he saw me, he scowled. I suspected something might be wrong.

СССР США

ПРИГЛАСИТЕЛЬНЫЙ БИЛЕТ

ПРЕССА

„Deil sport"

Федерация легкой атлетики СССР
приглашает Вас на матч между сборными
командами СССР и США по легкой
атлетике, который состоится 15—16 июля
1961 года в 17 часов на Центральном
стадионе имени В. И. Ленина.

SOVIET CREDENTIALS AND A PHOTO ARMBAND, 1961.

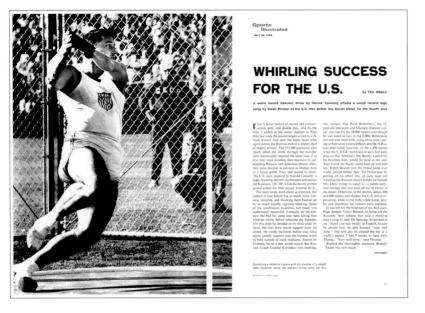

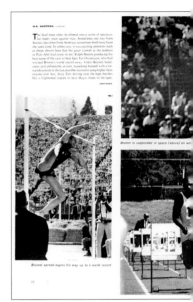

I stood in line with the other photographers and when my turn came, I handed him my letter. This time there was no interpreter. I think I said something like, "Hi, how are you?" And he said one word, which I will never forget. "Nyet!"

I had about six words of Russian. One of them was "Da" (yes). I said, "Da!" and again he said, "Nyet!" I had no idea what was wrong. Did he think my letter was a fake?

Someone in line who was actually bilingual came over and said, "What's the problem?"

Mr. Clean rose from the desk, grabbed a little stepladder, and began perusing the volumes of ledgers on the bookshelves. He pulled one down, slammed it on the desk, and flipped it open to the page from the 1961 track meet. There were maybe one hundred names on each page and every one had two signatures—except mine, which had only one because I had never signed out and returned my 1961 armband. He then accused me of stealing the armband.

Now, I pride myself on being a pretty honest guy. I don't lie, which sometimes gets me in trouble. But this time, I had no choice. I said, "I didn't know I had to return it."

Mr. Clean said, "Nyet!"

Eventually, someone from the *Time* bureau arrived, along with a representative of the Russian track federation, who translated. "It was

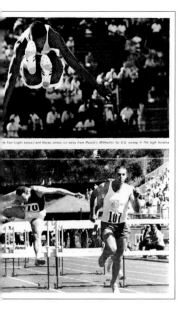

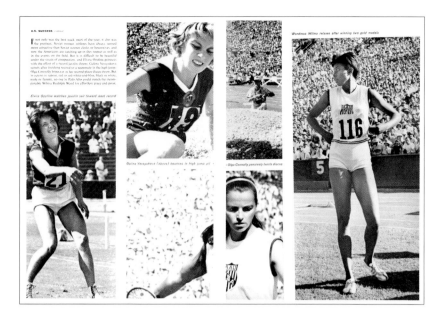

explained to you in English—that's what he's telling me," the bureau man said, laughing.

"Then I must have forgotten," I said.

Finally, the head of the AAU went to the Russian federation and said, "This is *Sports Illustrated*. It's the only American publication that sent a photographer." Mr. Clean was adamant, but he was finally overruled by the track federation official.

Grudgingly, he backed down. But he made me swear up and down that I would bring back the armband and that I understood perfectly that it had to be returned.

Which is why I have only one Russian armband in my collection.

- -

Russia was not to be my only problem on that trip. As part of my pitch to get *SI* to send me to the four AAU meets, I suggested an essay on top women athletes in each country for the following year's preview issue of the Olympics. I was accompanied by Anita Verschoth, a veteran *SI* reporter and writer, who was German by birth and specialized in Olympic coverage. The piece I wanted to do was about why American women couldn't ever beat the Europeans. In Poland, I shot some women posing, then we went to Germany to shoot the West German women. Not that I was expecting any Heidi Klums—in fact, there had been rumors about the

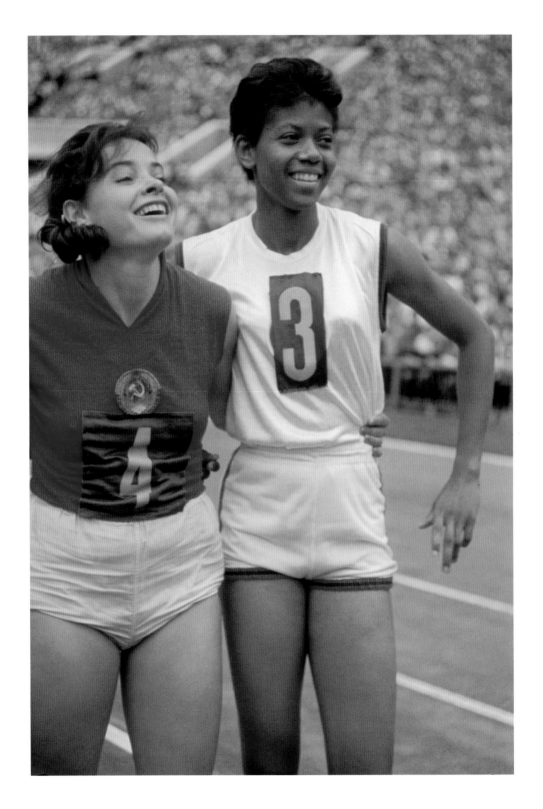

WILMA RUDOLPH, RIGHT, WITH GALINA POPOVA OF THE USSR, 1961.

gender of some Eastern European athletes—but most of the women I'd been photographing were not very attractive.

One exception was the West German Jutta Heine. She was one of the greatest sprinters on earth, having finished second to Wilma Rudolph at the 1960 Olympics in Rome in both the 200 meters and as part of the 4 × 100 relay team. She was also a champion pentathlete and a drop-dead beautiful blonde. Most of the athletes I was shooting were runners, so I saw a chance in her to do a strikingly different picture: Jutta Heine, poised to do the shot put, one arm pointing straight up in the air, as shot-putters do, ready to hurl it.

I was twenty years old and knew next to nothing about women. I certainly didn't know that European women, including Jutta Heine, did not shave their underarms. And while I didn't think there was anything wrong with hair under the arms, I knew it wouldn't be appealing to an American audience, and I worried that the editors might not run the picture.

So I asked, "Jutta, would it be possible for you to shave your underarms? In America, it's going to be a little off-putting."

Before Jutta could respond, Anita blew a gasket. She thought I was an idiot to begin with. I wasn't cool, I wasn't sophisticated, I didn't know how to order the right wine at dinner. And even though I always got along with her, she made it clear that she was an adult and I was still a child. "You can't ask her to shave her armpits," Anita fumed. "Are you crazy? She's not going to do that."

"Why can't I at least ask her?" I argued. "If she says no, there's nothing we can do about it, but I don't think they'll run the shot put picture. Besides, this girl's got a gorgeous face. It will be a perfect lead picture. All she can do is say no."

Anita turned on her heel and walked away muttering, "Well, I can't have anything to do with this."

Now I was on my own, and since Jutta didn't speak much English, it got a little difficult. I gestured shaving my armpit. She got the idea and said she really didn't want to do it, that her boyfriend wouldn't like it. Nothing I could say would change her mind. I took a picture of Jutta with the shot put over her head, but *SI* ended up running a different photo of her that wasn't nearly as good. And I think it's fair to say that they didn't use the shot put picture *because* of the armpit hair.

FOLLOWING PAGES: WILMA RUDOLPH WINS THE 100 METERS, 1962.

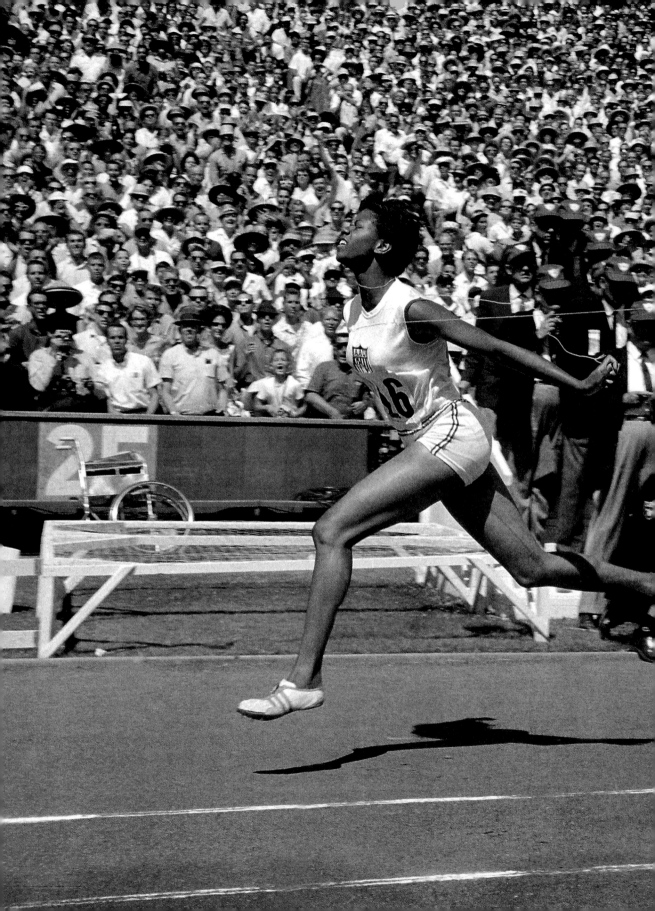

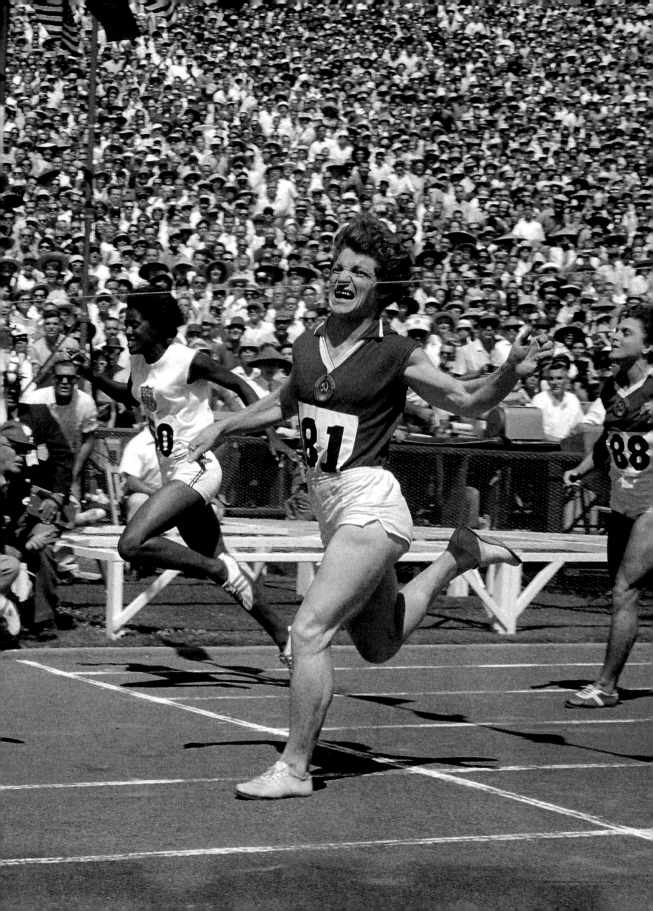

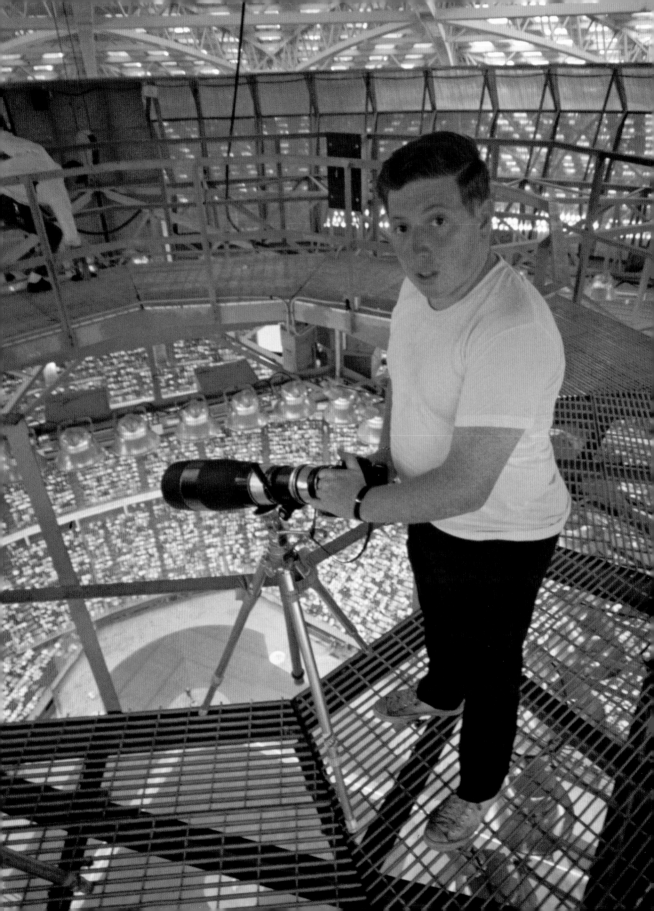

A TICKET TO ANYWHERE

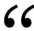 *He's incredibly tenacious. If you were going to move a mountain, don't use dynamite, just ask Neil. Eventually, he will convince it to move.*

—SYLVESTER STALLONE, actor,
screenwriter, and director

I really wanted to go to California. I had never been there, and the best way to get there was to give *SI* a reason to send me.

At the 1961 AAU track meet in Moscow, I had become friendly with a runner from the U.S. track team, Nick Kitt. He had a car that he'd be driving from his home in the Midwest to begin a teaching job in Los Angeles, and he told me that he'd love to have some company. A tight pennant race was heating up in the National League, and I convinced *SI* to assign me to shoot the Dodgers-Reds game at Crosley Field in Cincinnati.

Now all I needed were some assignments in Los Angeles, so I told Gerry Astor, the photo editor, that I'd be out there for the next month. I couldn't really afford such a trip, and being only nineteen years old, I couldn't even rent a car. But Nick had offered me a ride and said I could stay with him in L.A. My problems were solved! He picked me up in Cincinnati, and we headed west on the old Route 66.

Gerry Astor had already approved one idea I wanted to try. I had read about the water polo match between the Russians and the Hungarians at the Melbourne Olympics in 1956. The Hungarian Revolution began around the time of the Games—possibly even during the opening

SHOOTING THE HOUSTON ASTROS FROM
THE TOP OF THE ASTRODOME, 1965.

41

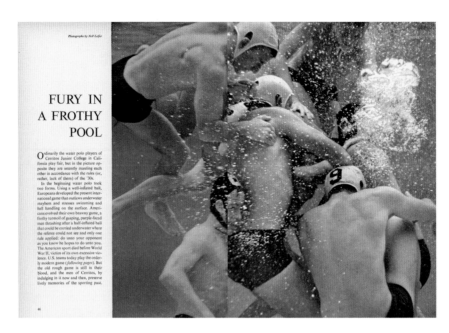

Photographs by Neil Leifer

FURY IN
A FROTHY
POOL

Ordinarily the water polo players of
Cerritos Junior College in Cali-
fornia play fair, but in the picture op-
posite they are intently mauling each
other in accordance with the rules (or,
rather, lack of them) of the '30s.
 In the beginning water polo took
two forms. Using a well-inflated ball,
Europeans developed the present inter-
national game that outlaws underwater
mayhem and stresses swimming and
ball handling on the surface. Ameri-
cans evolved their own brawny game, a
frothy turmoil of gasping, purple-faced
men thrashing after a half-inflated ball
that could be carried underwater where
the referee could not see and only one
rule applied: do unto your opponent
as you know he hopes to do unto you.
The American sport died before World
War II, victim of its own excessive vio-
lence. U.S. teams today play the order-
ly modern game (*following pages*). But
the old rough game is still in their
blood, and the men of Cerritos, by
indulging in it now and then, preserve
lively memories of the sporting past.

SPORTS ILLUSTRATED, APRIL 23, 1962.

ceremonies—and the Hungarian team didn't know if their families were being slaughtered back home by Russian troops.

One of the last events of the Olympics was this semifinal water polo match. Back then, rules allowed the ball to be handled underwater. What generally happened was that players would submerge to try to grab the ball, but they would avoid touching their opponent. This game proved different. These two teams hated each other, and the players went after each other's bodies. The Hungarians won, 4–0, in what became known as the "Blood Bath of Melbourne."

A change of the rules prohibited players from submerging the ball. I thought it would be great to do a piece that showed the old way the game was played and how it was played now. Gerry agreed. So now I had my first L.A. assignment.

This left me with two big problems. One, I had never taken an underwater picture—of course, I didn't tell Astor that—so I'd have to figure out how to do it, and fast. And two, I had never seen a water polo game, not even the "Blood Bath" that had caught my attention in the first place. I had no idea how it was even played. Nevertheless, I had already determined that I wanted to do a split-level shot—the top half above water, the bottom

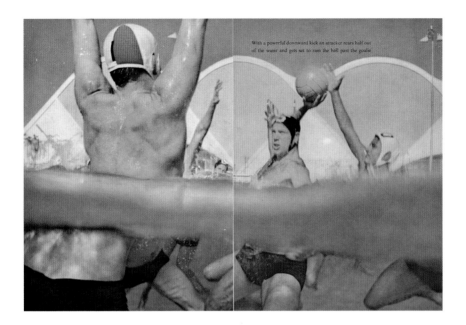

With a powerful downward kick an attacker rears half out of the water and gets set to ram the ball past the goalie

half below. I also wanted to shoot full frames underwater to show how the game used to be played.

I had seen some split-level pictures by John Zimmerman, and the guy who had modified John's cameras was Coles Phinizy, an editor and writer at *Sports Illustrated*. So before leaving New York, I went to Coles and told him what I wanted to do. He said no problem. He lent me a camera that he'd made and showed me how to use it.

The camera was in an underwater housing that floats, so the bottom half of the frame is shot underwater—showing feet kicking, for example— and the top half above the water. Then, because it's darker underwater, he used two lenses with slightly different f-stops and a neutral density filter above the water to make sure it's the same exposure as the under- water half of the frame. All I needed now were some water polo players to experiment with. When I got to Los Angeles, I started calling colleges.

I drove to Cerritos College, outside Los Angeles, and knocked on the door of the water polo coach, Bob Horn. I told him that I had an assignment from *Sports Illustrated* and explained my idea. He loved it. He put together a team of his players, who posed for me while I shot the split-frame pic- tures, and the underwater shots. The spread ran for four pages in *SI*.

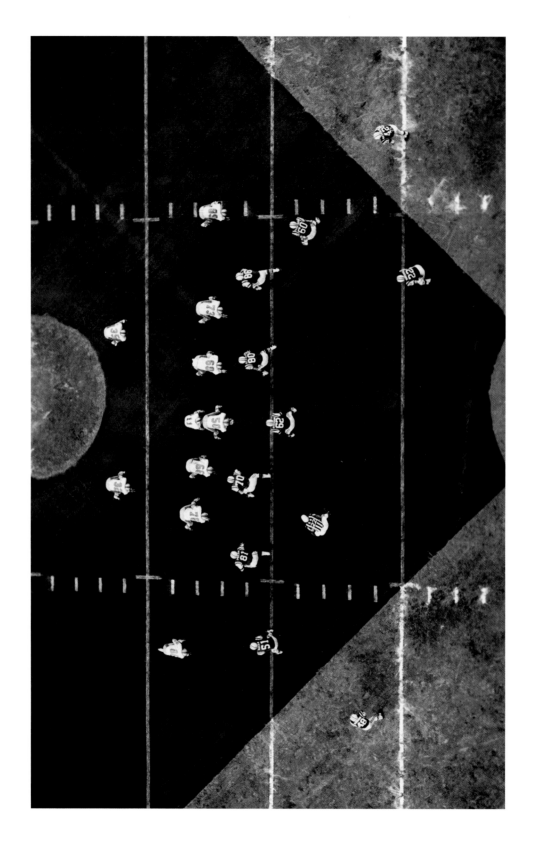

OILERS AND JETS, SHOT FROM THE TOP OF THE ASTRODOME, 1968.

I mention this particular assignment because it convinced me that my philosophy about how to get assignments worked. As early as 1960, I had decided I wanted to shoot everything I could—the World Series, the NFL championship, heavyweight title fights, the Olympics, all of it. I was amazed at how many photographers would come to the office and say to the photo editor, "What do you have this week?" Or even better, "We really should cover the World Series." Well, of course, they were going to cover the World Series. The photo editor would say, "Listen, I'll think about you, but I've got five other photographers." Sometimes, the photographers didn't even come into the office, they called from home. But I couldn't sit still in Queens, waiting for the phone to ring. I wanted to make myself irresistible to the photo editor.

So every Monday I'd go in and say, "I know we're covering the World Series, and I've got an idea that could work real well because that stadium has a peculiar characteristic." I'd study these things whenever I could. Every time I went somewhere, I looked for a new angle; then, when the opportunity arose, I'd go to the photo editor and say, "Listen, the Browns are playing the Giants in Cleveland and that stadium allows you to do this." Or, "I want to go to the Astrodome and shoot an Oilers game from the top of the stadium so the pictures will look like a coach's diagram of the plays." Often the editor would say, "I'm not crazy about that idea, but I want you to go anyway."

I knew that I couldn't be the best photographer at every sport. Hy Peskin was the best fight photographer I ever saw. Marvin Newman was a great football photographer. John Zimmerman was terrific shooting skiers . . . actually, John was terrific at everything. Back then, *SI* would send two, maybe three photographers to the big events, and I was happy to be chosen number two or three. So I'd always come in with an idea to give them a reason to send me, rather than wait for the luck of the draw. And it worked.

I remember Jerry Cooke telling me, "Well, Leifer, there are two kinds of assignments here at *Sports Illustrated*. You can do hockey in Detroit in the middle of winter, or you can do skiing in St. Moritz. Personally, I think it's a lot nicer to do skiing in St. Moritz."

This made me start thinking about assignments around the world. But basically, I thought that any time I took the element of luck out of the assignment process, it helped. I would always do a little homework and suggest a reason why I'd be a good choice for a particular assignment. "Why send Neil to the Kentucky Derby? We know Jerry Cooke will be

FLYING WITH TOP GUN IN AN F-14, 1986.

stationed at the finish line. But Neil suggested an angle that really hasn't been done before. If it works, it's going to be a winner."

Even when the editor rejected my idea, he kept me in mind. I didn't care whether or not he thought I was the best at a particular sport. I just wanted to go. I wanted to be the all-purpose No. 2 guy.

I viewed my camera as my ticket to anything in the world, anything. What kid from the Lower East Side was going to get ten minutes alone in the Oval Office with the president of the United States? I did—with a camera. Growing up, I had built model airplanes, navy planes. What kid with my background was going to get a chance to sit in the back seat of an F-14 and fly on and off an aircraft carrier—or fly with the Blue Angels?

My camera would be the ticket to make my dreams come true.

JOHN ZIMMERMAN, JERRY COOKE, AND ME WITH MEDAL STAND
ATTENDANTS, 1968. PHOTO BY JOHN G. ZIMMERMAN.

FIRST *SI* COVERS

> " *Neil Leifer and Walter Iooss are probably the best sports photographers of all time. What's the difference between them? That's a difficult question because in many cases you would never be able to tell the difference. But if you're talking about Neil's best work, you're probably talking about a photograph that required a lot of planning and thought. Whereas the Iooss photograph would be something he just saw and shot.*
>
> —JIM DRAKE, *Sports Illustrated* photographer

Although things were going extremely well, I was frustrated. I had yet to nail my first *Sports Illustrated* cover. It was 1961, fewer than three years since my Ameche picture, and I was getting plenty of assignments, but I was desperate to get the cover.

Now I should explain that back then, 99 percent of *SI*'s covers closed four weeks in advance. There would be a meeting, and Andre Laguerre, the managing editor, would decide the cover subjects for upcoming issues. The assignment would then be given either to a photographer or an artist. If you got the assignment, it was almost certain you would get the cover. Today, there might be ten photographers shooting a big game for *SI*, all of them competing for the cover. But at that time, there would usually be only one.

Then in October, my day finally came. The photo editor, Gerry Astor, called me into his office and said he wanted me to shoot the Texas-Oklahoma game at the Cotton Bowl in Dallas. Yes, he wanted pictures of the game, but, more specifically, he wanted me to shoot a Texas running

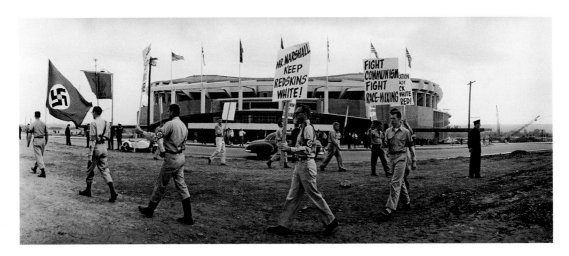

AMERICAN NAZI PARTY MEMBERS DEMONSTRATE, 1961.

back named Jimmy Saxton, a little guy, maybe 160 pounds. And there it was at last: a cover assignment!

Only Jimmy Saxton didn't play much, and as the game progressed, I grew increasingly worried. I had maybe one good action picture, and that's what I assumed the editors would want. I had also shot portraits of him on the bench. One of those, I hoped, would be good enough for the cover. I could hardly wait for the day Andre saw my take.

In the meantime, I was assigned to do a story in Washington, D.C., the next week. The Redskins and Giants would play the inaugural game at a brand new stadium that stood in the shadow of the U.S. Capitol. I was to shoot Redskins owner George Preston Marshall for an *SI* profile, one aspect of which was the fact that the Redskins were the only NFL team left that didn't include a black player, in no small part because Marshall had adamantly refused to recruit one. It was an unbelievable scene: right in front of the stadium I shot a group of black picketers, well dressed and peaceably assembled, holding up signs like the one that read, "A Redskin, A White skin, but no Black skins."

Across the street, and dressed quite differently, were members of the American Nazi Party, George Lincoln Rockwell's group. They were wearing full Nazi uniforms with swastika armbands, and they were chanting, "Mr. Marshall, keep the Redskins White." I was stunned. I don't have to tell you that as a Jew whose mother lost most of her family in the Holocaust, I found these people despicable. But I photographed them marching around, and then I went into the stadium.

It took only fifteen pre-game minutes with Marshall to get all I needed of him. Meantime, I had talked Nikon into letting me experiment with the prototype of a 500mm lens that you could hand hold. Because it was a mirror lens, it also produced this unusual effect, throwing the whole background way out of focus, making it look sort of like Cheerios. I was fascinated by the lens and thought it would be perfect for shooting football. I didn't consider the fact that it had absolutely no depth of field and that the odds of getting something that was moving in focus were not good. You could shoot a hitter in the batter's box because you knew exactly where he was standing, but you could not shoot a pitcher coming forward before he released the ball. When a quarterback drops straight back, though, it's relatively easy to keep him in focus.

I shot Y. A. Tittle, the Giants quarterback, and got a beautiful picture of him dropping back to pass. But I also knew I'd been wrong: this was definitely not the lens for shooting football games.

Anyway, two or three weeks later, Andre Laguerre looked at the Jimmy Saxton cover I had shot. I was so excited, I was pacing the hall outside the picture department. Finally, Gerry Astor came out of the meeting, holding a carousel of slides. At the time, there was a projected list of the covers for the next eight weeks. Jimmy Saxton was on that list for November 27. For November 20, the list said only, "pro football."

"Gerry, did I get the cover?" I asked.

"Yes. In fact, you got two covers."

"What?"

"Jimmy Saxton will be your second cover. We're running Y. A. Tittle first."

It had taken me until the ripe old age of eighteen, but at last I had my *SI* covers.

Y. A. TITTLE, NOVEMBER 20, 1961.

JIMMY SAXTON, NOVEMBER 27, 1961.

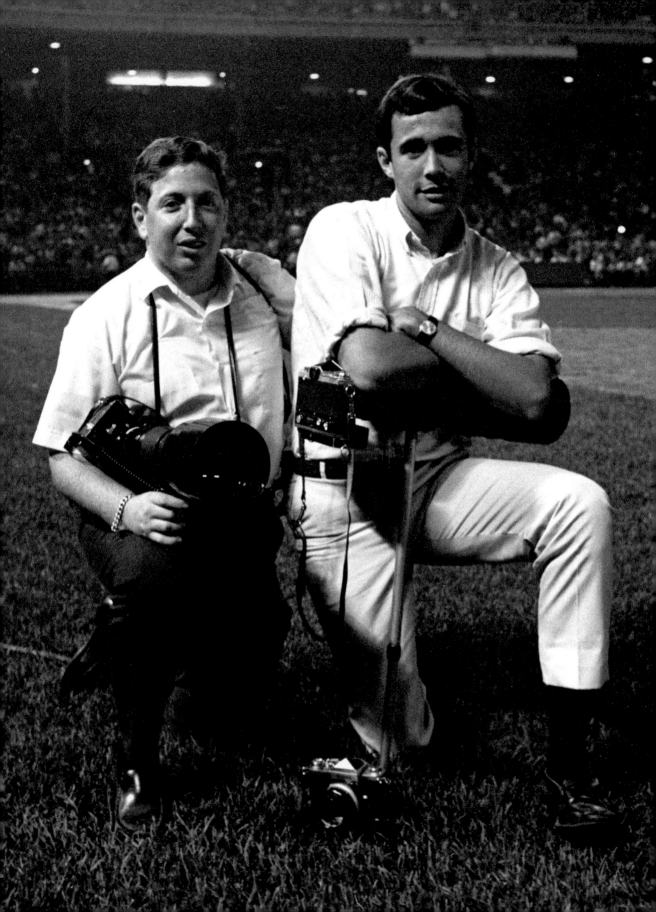

NEIL AND WALTER

> *I first met Neil in 1960 at a New York Titans (later the New Yorks Jets) game at the Polo Grounds. I was still in high school. I don't know how old he was . . . sixteen, seventeen? And I was there with my father, who got me started in this. He would buy the tickets and we'd sit in the stands and take turns shooting pictures. After a while, I became aware of Neil down on the field, the one place I wanted to be. I mean, I didn't know how he was doing it, how he got credentials. So my father yells down to him, "Hey, Red!" Neil came over and my father said, "My son's a budding young photographer. Could you guys meet?" So I met Neil in the lobby of the Time & Life Building and showed him my slim portfolio. Talk about two fucking knucklehead kids. But he took me upstairs to meet the deputy photo editor, George Bloodgood.*
>
> —**WALTER IOOSS**, *Sports Illustrated* photographer

From the moment Walter showed me his photographs in the lobby of the Time & Life Building, I knew he had an amazing talent. And it's true that maybe I helped him get his start by introducing him to George Bloodgood, but when opportunity presented itself, Walter seized it.

For example, after we met in the lobby, I took a project with CBS. They were putting out a book—a day in the life of the NFL—for their advertisers.

They were assigning photographers to each game. When they assigned me, I wanted to do it because it was a better assignment than anything *SI* had given me at that point. So I went to Cleveland and shot the game. I shot Jimmy Brown in the dressing room and Coach Paul Brown, too.

So now, with me shooting for CBS in Cleveland, *SI* had to find someone to shoot the Buffalo-Boston Patriots game. They gave the assignment to Walter. Elbert "Golden Wheels" Dubenion, Buffalo's return guy, ran a kickoff back 100 yards for a touchdown, and the magazine ran six pages of Walter's pictures. Later, Walter told me, "In the photo meeting, Laguerre stood up and said, 'Who is this I-ose fellow?' And George Bloodgood said, 'Oh, he's my guy.' It was my big break. It got me in the lineup. It was the turning point of my career." And he had just turned seventeen.

Walter did a fabulous set of pictures, including a double-truck opener. And I remember it very well because I was thinking I should have done that assignment.

One of the differences is what Walter's gift is versus what my gift isn't. I've always thought that if Walter worked the way I did, he would have been a big failure. He didn't have to work as hard because he did this stuff intuitively and probably could do it with his eyes closed. (Well, maybe that's stretching it a bit.) He could arrive when they were playing the national anthem. His equipment was never working. And he still never missed.

Once he tried to explain to me why he worked the way he did. He said, "By showing up too early, I lose my edge. The national anthem is too late, but an hour before the game? Plenty of time. I couldn't focus, being there early, looking around at an empty stadium, and figuring out where I'm gonna shoot. It doesn't take more than fifteen minutes to figure that out. You look. You know what you're going to do. And you shoot."

Not me. I needed that time. I needed to think where the sun might be at a certain time. I needed to think about the Marlboro billboard in left field that could be a reason Laguerre wouldn't put my picture on the cover. I needed fresh batteries in my motor drive. The lenses had to be clean.

And it was very frustrating to watch Walter arrive.

He had an approach that no one else ever had. He'd show up at the most important football games basically with one camera and one lens, a 600mm, which requires great hand-eye coordination and confidence. Walter was a genius. He never missed. I had to work four times as hard to keep up with him.

Here's an example. I did seventeen Derbies. I studied that track. You don't get to the Derby on Saturday; you get there on Wednesday. So this

one year, 1966, I arrived with six to ten cameras, maybe more, and I had to set them all up. Walter was also assigned—it would be his first Derby. We always looked to see where the other guy was. I knew where Jerry Cooke was. Then I thought: "Wait. Where's Walter?"

And I finally spotted him shooting from an angle I had never considered, with his 600mm lens, and I thought he obviously had no clue what he was doing. Until I saw the cover of the magazine, which, of course, was Walter's. He took one of the best racing covers ever. He also got the cover for the first Super Bowl in 1967. I'm not ashamed to say that Walter out-shot me at that Super Bowl . . . big time!

What was amazing about Walter then was that he took action, perfectly focused, with a very long lens, something that was really difficult to do at the time, and he did it consistently. One of my favorites was Walter's shot of Jimmy Orr, a receiver with the Baltimore Colts. It was one shot, not a motor drive, of Orr with his hands out and the ball, tack sharp, just about to go into his hands. Today, you see this kind of picture every Sunday or Monday, but in 1962, you had to be lucky to get one shot like that in a whole NFL season. And Walter was nineteen years old.

But if I had to pick one of Walter's pictures I wish I had taken? That's really hard. The temptation is to say one from the 1978 swimsuit issue that I will never forget. There was a double truck of a model in a lily pond in Brazil. The picture just stunned me.

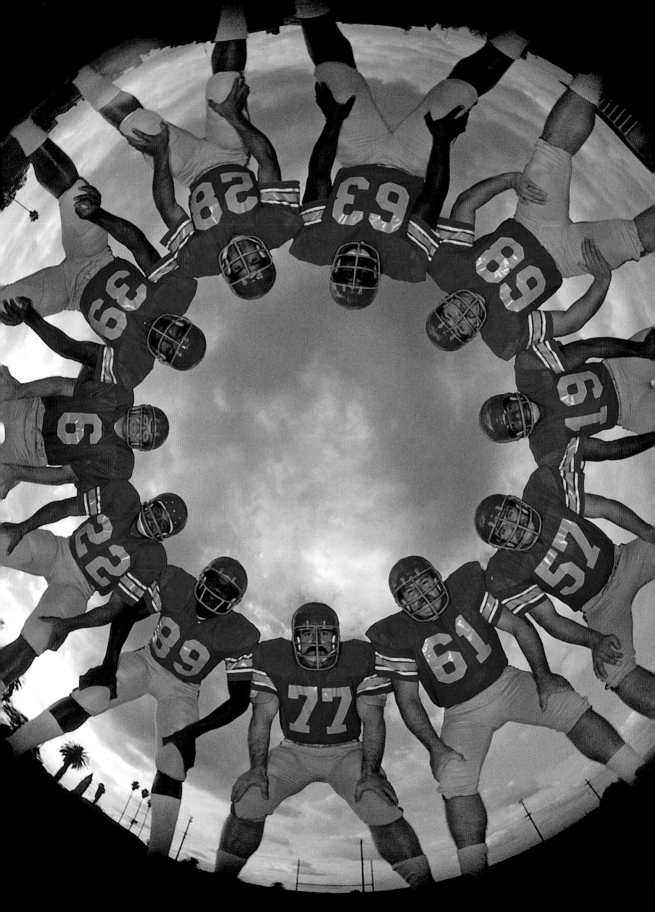

INNOVATION AND OPPORTUNITY

> " *I don't know whether he'll admit to this, but during an assignment with multiple* SI *photographers all competing for the cover or a two-page spread, Neil was extremely good at trying to psych out the other photographers by claiming that he'd just taken a fabulous shot. "You can't believe the picture I got!" And it worked on us to a degree. We didn't lay down our cameras and leave the stadium, but it made us think, "Okay, this guy is on fire. He's getting all the great stuff. What am I getting?"*
>
> —JIM DRAKE, *Sports Illustrated* photographer
>
> *He will deny this to the day he dies, but it's the absolute truth. We were both shooting the Cleveland–St. Louis game and Neil ran along the goal line, right past me, shouting, "Covah! Covah!"*
>
> —WALTER IOOSS, *Sports Illustrated* photographer

Not true. Definitely not true. I never trash-talked like that. Never! The game Walter was talking about—and still talks about—was a Browns-Cardinals game in 1964. And I was definitely in the wrong spot. As Charley Johnson, the St. Louis

quarterback, plunged across the goal line for the winning TD, Walter and I were both behind the goal line. But the play unfolded right in front of Walter. So, of course, he got the cover.

Even so, I would never have taunted him like that because, to tell the truth, I was always a little insecure. Outwardly, I had an ego, but privately, I never expected Walter to miss. And in fifty years, he didn't. Neither did Jim Drake. I mean, these guys were the best. I knew I had to work hard to beat them. And I could never get over feeling that I was the underdog, working at a disadvantage. Walter's father had bought him a Nikon. I had to deliver sandwiches to get mine. Jim majored in English at the University of Pennsylvania. Another of our top photographers, Heinz Kluetmeier, has a degree in engineering from Dartmouth. Me? I took a few semesters, realized I already had a job and didn't need a degree, and decided to drop out.

So I was always trying to get an edge, to do things no photographer had done before. To this end, I studied the best photographers, especially those who worked at *Life*. Ralph Morse was one of them.

Among other things, he was brilliant at creating multiple exposures. In one, taken at the Millrose Games at Madison Square Garden, he shot a triple exposure of the 60-yard dash showing the start, the middle point, and the finish of the race, all on one piece of film. I wanted to do multiples like that and I learned that the expert at this was an MIT professor, Dr. Harold Edgerton. He invented the strobe light—not to mention the trigger mechanism for the nuclear bomb tests. In photography, he is best known for pictures with very short duration strobes, like the one of a bullet being shot through an egg. The shot of a milk drop is maybe his most famous photograph. In addition to sports, he would always shoot the circus, especially the trapeze artists in multiple exposures.

In the early 1960s, I came upon a set of pictures that Edgerton had taken at a track and field meet at the Boston Garden. He shot a pole-vaulter planting the pole, ascending, clearing the bar, and landing—all in one frame. I couldn't figure out how he did that. But clearly this was my man. So I called Dr. Edgerton and introduced myself. "I'm just beginning as a sports photographer," I said, "and I've got an idea for doing a track meet that I think the *Saturday Evening Post* will let me shoot. Can I come up and talk to you about how you did those pictures at the Boston Garden?"

He said sure, so I met him for a cup of coffee at an automat in Boston. For the first fifteen minutes, I didn't speak. He was talking to me like I

was one of his physics students, saying, "See, if you use this kind of light, it has eight milliseconds of this and it needs four amps to get this going." I hadn't the foggiest idea what he was talking about. Finally, he showed me some photographs, explaining—in words I understood—how they were taken. I was fascinated. By that time, pole-vaulters had begun using fiberglass poles that bent almost in half under the weight of the vaulter. But they were either black or brown and barely stood out from the background. I noticed, though, that the vaulter in his picture used a white pole that showed up perfectly. "How did you find a vaulter with a white pole?" I asked.

"I didn't." He told me he brought a can of fast-drying white spray paint. Before the event, while the pole-vaulters were warming up, he'd show them a couple of his pictures. "But in order to do this," he'd say, "I need to paint your pole white." Nobody objected.

So that is what I did at Madison Square Garden. Indoor track meets were popular and frequent events in those days, and I shot two or three vaulting competitions to get the pictures I wanted. In the end, the *Saturday Evening Post* gave me four pages.

I don't want to sound like I copied Edgerton's idea or that I copied his pictures. What I did learn and practice was his technique. He was shooting with a large-format camera that I thought wasn't portable enough. So I invented—and I will take 100 percent credit—a 35mm camera that could synchronize with the strobe

MULTIPLE EXPOSURE OF A POLE VAULTER, 1963.

lights at a high shutter speed. You needed a camera with a focal-plane shutter, and a sequence camera called a Robot Royal would be perfect. The only problem, of course, was that every time you pressed the button on that camera, it advanced the film, so you couldn't get multiple exposures. I understood that if I could somehow prevent the Robot Royal from advancing the film, I could get exactly the shot I wanted. I asked Marty Forscher, a camera repairman who also modified cameras, to shave the

teeth off the winding mechanism (or sprocket wheel) that advances the film, so that when the wheel turned, the film stayed right where it was. Forscher did those modifications and I was ready to go.

I used this technique about a year later to shoot Pittsburgh Pirates pitcher Elroy Face. I had him winding up and throwing the ball in four pictures, all shot on the same frame of film. It ran on a June 1963 *SI* cover.

The next thing I wanted to try was a new view of a football huddle—all

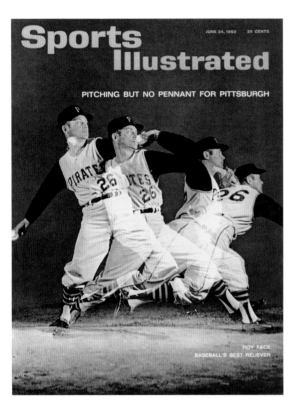

Sports Illustrated

JUNE 24, 1963 25 CENTS

PITCHING BUT NO PENNANT FOR PITTSBURGH

ROY FACE
BASEBALL'S BEST RELIEVER

ROY FACE OF THE PIRATES, JUNE 24, 1963.

eleven players, shown from their shoes to the tops of their helmets. The fish-eye lens, which takes a 180-degree round image, had just come on the market. My idea was to have eleven players huddling over the camera (and under a beautiful sky) in a perfectly symmetrical circle. My father made a rig for me that I could set on the ground to hold the camera, which I would fire remotely. We also took two little flash tubes out of a set of strobes and placed them on either side of the camera in the middle of the huddle, so when I snapped the shutter by remote control, the strobes lit up the inside of the huddle to the same exposure as the sky.

I wanted to use this technique to shoot the nation's top college teams, but obviously I had to test my new rig first. I was in Los Angeles at the time, so I went to Hollywood High School on Sunset Boulevard, knocked on the door at the athletic department, and asked to see the football coach. I told him I needed his starting eleven players to test this set-up. "If you give them to me in full uniform for ten or fifteen minutes," I said, "I promise I'll have a dozen prints made so you and each player can have one." He was happy to oblige, and when my test shots turned out exactly as I hoped they would, I was ready to try my huddle shot.

I pitched the idea to *SI* for the 1965 season. They bought it, and before long, I was off to shoot the Arkansas Razorbacks. My assignment that day was actually a game action cover try on a guy named Hurryin' Harry

EMERGING FROM AN ARKANSAS HUDDLE, 1965.

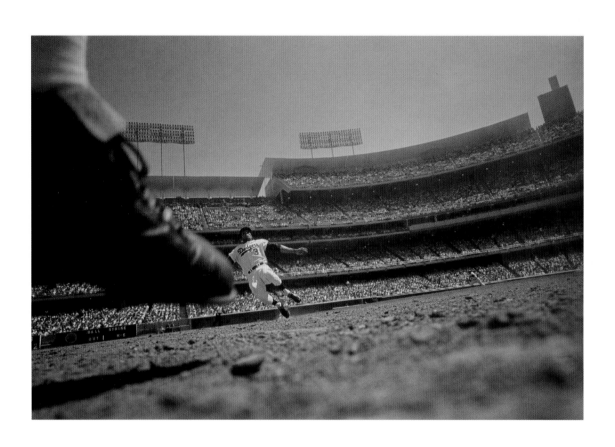

WILLIE DAVIS, 1965.

Jones. But while I was there, I also planned to shoot the fish-eye huddle shot. My secret hope was that it would be so good that *SI* would choose it, rather than a game action picture of Jones, for the cover.

Hurryin' Harry was a junior, and some kind of Arkansas etiquette requires a senior to be announced as the starting running back. The senior would stay in for the first series, then Hurryin' Harry would play the crucial downs the rest of the game. When I told the coach, Frank Broyles, what I wanted to do, he agreed to send out his starting team for the huddle. I had only thirty seconds to get my shot, so I told the behemoths surrounding me, "I want a perfectly round huddle, everybody with their hands on their knees." Then I left the middle of the huddle and quickly snapped two or three frames.

Back in New York, *SI* managing editor Andre Laguerre was sitting in a meeting, looking at the pictures, when someone said, "Wait. Let's count." And, sure enough, twelve players formed that huddle! Broyles, not wanting to slight Hurryin' Harry Jones or the senior running back, had sent both of them out to my huddle, and I hadn't noticed. Of course, the picture never ran, but I wouldn't made that mistake again.

A few years later, I tried the huddle picture at USC, then at the University of Texas, and then Notre Dame, all of which had a chance to win the national championship. In the end, though, *SI* never ran any of the pictures, and I could never understand why. In 1990, I shot the same picture of the University of Miami players and it ran on Page 1 of the *National Sports Daily*.

One other experiment I tried was at Dodger Stadium. I wanted to see if it was possible to shoot a runner sliding into second base, taken from the point of the view of the base. Major League bases are about three inches thick. So, what I needed to do was place a motor-driven camera—with a 20mm lens—inside the base, then cut a hole into the side of the bag facing first. The idea was to shoot from this perspective on a double play. The Dodgers were quite agreeable to my idea. Using a hoe, I dug a narrow trench for my remote-control wire, which looked like a lamp cord, and buried it about an inch underground near the grass, stretching from second base all the way to the first-base photo position. I raked the dirt over it.

My dream was to get the second baseman, or the shortstop, leaping over a sliding runner as he threw to first. The Dodgers' Maury Wills, one of baseball's greatest base stealers, promised me that, if he were on the base path in that situation, he would dive head first into second.

As luck would have it, my chance came early in the game. Willie Davis

was on first, and there was a grounder, a classic double-play ball. Davis slid into the bag, feet first. But he hit the bag so hard that he knocked the camera out of whack, and the umpire wasn't about to let me run out to fix it. So after one shot, that was the end of my experiment. Still, that one shot turned out to be a winner.

Not that I was the Thomas Edison of cameras, but after the second-base experiment, I had another idea. This one involved Billy Kidd, a member of the U.S. ski team from 1962–1970, and to pull it off, I had to dream up another modified camera. At the Innsbruck Olympics in 1964, Kidd became the first American man to medal in Alpine skiing when he won the silver. Now, as the 1970 World Championships in Val Gardena, Italy, approached, I wanted to shoot Kidd skiing with a photo-finish camera (also known as a "strip camera"), the kind used at racetracks.

In a normal camera, you set the shutter speed at $\frac{1}{250}$th of a second or $\frac{1}{500}$th of a second or $\frac{1}{1000}$th of a second, and the shutter opens and exposes the film for that period of time. The strip camera has no shutter; instead, it has a slit, and the film moves past the slit in one direction while the subject goes by in the other direction. At the racetrack, the camera is set up so that the film moves as closely as possible to the speed that the horse is running. When the nose of the horse hits the finish line, the camera records this and then advances the film as the rest of the horse follows. What you see is a tack-sharp picture with the horse looking frozen and the background appearing as long streaks of color.

I obviously wasn't the first photographer to use this kind of camera. It was standard equipment at racetracks, and George Silk, the great *Life* photographer, had used it quite successfully, sometimes to make odd, funny pictures, including a famous cover story set of pictures of his kids dressed for Halloween. But the camera he used was too big to easily transport. What I wanted didn't exist, but I figured there must be a way to make a strip camera very portable, one that I could bring up a mountain to shoot a skier going down the mountain.

I talked to Al Schneider, the *Life* photo lab technician, and he figured out how to do it. We determined that we'd have to in effect destroy a 250-exposure Nikon, by removing the shutter and installing the slit. We would then modify the film-advancing mechanism so that the film could flow through at a constant but adjustable rate of speed. You could make the film go faster or slower. It was a true Rube Goldberg contraption.

It works like this: you create a finish line where you want the subject to be and take one shot as the subject and the film pass the slit, so that

AT ALPINE WORLD SKI CHAMPIONSHIPS, VAL GARDENA, 1970.

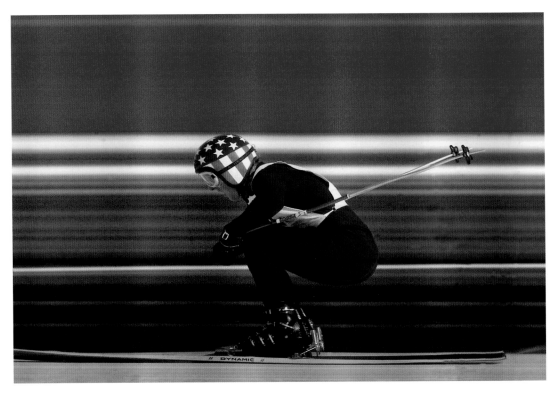

BILLY KIDD, TAKEN WITH A STRIP CAMERA, 1970.

the image of the subject records itself. The film is going in one direction, the subject in the opposite, and if they're going at the same speed, you get an undistorted picture. If the film is moving past the slit faster than the subject, you get an elongated subject. Matching speeds requires testing and preparation, but it can be done.

Anyway, I sat down with Billy Kidd and said, "At a particular spot on the hill during the downhill race, what speed would you be going?" He said, "I can show you any number of places where we're hitting sixty miles an hour, going straight down." We found a spot where Billy would be about thirty feet from the camera, going sixty miles an hour. Then I went to the Belt Parkway that goes out to JFK Airport and set up my tripod thirty feet from the fast lane of the highway, where most cars would be going sixty miles per hour or close to it. I probably looked like a cop setting up a speed trap. I did test shots, making notes of everything I shot. If a car was going sixty, the tires would look perfectly round. If the car was going eighty, the

BILLY KIDD WITH HIS GOLD MEDAL, VAL GARDENA, 1970.

tires would be elongated. Experimenting until I got a round tire, I carefully noted the camera speed I needed. I took the camera to Val Gardena for the World Championships. Kidd picked a spot on the hill where he'd be going sixty miles per hour. I positioned myself, set the camera exactly as I'd done back on the Belt Parkway, and captured a wonderful shot of Billy speeding downhill.

I subsequently used this camera to shoot a Grand Prix race in France, the Triple Crown horse races, and a photo essay on divers training for the Olympics. I then sold the camera to Heinz Kluetmeier, who's managed to make a cottage industry out of it.

SI had scheduled two pages of color in the Val Gardena issue. Before leaving New York for Italy, I told the *SI* photo editor, "Don't give away those two color pages because I'll get Billy Kidd with a gold medal around his neck."

"How do you plan to get that to us in time to get it into the magazine?" he asked.

Indeed, Billy's event, the Alpine combined, wouldn't be over until Sunday afternoon—local time in Italy—making it impossible for us to get a post-race photo into the magazine. But skiing was a long shot to get the two color pages, even though Billy Kidd had a real chance to win a gold medal.

I said, "What if I shoot Billy with his gold medal three days before he actually wins it? You'd have film in New York by Saturday, way ahead of Sunday's closing. All Billy would have to do is to win."

Nobody had ever done this before. I convinced the International Ski Federation to lend me a gold medal by telling them that I was going to shoot a still life of it. I then posed Billy with the medal. Sure enough, on Sunday afternoon, Billy became the first American man to win gold in Alpine skiing at the World Championships.

--

Still, my early success at the magazine wasn't due entirely to my pictures or to my pestering the editors. It also had to do with timing. Today, there are dozens of photographers who shoot for *SI*, so it's hard to move up the ladder. But I got lucky. In 1961, all the major stars were still at the magazine: Hy Peskin, Marvin Newman, John Zimmerman, and Mark Kauffman. And, unlike today when *SI* has a dozen photographers at the Super Bowl, we covered a World Series with three, the NFL championship with two, maybe three. In addition to me, there was Jim Drake, another

young, very talented photographer. John Zimmerman was doing his best work, Marvin Newman was a great football photographer, and anything Hy Peskin did—boxing, baseball, football—was excellent. That meant it was awfully hard to count on being assigned to those sports.

Then, very quickly, for one reason or another, the four stars all stopped shooting for *SI* on a regular basis. In 1964, Mark Kauffman, who had been borrowed from *Life*, went back to that magazine. John Zimmerman went to the *Saturday Evening Post*. Marvin Newman went abroad, fell in love, and stayed. Hy Peskin, always entrepreneurial, left to make his fortune in the business world.

Not only were Jim Drake and I waiting in the wings but also, right then, Walter Iooss arrived. Walter was a major talent from day one. His pictures were exceptional. A lot of photographers come out on top on a given day because the competition has a bad day. I never expected Walter to miss. One of the things that Walter and I did all the time—without ever admitting it—was, as soon as a big play was over, we'd look to see where the other guy was. Was Walter in a better spot than I was?

We were extremely competitive, each of us trying to outdo the other, each of us determined to get the cover. I always tried to get an edge, to use techniques or angles that other photographers weren't using, like the fisheye shot of the huddle or the strip camera. But if Mark Kauffman, John Zimmerman, Marvin Newman, and Hy Peskin had still been shooting the big events, we would never have had the opportunity to show what we could do. Suddenly, I was able to go to the NFL championship, the World Series, and the title fights.

And one more thing: I never shouted, "Covah! Covah!" Ever.

WORKING PHOTO

WORLD'S HEAVYWEIGHT CHAMPIONSHIP FIGHT
LISTON vs. CLAY
MIAMI BEACH CONVENTION HALL
TUE., FEB. 25, 1964, 8:45 P. M.

LEIFER S.I

THIS IS YOUR ADMISSION TICKET
Non-Transferable

N° ――― 16 ENTER PRESS
 GATE No. 2
 — ONLY —

(Southeast Side of Convention Hall)

SEC.	ROW	SEAT
E	A	14

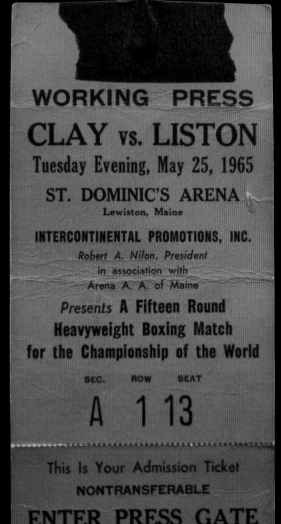

WORKING PRESS
CLAY vs. LISTON
Tuesday Evening, May 25, 1965
ST. DOMINIC'S ARENA
Lewiston, Maine

INTERCONTINENTAL PROMOTIONS, INC.
Robert A. Nilon, President
in association with
Arena A. A. of Maine

Presents **A Fifteen Round**
Heavyweight Boxing Match
for the Championship of the World

SEC.	ROW	SEAT
A	1	13

This Is Your Admission Ticket
NONTRANSFERABLE
ENTER PRESS GATE

NATIONAL TICKET CO.
SHAMOKIN, PA.

MY RINGSIDE CREDENTIALS FOR THE TWO ALI/LISTON FIGHTS, 1964 AND 1965.

ALI

> " *Ali standing over Liston. It's considered the greatest sports picture ever taken. It replaced maybe Nat Fein's picture of Babe Ruth retiring, which may have been the best sports picture of all time. But Neil has that now.*
>
> —**WALTER IOOSS**, *Sports Illustrated* photographer
>
> *The Ali-Liston rematch photo was instantly immortal. Years later, Neil sent a print to me. But it wasn't until decades later that he realized that I was one of the startled ringsiders. That's me, mouth agape, framed by Ali's legs. So it was that I became an anonymous extra in that captured historic moment.*
>
> —**LARRY MERCHANT**, sportswriter and former commentator, HBO boxing telecasts

The first time I saw Cassius Clay, he was on an escalator, two steps above me. We were at the Sheraton Hotel in Chicago, and we were both going to a weigh-in—though not his weigh-in. It was 1962, and Floyd Patterson, the heavyweight champion of the world, was set to fight the challenger, Sonny Liston. It wasn't unusual for the next challenger, or challengers, to show up at weigh-in, hoping to grab the attention of the boxing press. Clay had won the gold medal at the 1960 Summer Olympics in Rome and was still two years away from getting a shot at the title. Still, there he was in the audience, shouting, "I can beat both of them! I'm better than both of them!"

FOLLOWING PAGES: ALI (THEN KNOWN AS CASSIUS CLAY) HITS SONNY LISTON, 1964.

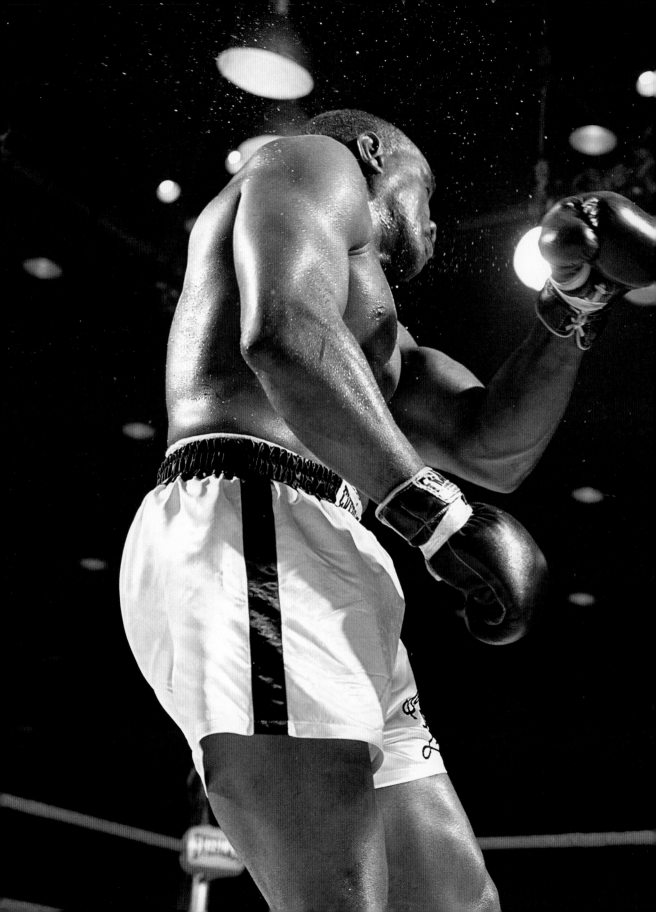

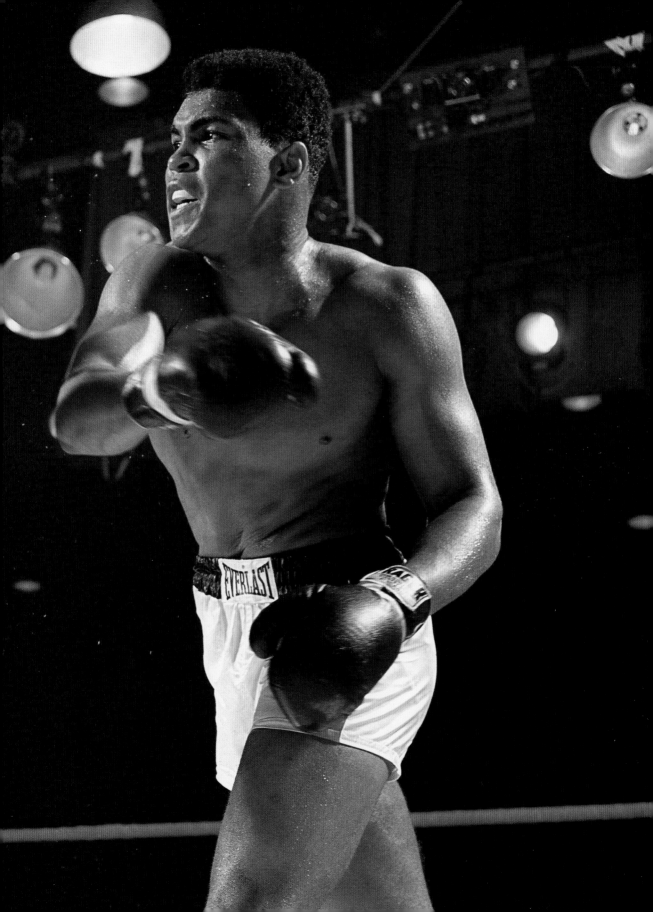

But what really struck me on that escalator was how big he was. Patterson was 6 feet, 190 pounds. Liston was 6'1" and 214 pounds. And here was this kid, Clay, who was 6'3" and probably weighed 210, 215, without an ounce of fat on him. He looked like a decathlon champ or a middle linebacker. So I was thinking, wow, if this guy can fight—if he can fight as well as he talks—he could really be something.

I went on to photograph three of his early big fights: against Doug Jones in 1963, a main event in Madison Square Garden; when he beat Sonny Liston in 1964 in Miami Beach to win the heavyweight title; and then the rematch in Lewiston, Maine, the following year. But it wasn't until 1966, when Clay—known by then as Muhammad Ali—walked into the *Life* Studios to pose for me at an *SI* cover shoot that I actually got to talk to him. Or tried to.

Little could I have known that day what an impact he would have on my career.

As I waited for him, I reviewed my preparations. With most subjects, you usually have a very limited amount of time to shoot, twenty minutes to a half hour, so I had tested everything in advance. I got Everlast to send over gloves and trunks, just in case. Then I got a stand-in with approximately the same skin tones to pose for lighting purposes. With all this advance work done, I could start shooting twenty seconds after Ali arrived.

First I would shoot a Polaroid because, among other things, it's a good psychological move to show the subject what you're doing. Also, if you get a perfect Polaroid, you're going to get a perfect color shot.

By now, of course, Ali was one of the best-known athletes on the planet. He was heavyweight champion of the world and had already posed for a number of the country's top photographers. Meanwhile, I was twenty-three years old, but I looked a lot more like fifteen.

At last Ali and his entourage arrived. His manager, Herbert Muhammad, came with a Hasselblad, the most expensive camera made. He was an amateur photographer, and I would always give him a few rolls of Ektachrome film and let him take some shots with my strobe lights when I had finished. His photos from those sessions would often appear on the cover of *Muhammad Speaks*, the newspaper that the Black Muslims gave away on street corners as recruitment materials. Some of Ali's hangers-on came in, too. So there I was with only my assistant, badly outnumbered.

Ali had brought his own gloves and trunks, which were crumpled into a little ball in a paper bag. I said, "Here, Champ, I've got this nicely pressed pair of trunks." Meanwhile, he was talking and carrying on and

I'm thinking I'm going to run out of time. He was taking great delight in telling everyone this must be a mistake. "Who is this kid, Herbert? We were just with Philippe Halsman yesterday. Who is this? He's just a boy."

I said, "Put on the trunks, put on the gloves, and please let me show you what we're going to do."

I had put a strip of tape on the floor, as in a theater, to mark the spot where I wanted his feet, and I finally got Ali to stand there for my first Polaroid. I was using a 4 × 5 camera, which is very slow and cumbersome to adjust, but I wanted to be sure the focus was right. Just as I was ready to shoot, Ali turned around and, pointing up at my strobe light behind him, said, "Hey! What's that?" I said, "Well, Champ, that's my backlight." Ali turned to Herbert. "You sure this kid's a photographer?" He turned back to me. "You ever hear of Halsman? He was shooting *Life* magazine covers before you were born."

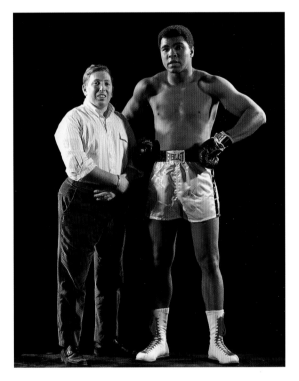

I said, "Sure."

"Well, he didn't have one of those!" Ali declared.

I said, "Why don't you let me take a picture?" because by then he had jumped off the mark. Ali returned to his place, and I was again ready to shoot when he pointed to my main front light. "What's that thing?"

I was using an umbrella light.

Ali took a long look at it. Then he turned back to me and said, "Halsman definitely didn't have one of those. Right, Herbert? Maybe this kid doesn't know what he's doing."

WITH ALI, 1966.

Once more I prepared to shoot, but he was getting such a good reaction from his entourage that he pointed to my side light and said, "And what's that? Halsman didn't have one of those either. You'd better know what you're doing."

Finally I said, "Would you stand still and give me a chance to take your picture?"

I shot the first Polaroid. In those days, the 4 × 5 Polaroid took sixty seconds to develop. But Ali had no intention of waiting a whole minute, and

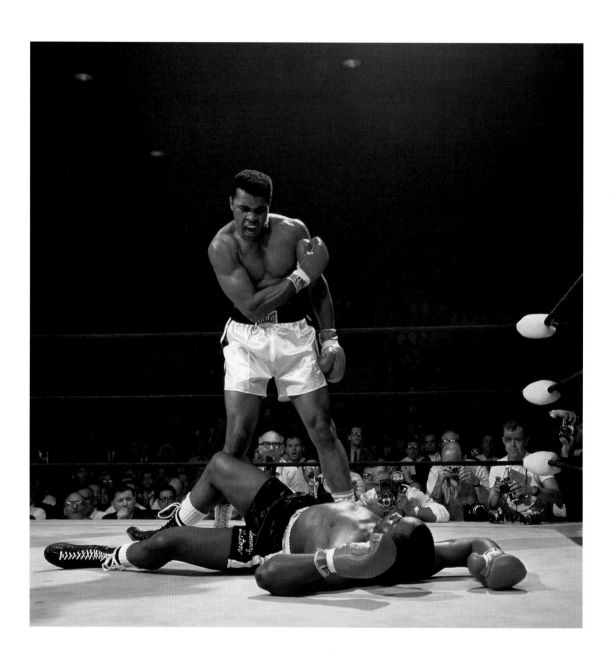

ALI AND LISTON AFTER THE "PHANTOM PUNCH," 1965.

he tried to wrestle it out of my hand to look at it. So I'm in a tug-of-war with the heavyweight champion, telling him, "It takes sixty seconds," to which he, of course, replied, "It didn't take Halsman sixty seconds! Are you using cheap film?"

By this time, I was laughing so hard, I was losing my concentration. At last, the sixty seconds elapsed. I peeled the backing off the Polaroid, and Ali immediately grabbed it out of my hand. He studied the picture and said, "Look at this, Herbert. Not bad. It's actually pretty good. Really good. Maybe he does know what he's doing."

He smiled and looked straight at me. "But then again, how can you miss with a subject like me?"

What I didn't know that day was that I had already shot the most iconic picture ever taken of Ali, the one, without question, that I will always be remembered for. I'm talking about Ali standing over a knocked-out Sonny Liston. The "Phantom Punch Fight," as many have called it.

It was their second match, this time with Liston challenging Ali for the title. The fight was May 25, 1965, in Lewiston, Maine. I was at ringside.

Seated directly opposite me was Herbie Scharfman, the other ringside photographer shooting for *SI*. In boxing, it all comes down to one moment: when one of the fighters is on the canvas. The knockout. It's the only picture the editor of the magazine is going to be looking for. All you can do is hope that when this happens, you're in the right seat and you don't get blocked by the referee.

Two minutes and eight seconds into the first round, Liston went down. I think it was the second punch Ali landed, and the only thing I was concerned about was whether or not I had it in focus. I knew I was in the right spot. I thought there was a chance I'd taken a pretty good picture, but I had no idea how good until the next day. The Associated Press photographer, John Rooney, who was sitting two seats to my left, basically had the same picture in the papers the next morning. It was a black-and-white shot with natural light, so it didn't have the sharpness of a picture shot with strobes, but it was pretty much the same composition as my picture. I said, "Wow, I was certainly on the right side of the ring."

Now, the fight was being telecast only on closed circuit in movie theaters, and they didn't have instant replays back then. I assumed that when Ali whipped his arm across his chest, it was there for a few seconds. I also assumed that he was yelling at Liston to get up. I didn't hear anything;

SPORTS
ILLUSTRATED,
JUNE 7, 1965
(PHOTO BY
GEORGE SILK)
AND JULY 26, 1999.

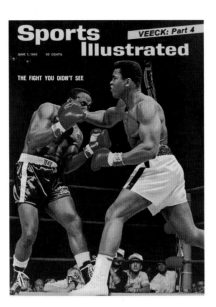 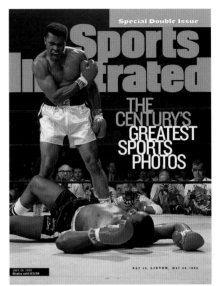

I just assumed it. It might have been two or three years later that I saw film of the fight for the first time, and I realized that Ali had snapped his arm across his chest in an instant. It was there for a fraction of a second and I got that shot. In that extraordinary moment, I had managed to capture the split-second that would live forever. Meanwhile, poor Herbie Scharfman is clearly visible in my photo, between Ali's legs, looking forlorn. All he was able to shoot was Ali's backside.

Believe it or not, *Sports Illustrated* didn't use my picture on the cover. In fact, it was a little insulting to all of us shooting for *SI* that they picked a *Life* magazine picture taken by George Silk. It was a punching picture that no one will remember. The lead was my fish-eye picture that was done by remote over the center of the ring. The knockout picture was used as a full page on Page 4.

I'm not trying to sound modest, but I do believe if Ali hadn't become the sports legend that he did, it would have been just another nice knockout picture. But as his stature grew, this shot showed him the way people wanted to remember him—young, good-looking, his shining best. As a result, over time, that picture took on a life of its own. Yet, even when *SI* put out its special end-of-the-decade issue in 1969 and ran the Ali picture again, it still got little notice. It did, however, finally make the cover of *SI* for the 1999 issue celebrating "The Century's Greatest Sports Photos."

Thirty-five years after the picture was taken, it had become *the* iconic photo of Muhammad Ali.

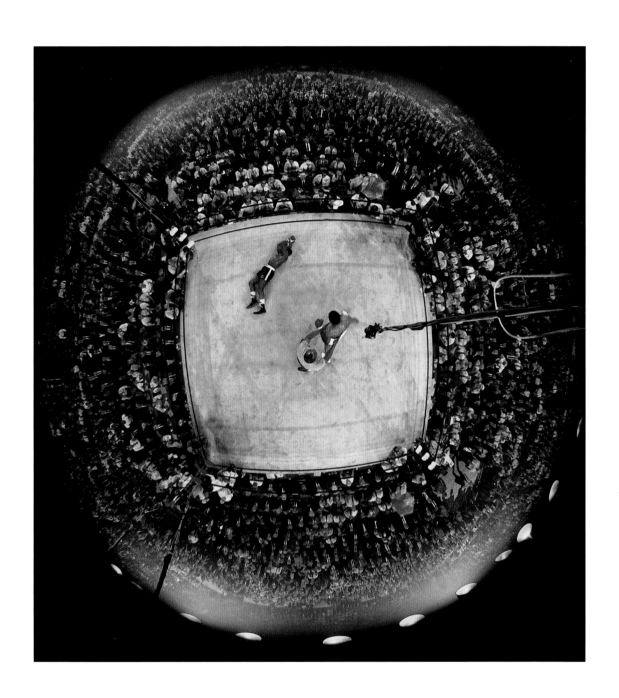

ALI VS. LISTON II, TAKEN WITH A FISHEYE LENS, 1965.

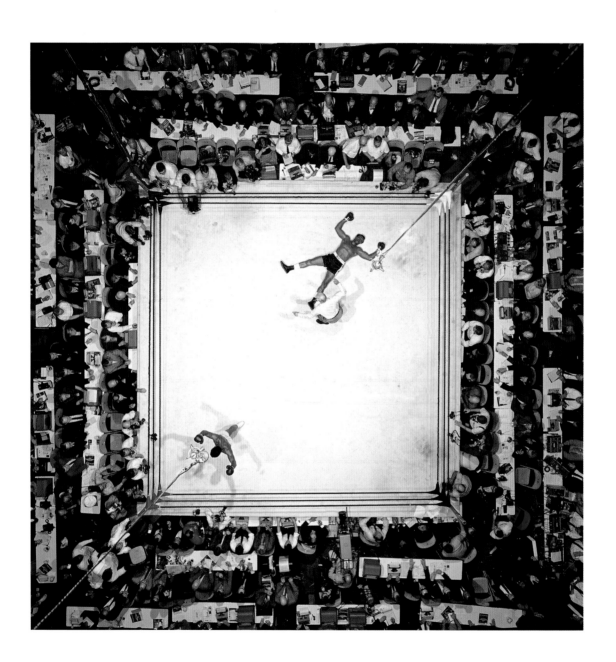

ALI VS. WILLIAMS, 1966.

At some point, the thrill of the shoot begins to vanish. After countless baseball games, you've seen the perfect double play as the shortstop pirouettes over the sliding runner and you've got a great picture. Maybe ten times you've seen a great play at the plate. The same goes for football. You've seen umpteen big running backs—Jimmy Brown being the best of them all—leap over the goal line from the one-yard line, and eventually you think, okay, I've done that. What can motivate me to keep pushing to get something better?

That thought was in my head in 1966 as I prepared to go to Houston to shoot Muhammad Ali defending his heavyweight title against Cleveland Williams, a worthy opponent. In fact, if Williams had not been shot in the stomach by a policeman in 1964, many believed he might have beaten Ali.

The bout was scheduled for November 1966 at the newly opened Houston Astrodome. One way I motivated myself was to try to do something no one had done before. Shooting overheads in boxing had been done for decades by mounting remote cameras on the lighting grid hanging twenty feet above the ring. What you couldn't do was get a symmetrical shot from straight overhead because even the widest lens couldn't take in the whole ring. A fish-eye lens would cover the entire ring—in fact, I'd done this for Ali-Liston II in Lewiston—but the image it produces isn't a square ring; it's more like a basketball-shaped one. In short, nobody had ever taken the kind of picture I had in mind because it had never been possible to do so.

This was a picture I knew would be a good one: the remote camera would be placed above the center of the ring, and I would shoot straight, capturing the undistorted symmetry of the square ring and the press rows lined up around it. I knew this was now possible for the first time in the Astrodome (more on that in a moment). What would turn out to be equally important was that, in 1966, you could shoot down onto a clean canvas, one free of logos for Budweiser, Don King Presents, Top Rank Promotions, Hilton Hotels in Association with . . . you name it. Today, the ring looks like so many athletes—tattooed on every visible surface! Also, fighters now wear multi-colored trunks, instead of the traditional simplicity of white trunks for the champ, black for the challenger.

I had made a number of trips to the Astrodome already. I shot pictures for a story on its construction and one on Houston Astros owner Judge Roy Hofheinz. So I got my idea on one of those assignments when it was explained to me that the ring lights would be on a gondola in the center of the Astrodome. The gondola was eighty feet wide and usually rested 208

feet above the floor. It was like an elevator; it could be lowered all the way to the floor, but for the fight, it would be eighty feet above the ring—not the usual twenty feet—so it didn't obstruct the view of fans in the upper deck. When the gondola was at floor level, it was easy for me to rig my camera on it, and I mounted it dead center, pointing straight down. I was pretty sure I could make a good picture, one that would show the symmetry of the ring and the press rows. And if I was lucky enough to get a knockdown—certainly one anywhere near the middle of the ring—it was going to make a great picture.

Even if the fight went fifteen rounds and there was no knockdown, I could get a terrific picture when the fighters touch gloves to start the fight or any time the action was in the center of the ring. The only concern I had was that in using a Hasselblad, I had only twelve frames, so I would have to be patient and hold my fire, waiting for one fighter or the other to go down.

I began experimenting with the shot when I got to Houston. The electricians were moving the gondola up and down, adjusting the lights, so I was able to shoot a test roll a couple of days before the fight and knew exactly what the picture would look like if one of the fighters was knocked flat on his back, looking straight up at the camera. I also knew that my strobe lights would take about eight seconds to recharge the batteries after every shot. That meant if there was a knockdown, I could get only one shot at it, one frame.

It wasn't a great fight even though Ali knocked Williams down four times. The picture that I snapped came when Ali sent Williams to the canvas in the second round. Williams went down in a perfect spot, flat on his back.

I couldn't wait to see the picture, and, as usual, I got to the lab and saw my roll of film from the Hasselblad while it was still wet, before it even went into the dryer. I knew what I had as soon as I laid eyes on the picture. "Oh, man!" was all I could say.

I have collected other people's photographs for many years and more than a hundred of them line the walls of my apartment. Only one picture in that collection is mine and that is the overhead from the Cleveland Williams-Ali fight. Forty inches square, it hangs in my living room.

It's the only picture I've ever taken that I believe I could not have made better.

THE SHOOTS I WISH HAD NEVER HAPPENED

> " *If you are a sports fan, Neil Leifer's pictures have been shaping your impressions and memories for five decades.*
>
> —**BOB COSTAS**, sportscaster, NBC Sports

Sports photography is almost always a positive experience, and the memories are usually great ones. I love to run into subjects I photographed years ago, reminisce about the good old days, and relive the fun we had together. But a few assignments left me with memories that haunt me to this day.

The best example involved a college basketball player. It was March 1961, at the finals of the NCAA tournament. Looking back, I find it hard to believe today that it was the culmination of a lightly regarded post-season competition called the "NCAA Basketball Championship" that took a backseat to the much more prestigious National Invitation Tournament. The final games were to be held in Kansas City, and I was thrilled to get the assignment. I was still new at *SI* and was getting stories they called "secondaries," which were two-pagers with black-and-white photos. I wasn't getting big news stories or the long back-of-the-book features (called "bonus pieces") that opened with a double-truck photo. And I certainly wasn't getting regular assignments to shoot the cover. I was, in fact, only beginning to get decent assignments.

The photo editor, Gerry Astor, called me in to meet with Jerry Tax, a senior editor. Jerry looked across his desk at me and said, "I know you've

been assigned to the NCAA championship, but something's changed and we might want to send someone else."

What a letdown! Had I done something wrong? "Why?" I asked.

"This story has taken an unexpected turn," Jerry said, "and it might be the kind of thing someone else should shoot. I'll tell you what's going on and you tell me what you think."

He went on to say that New York District Attorney Frank Hogan was investigating a case involving point shaving in college basketball. A number of players from various teams had already been arrested and more arrests were expected. "As it turns out," Jerry said, "we got a tip that three players on one of the teams that will play for the NCAA title could be arrested in Kansas City."

That team was St. Joseph's. They were the Cinderella story of the tournament, so you can easily imagine how big a story that would be.

Jerry said, "Do you think you can handle this kind of story?"

I answered very calmly and confidently, "Sure, I can." But, in fact, I was also a little scared and extremely excited. This was no longer going to be a sports story but instead a big crime story.

"We don't know if they're going to arrest these players in Kansas City," Jerry added, "so you'll have to be ready to shoot it either way—with or without the arrest angle."

I said I would be ready for both, and after a short discussion, they agreed to let me go and told me the writer would be a guy named Ray Cave.

"So who are the players?" I asked.

"I'm not going to tell you that," Jerry said, "and neither will Cave. If we did, the players might figure out why you're focusing on them. What we want you to do is meet Ray in Philadelphia and then fly with him on the St. Joseph's team plane to Kansas City."

SI had told St. Joseph's that we were doing a story on them because they were the Cinderella team (Cincinnati and Ohio State were the favorites). The St. Joe's coaches had no idea that some of their players were about to be implicated in the point-shaving scandal. In fact, nobody knew, with the possible exception of the players themselves.

"We're not really interested in the Cinderella aspect at all," Jerry said. "So photograph everybody on the team. Be sure to shoot as many of the players as you can. You'll be on a plane with them and at the hotel with them. Shoot them on the bench. And obviously, if they're arrested, do everything you can to get whatever you can."

I went to Philadelphia and met Ray Cave for the first time. He was the

Sports Illustrated
MAY 8, 1961

Photograph by Neil Leifer

PORTRAIT OF A FIXER

Five weeks ago (SI, March 27) revelations of fixed college basketball games began to spread over the nation's front pages. At first, only four students from two colleges—Seton Hall and the University of Connecticut—were named by New York District Attorney Frank Hogan as having taken bribes. Last week Mr. Hogan's office listed as conspirators eight students from five other schools: Mississippi State, the universities of North Carolina and Tennessee, LaSalle and St. Joseph's colleges. Sadly, more are still to come. When the scandal broke, play for the national championship was reaching its final stages, and of the four teams that were to fight it out in Kansas City, one was St. Joseph's, which had not yet been mentioned in connection with the fixes. But Sports Illustrated was aware that one St. Joseph's players had accepted bribes. Accordingly, Basketball Editor Ray Cave spent several days in Philadelphia with the team, and traveled with it to Kansas City, where he watched it win third place in the tournament. He particularly observed one of the three players, a forward named Frank Majewski, because it was Majewski who had brought the other two into the conspiracy. Cave's report on Majewski, out of deference to the grand jury's inquiries, has been held up until now. What follows, then, is a unique sports story: a portrait of a fixer drawn at a time when he was still unexposed, but operating under the dual stress of national championship play and of the knowledge that an investigation was in progress that might bring his private world crashing down around his ears. Last week Frank Majewski's private world crashed.

by RAY CAVE

The St. Joseph's College basketball team, champion of the East and winner of 24 out of 28 games, was holding its final practice before leaving Philadelphia for the national championship tournament at Kansas City. Its members looked crisp and confident as they scrimmaged, with one marked exception—a round-shouldered, burly 6-foot-3 blond who was moving with the mechanical listlessness of a sleepwalker. "Everybody looks good but Majewski," said the Rev. Joseph M. Geib, faculty athletic moderator, as the practice ended. "I don't know where his mind is, but it certainly isn't here."

Frank Majewski's mind was in the New York district attorney's office. Only five days before, on March 17, D.A. Frank Hogan had disclosed a new basketball scandal. Two players from Seton Hall University had admitted taking bribes to shave points, players from other schools were being questioned, and as many as 20 colleges were said to be involved. That very Wednesday morning detectives had come to Philadelphia to pick up a LaSalle College player and take him to New York for questioning.

Now, with his team preparing to play Ohio State in the semifinals of the national championship—an athletic stature little St. Joseph's College had never achieved before—Majewski was surely wondering how close the bribery investigation was getting to him. For he knew he could be charged with:

• Accepting $2,750 to shave points in three St. Joseph's games.
• Successfully recruiting the two best St. Joseph's players, Captain Jack Egan and Center Vincent Kempton, to join in the game-fixing conspiracy.
• Causing his nationally ranked team to lose at least one game it could and should have won.

Majewski knew that if he were questioned he not only would face personal disaster but his team would not be allowed to play in the championship games. And in spite of his muddied morality, Majewski wanted St. Joseph's to do well in the NCAA tournament. He was greatly worried, and he looked it.

St. Joseph's is a small school (1,450, with only 150 living on campus), located on the fringe of big-college basketball much as it is located on the fringe of Philadelphia's exclusive Main Line—just outside, wishing it were in. Jack Ramsay is athletic director and a teacher of education courses as well as basketball coach. His office is a small, unpainted cubicle. His budget is small, too. St. Joseph's players got hats as gifts for their good season this year, and even that modest purchase made Ramsay *continued*

HAUNTED CONSPIRATOR Frank Majewski, fearful that scandal will soon engulf him, waits in uniform in Kansas City hotel before last game.

FRANK MAJEWSKI IN *SPORTS ILLUSTRATED*, MAY 8, 1961.

stepson of an army general and had himself served in the Korean War as an interrogator of returning POWs who had been brainwashed. So I wasn't surprised to learn that Ray was very guarded. When I asked him who the three players were, he said, "I'm not going to tell you anything. Shoot whatever you want to shoot."

But it didn't take me long to figure out who the three were. They appeared nervous, uptight. I shot practice when we arrived in Kansas City and I shot them at team meals. My recollection is that every time I pointed the camera at Frank Majewski, Vincent Kempton, or Jack Egan, I could see them stiffen.

I photographed the semifinal game, which St. Joseph's lost. Even though I was sure I had the three players figured out, I made a point of taking pictures of everybody. One that particularly haunts me was the picture I took of Majewski in the lobby of the Muehlebach Hotel. He was sitting

in a chair beside a table and lamp. You might say he had his game face on, but to me, he looked frightened. You know how people light up when you point a camera at them? Those three never did. I don't remember them even cracking a smile.

As it turned out, they were not arrested in Kansas City, and *Sports Illustrated* ran a two-page story on the NCAA finals. Two or three weeks later, they were picked up and indicted. *SI* ran a big piece that Ray Cave wrote, and the lead picture was my full-page shot of Majewski sitting in that lobby chair. The boldface headline opposite my picture was "Portrait of a Fixer."

I felt somehow guilty. I had known what I was doing. I wouldn't normally photograph a college basketball player sitting in a chair, looking forlorn. I knew I was photographing a player whose whole world would soon come crashing down. He and his teammates were convicted and sent to prison. It was the first time in my career that I'd taken a picture of someone I hoped I would never see again.

--

I did feel a personal connection to another story that ended in tragedy—the death of race car driver Peter Revson. His uncle, Charles Revson, had founded Revlon, but the last thing Peter wanted to do was sit in an office and run a cosmetics empire. I came to know him when I spent a week in 1973 following him from the Indianapolis 500 to the Monaco Grand Prix. We flew in a Lear jet from Indianapolis to New York then sat together in first class from New York to Paris and on to Monaco.

He had met Marjorie Wallace at the Indy 500 that year, and I had photographed their courtship. That November, she became the first American to win the Miss World contest, but days later she was dethroned. Rumors went around that she was engaged to Revson, which somehow broke the rules. The next March, as he was preparing to leave for the South African Grand Prix, he came up to my office. For an engagement present for Marjorie, he wanted to buy a camera. What should he get? We talked about which Nikon I thought would be best, and what lens, and I offered to pick them up for him; he could drop by and get them on his way back.

Days later, I was driving to work when I heard on the radio that Revson had crashed during a practice run in South Africa and had been killed in the wreck. We were young men—Peter Revson was about my age—and now he was dead. Pete Biro, by then a great racing photographer, had assisted me very early in my career, and I remembered hearing him talk

about the many funerals he had gone to for people our age. I decided this wasn't a sport I wanted to be close to.

I certainly never wanted to get close to another race car driver. But a few years later, *Newsweek* offered me an assignment to shoot a cover on Mario Andretti and I really wanted a cover on *Newsweek*, so I took the assignment. I did get to know and like Andretti, and every time I watched him race over the years, I prayed nothing would happen to him.

Ironically, one of the knocks on Revson—the reason he didn't win despite being hugely talented—was that he was considered too safe a driver. Men like Jackie Stewart, Jimmy Clark, Graham Hill would run as close as possible to the point of losing control, but they wouldn't go over that line. Revson would stay a tick or two in the safe zone, which many thought was why he wasn't a world champion. But the real irony was that what killed him was an inexpensive bolt that had broken in his Formula One race car, which cost a couple of hundred thousand dollars. Revson had turned his wheel to the left but the car had veered right and crashed into a wall.

I couldn't help remembering what Peter had once said to me: "It's far more dangerous to drive on a freeway."

When Arthur Ashe announced in 1992 that he had AIDS, it was obviously a very big story, and I was assigned to photograph him. Years before, in 1979, he'd suffered a heart attack and had a quadruple bypass that ended his career. In 1983, he needed more heart surgery and received a transfusion of tainted blood. Five years later, he learned he was HIV-positive, but he had kept it a secret. It had been hard enough to accept that a thin athletic man could have a heart attack at such a young age, but this news was devastating. The afternoon of my shoot, Frank Deford interviewed Arthur, and I was told to go to Ashe's apartment where he would pose for me with his family: his wife, Jeanne, a photographer, and his five-year-old daughter, Camera.

Arthur was gracious, as always, when he greeted me and my assistant, Dan Cohen. But his shirt collar was loose and I could tell right away that he had lost weight. As we set up lights, I told Arthur I'd like to do a family portrait. He said Camera was hiding and he wasn't sure she would pose for me, but he invited me to ask her. From time to time, I could spot her moving from one room to another, but, as a father, I felt that it wasn't right to try to change her mind and talk her into posing.

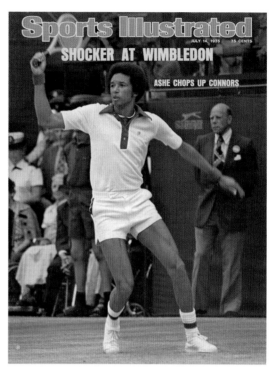

SPORTS ILLUSTRATED, AUGUST 29, 1966, AND (WITH A PHOTO BY TONY TRIOLO) JULY 14, 1975.

As Arthur walked me through the apartment so I could choose the spot where I wanted to shoot, he led me into Camera's bedroom. He said, "I thought you'd enjoy seeing this." On the wall were two poster-size *Sports Illustrated* covers bearing Ashe's image. One I had shot at UCLA in 1966, when he was playing for the U.S. Davis Cup team. It was a beautiful picture, a portrait that I love and still put in all of my presentations. The other cover was a shot of Arthur winning Wimbledon. Tony Triolo had shot it, and the moment I saw the two *SI* covers, I wanted to cry.

I quickly left the room to collect myself and told Dan, "Let's get this over with as fast as possible." I was devastated and couldn't wait to leave. I was used to photographing athletes—young people, mostly, thriving and in their physical prime, not a man I greatly admired who was soon going to die.

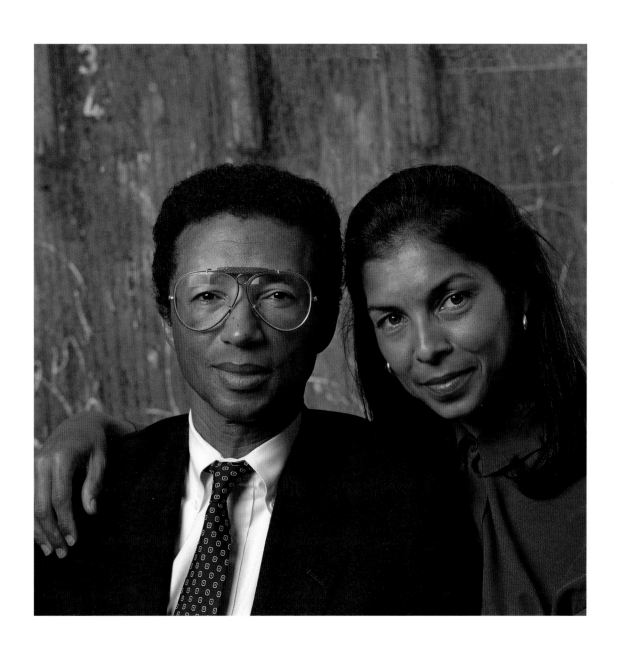

ARTHUR AND JEANNE ASHE, 1992.

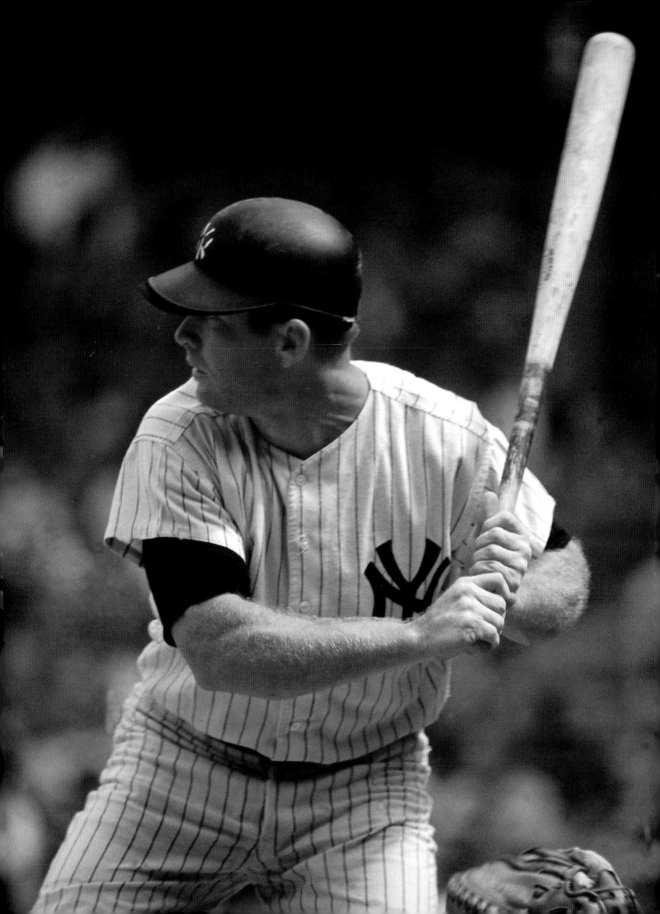

MICKEY MANTLE

> " *Neil's ingenious. It's his ideas. I don't think he's ever sold the notion that it was his talent that made him what he is. It's his analysis. He knows himself and therefore knows how to play that person who came from the Lower East Side and who made himself into what he is today.*
>
> —**PAT RYAN**, former *Sports Illustrated* editor
> and *People* and *Life* managing editor

Mickey Mantle really loved women.

I discovered just how true this was in 1956, when I was delivering sandwiches for the Stage Deli. Once during a Yankees home stand, I was given an order for Mickey, who was one of our regular customers. I was thirteen years old and no one had ever accused me of being worldly. Even though I was a Dodgers fan and hated the Yankees, I was thrilled by the prospect of meeting The Mick. The doorman at his building wanted to bring the sandwiches up to Mantle's apartment himself, but I was persistent (something I am, to this day, often accused of being), and I insisted on delivering them personally. Sure, I wanted to meet Mickey, but more important, I knew that if I made the delivery myself, I'd get a big tip. The doorman finally relented.

I knocked on Mickey's door and a beautiful blonde lady opened up. She said something like, "Mickey's in the shower but he told me to give you this," and she handed me a couple of bucks. I remember thinking, "What a nice wife Mr. Mantle has." A few days later, I was again sent to bring

Mantle food and again a woman opened the door. Only this one had black hair and was equally pretty, smiling at me as she gave me two dollars and took the sandwiches. I thought, that's funny, I could swear his wife was blonde. Something seemed odd, but it wasn't until my fourth or fifth delivery, when a black woman opened the door, that it struck me that none of the women I met could possibly be Mrs. Mantle. It was, in some small way at least, the end of my innocence. But I should add that Mickey himself often came to the door for the sandwiches and was always very nice to me. And, more important, he was always a great tipper.

It would be years before I encountered Mantle again.

During many of those years, when I was just starting out, I was banned from Yankee Stadium. The old New York press photographers, who controlled the press box, resented me and made sure I didn't get in.

Remembering the aggravation that the Yankees had caused me as a kid, I was surprised one morning in 1966—two years after the team had been purchased by CBS—to get a phone call at my *SI* office from Mike Burke, the Yankees' new president. "Could you come up to the stadium?" he asked. "I'd like to meet with you. I want to talk to you about something."

I entered Burke's magnificent office, having no idea what this was about. He greeted me warmly and got right to the point. "I want to hire you to shoot the Yankee yearbook."

I said I would love to, but I knew the man who had done the job for many years. "I don't want to be the guy who causes him to lose his job," I said.

"Well, I'm not happy with the pictures and I'm going to get somebody else to do the job," Burke said. "And I like your stuff in *Sports Illustrated*." He then listed the many things about the yearbook he wasn't happy with, including the team picture, and handed me several examples. "What's wrong with these?" he asked.

I studied the photos. The players were lined up perfectly, with the manager sitting in the middle, and they were all looking at the camera. It was well lit and well composed, technically adequate but boring. "I don't know," I said.

"Okay, see if you can find Mickey Mantle."

It took me a moment. I realized that in almost every team photo the batboy was more prominent than the team's biggest star. I knew how the logistics of team photographs worked—the precise, but unwritten, rules so

common in baseball. The bigger the star, the later he came sauntering out of the clubhouse for the shoot. A space was always held for the manager, with the coaches seated on either side of him. The players would then find a space to stand or sit. Mickey, Whitey Ford, and Yogi Berra were often hard to pick out.

"How would you improve on this?" Burke asked.

I handed back the pictures and thought about it. Then I had an idea. "It sounds crazy," I said, "but I'd tell Mickey and the other stars exactly where to sit."

Burke shook his head. "We want to do a little better than that."

I told him I'd take the job and that I would like to photograph the whole team in the stands. It would make a different kind of team picture. I would get there a couple of hours early and put each player's name on a seat. Then I caught Burke off guard. "These guys aren't gonna listen to me unless you're standing beside me," I said.

When the day came at spring training in Fort Lauderdale, there was Burke right next to me as the Yankees trickled out of the clubhouse and found their seats. I still remember the moment when Mantle showed up and I said, "Excuse me, Mickey. I've got a seat right here for you. And Whitey, you're here."

I knew that players usually had an attention span of about four seconds. I got up on my little ladder and placed a clock right where they could see it, then tried to lighten things up with a funny announcement: "I'm supposed to take five minutes," I said, "but it won't take that long." I pointed to the clock face. "The five minutes begin when the big hand is here and end when it gets to here." They looked at me like, where did they find this asshole? But the president of the team was standing right next to my ladder and no one said a word, so I shot the picture. Burke said, "It looks great, guys." I took about two minutes more and thought I had what I needed, but just to be sure, I kept going, using a wider angle lens. At the three-and-a-half minute mark, the players were all getting antsy. I said, "Thank you very much. I've got everything I need."

Among Burke's other complaints about the yearbook was a lack of shots that would humanize Mantle. Would I try to get some? That made me want to catch Mickey away from the stadium. Frank Messer, the former Orioles broadcaster—who was about to become a Yankees broadcaster—told me that Mantle liked to go fishing with his sons. So I asked Mickey if Frank and I could tag along. Although he remembered me from the Stage Deli days, he said, "I don't really want to do that."

FOLLOWING PAGES: MANTLE HITS DURING WORLD SERIES, 1962.

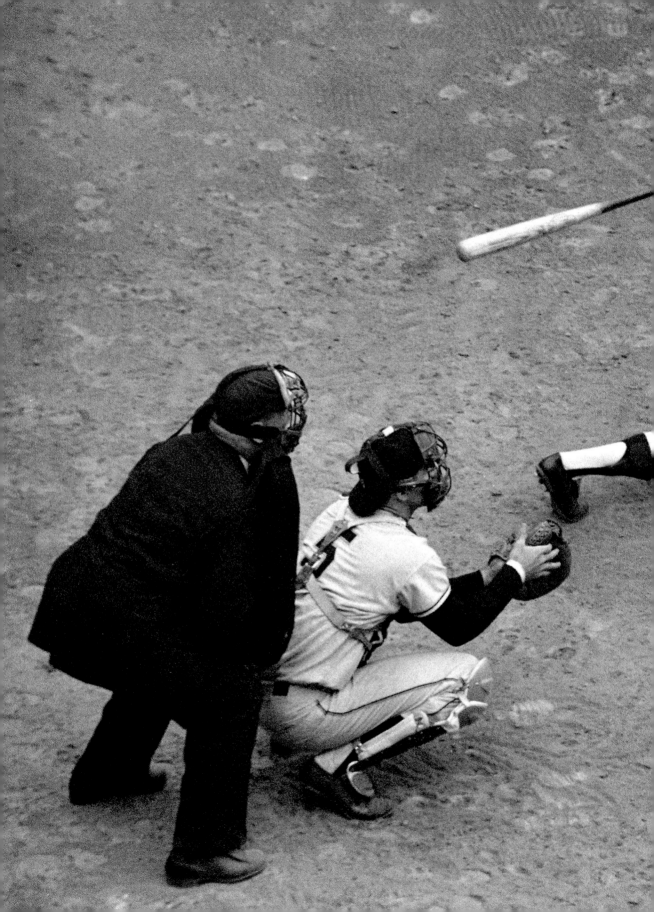

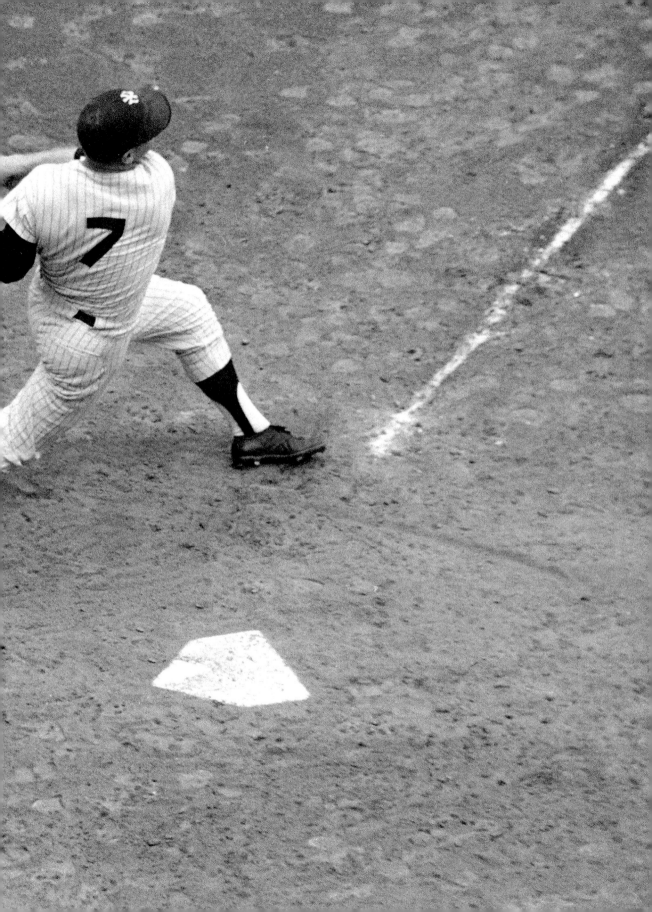

"It would make such a human picture," I said. "It would be nice to humanize you." Mickey may or may not have known what "humanize" meant, but he finally agreed to let me go along "if you promise," he said, "you won't talk to me. Fishing and talking don't go together. You and Frank have to be in another boat."

We rented a boat and followed Mickey's boat down a little inlet. We were out for two or three hours, and it was nice to see Mickey out of uniform, relaxing and joking around with his oldest son. Once he was satisfied that I wasn't going to scare the fish or get in his way, he let loose that wonderful smile of his, and I got my pictures from maybe twenty feet away. The photos were beautiful, and they ran in the yearbook, just as Mike Burke wanted. Unfortunately, every bit of film I shot that day has disappeared. I guess it's inevitable, when you shoot millions of pictures over the years, that some will get lost. Sadly, those shots of Mantle are among the missing.

--

After Mike Burke asked me to shoot the yearbook, I began to study past Yankee yearbooks, and one day I approached him. "The Yankee pinstripes are one of the most famous uniforms in all of sports," I said, "yet when you look at the Yankee pictures, they're wearing gray uniforms in most of the really good ones, because they're all taken on the road.

"The photo positions in Yankee Stadium and the spring training ballpark are horrible," I continued. I told him that the two field-level positions beside the dugouts were rarely used and everything else is shot looking down from the press box. The best pictures are taken at field level, I said, and other stadiums either have field-level positions or permit photographers to squat in the aisles and shoot from there. "I can get some really great pictures if you give me permission to be in the aisles."

"Neil, it's my stadium," Burke said matter of factly. "You can go anywhere you want to."

It was that spring of 1966 when I had my one and only conversation with the other legendary Yankee centerfielder, the great Joe DiMaggio. We were still at spring training, and I found a good position on the home plate side of the Yankees dugout next to the owner's box. I set up a tripod and a camera with a 600mm lens.

DiMaggio was a spring training hitting instructor, and after batting practice, he would shower and sit down in the owner's box to watch the game. On this particular day, the game was about to begin, and I was

JOE DIMAGGIO, 1967.

looking through my big lens, sixty feet from home plate where I'd be getting tight shots of all the hitters, as well as pictures of the pitcher. Out came DiMaggio. He sat down in the owner's box, a few feet from me; no one else was there. I don't remember if it was the first or second inning, but he tapped me on the shoulder and said, "Excuse me, Red. Can I look through that lens?"

"Sure, Mr. DiMaggio."

I moved over so he could look through the lens. I showed him how it worked. He put his eye on the viewfinder, but instead of aiming the camera at the batter, he was pointing to the left of the batter's box. "Look at that!" he exclaimed.

He was looking at a woman sitting in the front row. He looked through the lens a couple more times and smiled. "Look at those tits!" Then he turned to me. "So, Red. Getting any puss lately?"

I turned beet red. I stammered something, I don't remember what.

And so went my one and only conversation with the great DiMaggio.

MY SHORT-LIVED CRUSH ON DORIS DAY

> *Neil Leifer photographs legends—and is a legend himself.*
>
> —SHELBY COFFEY, former *Los Angeles Times* editor

It was the early '60s, not long after Dodger Stadium had opened, and Doris Day was America's sweetheart. Since most of the top *SI* shooters lived in New York at the time, it wasn't unusual for me to be sent out west for a big series. The stadium was like no other: instead of forcing photographers to crouch in an aisle and possibly block the fans' views, the Dodgers had set up four fabulous positions—two on either end of each dugout at ground level, which produced dramatic pictures.

Now between the photo boxes and the dugouts were two rows of special seats, very private, that Hollywood celebrities loved. Nobody could bother the stars for autographs and they had waiters to bring them food. I wasn't quite tall enough to stand behind these seats, so I would stand on one of my photo cases.

Doris Day was a season ticket holder in the box. Her seats were closest to the Dodgers' dugout. Although she was working full time, she never seemed to miss a game. She was in the front row, and sometimes she'd get a hot dog or some ice cream. My favorite position was less than seven or eight feet from her. I remember thinking, "Wow, she's so close, and she's

DORIS DAY AT DODGER STADIUM, 1963.

got such big binoculars—I wonder what she's watching." I wasn't a movie buff in those days, but I knew who Doris Day was and once in a while I'd snap a picture of her. And she was so cute that I developed a crush on her.

She was also a big Lakers fan and went to all their games. Until then, *Sports Illustrated* usually had no interest in celebrities, but in January 1965, they wanted to run a story about the Lakers attracting so many famous fans. I was assigned to shoot it. At one point in the first game that I shot at the L.A. Sports Arena, the Lakers scored a big basket. Doris Day jumped up like a cheerleader, and the crowd was hooting and hollering behind her. It was exactly the sort of thing the editors had hoped for, and it ran as the opening picture in the magazine.

By that time, I had quite a number of nice pictures of her, and whenever I saw her at the ballpark or the arena, she was very friendly, which naturally fueled my crush—and my romantic delusions. So I decided to make up three or four black-and-white, 11 × 14 prints to give her. I think I told the guys in the *SI* photo lab that I'd get them autographs, and the prints they made were beautiful. I was worried they wouldn't travel well, so I slid them into a big envelope between two pieces of cardboard and carried them on the plane and then schlepped them to Dodger Stadium. And there she was, watching batting practice with her big binoculars. I approached her and said, "Miss Day, how nice to see you. How are you? You know, over the course of the season, I've taken several pictures of you, and I had some prints made. I'd like you to have them."

She said, "Oh, thank you very much."

She opened the envelope and looked at the first one. She showed it to the woman she was with, but I could see immediately that she didn't like it. She looked at the second picture. "I've got a mustache in this one!" I hadn't noticed it, and I'm not even sure there was one, but obviously she saw some imperfection on her upper lip. She showed this one to the other woman. Then, right in front of me, Doris Day ripped the picture into shreds. My heart sank. She looked at the other prints and gave me a polite, "Thank you." Then I watched her fold them in half and jam them into the envelope, crushing my heart along with them.

SAY HEY AND SUGAR RAY

> " *Neil was always very persuasive. When he was twelve and I was seven, he'd insist I go with him when he shot pictures. Once he woke me up at some ungodly hour because he wanted to photograph a ship coming into the Brooklyn Navy Yard. He didn't need me to do anything. He just needed an audience.*
>
> —**HOWIE LEIFER**, Neil's brother

Every photographer occasionally falls on his face. The very best and the very luckiest do it far less often than most, but their day of doom will surely come—no one escapes this fate—and every photographer recalls in lurid (and, if he's got a sense of humor, comic) detail his most humiliating pratfall. For me, that distinction belongs to my *SI* cover shoot with Willie Mays.

It was 1964 and the San Francisco Giants were in town to play the Mets. *Sports Illustrated* assigned me to shoot a Willie Mays cover. All I had to do was set up a chair, an umbrella light, and a strobe right next to the dugout and, with my Hasselblad, shoot Willie's face with that famous grin. Having grown up in New York, I knew that of the big three—Mantle, Mays, and Duke Snider—only Willie would sign autographs. He would sign for anyone and everyone. He was the darling of the New York press. He was the Say Hey Kid with a big smile on his face all the time. This assignment would be a piece of cake.

I went down the tunnel and into the clubhouse and told Willie what I wanted to do. "I don't know," he grumbled. "I have things to do. I don't have time for this."

I told him it was for *Sports Illustrated*, probably for a cover. Willie kept protesting. I began to worry. If I didn't get the picture, what would my editor think? And, of course, I really, really wanted the cover. Willie kept grumbling, but finally I wore him down. "Okay," he sighed, "when batting practice is over, but this better be quick."

I waited for batting practice to end and felt relieved when Willie walked over and sat on the stool. I took the standard Polaroid to make sure I had the exposure right, then took the Polaroid back off the camera and replaced it with a Hasselblad back. Each back had twelve exposures and I had three backs ready to go. My assistant, Anthony Donna, had loaded them.

"Okay, Willie," I said, "What I want is a nice smile."

He glowered. "What if I don't feel like smiling?"

"Please, Willie. All I want is a laugh."

"Then tell me a joke," he said.

I froze. I certainly didn't have any jokes. Willie sat there for a minute or so and finally gave me a half-smile. Then he stood. "You got enough," he said and headed for the locker room. I knew immediately that I didn't have the cover—they wanted a laughing Willie Mays. I had maybe a pleasant-looking Willie Mays. I wondered what to do. Go back and tell my editor that he hadn't been cooperative? I was still a kid, excited about shooting the legendary Willie Mays, and I wanted badly to succeed. I wanted that cover. But all I had shot were four or five frames.

I took the back off the Hasselblad. To be safe, you want to get the film out of the camera. I started to rewind the Hasselblad back and on the first twist, I knew something was wrong. There was no tension when I turned the knob. By the second twist, I knew exactly what was wrong. By the third twist, my heart stopped. It was the worst feeling a photographer can ever have. There wasn't any film in the camera! Desperate, I kept turning the knob, just in case. But, no film.

Now what? It was one thing to tell my editor, "Look, I didn't get a picture because Willie wasn't cooperating." It was another to say, "I didn't get a picture because we didn't load the camera." I wanted to kill Anthony, but I knew I was ultimately responsible, that I had to take the blame. I realized I had no choice.

I trooped back down the tunnel and into the clubhouse. Willie was sitting by his locker reading the paper. He had his uniform pants on but no shirt. He looked up at me. "Yeah? What do you need now?"

"Willie, I'm very sorry to bother you again, but I've got a problem. And I want to tell you the truth." Better Willie Mays, I thought, than my editor.

"You know those pictures I took of you? There was no film in the camera. I would really appreciate it if you could come back out."

Willie looked at me like I was out of my mind. "What do you mean?" he said. "You must be kidding."

"Please, will you come back out and let me try again," I pleaded. "All I need is thirty seconds. It's my job, and I'm gonna be in trouble with my boss."

"I don't have time for this."

"Please," I said again. "I'll do this very quickly."

"Okay," he grunted. "When I go out, I'll sit down for you."

A while later, he appeared in the dugout. He sat down, and this time when he looked at me, I got that big grin. In fact, looking at the *SI* shooter who forgot to put film in his camera, Willie Mays couldn't keep a straight face. It wasn't a good picture, but at least I got him.

As it turned out, the cover never ran. I don't remember why, maybe Willie went into a slump. But in looking back, I've got to say that the whole assignment was cursed from the start.

--

Then there was my Sugar Ray Robinson disaster.

I was always trying to figure out new ways to photograph people, to do something different, particularly for a cover. In 1965, *Sports Illustrated* sent me to Hawaii to photograph Robinson. Being assigned to photograph the former welterweight and middleweight champ was a thrill and an honor. Robinson was from my father's generation but, at forty-four, he was still boxing. He had agreed to an upcoming fight in Honolulu against a guy named Stan Harrington because he needed money to pay for his recent honeymoon. Nobody expected him to win the ten-rounder, and he didn't. In the post-fight press conference, Harrington was asked why he didn't knock Sugar Ray out. "Because," he said, "I didn't want to be the guy who left him on the canvas."

Before leaving New York, I'd come up with a brilliant idea for a cover. I would make Sugar Ray look like an Academy Award Oscar—an idea inspired by a *Life* magazine cover story about the movie *Goldfinger*. An actress had been painted gold for the *Life* cover. Why not gild Sugar Ray? He's a golden figure of sport, I thought. I'll photograph him in Hawaii at dusk.

I began to prepare. I contacted makeup people, and they put me in touch with a guy who lived in Hawaii. He was quite famous, having done

the Elvis movies shot there. I called him and asked if he could paint a human being gold and he said absolutely. Then I went to my editor and got approval to do this. I arrived in Hawaii five or six days before the fight and went to see Sugar Ray in his hotel suite.

I was excited as someone ushered me in and asked me to sit down. A moment later, in walked Sugar Ray and he couldn't have been nicer. I told him I had an idea, that it may sound a little strange and that I would need about an hour.

He said, "What do you want to do?"

But before I could answer, he said, "And more importantly, how much you paying me to pose for the magazine?"

I knew he had no money. I also knew that getting shaken down by an athlete was not unusual. In those days, subjects would often ask what we were paying for the shoot and we had to explain we didn't pay at all, ever.

Now I told Sugar Ray that *SI* never paid subjects.

He said, "You want me to pose for free? Why would I do that?"

I began to explain why, something I had done many times, and usually I was convincing. Most athletes were smart enough to realize that an *SI* cover could help generate commercial offers. But Sugar Ray insisted he had to get paid and we batted this back and forth. His wife was sitting there, and it soon became obvious that he wasn't going to pose for free. I tried everything I could think of, but still he said, "There's no way. I don't need to be on the cover of *Sports Illustrated*. If people don't know by now who Sugar Ray Robinson is, they're never going to know. So I want to get paid."

I got up to leave. "I'm really sorry," I said, "I had a good idea how I wanted to shoot you."

I started to walk out. "Wait," he said. "I'm curious. What kind of picture do you want to take?"

My hopes soared as I turned back. "I want to paint you gold, Champ. I want to make you the golden figure of the sport."

Sugar Ray Robinson burst out laughing. He looked at his wife and they smiled at each other. Finally he said, "Let me get this straight. You want to paint me gold?"—a dramatic pause—"For free? Not a chance! But I do like the idea."

And that was it. I never got to paint Sugar Ray Robinson gold, but the trip to Hawaii wasn't a total waste. I did get a shot of him during the fight that ran on the cover.

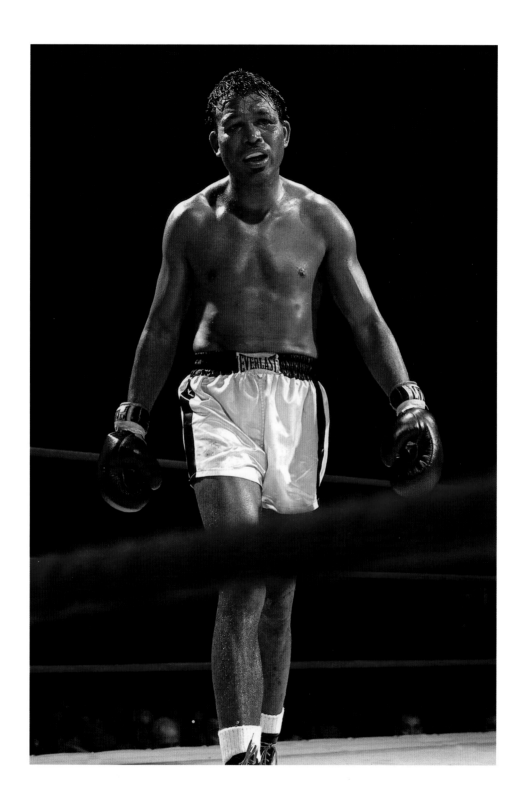

SUGAR RAY ROBINSON, 1965.

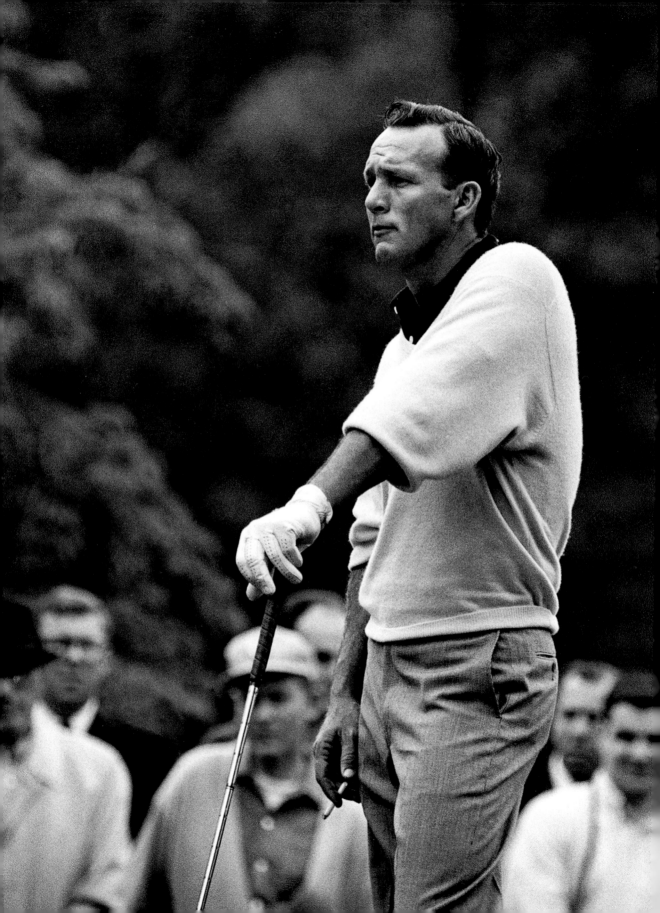

ARNOLD PALMER

> " *If you mix together equal parts of persistence, exuberance, talent, chutzpah, tenacity, excellence, and generosity you will discover the magic of Neil Leifer. I have known him for more than forty years, and I don't know anyone who is better at what he does, and who has more fun doing it than Neil.*
>
> —DAVID HUME KENNERLY,
> Pulitzer Prize–winning photographer

Arnold Palmer was not having a good day. And neither was I. I had never been on a golf course before and was completely out of my element. As a kid, I had played stickball and touch football, not rich guys' sports like golf. I had never even met a golfer, but getting this assignment—to shoot Arnold Palmer for a preview cover of the 1962 Masters—meant a lot, even to me. Palmer was like Babe Ruth. He was the biggest name in sports, a huge superstar who had been on the cover of *Time* magazine and had ushered golf into the TV era. I had studied enough pictures of him to learn that he loved the camera. He was so charismatic. And in the thick of competition, he would emote. Whether he sank a putt—and you got a triumphant look on his face—or rimmed it out—and you caught him grimacing at the pain of it—you couldn't miss with Arnold Palmer. Also, he was a handsome guy who never wore a hat, so you could always see his face without the shadow of a brim. Perfect.

I was shooting at a tournament in Baton Rouge, Louisiana, in March—a month before the Masters—because back then *SI* had to close the cover a month in advance. I expected beautiful Southern weather with temperatures in the seventies. Only it rained—I mean, poured—more or less

constantly for days. Worse, Palmer had abscessed ears, and it wasn't clear that he'd even play.

Eventually, the rain let up, but it was damp and cold. Palmer came out looking nothing like the golfer I had seen in all the photographs I'd studied. In those, he wore short-sleeved shirts that showed off how muscular he was, and his expressive face was all thrill-of-victory or agony-of-defeat. He could have been a model or a movie star.

The Arnold Palmer who set foot on this course was wearing a sweater and, worse, a hat. Not even a good-looking hat but a gray baseball cap. If that wasn't bad enough, he had big wads of cotton sticking out of each ear. They looked like golf balls growing out of his head.

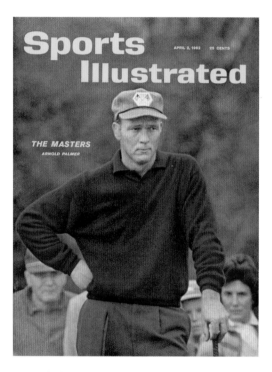

SPORTS ILLUSTRATED, APRIL 2, 1962.

We shook hands. "I'm going to be following you for the next four days," I said. "I'm shooting a *Sports Illustrated* cover." And I mentioned the writer, a man he already knew.

"It's a pleasure to have you," Palmer said.

"Are you going to wear that hat?" I couldn't help asking.

"It's cold."

"What about the cotton?"

"My doctor said . . . actually, I'm not even supposed to play."

This, I decided, was the kiss of death. The magazine would never run one of these pictures. Maybe, I thought, it would get a little warmer and he would at least change into a short-sleeved shirt. That never happened either. He played eighteen holes, though not particularly well. The whole time the hat stayed on his head and the cotton plugged his ears.

The second day was more of the same, and he finished the tournament tied for ninth place. He was feeling lousy and playing poorly. I flew back to New York, assuming I had no chance of getting the cover. This was a preview of the Masters. It was the beginning of spring, the azaleas would be blooming in Augusta. Why would they run a depressing picture on the cover?

But, much to my amazement, they picked a frame in which Palmer

looked tough. He was standing on the green, leaning on his golf club with a look of calm determination on his face. They airbrushed out the wads of cotton and, lo and behold, ran the photo on the cover! It was only my third *SI* cover and not a particularly great one, but I was as surprised as I was pleased. On top of that, Palmer went on to win the Masters, and I thought, Aha! Forget the notorious *Sports Illustrated* cover jinx. I was Arnold Palmer's good luck charm.

Now jump ahead one year. It's 1963 and I'd covered a few more golf tournaments. Palmer's great rivalry with Jack Nicklaus had begun at the U.S. Open the year before, and golf was on the rise as a TV sport. Palmer was playing in the Thunderbird Classic in Westchester, New York, and I was assigned to shoot it. About halfway through the back nine on Sunday, Palmer was leading the tournament. It felt like a million people—Arnie's Army—were all traipsing along with him.

On either the fourteenth or fifteenth hole, his second shot landed at the edge of a huge green. He stood behind the ball lining up his putt. He must have been seventy-five feet from the hole. I was directly opposite him, so all together he was about one hundred and fifty feet from me. He was putting for a birdie and I was crouching down behind my 600mm lens resting on a unipod. Often when golfers are putting from off the green, they leave the flagstick in the hole so the players can see where they're shooting and have the caddies tend the pin. This makes a wonderful picture, the golfer lining up his putt, framed under the arm of the caddy and the flagstick. I was positioned across from Palmer, maybe a foot to the left, lining up my shot. He was walking around the green, lining up his. I began shooting and through the lens I could see Palmer waving his hands. I was thinking, what a great picture, never imagining in a million years that he might have been waving at me.

All of this was being carried live on CBS. Finally, I saw him put his club down and, as etiquette required, walk around the green, not across it. The next thing I knew he was leaning down next to me, putting his arm around my shoulder. "Neil," he whispered (and I remember being amazed that he remembered my name), "do you think you could move about a foot to your left? You're right in my line of vision."

I turned bright red. People were staring, wondering what he was saying to me. Arnie walked back to his ball and by the time he got there, I had slid over.

Golfers, of course, often look for a scapegoat, and so do their caddies. The worst one I can think of is Steve Williams, Tiger Woods's former

FOLLOWING PAGES: PALMER AT THE U.S. OPEN, 1966.

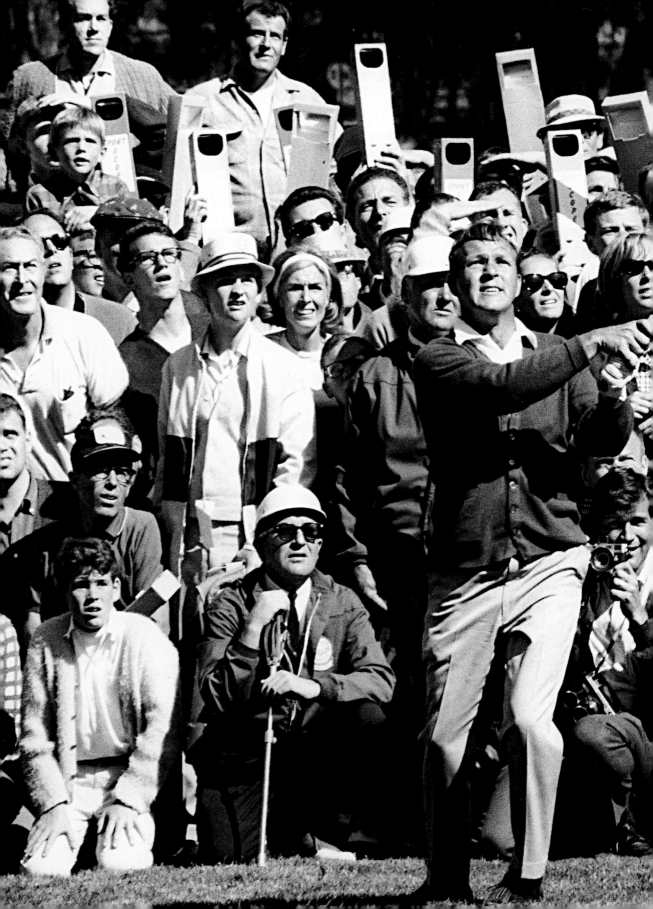

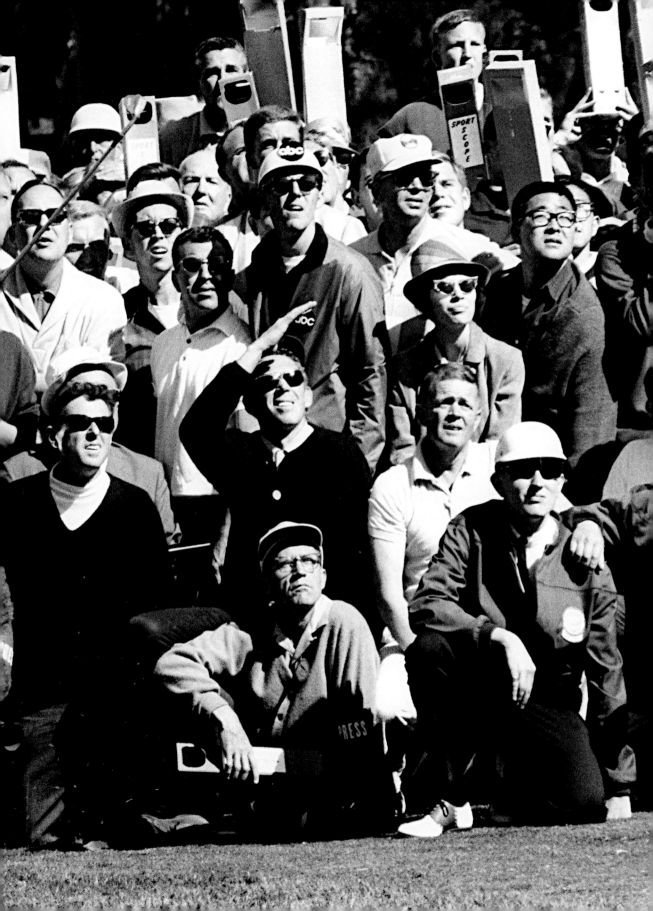

caddie. I've heard horror stories about Williams from other photographers. He made a habit of glowering at the gallery and the photographers, almost daring someone to click his shutter on Tiger's back swing. One year, Tom Weiskopf threatened to have me thrown out of the Masters because he thought he heard my motor drive. In fact, it was turned off; he had heard someone else's. Tennis and golf tournaments both require absolute silence at certain moments. Sometimes a photographer makes a mistake. I've had the motor drive accidentally go off when a tennis player is preparing to serve. They glare at you like you're their worst enemy. If Arnold Palmer had shouted across the green, "Neil, will you move over two feet? You're in my way," the officials probably would have thrown me out and taken away my credential.

I will never forget that moment at the Thunderbird Classic. But then, Palmer produced so many memorable moments. There was one in 1970, when Jack Nicklaus had taken his place as the king of the links. But Palmer still showed up at most tournaments, looking stylish and classy as ever. It was the week leading up to the Masters, when golfers had typically prepared at the Greensboro Classic. *Sports Illustrated* had been tipped that Palmer was invited to a white-tie dinner at the Nixon White House. I was assigned to get a picture out of it.

Palmer left North Carolina at the controls of his own Lear jet. I was waiting on the tarmac when he landed in Washington, and I will never forget the sight. He stepped out of the plane wearing his tuxedo trousers, formal white shirt, white bow tie (untied), and a leather flight jacket. He stood on the top step and I got a nice picture. Then his wife, Winnie, already in a formal gown, joined him and I took photos of them as they walked down the three little steps and slipped into a waiting limousine.

I thought, Wow! Here's a guy who walked off the golf course, flew his own plane, and stepped into a limo to go have dinner at the White House with the president. I always thought of it as a James Bond moment. Palmer might not have been the king of the golf world anymore, but he was still on top of the world when it came to charisma.

PALMER WITH WIFE WINNIE, 1970.

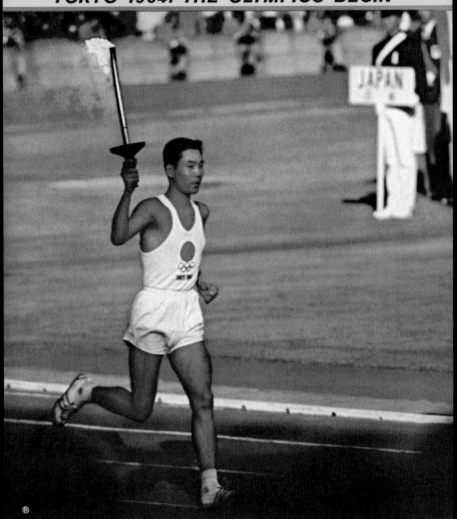

OCTOBER 19, 1964 **35 CENTS**

Sports Illustrated

TOKYO 1964: THE OLYMPICS BEGIN

TOKYO OLYMPICS '64

> " *Neil could arrive at a major sporting event with no parking pass and no credentials to get into the event. Somehow he would talk his way into the parking lot and get one of the prime spots, get into the event with no credential of any kind, and end up with one of the prime shooting locations. That's Neil Leifer.*
>
> —JIM DRAKE, *Sports Illustrated* photographer

It never occurred to me I would not go to the Tokyo Olympics in 1964. I had worked on the preview issue, and my pictures from the 1962 U.S.-Russia track meet in Palo Alto were some of the best I'd ever shot. But when the Tokyo assignments were handed out, I didn't get one. Instead, they chose Jerry Cooke, who always went to the Olympics; Dick Meek, a wonderful staff photographer; and Takeo Tanuma, a Japanese photographer. I was very disappointed. I had done everything I could to earn the trip and I didn't get it. Now I had to dream up another way to get there.

I remembered a publication called *Track & Field News*, which all track aficionados read, just as horse-racing fans read the *Daily Racing Form*. I had seen an ad in a sports magazine that said *Track & Field News* was selling package trips to the Tokyo games, including hotel, flights, and tickets to the best track and field events. I contacted them and made a deal: if they would fly me to Japan and give me two tickets to all track and field events and a hotel room, I'd let them use my pictures for free. My plan was to use one of the coveted track and field tickets myself and to swap the second one for tickets to as many other events as possible.

Next I went to *Time*. "If you give me film and process it, I'll let you look

at my pictures on spec," I said. They gave me two or three hundred rolls of film and promised to pay me for anything they used. Then I went to *Sports Illustrated* and said, "Would you like to look at my *Time* magazine pictures, if it's okay with them?" *SI* also said they would look at my photos and offered to give me some additional film, so I now had all the film I would need to cover the Games.

Two other things happened that were incredibly lucky for me. (The whole trip was lucky—I mean, God was clearly watching over me.) I can't remember any other time in my career when so many things went right—starting with my flight.

My plane to Tokyo left out of JFK and many *Life* magazine people—lab technicians, photographers, and editors—were on that flight. I am never late, but my taxi got stuck in traffic and I arrived later than I normally would. When I went up to the counter to check in, the agent said, "Mr. Leifer, we oversold the flight and we don't have any tourist seats left. Would you mind if we put you in first class?" Would I mind? As I walked through the cabin, the *Life* guys were looking at me, saying, "He's in first class! This kid who's going there on spec!" That's how my Olympics started.

 But it got better!

In Tokyo, the *Life* people were staying at a brand new Hilton, close to the press center, and my deal with *Track & Field News* put me in the Marunouchi Hotel downtown, much farther away. Now, you're not going to believe this story. *Life* had a star system in those days and a New Zealand photographer named Brian Brake was one of the brightest stars among them. For whatever reason, he had not wanted to stay at the Hilton, so he made his own reservation for a Japanese suite at the Marunouchi. At the Tokyo airport, cars were waiting to drive us to our hotels. As we walked into the terminal, someone from the Time Inc. Tokyo bureau approached John McDermott, the *Life* sports editor, and said, "Brian Brake"—and I'm not being funny when I say this—"Brian Brake broke his leg. Badly. He will not be coming. Unfortunately, we have this suite, which was pre-paid for the entire Olympic Games, reserved for him. Would you like to stay there?"

John said no, he wanted to be with the rest of his team at the Hilton. Several others were asked and also said no. So here was my second bit of luck. The man turned to me, "Would you—?" I said I'd check it out. I wasn't sure I wanted to sleep on a Japanese-style bed on the floor, but when I got to the hotel, I looked at my assigned room. I could barely turn around in it. Then I went up to the suite. It had to be ten times as big. It had a sitting

room, it had a little table where you squatted on the floor for your Japanese breakfast, and it had a fabulous bedroom with a futon on the floor. It was irresistible. I took the room.

So now I had film, a spacious room, and a first-class flight over, but no assignment or credentials.

However . . .

My *Track & Field News* package included tickets to the opening and closing ceremonies. As it happened, at the opening ceremonies, I met the parents of Don Schollander—the swimmer from Yale who would end up winning four gold medals. And since I had been given two tickets to every track and field event, I swapped my extras with the Schollanders for their extras to swimming. So my seat at the swimming events was right next the Schollanders' seats, which put me near the finish line. After Don won his fourth, I said to his parents, "I'd love to get a picture of Don with his four gold medals." Not since Jesse Owens in 1936 had any American won four gold medals in an Olympics, and suddenly Schollander was an American hero. They said, oh sure, Don will pose for you. So I took him up to the top diving platform and shot him with the pool below as the background.

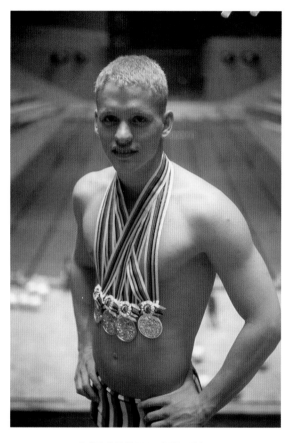

DON SCHOLLANDER, 1964.

Meanwhile, I had no credentials, which meant I had no access to photo positions. That left me no choice but to shoot from the aisles. So I had to improvise again. *Time* gave me an official-looking armband that said "*Time* magazine." Although it wasn't a credential—wasn't anything remotely official—the Japanese must've assumed that it was and respected it.

I began to plan ahead. *SI* was going to close an opening ceremonies cover on Saturday. Because of the International Date Line, the film had to make the plane right after the ceremonies so it would arrive in the States just in time to make the *SI* cover.

Of course, the magazine already had three photographers there, and they were all going to ship their film with a messenger, who would take mine as well. Since *Time* closed on Friday night, it was agreed that *SI* could look at my pictures.

At the opening ceremonies, I found a spot in an aisle, probably fifty or seventy-five feet from the box where Emperor Hirohito of Japan was sitting, his wife beside him. I was crouching down to his left and I started shooting some pictures of the emperor and his wife watching the opening ceremonies. I thought I had taken some really good shots.

The scene of the runner with the torch entering the stadium is very familiar to U.S. audiences by now, thanks to TV, but in 1964, it was the most thrilling, heart-stopping moment I'd ever seen. All the teams were on the infield and this one man with a torch ran around three-quarters of the track, then up a stairway to light the Olympic cauldron. It was so exciting that I was actually shaking. But I was right on it, willing my hands to be still. I shot a simple, clean picture of the torch-bearer, right in front of me down on the track, and that shot was chosen as the *SI* cover—the only Olympics cover the magazine ran during those Games—and a half-page picture of the emperor ran inside.

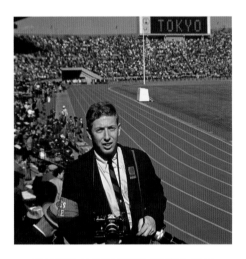

OPENING CEREMONIES, TOKYO, 1964.

The second week, they used one of my Don Schollander pictures on the medal stand, in color, so I was killing it at *Sports Illustrated*. The third week, crouching in the aisles, I got Bob Schul, the American who won the 5,000-meter race, and that was the opening picture that ran for five columns. I might've had more space than any photographer *SI* assigned. And *Time* ran a bunch of my pictures inside, small black-and-white photos. *Track & Field News* gave me a nice spread and used some of the pictures for a couple of years.

But if there was a time when I knew I had a career at *SI*, it was the following year. At the end of 1965, I had fifteen covers for the year. There were fifty-one issues, nine of which used artwork or illustrations on the cover, so I had more than one-third of all the available photo covers. Fifteen covers in one year—trust me, no one will ever do that again.

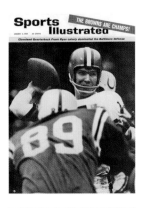

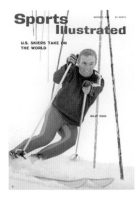

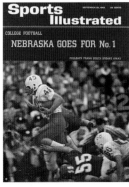

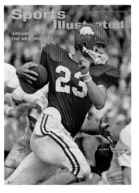

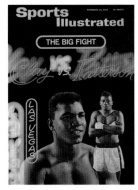

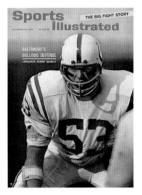

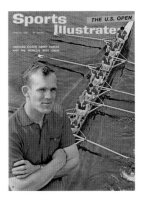

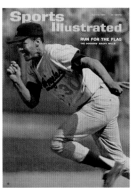

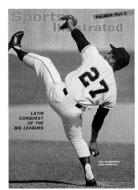

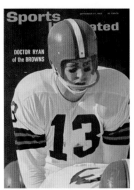

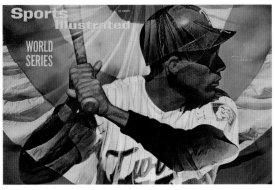

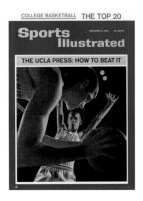

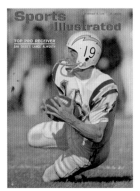

MY FIFTEEN 1965 COVERS.

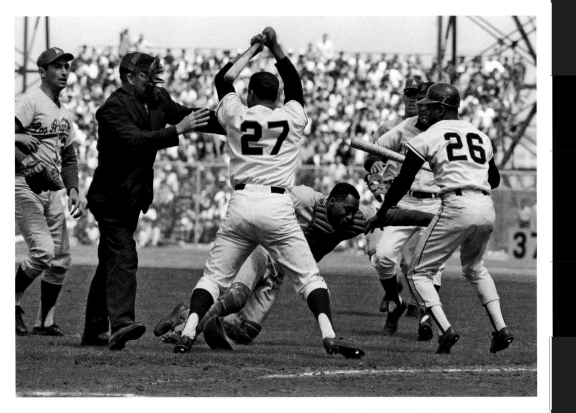

KOUFAX, ROSEBORO, MARICHAL, AND DRYSDALE

" *Luck is the residue of design, and that is Neil Leifer the photographer. Luck happens because he prepared himself to be in exactly the right place.*

—FRANK DEFORD, *Sports Illustrated* writer

Sunday, Bloody Sunday came from out of nowhere.

That's what a stadium full of fans witnessed on a hot summer day at Candlestick Park in San Francisco. It was late August 1965, and the National League pennant race was heating up. *Sports Illustrated* assigned me to shoot the four-game series between the neck-and-neck Giants and Dodgers. Back then, the magazine closed on Sunday, so unless something extraordinary happened—like a perfect game—no pictures from Sunday would make the deadline. I shot the first three games and was supposed to hand carry the film back to New York on the red-eye on Saturday night. But after the third game, I called my photo editor, George Bloodgood. The two best pitchers in baseball—Sandy Koufax and Juan Marichal—would be starting the next day. I said to Bloodgood, "Listen, Sunday is a day game. We never get to see these guys in daytime. I've got a great position behind home plate." I also had a 1000mm lens to use. "I'd love to stay for the Sunday game," I said. "I'll shoot color. We'll have a chance to get some daytime color of Sandy and Juan."

The color photos wouldn't run that week, of course, but we'd have them in the bank to use another time, maybe for a World Series cover. Bloodgood

agreed. "Ship the film you've taken, stay for Sunday's game, and shoot color. But have a black-and-white camera in case something happens."

The "something" could have been a no-hitter or a perfect game, but what were the chances of that?

I took my place behind home plate. Normally, this was not a great position unless you were only interested in shooting the pitchers, which I was, or there was a play at the plate. But it was a lousy position for plays at second base. I had one camera loaded with black-and-white film around my neck; the other camera had color film and was on the 1000mm lens.

In the third inning, with the pitcher Marichal batting, Koufax threw a brushback pitch. That's what opposing pitchers do. The catcher, Johnny Roseboro, came out of his crouch to throw the ball back to the mound and grazed Marichal's ear. All of a sudden, Marichal spun around and I could see something was going to happen. I picked up the camera around my neck and I shot Marichal. It happened so fast I never actually saw what happened—Marichal bopping Roseboro on the head with his bat. I shot one more frame, then I was out of film.

As it turned out, when Marichal clobbered Roseboro, I was on Frame 36, normally the last on the roll. I reloaded the camera quickly as I ran onto the field. Only a television cameraman and I were down there. The other photographers were up on the mezzanine level.

I reached home plate where the players were crowded around Roseboro. I was standing right in front of him. He had blood dripping down his face and all over his catcher's chest protector. Willie Mays helped him to his feet, walked him off the field, and sat him down in the dugout. I got there and shot more pictures. Then, after the game, I immediately flew back to New York on the red-eye, carrying the film.

The editors held space for me for a Monday close, and my shots turned out to be the only pictures of that incident taken from field level: the shot of Marichal clobbering Roseboro was perfect. It's an iconic baseball picture, but I truly believe a lot of it was luck. I was in the right place at the right time, and, thankfully, I didn't miss.

--

Two years earlier, I had also been at Dodger Stadium, hoping my day's work would end up in print but never dreaming that I would make newspaper headlines.

It was Game 3 of the 1963 World Series—the Dodgers and the Yankees—on a hot Saturday afternoon. I was seated in the third-base photo position.

SANDY KOUFAX WINS WORLD SERIES, 1963.

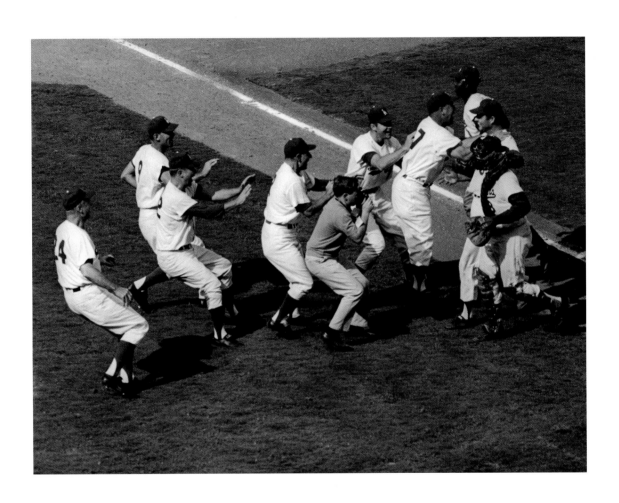

ON THE FIELD WITH DODGER PLAYERS MOMENTS AFTER TAKING THE PHOTO
SHOWN ON THE NEXT TWO PAGES, 1963. PHOTO BY *LOS ANGELES TIMES*.

I could have chosen the first-base position, but I'd studied the light. Sitting on the third-base side, I had the sun behind me, and color film would produce a beautiful Kodak-like moment. I had an idea for a picture. Typically, when a game ended—more so then because pitchers frequently pitched complete games—the catcher would run out to the mound, sometimes even leaping into the pitcher's arms. I wanted to capture this, but in a way that hadn't been done before. I thought that if the game ends on a long fly ball—a sure out—and if they would let me onto the field, I might be able to get close enough to shoot a wide-angle picture of them hugging near the third-base line, with the stands in the background on a beautiful day.

In the ninth inning—with Don Drysdale still on the mound and one out—I said to the security guard, "If the ball is hit in the air with two outs, can you let me through the gate if it's a sure out?" He shrugged. "Okay."

Two outs. Now Drysdale was pitching to the Yankee first baseman Joe Pepitone, who hit a towering fly ball to deep right field. The guard opened the gate for me. Holding my wide-angle lens, I put my head down and raced toward Drysdale. The catcher—again, Roseboro—couldn't move until the ball was caught so I stopped at the foul line. The ball was caught and—bingo!— Roseboro ran to Drysdale. I was probably five feet in front of them with the rest of the Dodgers pouring out of the third-base dugout behind me. The lighting was absolutely perfect, and I knew I had it. I was feeling pretty good.

Though not for long.

The next morning, splashed across the front page of the *Los Angeles Times* sports section was a five-column picture of the same scene taken from the mezzanine. Seven people were in that shot—six Dodgers and me—right in front of Roseboro and Drysdale. The other photographers were in an uproar. Major League baseball accused me of jumping the gate, meaning I had broken a rule. They were going to lift my credential, and surely would have if the security guard hadn't spoken up, admitting he had opened the gate for me. In the end, I got to keep my credential.

That afternoon, Sandy Koufax pitched a fabulous game. This time, I did not run onto the field and I actually got a better picture, this one in black and white. I captured Koufax jumping up after the final out of a World Series sweep of the despised Yankees—with the scoreboard telling the story of the game in the background.

FOLLOWING PAGES: DON DRYSDALE WITH JIM GILLIAM AND JOHN ROSEBORO AFTER WORLD SERIES WIN, 1963.

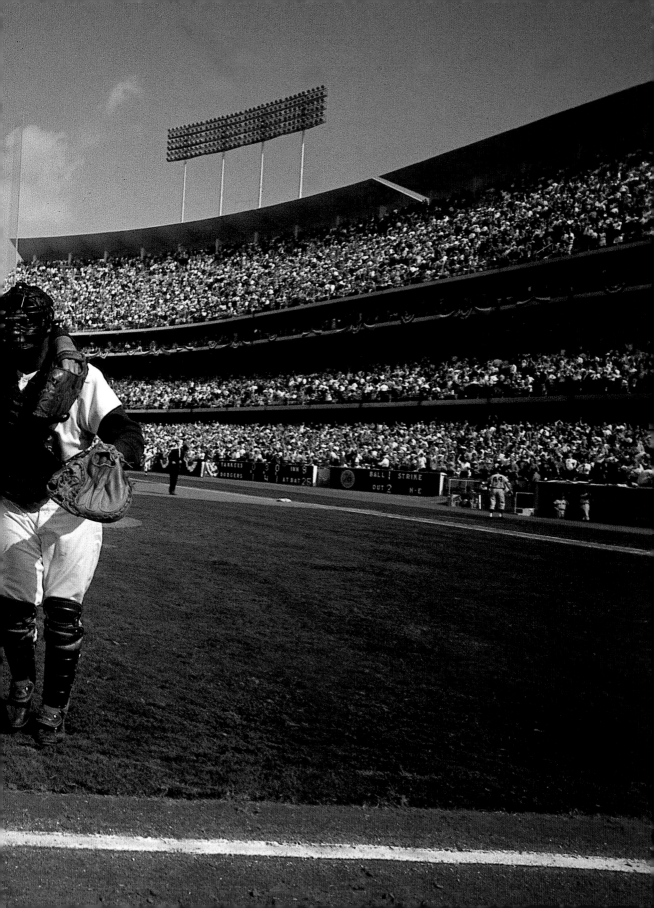

ANDRE LAGUERRE

" *In describing Neil Leifer, the word "tenacious" is an understatement. So is the word "brilliant."*

—FRANK PELLEGRINO, owner, Rao's Restaurant

I have come across many characters in the world of journalism, but none more charismatic or memorable than Andre Laguerre.

For fourteen years, Laguerre was the managing editor of *Sports Illustrated*, a true eccentric some might say, but a brilliant one, a bon vivant with a gift for surprise. During World War II, he was Charles de Gaulle's press attaché, and he spoke perfect English with a proper British accent. People feared Laguerre, even though he had a wonderful soft side. But he walked around the halls of the Time & Life Building swinging a mean, four-foot pointer, usually in the mornings, like a teacher patrolling a classroom. A heavy drinker, he spent every lunchtime at the Ho Ho, a Chinese restaurant next door to the Time & Life Building, sitting at the bar and happily talking to anyone who came by. All you had to do was saunter down there. You could be the mailroom boy or the cleaning lady and he would talk to you. Afternoons were another story. If you were a photo editor, you couldn't show him pictures after lunch because he had difficulty seeing whether they were in focus or not. So the editors made sure that important picture showings were scheduled before lunch.

For years, I had only a nodding acquaintance with Laguerre because, like everyone else, I was afraid to go anywhere near him. Then, in 1966, Tony Triolo and I were assigned to shoot the World Cup final between England and Germany at Wembley Stadium. Laguerre was a huge soccer fan, and it turned out to be one of the most famous games of all time. But

what I remember most is my encounter with him. He was staying at one of the great old London hotels and he invited Tony and me to stop by one evening at nine o'clock to join him for a drink. I mentioned I would like to bring my wife, Renae, and he said, of course!

For days, I had been going on and on to Renae about what a great man she was about to meet. We arrived at the hotel early, and since he wasn't there yet, we waited for him at the entrance. It was pouring rain, and there were big puddles everywhere. At last, a taxi pulled up and the *SI* writer Tex Maule climbed out, followed by Laguerre. British taxis have a little running board and Laguerre somehow missed it and did a frightening belly flop onto the pavement. After all my bragging to my wife about the great Laguerre, there was the man himself, lying face down in a puddle. Actually, I thought he was dead. But after a moment he got up, brushed himself off like nothing had happened, and said quite charmingly, "What a pleasure to meet you, Mrs. Leifer!"

My next encounter with Laguerre was even more memorable and, to me, downright harrowing. He had been impressed with my pictures, and he offered me a contract. There were no staff photographers then, and I had been working as a freelancer, which meant I was paid a day rate of two hundred dollars, plus a space rate of two hundred and fifty dollars per page for black and white and three hundred dollars for color. A cover was five hundred dollars.

The contract he offered meant guaranteed money—in my case, eighteen thousand dollars a year, which was probably the biggest contract they had ever given anybody. They kept track of your assignments, and if your work—meaning day and space rates—added up to more than the contract guaranteed, they would pay you the difference at year's end. It was a great deal, but it stipulated that I could not shoot sports for any other magazine, not even for *Life*, which, like *SI*, was a Time Inc. publication. For the two years I was under contract, I had probably made twenty thousand dollars each year, wonderful money for a young newlywed in those days. Problem was, I wanted to shoot for *Life* and for *Look*. *Newsweek* was now running photographs on the cover, and I wanted to do that, too. So I decided it wasn't in my best interest to stay on contract. When my contract arrived for renewal in 1967, I simply didn't sign it and, much to my surprise, nobody made a big deal of it because, they must have figured, who else was I going to shoot for?

In fact, I had been getting assignments from *Life* and an occasional cover assignment from *Newsweek*. This was about the time when one of

Laguerre's top writers, Pete Axthelm, left *SI* for *Newsweek* and took Jonathan Rodgers with him. Rodgers was a brilliant young reporter whom Laguerre liked. Axthelm loved horse racing, gambling, and drinking, making him one of Laguerre's favorites at the magazine. When Ax was assigned his first piece at *Newsweek*, on Mario Andretti, I was hired to shoot the cover.

Until then I don't think Laguerre even knew I was no longer under contract. He should have been alerted by my boss, George Bloodgood, but apparently Buddy—which is what everyone called Bloodgood—wasn't concerned because every time he asked me to do an assignment, I said yes. I had already shot two four-page color spreads for *Newsweek*—the Americas Cup and spring training—but I guess no one at *SI* had noticed. The Andretti cover they noticed. But still nobody said anything.

Meanwhile, the 1968 Summer Olympics were approaching. Jack Olsen, one of the top writers at *Sports Illustrated*, had been assigned a five-part series about black athletes, some of whom were threatening to boycott the Mexico City Games. Before leaving *SI*, Axthelm and Rodgers had been working on this story, and it only made sense that they would now do it for *Newsweek*. Laguerre was peeved. He wasn't concerned so much that Ax would outwrite Olsen; he was pissed off that guys from his team—Axthelm and Rodgers— were going ahead with what everyone expected to be the big story out of Mexico

NEWSWEEK, JULY 15, 1968.

City. What Laguerre did not know was that *Newsweek* had hired me to shoot the cover. The magazine was also going to run four pages of color, the cover editor Bob Engle told me. "The cover will be Tommie Smith," he said, "and we want Lee Evans, John Carlos, and Harry Edwards inside."

I shot the pictures at the Olympic trials in Los Angeles. If *SI* had assigned me to the trials, of course, I would have accepted. But I wasn't asked. Engle picked the best single frame for the cover: Tommie Smith coming around

TOMMIE SMITH AND JOHN CARLOS, 1968. THE SILVER MEDAL WINNER WAS PETER NORMAN OF AUSTRALIA.

a turn at full speed. Smith would go on to win the gold medal in the 200 meters in Mexico City. The lead picture inside was Lee Evans, and I had four pages of color inside, in addition to the *Newsweek* cover.

When Laguerre saw my pictures and Axthelm's story, he went nuts. That, combined with a color essay, a preview of the upcoming football season, that I did for *Look* sent him through the roof.

Bloodgood called me into his office. "Laguerre wants to meet with you," he said. "He's really upset about *Newsweek* and he wants you back on contract."

I went home and thought it over. At first, I wanted to be on staff, which meant I'd get health insurance and a pension. But the more I thought about it, the surer I was that I also wanted to shoot things other than sports, so I decided to ask for another contract—not an eighteen thousand-dollar contract, or even twenty thousand dollars. In each of the previous three years, I had made at least twenty-five thousand dollars from *SI*, and my feeling was, if they're going to take away my opportunity to work elsewhere, they're going have to pay me more.

But there was a problem. My boss was making twenty-five thousand dollars. How can you ask for the same or more than your boss makes? Laguerre, although generous, took the job of managing editor seriously: he kept a close eye on the company's money. I was still a kid, twenty-five years old, and I was about to face this guy we all feared, this guy who brandished a scary four-foot pointer! I didn't sleep that night and was really nervous as I rode the elevator to his office the next morning.

His secretary showed me in, and Laguerre asked me to close the door. This was something he rarely did. I gulped, shut the door, and sat down. I had rehearsed my spiel while driving to work and was determined to ask for $27,500, figuring the extra $2,500 was reasonable since they would be taking away my ability to shoot sports for anyone else.

Now, in those days, there was a barbershop in the sub-basement of the Time & Life Building where everyone got their hair cut. There was also a shoeshine man from the barbershop who would come upstairs to shine the shoes of the executives in their offices. Me, I got my shoeshine from him in the basement, so I knew firsthand that he was the biggest gossip in the building. But he was a great, old character, and the barber was a little Italian guy. Between the two of them, they had more information and spread more rumors than anyone in the company.

So there I was in Andre's office, making small talk before getting down to business. Suddenly the buzzer rang. I didn't think Andre was one to take

a call in the middle of a meeting, but he picked up the phone. "Yes, Ann?" Then, "Oh, I forgot." He turned to me, cleared his throat, and said, "Neil, I completely forgot, but I'm scheduled for a haircut and a shine. Do you mind if they do it while we're talking?"

Like hell he forgot! It was a psychological ploy. Of course, I minded. I'm supposed to talk money in front of the two most notorious gossips in the building? But I said, "No problem, Andre, of course." And in came the barber and the shoeshine man. The barber threw a cape over Laguerre, and the shoeshine guy sat on his box and went to work on Andre's shoes. Andre said to me, "I was very upset about the *Newsweek* cover. Not upset with you personally. I understand you're a freelancer. But I thought you were under contract. What happened?"

I told him nobody had spoken to me about re-signing two years ago and I hadn't done anything about it.

"I want to remedy that and I want to remedy it right now. How much money do you want?"

I couldn't help looking at the barber, who was beginning to clip Andre's hair, and the other guy, who was energetically buffing his shoes. If Andre had said, "I'll offer you eighteen thousand dollars a year," I would have said, "Yes, sir," just to get out of the room. His ploy was working. I was terrified. I realized I wouldn't be able to keep him talking long enough for these guys to finish their jobs and get out. Maybe I could filibuster my way through the shoeshine, but I was never going get through the whole haircut. I started to stutter.

"You know . . . well . . . I mean . . . I think . . . um, one of the reasons I wanted to speak with you is that I wanted to ask you for more money than Bloodgood is getting. It's awkward and I couldn't talk to him about it. I, uh, appreciate your seeing me."

Andre said, "Get to the number."

"Well, I think I should be making a little more. I ought to be getting something for what you're taking away."

"Yeah? So what do you want?"

What I wanted was for the damn barber and the shoeshine guy to leave!

Andre said, "I'm telling you that I want you here and I don't want you working elsewhere. What do you want?"

Neither the barber nor the shoeshine guy looked up, but I knew they were taking in every word.

I said, "Well, sir, I made twenty-five-thousand-two last year. I looked at my tax return from the year before and I made twenty-five thousand. I'm

surely on target to make twenty-five thousand now." I took a deep breath. "I would like twenty-seven-five because I think I might earn that much."

As I spoke, I was thinking that these guys will spread this conversation all over the building by lunchtime. But the barber just kept cutting and the shoeshine guy kept polishing. And Andre said, "Fine. You got it. I'll tell them to draw up the contract."

He shook my hand and I gratefully left.

--

Two years later, Andre summoned me to his office again. He always read the European sports papers, which were delivered to him each morning. In addition, don't ask me why, he had become a rabid St. Louis Cardinals fan, and he'd sit at his desk, Cardinals cap on his head, twirling that damn pointer and scaring the hell out of anyone he was meeting with.

But soccer was his sport. He followed the English and European soccer leagues religiously. This was 1971, and it was a Monday morning when Laguerre asked to see me. Arsenal had won the League Final Cup the night before, and if they won the FA Cup final against Liverpool at Wembley Stadium on Saturday, it would be an almost unheard-of feat, roughly equivalent to a perfect season in the NFL. The British called it a "double."

Laguerre had already set aside two pages of color for the Arsenal-Liverpool match. He was going to make this a big story. Hugh McIlvanney, the great Scottish sportswriter, would write it. As soon as I got to the office, Bloodgood called and asked if my passport was in order. "We're sending you to London to do the FA Cup final."

I said, "The what?" There were probably three Americans who had ever heard of the FA Cup final and I wasn't one of them. So I was understandably surprised.

"Laguerre has some ideas," Bloodgood said. "He wants to see you."

In all my years at *Sports Illustrated*, this was the only time Laguerre ever discussed an assignment with me. Sitting behind his desk, cigar ash on his shirt and Cardinals cap on his head, he greeted me with, "I'm sure you don't know anything about football, just like all Americans. So I want to tell you a little about the game and what I want you to shoot."

He started to explain how to photograph soccer. I'm thinking, I've photographed soccer before! Did he forget the 1966 World Cup final in London? Suddenly, he pulled out a section of the *New York Times*, rolled it up into a fat ball, stood, and came around the side of his desk. "This," he said, "is the kind of picture I want." Then he kicked the paper soccer ball.

Trying to suppress a laugh, I said, "Yes, sir."

ABC Wide World of Sports was broadcasting the game, and on the flight over, I sat with Jim McKay, the on-air commentator, and producers Don Ohlmeyer and Geoff Mason. This turned out to be fortuitous for me. We were all staying at the same hotel, and our first night there, I was in the bar telling them that when I went to collect my credential, the FA Cup people refused to give one to *Sports Illustrated.* I had gone to see a man named Leonard Went. He was the press chief, a very proper Brit. I told him, "This is *Sports Illustrated.* We have 3.5 million subscribers." And he said, "Young man, I know the magazine. But the FA Cup final is a British game, played by Brits and covered by Brits. We simply don't have room for one more photographer, so I am not giving *Sports Illustrated* a credential. As far as I'm concerned, you can photograph the game from the loo." Thankfully, the Time Inc. London Bureau had gotten me a ticket for the game, so I could shoot from my seat—not a great location, but a good deal better than the loo.

As I was telling this story, a fourth man joined us at the bar. He was Frank McLintock, a former British soccer hero who worked for ABC Sports as a commentator. McLintock was, I later learned, a local god. My story upset him. "I'll meet you here at the hotel tomorrow," he said. "You'll come to the game with me. Don't worry, we'll work it out."

He had a sports car, and as we drove to Wembley Stadium, people beeped at him and waved. Everybody seemed to recognize him. It was like riding to Yankee Stadium with Mickey Mantle at the wheel. Once there, he took me by the arm and walked me right through the VIP entrance and onto the field. The next thing I knew, he had secured an on-field credential from a BBC production guy. Then I really got lucky, because all the important action happened right in front of me. Arsenal won, the sun was out, Liverpool wore red, Arsenal yellow, and the pictures were beautiful. Laguerre was pleased.

Two years later, I asked Laguerre if I could go on staff, thinking that at this point it would be to my advantage. He immediately said yes.

Then, two years after that, Andre was gone. His fourteen-year tenure, the longest by a managing editor of any Time Inc. magazine, was over. He had been pushed out. Hedley Donovan had replaced Henry Luce as editor-in-chief, and it was a tradition that every Friday there would be a managing editors' lunch. Laguerre was not only the most successful managing editor in the building, but also the most senior. Nevertheless, he was the managing editor of a mere sports magazine, not the illustrious

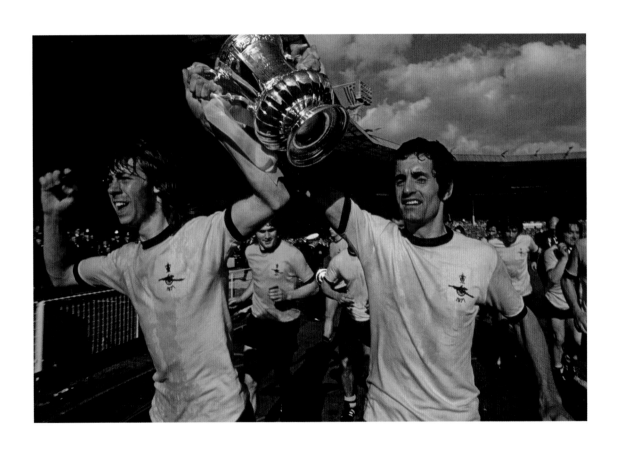

ARSENAL'S CHARLIE GEORGE (LEFT) AND FRANK MCLINTOCK, 1971.

Time, Fortune, or *Life.* Attendance was mandatory at these lunches, but Laguerre, who made millions of dollars a year for the company, saw no reason to show up. It would've taken him away from his lunch at the Ho Ho. Rumor had it that his absences infuriated Hedley. Worse than that, Andre would send his number two to represent him, and everyone in the room knew that Andre wasn't sick or working against a deadline, but was imbibing at the Ho.

Still, every three months—or so I've been told—Andre felt he ought to show up. Henry Grunwald, the editor of *Time* and a truly erudite gentleman, would stand up and pontificate about, for example, why *Time* was going to do a cover on the premier of the Soviet Union. Suddenly, Andre, who'd already put away five scotches—I think he would make a quick trip down to the Ho before the managing editors' lunch, plus there was always a bar at these events—would look up and say, "Henry, you're full of shit." In fact, he made a habit of insulting the other managing editors if he felt they were blowing hot air. Nobody was supposed to tell the managing editor of *Fortune* anything about business or the managing editor of *Time* about politics or the world. But Laguerre was quite worldly himself and fully capable of running any of those magazines.

By 1973, he had been managing editor of *SI* for thirteen years, five years longer than the typical managing editor stewardship. I had come to love Andre. He'd given me the opportunity of a lifetime, and I had capitalized on it. Obviously, he couldn't run the magazine forever so I got up my nerve one day and went to see him in his office. As usual, he was sitting behind his desk with a cigar in his mouth and brandishing his pointer. He was a tough man's man, the last guy on earth you would be comfortable inviting to your home for dinner. But that's what I intended to do.

"Andre," I said, "I would be honored if you and your wife would come out and have dinner at my house. You've been so good to me, and I keep hearing rumors that maybe you are going to move on." I quickly added that I lived in Dix Hills on Long Island, more than forty miles from Manhattan.

Immediately he said, "Yes, we'd love to come, with pleasure." Then he said something I will never forget. "You know, nobody ever invites me to their home for dinner. You're the first one."

We set a date, and I invited Ray Cave and Pat Ryan, then an *SI* editor. I also invited Jerry Cooke, who did all the cooking, and Barry Ryan, a famous horse trainer and a wealthy Kentuckian who was close to Laguerre.

It was a big deal for my wife, Renae, and me. I think it was the first and only time we used the dining room. My daughter, Jodi, who was six,

begged me to let her stay up to meet the guests. Andre showed up in a limo with his wife and Ray and Pat.

When they walked in they all said hello to Jodi then continued inside to have drinks. Except Andre. At one point, I walked back into the living room, where Andre and Jodi were sitting on the floor. He had his hand up, like a ventriloquist, holding her little stuffed dog and making it "talk." As I approached them, I heard him say, "I have a daughter your age." I don't know if he didn't see me or simply chose to ignore me. He was totally focused on Jodi. "And my daughter," he said, "has a little stuffed dog just like this. Only her dog talks." Which is when he broke into a little ventriloquist act.

It was a wonderful moment, but I was stunned. He was the last man on earth I would imagine sitting yoga-style on the floor, communing with a six-year-old.

Not long after that, Hedley Donovan decided he'd had enough and "promoted" Andre. He was given a bullshit job in London designing a prototype for an international edition of *SI*. When they decided not to go forward with it, Andre was finished.

I lost track of him after that. I knew he was the editor of a new horse-racing magazine called *Classic*, and several people from *SI* had joined him or did freelance work there. He still hung out at the Ho, but I wasn't much of a drinker and I never stopped by to see him. Meanwhile, I was having my own problems at the magazine.

One day the phone rang in my *SI* office and it was Laguerre's secretary. She said Andre would like to see me, could I come by? I said, of course, although I couldn't imagine what it might be about.

His offices were on Fifth Avenue—not the fancy part but the low-rent district near Forty-Second Street. Laguerre met me at the elevator, which, as I recall, was a freight elevator. "Neil," he said, "great to see you. Thanks for coming over. I know these offices aren't like the Time & Life Building, but we're just beginning."

His office was comfortable and had the same pictures on the wall that had hung in his office at *SI*. After asking how I was doing, he said, "I've got pigeons that tell me things. I hear you're having a hard time and you're not really happy over there."

"Actually, I'm having a very hard time with Jerry," I said, referring to the photo editor Jerry Cooke.

Laguerre nodded. "I know. I've heard all about it."

Then he said something I will never forget. I was looking across the desk at a frumpy sixty-year-old with the usual cigar ash on his shirt, the man who had made *Sports Illustrated* viable. For the first ten years of its existence, it had lost money, and only because Henry Luce stood behind it was it allowed to survive. But it was Andre's vision that turned it around and made *SI* a thriving enterprise.

He said, "A lot of people think it was just me who made *Sports Illustrated* the success that it is. It wasn't. I had a lot of very talented people who did great work for me and made me and the magazine look good. And you were always one of them. I'm very fond of you and I hear you've got problems. I have this small magazine. We don't have a lot of money, but I want you to know that if you ever need work, there will always be work for you here. I can't do what *SI* does, but anytime you have an idea, I'll be happy to use you."

I almost started to cry. Here was this great and still proud man, a man still widely feared. There was nothing humble about Laguerre, and as far as he was concerned, *Classic* would undoubtedly be his next great magazine, and he wanted me to know that he was there if I needed him.

He walked me to the elevator, put his arm around me, and said, "Please, don't be shy. You come by anytime you need to see me."

In late 1978, I was preparing to go to London for six months to direct my first feature film, *Yesterday's Hero*. Andre always had a passion for movies, and I wanted to see him before I left and tell him about my film. I called his secretary and asked if I could set up a dinner with Andre. It was December, right around holiday time, and she said, "Let me look at his calendar. He's really, really tied up. Okay, the one day he's free would be December 28."

That was my birthday, which I had intended to spend with my wife and two kids, but it would be my only chance to see him for a long time. I said okay. I decided I would take him to the 21 Club and I made a reservation. On the 27th, his secretary called and said, "Unfortunately, Andre isn't feeling well. He has to cancel."

I was so disappointed, but I went off to London and while I was there, Andre died. He had a heart attack. Those of us lucky enough to have worked for Andre cherish his memory and honor him still by telling great stories about this singular character from another, more glorious time.

THE GREAT SHRIMP CAPER

> " *Neil plans everything to a tee—including practical jokes. Nobody knows this better than me. It started in high school when he was the photo editor and assigned me all those dances and suddenly I became the fashion guy. I began to wonder, how can I get even with him? When Neil's family moved to Laurelton, he would stay over at my house on school nights. I thought, "Aha! Got him!" The first night I put six alarm clocks under his bed. I've never seen a guy jump out of bed so fast. So in ways like that, I got even with him. At least for a while.*
>
> —**JOHNNY IACONO**, *Sports Illustrated* photographer

New Orleans was the scene of Super Bowl IX between the Pittsburgh Steelers and the Minnesota Vikings in January 1975. The Superdome wasn't quite finished, so the game was played at Tulane Stadium, but the dome was far enough along to host the NFL's annual Super Bowl party. Even then, several thousand people attended, and, as always, there were tables piled with food. More specifically, they were piled with Egyptian-size pyramids of very large shrimp. I hate shrimp. I hate seafood. I can barely look at the stuff, and all my friends know this. At the party, unbeknownst to me, Johnny Iacono and

several accomplices filled garbage bags with shrimp. That evening, while some of the guys were plying me with liquor at the hotel bar, the schemers snuck into my hotel room, pulled back the sheets, and filled my bed with the shrimp. Hundreds of them! They covered the mattress with them and dumped more into the pillowcases. Then they made up the bed very neatly and left.

Much later, when I got to my room, I took off my pants, took off my shirt, stopped in the bathroom, and headed to bed. I pulled back the covers and I could see through the pillowcase red streaks, which would turn out to be shrimp blood, and hundreds of shrimp. I ran downstairs to the hotel desk, screaming, and insisted they give me a new room. I was told there were no more rooms. Demanding they do something, I finally got them to rush right up and change all of the bedding. For me, this was the nightmare of all nightmares!

I knew immediately that this was Johnny Iacono's handiwork.

The next morning, I had breakfast with Johnny and the other *SI* photographers. They were all sitting there, smugly waiting for my reaction to their stunt, but I didn't say a word. It's the first rule of retaliation: never let on that something has happened. Nothing is worse for the perpetrators than having to wait, looking over their shoulders, wondering when is he going to strike?

Besides Johnny, I was sure the perps included my assistant Al Szabo and the *SI* director of photography Jerry Cooke. I made two decisions. First, I would investigate very carefully. Over time, people will talk. They will brag that they were there when it was planned or let something slip about how the plan was executed. Second, although I hadn't quite decided when I would repay them, I had made up my mind that it wouldn't be for at least six months. Let them twist slowly in the wind, waiting for the inevitable. I never acknowledged that anything had happened. I simply went about my business, plotting and planning and trying to come up with the right idea. Johnny, meanwhile, was going crazy. He knew I suspected him and he kept asking me, "When are you gonna get me?"

"I'm sure if something happened, Johnny, you had nothing to do with it," I would reply. "You would never be so foolish as to try to get me."

One time—and I know this sounds bad—I actually said, "I've got to admit, Johnny. You're the only guy who's smarter than I am at practical jokes. I'll never be good enough to get back at you. So I'm gonna get your wife or maybe . . . your daughter!"

He said, "I'll kill you! You touch my family, I'll kill you." Johnny, of course, hasn't got a mean bone in his body. He could never hurt anybody.

By the time Super Bowl X came around, I had hatched my plot for revenge. The game would be played in Miami, and I had the perfect accomplice already in place. Laurel Frankel, one of *SI*'s photo researchers, had dated a guy who had been a *New York Daily News* photographer. He left to go into the army during Vietnam, where he became a helicopter pilot. Now he was a uniformed police officer with the Dade County Public Safety Department in Miami, where he flew police helicopters. When he agreed to my idea, I was in business.

I needed one more person to aid and abet me, and that person had to be Walter Iooss. I knew Walter had been one of the perpetrators, but I needed him to supply the marijuana that my plan would require. I told Walter what I had in mind, and he said he was in. I had also asked one of our writers, Roy Blount Jr., to join the team and assigned him to bring along a batch of marijuana brownies.

Now I was ready.

Walter and I invited Cooke, Iacono, Szabo, and about twenty others to a cocktail party we were hosting in an *SI* suite the night before the game. Walter had started smoking dope early that night, so the smell in the suite was pungent and the brownies were out. I was playing host, trying to contain my excitement. Finally, I said to the guys, "Listen, I promised my wife I'd call her. It's too noisy in here. I'll be right back."

I hurried to my room, where Laurel's friend and another cop had changed into uniforms and were ready to go. They burst into the suite, announced everyone was under arrest, and read them their Miranda rights. Then the cops started around the room, asking each guy for his name and birthdate. I was amazed at how many began to stutter when asked their birthdays.

Meanwhile, I was out in the hall—ear stuck to the door—waiting for my cue. Through the door, I could hear every word the cops said. They handcuffed three of the guys, and Blount was dragged out of the bathroom where he was trying to flush the brownies down the toilet. In a loud commanding voice, one of the cops asked if anyone in the room had ever been arrested in the state of Florida.

One of the *SI* assistants, Anthony Donna, nearly died. Years before, he had been arrested for making a joke about a bomb in his suitcase at the airport. "B...b...but, I mean, I wasn't charged!" he stammered.

STANDING, LEFT TO RIGHT: JOHNNY IACONO, ROY BLOUNT JR., WALTER IOOSS JR., AND MIAMI COP, 1976.

They made everyone empty their pockets. Jerry Cooke produced an envelope with all of the *SI* game credentials, which he planned to hand out at the party. The cops snatched them up. "But those are our Super Bowl credentials!" Jerry protested. "I can't give you those."

One of the cops said, "Well I wouldn't worry about that if I were you. You won't be needing them. Court doesn't open until Monday morning."

"Okay, everybody," the other cop barked, "I want you to face the windows before we take you downstairs. You all think you can come down here and play with us small-town police? Well, we're gonna make an example of you New York city slickers. Bring in the *Miami Herald* photographer!"

The door opened and in I walked with my camera, the motor drive purring. One by one, the shaken photographers turned around and everyone broke up. I got plenty of pictures, but one thing I learned that day was that you can't take in-focus pictures in a dimly lit room—not when you're laughing as hard as I was.

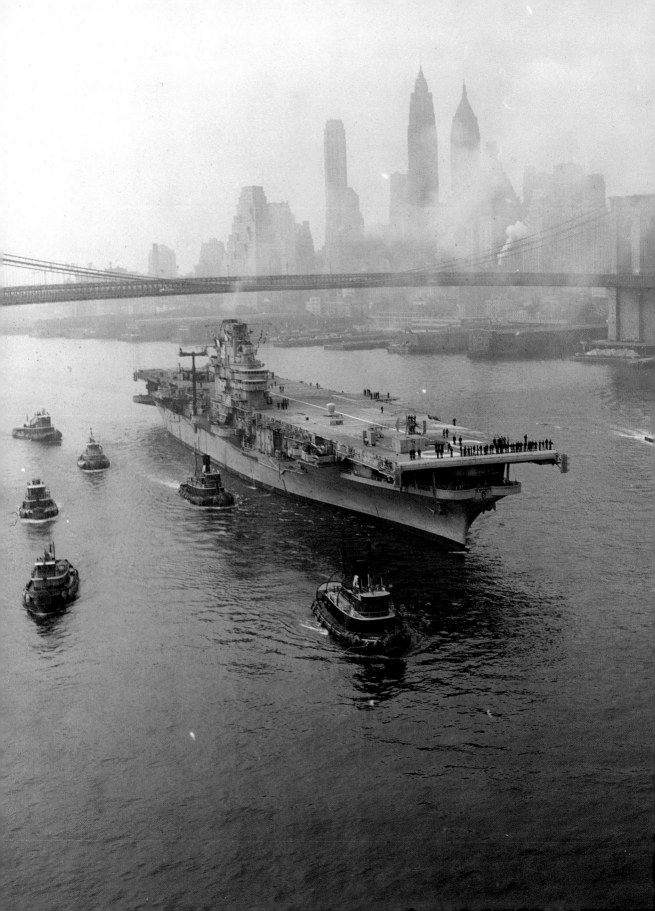

VIETNAM TO MEXICO CITY

> **"** *Neil's photograph of the nine-gun salvo was the only one ever done. I was firing it for him; I wasn't firing it against the Vietnamese. If you know Neil, he can talk you into selling ice cream to the Eskimos. The men on the ship owed an awful lot to Neil Leifer. When the* New Jersey *came home, instead of being spit upon like some of the Vietnam veterans, they were honored.*
>
> —CAPTAIN J. EDWARD SNYDER JR., former commanding officer, USS *New Jersey*

When I was eleven or twelve my hobby was building plastic models of navy warships. A few years later, when photography had become my hobby, it was only natural to begin snapping pictures of ships coming in and out of the Brooklyn Naval Shipyard, just across the East River from where I lived. I loved shooting aircraft carriers, battleships—in short, any warship that I could.

In 1967, the Vietnam War had heated up and Defense Secretary Robert McNamara decided to bring back a battleship, thinking it would be the perfect weapon for Vietnam. The battleship they chose to bring back was the USS *New Jersey*.

I had photographed the *New Jersey* a few years earlier when preparations were being made to take it out of service and mothball it in Philadelphia. Nothing looks deader than a mothballed ship. Cocoons are fitted over the guns to keep the humidity from rusting them. A mothballed fleet looks like a cemetery.

USS *LAKE CHAMPLAIN*, 1958.

I could hardly wait to get to the office the day I heard the news. I didn't even take my coat off before riding the elevator up to the *Life* magazine floor and pitching my idea to the picture department. I was then brought in to see Roy Rowan, the assistant managing editor.

"I'd like to do a piece called 'Mothballs to Vietnam,'" I announced. "The ship is in Philadelphia. I want to show how they bring the ship back to life, and this will take time. I really want to do this. I'll do it for very little money."

Rowan loved the idea, but *Life* already had great photographers in Vietnam, plus staff photographers at home, and they didn't use me for this sort of thing. So I went to see Dick Pollard, the photo editor, who so far had never given me an important assignment. I said, "I don't want you to worry about how many days I work. All I want is a flat fee (quite a meager one), plus all my expenses. I will start shooting in Philadelphia." I took a deep breath. "I'll do the whole thing for five thousand dollars. I'll go through the whole process; the crew arriving to refurbish the ship, the sailors coming aboard, the first sea trials, and, if they'll let me do it, the first time they fire their sixteen-inch guns since the Korean War. I'll be on the ship as they move from the Atlantic through the Panama Canal, on into the Pacific Ocean, all the way until the ship is on the gun line in Vietnam." Five thousand dollars, I repeated, a pittance for what would be a year's work.

Photographers were making two hundred and fifty dollars a day, so I'm sure that Pollard thought I was nuts. But for a total of five thousand dollars, how could he say no? So I had the assignment. The way it worked, I didn't even have to call the office. I would just take the train to Philadelphia whenever I found out something interesting was about to happen.

I started shooting the mothballed ship and the men working to bring it back to life. Soon I knew all the workers, as well as most of the ship's officers, including the captain, Ed Snyder. We hit it off right away, and he granted me virtually unlimited access. When he wanted to have the old traditional footed bathtub, I photographed it the day it arrived. I photographed the first dinner in the captain's quarters, things like that. Already I was living out a dream—I had built a plastic model of this ship as a kid and here I was on it. I could hardly contain my excitement as the USS *New Jersey* began its journey.

The first time they fired the guns was at a target near Guantanamo, a navy range. Next, we passed through the Panama Canal, and the pictures I took were priceless. The Canal is one hundred and ten feet wide and, at the time, all American naval war vessels were built so they could squeeze

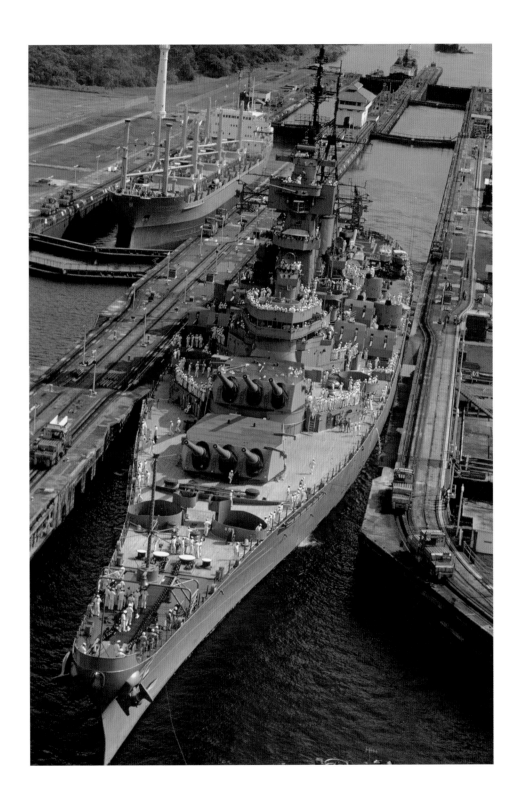

USS *NEW JERSEY* IN THE PANAMA CANAL, 1968.

through it. They had to take off the spigots that spew out water on the side of the ship so that it could fit into a lock. The navy gave me a helicopter to shoot from, and it was breathtakingly beautiful because the ship fills up the whole lock. I rode on the ship through one of the locks and shot from the air over one or two others. Before we entered the Canal, I shot two of the most beautiful sunsets you can possibly imagine.

As we were heading into Panama City, a doctor from the navy's Surgeon General's office, came on over the loudspeaker during dinner. He said, "We're going to be in Panama City tomorrow. We know where you all like to go. The following places are off limits." And he proceeded to list all of the whorehouses. "I want to tell you right now," he added, "the venereal disease rate in Panama is the highest in the world. They have a couple of strange strains of venereal disease we don't know how to get rid of. Please stay away. Furthermore, the military police are going to lock you up if they catch you going into these places."

The sailors were all making notes. And, of course, the minute the ship docked, everyone made a beeline for the forbidden places. Some of the boys decided to take me out. There was an old expression in the navy that when they went into port they got "screwed, blued, and tattooed." One whorehouse they took me to you wouldn't dare to put in a bad movie. No way was I gonna touch one of those girls. This greatly disappointed the sailors, who kept insisting they would buy me one. The guys would get up to dance and, wanting to be agreeable, I would dance with one or two of the girls. Then six guys would try to buy her for me! I also had no intention of getting a tattoo. But it was an experience I will never forget.

I was trying to be a good sport because the guys were always teasing me about hanging out with the captain. Normally, he ate by himself—"the loneliness of command," as they call it. He had his own dining room and his own chef. Often, he asked me to join him for dinner because usually I was the only civilian on board. That made me the only person he could invite to dinner without having to deal with the politics of which of his senior officers he hadn't invited often enough. So two nights a week that's what I did. The ward room was where the officers ate. The warrant officers—who are like sergeant majors—had the best food on the whole ship. So what I'd do is an hour before mealtime, I'd go to the various dining rooms, look at the menus posted, and see where the best meals were being served that day. And that's where I'd eat.

The final training took place near San Diego, where the ship was loaded with weapons and ammo. Of course, most of the attention was on the

sixteen-inch guns. The diameter is sixteen inches; the shells they fire are six feet long and weigh nearly twenty-five hundred pounds each, and they can travel twenty-five to thirty miles. With the *New Jersey* moored five miles offshore, these weapons could strike deep into North Vietnam.

I wanted to stay on the ship all the way to Vietnam and the captain said okay. The navy, however, said no. So I petitioned the navy, and the captain wrote a letter on my behalf to a two-star admiral who was the chief of naval information, known as CHINFO. A meeting was arranged in Washington. I had already been turned down to board the ship in San Diego, so now I was going to ask if I could join the ship in Honolulu, where they were going to spend a few days at Pearl Harbor to load more weapons and supplies. The admiral couldn't have been more charming, but he clearly wasn't going to allow me on board. Instead, he did agree to let me rejoin the ship in Vietnam.

Before I left New York, the *Life* editors did a preliminary layout of my story. It was going to be a cover, plus sixteen to twenty pages inside. They left room for two or three pictures of the ship that would be taken in the Gulf of Tonkin, right off the coast of North Vietnam.

In mid-September 1968, I flew to Tokyo, then Saigon, and was met at the airport by someone from *Time*'s Saigon bureau, who brought me to the hotel. Now, remember, this was eight months after the Tet Offensive and things were really tense. *Life* had a permanent room at the Hotel Continental Saigon. I had been watching the news every night, and I knew that the Viet Cong were constantly shelling the National Assembly building with mortars. And the National Assembly was right next door to my hotel.

I was dead tired when I reached the hotel. I had a lot of luggage and equipment, and the hotel staff brought it up for me. My room was used by the *Life* photographers when they were in Saigon. It was dark when I entered. I switched on the light—and jumped eight feet! There, on the wall, was a three-foot long reptile. It might have been an iguana. I was terrified. They said, "Oh, we'll get rid of this," and somehow they got it out of there. Welcome to Saigon! Then, they were showing me the room and someone opened the closet. Inside, I counted three submachine guns and other smaller guns. They belonged to the *Life* photographers who were working out of the Saigon bureau. But I was definitely taken aback. Automatic weapons in my closet? A building getting shelled next door? All I wanted to do was get out to the ship.

But first, I had to cut through the military red tape. I had to fill out applications to get full accreditation, which would allow me to fly in military

USS *NEW JERSEY* LEAVES THE PHILADELPHIA NAVY YARD, 1968.

planes, the only way you could travel in Vietnam. I had to get to Da Nang, which was a few hundred miles from Saigon, in order to get the helicopter out to the ship. I did the paperwork and was shuttled in to see a noncommissioned officer who would give me my orientation. He looked like he had just stepped off a military poster in a role played by John Wayne.

He examined me from the across his desk. "Welcome to Saigon," he said. "Now I want to give you a bit of advice. You're not going to get to the ship for five days. We have very simple rules here. There is a 10:00 p.m. curfew. I'm going to tell you this very slowly. If you are on the street one minute after ten and someone shoots you—I mean even if it's one of our people—you're wrong and he's right. You have no business being out at that time even with your credential unless you're with a military unit."

The curfew was imposed to facilitate the moving of heavy equipment. During the day, the streets of Saigon were packed, like New York at rush hour. I hadn't yet seen what 10:00 p.m. looked like.

The officer went on, "Now the boys are going to tell you to disregard this bullshit. But they live here. So if I take away their accreditation for a week, they go to Hong Kong for R&R and they come back and get their credentials back. You, on the other hand, have one chance to get to the battleship when we fly the press group out. There will be thirty-plus journalists going out to the ship the first day on the gun line."

Only one of us would be allowed to remain on the ship, and that would be me.

"I'm going to tell you this very carefully: if we catch you breaking the rules . . . drug use is, of course, prohibited. If you're out after curfew and we catch you—if you're lucky enough not to be shot—I will take away your credentials. It will be a minimum of one week before you can get them back. That means you're not getting to the ship because you can't get on a plane and you can't get on a helicopter. So I'm advising you to please obey the rules. Got it?"

"Yes, sir," I said.

No sooner did I leave the press headquarters than I started running into photographers I knew. The first one said, "Hey, you're coming to dinner with us tonight. We've got this great joint on Tu Do Street." Tu Do Street, it turned out, was sort of like an X-rated Greenwich Village. The bars were all there and the striptease joints, and this is where the guys hung out. "We're going to have dinner at six."

The restaurant was a five-minute walk from my hotel, and the streets were packed with commercial traffic and military vehicles when I set out

at six. The place itself was another semi-whorehouse, with girls and strippers everywhere. It was a good restaurant, and I was enjoying seeing old friends and meeting new guys, some of whom I had seen on TV. About 9:30, I started looking at my watch. I said, "I'll buy a round and then I've got to go back."

"No, you don't have to leave," someone said. "Nobody is leaving. Nobody leaves at ten."

I insisted that I had to. I wasn't worried that someone would shoot me, but I couldn't afford to risk losing my credential. They started to get on me. "Neil, what kind of wimp are you?" (Actually, they used words worse than "wimp.") My protests were shrugged off. At a quarter to ten, I said, "Look, I've got to go." And the guys laughed and said, "You're not going anywhere. No one is leaving."

The next thing I knew they were pulling down the shades at the front windows. Not a single person left before curfew. The place was still packed.

Finally, at eleven, I decided enough was enough and I walked out onto the street. There was not a soul, anywhere. In the distance, I could hear a tank convoy, and I couldn't help but feel a little scared. My hotel was only a few hundred yards away. I started walking, eyes darting right and left. I reached the corner across the street from the Caravelle Hotel. After the Caravelle came the National Assembly building, then my hotel. I was moving quickly now, passing the National Assembly when, suddenly, a guard was pointing his rifle at me.

I raised my hands.

He was yelling at me in Vietnamese. All that went through my head was that he was going to shoot me and it was my fault. I started walking slowly with my hands up. The guard raised his rifle higher, aiming it at my head. I froze. I pointed to my hotel yelling, "Hotel!" I have no idea if he understood me, but for some reason, when I started to walk again, he followed at a distance, gun pointed, until I bolted through the hotel's front door.

Needless to say, that was the last time I stayed out past curfew.

To get to the battleship, we first had to fly to Da Nang. There were thirty of us, all journalists or photographers, including the head of the AP bureau, Horst Faas, who had won a Pulitzer Prize. Each of the networks had their main correspondents. All of them had been through real combat. They'd been at Khe Sanh and Con Thien and the Tet Offensive. And I had seen nothing resembling a war. I hadn't heard a shot. Until that night.

A loud, noisy poker game was in progress, but you could still hear the incoming shells because the Viet Cong were always trying to hit Da

Nang. The journalists didn't flinch. But every time I heard something, I would jump.

The next day we were flown by helicopter from Da Nang to the Tonkin Gulf and onto the *New Jersey*. I still had to shoot one last picture: the sixteen-inch guns firing into North Vietnam.

One memorable picture I shot isn't great, but I still laugh every time I see it. These hardened war reporters and photographers had seen far more real combat than anybody else on the ship, including the captain, but none of them had heard a three-gun salvo of sixteen-inch guns, and when the first salvo fired, all of these tough, experienced war correspondents jumped a foot.

Later, after all the others journalists had left, I was able to photograph the big guns firing while I sat in the bow of the ship. I used a Hulcher camera, which takes fifty frames of 35mm film per second. What would happen is this: when they got ready to fire the main battery of guns, there was a three-second warning buzzer so you could protect your ears. At two seconds, I would press the button so that my film was going through the camera before the bullets came out. The result was that I caught the shells every single time. I had used this camera for sports photography—this is how you get the ball hitting the bat or a foot slamming the ball on a kick-off—and this was just one more way I was able to use my experience from shooting sports.

When the guns are fired, a black gas comes out first. Then a white flame shoots out so fast that your eye doesn't see it. Next the sixteen-inch shells come right through the flames. And I got that every time because at fifty frames per second, you couldn't miss. I knew I had great pictures. The plan was for the Saigon bureau to ship the film back to New York, then the layout of my *Battleship New Jersey* photo essay could be completed.

Meanwhile, half a world away in Washington, President Johnson announced that we would stop bombing North Vietnam in an effort to end the war. It didn't end until 1975, but at the time, prospects for peace looked favorable and it was definitely the wrong moment for *Life* magazine to publish a big cover story on a recommissioned battleship and a weapon that had no purpose other than to shoot at North Vietnam. As a result, my year's work—and an incredible set of pictures—never ran.

FOLLOWING PAGES: USS *NEW JERSEY* FIRES FROM THE GULF OF TONKIN, 1968.

My Vietnam shoot ended, and now I had to race to my next assignment—the 1968 Summer Olympics in Mexico City. If all went well,

I would get there in time for the opening ceremonies. The *New Jersey* was in the Tonkin Gulf, five miles off the coast of Vietnam, and the only way to get off the ship was by helicopter to Da Nang. From there, I would fly in a military transport to Saigon, then fly commercially to Tokyo, on to Vancouver, and finally arriving in Mexico City the night before the Games were to open.

Secretary of the Navy Paul Ignatius was also on the ship and would be on the helicopter to Da Nang. We may have been preparing to stop bombing North Vietnam, but the war was certainly not over and the North Vietnamese were shooting down helicopters. I was brought into a meeting and told what time we would leave. They said, "You can fly on the helicopter with the secretary and his four aides, but the situation is this. Not counting the crew, the helicopter seats six. But if that helicopter goes down, the backup helicopter that we'll use seats only five. One person can't go and that, unfortunately, would have to be you."

I thought, You're kidding! The helicopter crashes and you're gonna leave me there? But I had no choice. As it turned out, we had a rather uneventful flight to Da Nang. Once we landed, they ushered the secretary and his four aides off the helicopter and onto a private jet, leaving me standing alone on the runway with all my luggage and equipment. Eventually, a vehicle picked me up and drove me to a military plane, which took me to Saigon. From there, I flew to Mexico City.

When I arrived, I met up with the rest of the *Sports Illustrated* contingent, including Jerry Cooke, Jim Drake, and Walter Iooss. Several nights before, they told me, a big ceremony had been scheduled outside Mexico City, where the Olympic torch would reach the pyramids. It was going to be a spectacular show with fireworks—only the fireworks turned out to be real gunfire. This was 1968, remember, and students all over the world were mounting protests, and when the Mexican students got out of hand, the police opened fire. In what became known as the "Tlatelolco massacre," more than forty people were killed. As they were telling me this, I was thinking, I just came back from a real war zone where no one took a shot at me, and their war stories are twice as scary as mine.

MUNICH, 1972, AND PEGGY FLEMING, 1968

> " *There was a small group of journalists covering sports events back in the 1960s. We learned from each other. You were sure to see the same people week after week. It seems that Neil was always in our shot. There is a simple reason for that: he was always in the right place.*
>
> —ROONE ARLEDGE, president of ABC Sports from 1968–1986, from the foreword, *Neil Leifer's Sports Stars*

After *Sports Illustrated* did not send me to the Tokyo Games, I vowed I would never get shut out of another Olympics that I wanted to attend. And I never did.

So there I was at the Games in Munich in 1972, and while it's true I have screwed up assignments from time to time, this was the first—and I'm pretty sure the only—time I screwed up twice at one event.

The first came one morning when my phone rang at an ungodly hour. My assistant, who was also the wife of a producer for ABC-TV, which was televising the Games, said, "My husband just got a call and was told to get over to the Olympic Village right away. Something is going on there. I thought you should know."

If I had acted, I would have been one of the last journalists allowed into the Olympic Village where eleven Israeli athletes had been taken hostage by Palestinian terrorists. Instead, I figured it was probably nothing important enough for me to get out of bed in the middle of the night. By the time I learned what was happening, the compound had been locked down, and

I was locked out of the biggest story of the Munich Games, or probably any Olympics.

But that was only my first screw-up at those Games. On the day before the closing ceremonies, the U.S. basketball team was set to play the Soviets for the gold medal. This was not a big deal. American basketball teams not only had won every gold medal, they had also never lost a single game since basketball became an Olympic sport in 1936. The Americans were the basketball powerhouse of the world, and I was positive that we would breeze right past the Soviets.

Moreover, *Sports Illustrated* was closing tight on Sunday in New York. Because the game was being played on Saturday night in Munich, the film couldn't get to New York until Monday morning at the earliest. So there was no way *SI* would stay open to run a picture from a meaningless game, which this one surely would be. The only question was, would the United States win by thirty points or twenty?

I was looking forward to a leisurely dinner at the Schwabinger Grill, one of my favorite restaurants in Munich. But the two other *SI* photographers, Jim Drake and Heinz Kluetmeier, thought we should go to the game. Heinz was ambitious; he was new to the magazine and wanted to cover everything he could. I was always conscientious about my job, but the Olympics are a killer. They drain every ounce of your energy. Why bother to go to this boring game when nobody would ever see the pictures?

Eventually, I talked Jim Drake into joining me at dinner. The game was shown on TV in the restaurant, and midway through the first half, Jim got up to check the score. Returning to the table, he said, "You won't believe this. It's very close." There was no chance we could still get to the arena in time, but from that point on, Jim kept hopping up and running over to the TV. Then, with three seconds left, and the United States leading 50–49 after making two free throws, the officials stopped the game and turned back the clock. After a series of throw-in attempts, the Soviets eventually scored and were handed a 51–50 victory. The Americans protested and refused to sign the official score sheet, but no matter. The U.S. team lost its protest, and the Soviets won the gold medal. I thought Jim was going to kill me.

Meanwhile, back at the arena, something about the dispute set off our senior editor, Gil Rogin, because he ran onto the floor and started yelling at the officials. This, of course, became part of the story. Gil was even more upset when he discovered he had only one photographer at the game. *SI* held open the magazine and ran Heinz's pictures big.

POLICE OFFICERS IN THE OLYMPIC VILLAGE, 1972.

I felt so badly for Jim. Instead of photographing an historic Olympic event, poor Drake was having Wiener schnitzel with me at the Schwabinger Grill.

When I think of the Winter Olympics, what comes to mind is the 1968 Games in Grenoble, and not a photograph but a dinner with skating star Peggy Fleming. She had posed for the cover of our preview issue, the week before the Olympics, and the photographer, John Zimmerman, had asked her to pose in the outfit she planned to wear the night of the figure skating finals. She chose a beautiful lime green costume.

Once the Games began, Bob Ottum, who was writing the story, invited Peggy and her mother to join us for dinner the night that Peggy would undoubtedly win the gold. They said yes. This was a great coup for Ottum because now he'd get information no other journalist would.

And did he ever.

Figure skating was a two-day event. The first day was compulsories, which made up 50 percent of the overall score and were boring as hell to watch. Basically, the skaters did figure eights and the judges would get down on their hands and knees with their faces a few inches from the ice. They used magnifying glasses to see how close the lines on the ice were to each other. (I'm not exaggerating!) At the end of the compulsories, Peggy had such a huge lead—unheard of—that she probably could have fallen a couple of times in her long program and still won the gold medal.

For the free skating program on the second day, skaters are divided into groups of five, and the order in which they perform is decided by drawing lots. Peggy would be the first to skate in her group. She had such a great smile and was always beautiful in the free skate, looking like she was under no stress at all. She gave a magnificent performance, but what caught Bob Ottum's eye was the look on her face. Something seemed to be troubling her. Could she have been worried about missing her double axel or triple lutz or quadruple whatever? Although she performed a beautiful program—and indeed won the gold—she wasn't her usual relaxed self.

That night, there were twelve of us at dinner, all hanging on every word Peggy uttered. At last Bob Ottum broke in. "You were magnificent tonight, obviously. But you looked so serious. Was something wrong?"

Peggy started to laugh. "Yes, you're right," she said. "Something was bothering me." And then she told one of the great Olympic stories of all time.

Each group of five skaters had ten minutes to warm up on the ice before competing. When the buzzer sounded, four of the skaters would leave the ice while the first to skate stayed. Peggy came out to warm up wearing her lime green outfit as she had promised. The first few minutes they get their muscles loose and their adrenaline pumping. But in the last minute or two, they practice a couple of jumps.

Peggy performed a leap, her legs wide in the air. "You guys don't know anything about our outfits, but they are stitched together right under the crotch," she told us. "And there are no panties underneath, nothing."

As she did that first warm-up jump, she heard a tearing noise and she knew the crotch was coming open. She was terrified! There was little time left on the clock, and if she went to the judges asking for time to change, she didn't know if they would give it to her. She performed a second leap. Another ripping sound! She couldn't tell how big the rip was; she knew only that she couldn't leave the ice.

Having no choice, she started her program. "The reason I had that look on my face is that I was absolutely certain the dress would break open and I would be skating bare-ass in front of the whole world," she said. "And there was nothing I could do about it!"

Then she smiled her lovely smile and took a sip of champagne.

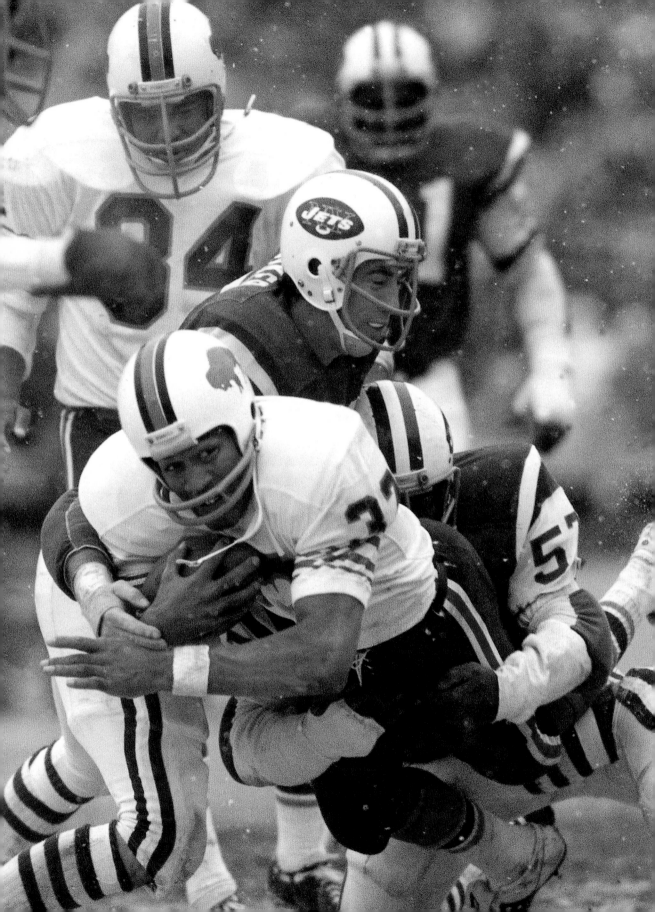

WHAT'S LUCK GOT TO DO WITH IT?

> " *His intensity was always at work and made things happen. Sometimes, that intensity made something unintended happen.*
>
> —RICH CLARKSON, former director of photography, National Geographic Society

Starting long before he was infamous, O. J. Simpson always grabbed headlines. No football player was more charismatic or cooperative—even when he didn't mean to be.

Now I have always said that what separates the great sports photographers from the ordinary ones is this: when the great ones are in the right spot, they don't miss. On December 16, 1973, O. J. needed only 61 yards to break Jim Brown's single-season rushing record of 1,863 yards. The Bills were playing the Jets at Shea Stadium on a snowy day, and barring injury, O. J. would surely break the record. This was a big deal—maybe not Roger Maris hitting 61 home runs, but close.

Sports Illustrated had assigned me and my Lower East Side pal Johnny Iacono, who had been promoted out of the lab and was now shooting regularly, to cover the game. The way it worked was that we would be stationed on opposite sidelines. I was on the Bills' sideline, but there was no advantage to that since O. J. probably ran the ball to the right one-third of the time, to the left one-third of the time, and up the middle one-third of the time. Because of the width of the football field, he had to run in your direction to give you the best chance to get a good picture.

With four minutes and twenty-six seconds to go in the first quarter, we knew O. J. was getting close. The Bills' quarterback handed off to Simpson and he ran right toward me. I got a wonderful sequence. The best picture was him with a Jet wrapped around him as he leaned forward for what was the yard or two he needed to break the record. Had he run toward Johnny, it would've been Johnny who snapped the picture. It was less than a 50–50 proposition, but that play happened to go my way.

--

Luck can make you a hero or a failure in my business, more so I'd guess than in most professions. Your camera position, which is often assigned to you, can make or break you. The sideline position that gave me the best vantage point to shoot O. J. was pure happenstance. Being seated in the perfect spot to get the picture of Muhammad Ali standing over a knocked-out Sonny Liston—again, pure luck.

But, of course, luck cuts both ways. My worst luck came in 1971 at another Ali fight, his first with Joe Frazier. Ali was finally back from his 3½-year suspension from boxing for refusing to be inducted into the army. Having been stripped of his title, he now wanted to reclaim it. It was billed as "The Fight of the Century"—something we now get every year or so. Tony Triolo and I were the two ringside photographers for *Sports Illustrated* and we were assigned opposite sides of the ring, just as Herbie Scharfman and I had been at the 1965 Ali-Liston fight. From the opening bell and for the first fourteen rounds, everything seemed to be going my way, and I was confident that I'd get the shot that would be the *SI* cover.

Then, in the fifteenth round, my luck ran out. Ali got hit and went down, and I was looking at Frazier's backside—just like Herbie Scharfman had been looking at Ali's backside in the Liston fight, only this was even worse because the referee scurried over and partially blocked my view. I knew right then that it was over and that Tony would get the cover. But I did get a picture of Ali on his back—with a third of my frame obscured by the referee, who had moved out of the way just enough—and they ran it for a page and a half inside the magazine. But that was small consolation. I was in a perfect groove all night, but when it mattered most, I was just in the wrong seat.

But that was not the last thing to go wrong for me that night. *SI* had agreed to let *Life* look at my pictures and Tony's, and I had been hoping to hit a double jackpot—the covers of both magazines. But wouldn't you know? An hour before the fight, a *Life* editor shared a deep secret with me:

ALI AFTER KNOCKDOWN BY FRAZIER, 1971.

FRANK SINATRA

April 15, 1980
(New York City)

Mr. Neil Leifer
TIME Magazine
Time-Life Building
1271 Ave. of the Americas
New York, New York 10020

Dear Neil:

Your book is simply marvelous and
a credit to your enormous talent and
professionalism. I thank you most
sincerely for sending it to me and for your
kind words in the inscription.

I'll also make damn sure I'm never
caught covering the same sports event with
you!

Kindest regards,

Frank Sinatra

FS:d

FRANK SINATRA
SHOOTING ALI VS. FRAZIER
FIGHT FOR *LIFE*, 1971.

the writer for their story would be Norman Mailer, and the photographer would be Frank Sinatra. I knew right then that I'd have no chance of getting the *Life* cover; in fact, Sinatra got it. But, of course, the "fix" was in on that one. What the *Life* editor wanted from me was a picture of Sinatra ringside, with camera at the ready, for the editor's note that would run on the contents page.

Another example of bad luck? Take the famous Ice Bowl Game in Green Bay in 1967. The Packers were playing the Dallas Cowboys in the NFL championship game, with the winner going to Super Bowl II. *SI* sent Walter Iooss, one of the best football photographers I've ever seen, and me. Walter hated the cold, but this was the big game of the week and he had to go.

I definitely had Walter psyched out because I did not even wear gloves (mainly because I found it easier to change film and load cameras without gloves, but if it gave me an edge over Walter, all the better). Walter, on the other hand, was a beach guy. And here we were at Lambeau Field, where the wind chill factor was well below zero. We were both shooting for a cover, of course, and the lead story in the magazine. Every time I looked over at Walter, he was shivering. After a big play, I would look around to see where my competition was. Was Walter in position? Did he have a better angle than I did?

And for fifty-nine minutes and forty-seven seconds, I thought I had Walter's number big-time because every time I looked at him, he was shivering. Between plays, I would catch him at the heaters by the Dallas bench, warming his hands. Up until the very end, things had broken my way. There had been a couple of big plays, and I had them.

But now the Packers had the ball on the Cowboys' one-foot line. It was simple: Bart Starr was going to score the winning touchdown himself, or hand the ball off to the fullback, who would dive over the line, or, less likely, throw a pass. Every photographer in the stadium was behind the end zone, ten yards away. I figured they would run a sweep, not try to go straight in, so the position I chose was not head-on to the play. Walter chose to be head-on, and lineman Jerry Kramer opened the hole for a quarterback sneak by Starr—right in front of Walter.

I took one glance at him to make sure his camera hadn't failed him and I could see from his body language that he'd gotten the picture. One of the things I always respected about Walter was that he didn't miss. His picture of Bart Starr going in for the winning touchdown ran as a double-truck opener. It's a classic, one of the most famous football pictures of all time.

Mine? It was nowhere near as good as Walter's and has been published only once—in one of my own photo books.

Back to O. J., although this is not exactly a story about luck. True, he did make me a hero—though I'm not going to show you the picture that proves it.

It was the summer of 1969. Having just won the Heisman Trophy, he was clearly the number one football player in the country. I had photographed him at USC, and I thought he was the greatest running back I'd ever seen other than Jimmy Brown. Only now there was a problem. The Buffalo Bills had drafted him, but O. J. didn't want to play for them. He wanted to play for a team in California, where he'd grown up. Thinking that Bills owner Ralph Wilson would trade him, O. J. didn't report to training camp. But Wilson refused to cooperate, and at the last possible moment, O. J. ended his holdout and signed on with the Bills. He was due to report to camp on a Monday.

Accommodating as always, O. J. had given permission for an *SI* writer and me to hang out with him for the week leading up to the first preseason game. Whether he was ready to play or not, I was certain *SI* would put him on the cover. The first couple of days, O. J. had to go through an extensive physical. Given his hefty contract, the Bills wanted to make sure he hadn't torn ligaments in his knee playing golf and that his heart was sound. The first day he had his blood pressure taken, did an EKG, and had blood drawn. The next day he had eye and hearing tests. I dutifully followed him from doctor to doctor.

I was shooting with three Nikons around my neck, each with a different lens and all black-and-white film for the inside pages. By then, I had lost track of where I was in the 36-picture rolls because I kept switching from one camera to another. At one point, when we were in an examination room alone, waiting for a doctor, O. J. asked why I didn't use a flash. I told him I wasn't using my strobe light because the room was bright enough to shoot without it.

He was standing there naked, with only a towel wrapped around him. "Say you wanted to photograph something that—let's say—is two feet away. Can you come in that close?" he asked.

I said I could with my 50mm lens.

"Is it set for the light in this room?" O. J. asked.

"Yes," I told him.

"Let me have the camera," he said. So I handed it to him.

With that, O. J. dropped the towel and did what so many athletes like to do—show off their manhood. He clutched his with one hand and held the camera two feet away with the other. As he pressed the button, I was standing there thinking, Oh, God. What the hell is the photo lab going to make of this? The camera was on a motor drive and I heard it go, "Click, click, click, click, click." And I thought, Oh, shit.

O. J. was laughing. He thought this was great.

I was mortified. Instead of carrying the film back to New York myself, I would be shipping it to the lab to be processed, so I knew I wouldn't see it. Working in the lab were two young ladies, one of whom was a huge sports fan who really liked my photographs. Their job was to take the five-foot-long roll of film, once it was developed and out of the drier, cut it into six pieces, and make contact sheets for the editors to view. I knew I had to do something.

I didn't want to throw the whole roll of film away, but I also didn't want those two young women to see O. J., well, overexposed. So I took the lens off, rolled back the film at least five or six clicks, and exposed those frames again to obliterate the images O. J. had shot. I was sure I had wiped out those frames forever. I shipped the film back to New York and forgot about what had just happened.

A month or so later, I was in the lab and the young woman who was a big sports fan said, "Neil, I loved your O. J. Simpson pictures. The guys made me a print—actually, a couple of prints of my favorite frame. Do you think you could get him to autograph them for me the next time you see him?"

She handed me an envelope and, curious to see which shots she'd chosen for prints, I opened it. And there it was, this perfectly in focus, perfectly composed picture of O. J.'s johnson. I had obviously failed to erase all of the frames he shot. Everyone in the lab broke into gales of laughter. When I saw O. J. a few weeks later, I asked him if he would autograph a picture for the girl in the lab. When he saw what it was, he was delighted. Could he have a copy for himself, he asked?

Years later, when he was on trial for murder, I thought about how lucky the people at the *National Inquirer* would feel if they could get their hands on that picture. I even thought there might be a certain justice in making it public.

Lucky for O. J. that I'd never do a thing like that.

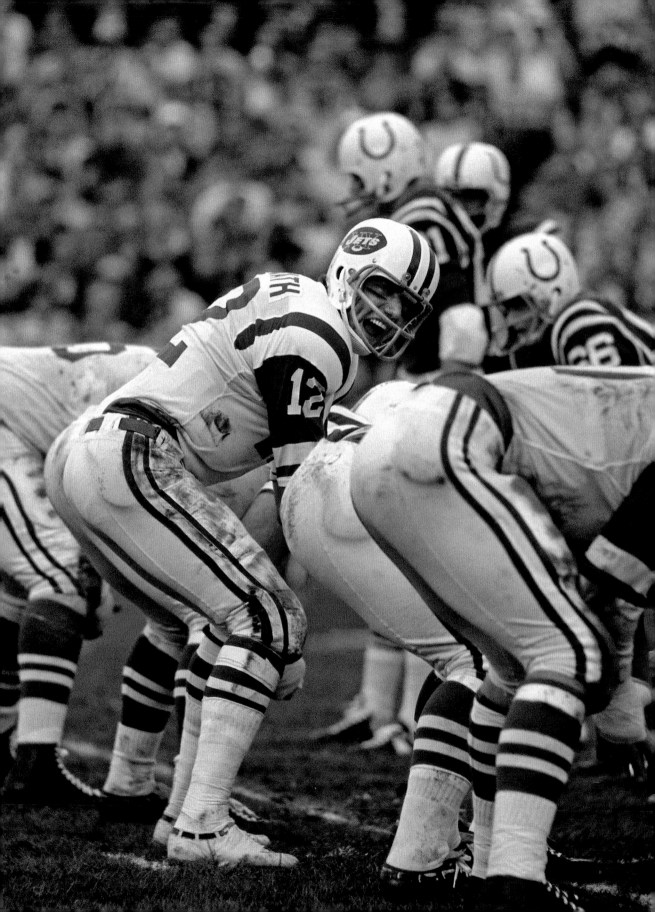

JOE NAMATH

> " *Neil knew how to get the best picture he could possibly get. And he knew how he was going to kick everybody's ass. I love that mentality, I do. It meant I had to try a bit harder because I didn't want to beat other photographers. I wanted to kill them. This was not a gentle business we were in. And yes, I wanted to kill Neil, too. I do have to say, though, that Neil was most definitely the best sports photographer of his generation.*
>
> —HARRY BENSON, photographer

> *Neil's sensational sports photographs have been some of the best I've ever seen.*
>
> —JOE NAMATH, New York Jets quarterback

By 1970, Joe Namath was the biggest star in football, one of the most famous men in the United States, and perhaps its most eligible bachelor. After boasting that his underdog New York Jets would beat the Baltimore Colts in Super Bowl III—and then pulling off an astonishing 16–7 upset—his popularity only grew. He was offered TV and film roles and, along with two partners, he opened Bachelors III, a restaurant in midtown Manhattan. The place crawled with celebrities—DiMaggio, Mantle, Sinatra, and movie stars galore. Rumor also had it that Namath lived in an over-the-top bachelor pad on the Upper East Side, which he refused to let journalists see.

At the time, I was doing plenty of work for *Life*, but it was always sports and they were never big, important stories. I was trying desperately to

persuade the magazine to assign me to other kinds of stories. One day I was up in the office of John McDermott, the sports editor, and he said, "Neil, we have an assignment that we'd love you to try. If you can pull this off, I think we'll get it on the cover and we'll definitely give it a huge spread."

I'd never had the cover on *Life* or even a big spread. I waited.

"We would love to get Joe Namath to pose at home, and if you can get him with one of his ladies, that would be even nicer."

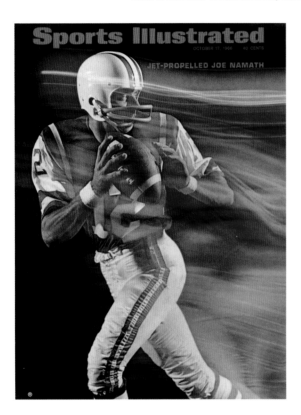

SPORTS ILLUSTRATED, OCTOBER 17, 1966.

This was a prospect that really excited me. And I had a history with Joe, a good one. Three times I had photographed him for the cover of *SI*. And during one of those shoots I almost cost him his football career. The idea had been to do a photo in the *Life* studio using a technique that creates a blurred, as well as a sharp, frozen image of the subject, all on one frame of film. You open the shutter to create the blurred image, and when you press the button the second time, the strobe goes off and freezes the subject. This technique had been used before, but what I wanted to do with it was something new.

As usual, I spent two or three days preparing. Everything in the room had to be black, right down to Namath's feet, so I covered the concrete floor with black paper. There could be no extraneous lights, and to test this, I worked with a stand-in who could drop back to pass the way I wanted Namath to do it. That motion would create the blur, then I'd freeze the image when his legs crossed and he was about to cock his arm to throw. I was confident I had everything right.

Joe showed up and put on his Jets uniform—white pants, shoulder pads, green jersey, and a pair of his trademark white cleats. He hadn't brought his famous knee brace because, well, why would he? When he was ready, I told him I wanted him to drop back smoothly, as if to pass. It just wasn't happening. So I showed him again how I wanted him to drop back, and when he finally had it down, I started shooting.

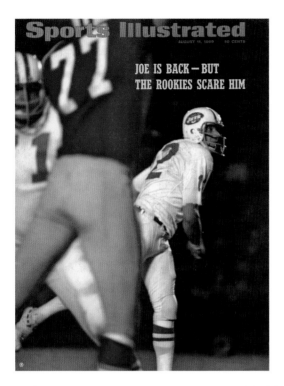
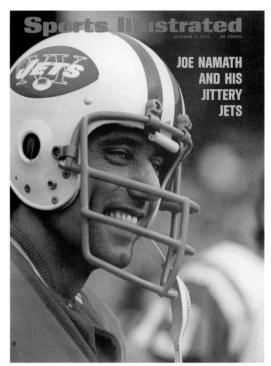

SPORTS ILLUSTRATED, AUGUST 11, 1969, AND OCTOBER 9, 1972.

On the second or third attempt, the black paper on the floor ripped, and Joe slipped and went down hard on the concrete. I thought, "Oh God! I've just cost the Jets their famous $400,000 quarterback!" Joe laid there for several heart-stopping seconds, then slowly got up and I began to breathe again. We went back to work, and he tried to be more careful, which only made it harder to get the smooth, natural motion I was looking for. In the end, I did get exactly the picture I wanted, which ran on the cover of the October 17, 1966, issue of *SI*. Joe really liked it, too, and I had several prints made for him.

So I knew Joe fairly well by the time the *Life* assignment came up, and if I needed to see him, I would simply go out to practice and talk with him. I drove out to Hofstra, where the Jets practiced, and after the drills were over, I followed Joe into the locker room. It had been a year or so since I'd last seen him, and in that time he had been involved in a headline-grabbing scandal. The NFL had been monitoring the comings and goings of some of the patrons at Bachelors III and had identified a number of known gamblers and mobsters. Now, nothing terrified the NFL more than the specter

of gambling and mobsters and even the vaguest hint of point shaving or fixed games. Although Namath was never accused of gambling, Commissioner Pete Rozelle demanded that he sell his share of Bachelors III. Joe refused, and Rozelle ruled him ineligible to play. Eventually, Namath backed down, selling his stake in the business.

I mention this because a *Time* magazine sports writer had done an article about the unsavory clientele at Bachelors III, and this was followed by an even more damaging piece in *SI*, written by Nick Pileggi. Furthermore, the *Time* writer had some kind of face-to-face confrontation with Joe, and lawsuits were threatened. All of this happened in the spring of 1969. Now it was September or October, and Joe was still smarting. But when I approached him, he was as friendly as ever.

"Hey, Neil, how are you?" he said. "Nice to see you."

We chatted amiably before I got down to business. "*Life* wants me to photograph you at home," I said, "for a possible cover. I know how private you are, but I'm hoping you'll consider this. It would be a really big break for me."

Joe shook his head. "Neil, you're one of the few photographers that I would say yes to, but it ain't gonna be for *Life* magazine. I hate Time Inc. I don't care if the Time & Life Building burns down. My parents were hurt by those stories, and so was I. And they weren't true! Come back to me with another publication and I will consider it for sure, but I'm not gonna do it for Time Inc."

A few days later, I returned to practice and asked Joe if he'd reconsider. Again, he turned me down, but I don't give up easily. I called my good friend, Dick Schaap, who did a weekly TV show with Namath and who often took him to dinner at Rao's, a famous Italian restaurant in Spanish Harlem that was and is impossible to get into, but where Dick had a regular table. "Is there any way I can get Joe to do this?" I asked.

Schaap said, "I know how adamant he is about Time Inc., but I'll talk to him. Because it's you, maybe I can get him to change his mind."

A couple of days later, Schaap said, "I had a really good talk with Joe, but there's no way he's ever going to do this for any Time Inc. publication. It's not going to happen."

At that point, I felt I had taken my best shot. So I went up to the *Life* offices and told John McDermott that there was "no way" that Namath would pose for the magazine.

Two or three months passed and I was at the *Life* offices, working on some minor story, when I stopped dead in my tracks. In those days, when

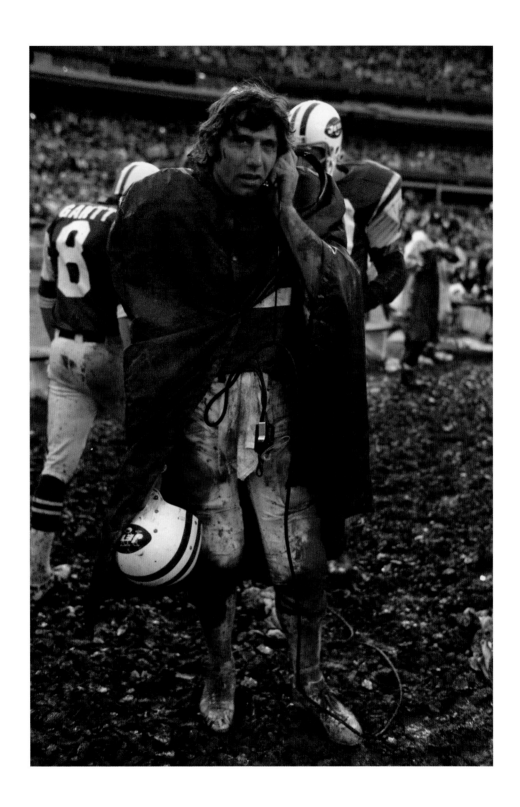

NAMATH IN THE MUD, 1974.

a story had reached the final stages of editing, photostats of the pages were tacked up on a wall. Twenty pages hung on the wall in McDermott's office and on the cover was Joe Namath, wearing a tuxedo and sitting in a chair that was clearly in his living room. There was also a picture of him in the billiard room and another taken in his bathroom! I turned bright red. I couldn't believe my eyes.

"How did this happen?" I blurted out. "Whose pictures are these?" Had someone lied his way into Namath's fabled bachelor pad by telling him the photos weren't for *Life*?

"They're Harry Benson's," McDermott said.

Harry had made quite a name for himself eight years earlier when a British tabloid assigned him to travel to the United States with a new group called the Beatles. Among his most famous shots was the band having a pillow fight on a bed. I knew Harry, knew that he was aggressive as hell. But still!

"After you told me Namath had turned you down," McDermott explained, "Harry said he thought he could get to him."

I was furious. Harry didn't know the first thing about football. There had to be more to this story, so I got in my car and sped out to Hofstra. After practice, I marched into the locker room and straight over to Joe.

"What happened?" I said. "You told me you didn't care if the Time & Life Building burned down, and then you posed for Harry Benson? It embarrassed me. Why would you say yes to Harry after you'd turned me down repeatedly?"

Joe grinned. "I knew you'd be coming to ask me," he said. "So here's how it happened."

I was still hot, but I sat on a stool and waited.

"I'm sitting here at my locker," Joe began, "and this character comes by. I couldn't even understand him with that very heavy Scottish accent, but he says he's Harry Benson and he worked for *Life* magazine and he wanted to do these pictures of me at home. I told him I had already turned down Neil Leifer, who's a very good photographer, and I wasn't going to do this. If I were, I'd have done it for Neil. And Harry says, 'Yeah, well, but I've done this and I've done that.' And I said forget about it. You don't have a prayer of getting me to change my mind.

"A couple night later, I'm sitting at home and the phone rings. Now, very few people have my number, so I picked up and said, 'Who's this?'

"A man said, 'Joe, is that you? This is Johnny.'

"I said, 'Who?'

"He said, 'Johnny. Johnny Carson.'

"I said, 'Oh, hi, Johnny. Sorry I didn't recognize the voice. What's up?'

"We chitchat for a while and finally he says, 'Joe, I've got a favor to ask. You really hurt a good friend of mine. You know how private I am, how I don't let anybody into my private world. But Harry Benson did a great set of pictures that I love. It was on the cover of *Life* with maybe twenty pages inside. I let him into my home. He's one of the good guys and he's a great photographer. Anyway, he called me almost in tears. He's devastated that you turned him down. So please, Joe, do this for me: say yes to Harry.'"

According to Namath, he told Carson that I had already asked and that I was one of the best, that he liked me, and he liked Dick Schaap. He gave him the whole bit.

"But then," Joe went on, "Johnny says, 'Harry is devastated. Think about it please. It would mean a great deal to me.' So I told him I would.

"If my number wasn't so private," Joe said to me, "I would have thought these were impersonators, but obviously it was Johnny.

"A day later, Harry comes out to practice and says, 'I hope you've reconsidered.' I had no choice, so I said, 'All right! I give up!'"

And that's how Harry Benson got the pictures. Nine pages and the cover of *Life*. Frankly, the whole story sounded familiar. Harry had done exactly what I would do, but in this case, he used the perfect weapon. I mean, Johnny Carson? It's tough to compete with that. I expected that Harry would have President Nixon calling next.

But it's not the end of the story because Harry parlayed that assignment into a gold mine. Although he knew nothing about football, he became Joe Namath's number one photographer, even doing all of Joe's commercial shoots, including the famous pantyhose ad. Harry made a fortune.

For a long time, Harry had no interest in me. If we passed in the halls, he might say hi, but that was as far as it went. He was a big star at *Life* and he was branching out into the other Time Inc. publications. Then in 1974, Jerry Cooke became director of photography at *SI*, meaning he made the assignments. He also happened to be my closest friend at the magazine.

And guess who called me?

"Hey, Neil, it's Harry Benson," came the voice on the line. "You and I should really get to know each other."

I thought, that son of a bitch. Of course he wants to know me! He wants me to put in a good word with Jerry Cooke. Then he invited me to lunch at Raga, a wonderful Indian restaurant. I said, "Fine, Harry."

FOLLOWING PAGES: NAMATH WITH TEAMMATES DURING SUPER BOWL III, 1969.

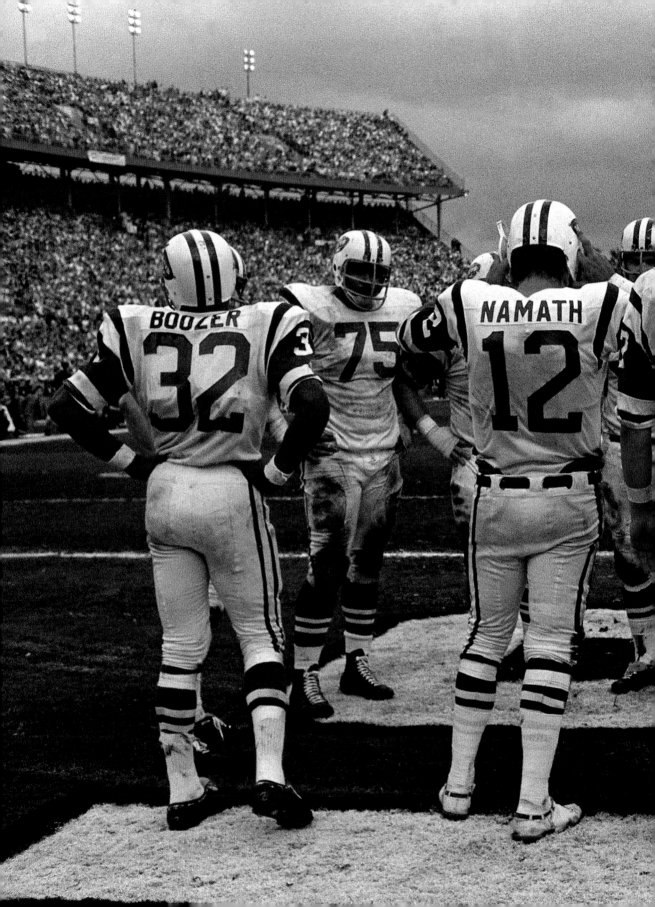

As I walked to the restaurant, I thought, he's never going to win me over. I'll have a nice lunch. I was a big fan of his pictures, but this was such a blatant butter-Neil-up moment.

We had a couple of drinks and a fairly long lunch. Harry was fascinating. He was funny and charismatic, a great storyteller, and he was full of compliments for me. By the end of the lunch, I was Harry's biggest fan. He totally won me over. I would have told Jerry Cooke anything he wanted me to say.

It's now decades later and we're old friends. Harry can flatter the hell out of you, but when all the bullshit is said and done, he delivers. A lot of charming people talk a good game, but their pictures don't live up to all the chatter. Harry Benson talks his way in, then gets his subjects to relax and reveal who they really are for the camera. He's great with people. He charms his subjects the way he charmed me. And he has built a body of work that just knocks your socks off.

CHARLES FINLEY

> 66 *Neil has taken some of the greatest photos you've ever seen, even if you've seen them before.*
>
> —YOGI BERRA, Baseball Hall of Fame catcher, manager, and coach

In the early '70s, one of the most colorful and controversial figures in sports was the owner of the Oakland A's, Charles A. Finley. The A's won the World Series in 1972 and 1973, and I was assigned to shoot one of their ace pitchers, Catfish Hunter, for a cover in 1974. (They would win the World Series that year, too.)

Finley was an iconoclast who tried to modernize—or at least jazz up—the tradition-bound game. At a time when teams were still wearing white uniforms for home games and gray for road games, he made his players wear kelly green, gold, and white uniforms. He tried to use orange baseballs, but that experiment failed. He pushed for the designated hitter rule and night World Series games, both of which are now standard. And he managed to alienate everyone from the commissioner to his groundskeeper. But most of all, he alienated his players.

All of this I knew. What I did not know was how much his players hated him. I mean really hated him. And what I wanted to do was take a picture of Finley surrounded by eight or nine of his best players. I knew I would need help.

I appealed to Reggie Jackson—I had shot him for an *SI* cover—and he agreed to help me get the players I needed. But there was one player who was going to be a problem: the other ace pitcher, Vida Blue. As soon as I

entered the locker room, I knew that Vida was going to be difficult; he was wearing a T-shirt with two words emblazoned on it: "Fuck Finley."

I talked to each player I wanted to photograph and explained that I would shoot the next day before batting practice, that it would take five minutes at most. Catfish, Rollie Fingers, and Reggie said fine. Then I approached Vida Blue.

He was, in fact, one of the really nice ballplayers I had dealt with. But when I told him what I wanted, he said, "I won't pose with that man. I hate that guy." He had gone through a particularly bitter salary dispute with Finley—this was before free agency—and he said he didn't care what the other players did; he was not going to pose.

I wasn't about to give up, so again I turned to Reggie. And thanks to him, the next day Vida Blue put on his uniform and took a position in the back row. The problem was I needed him in the front row because of his particularly dark skin color. I wanted him in the middle where he'd suck up the light. But in the middle would have meant sitting in front of Finley, who would have put his hands on Vida's shoulders.

That was too much for Vida. Instead, he stood in the right upper corner of the picture, leaning as far away from Finley as he could. Thinking this might be a cover shot, I kept urging him to move to his right. He had nothing against posing next to the player who was to his right, but the idea of being that close to Finley was offensive to him.

The resulting picture wasn't perfect, but it ran as the lead page in the magazine, and just getting it was a coup.

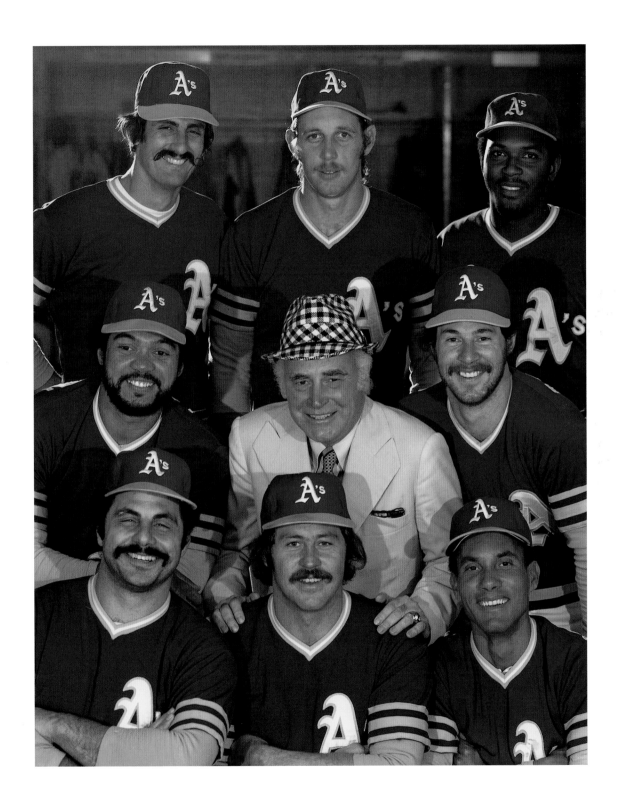

A'S OWNER CHARLIE FINLEY WITH HIS PLAYERS, INCLUDING VIDA BLUE (TOP RIGHT), 1974.

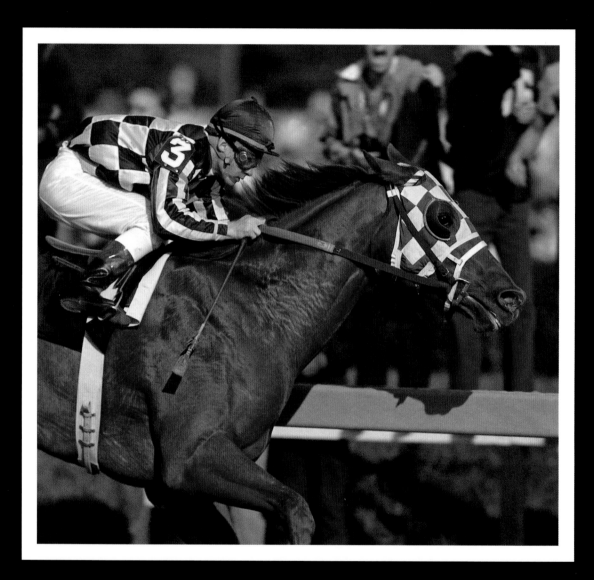

RON TURCOTTE ATOP SECRETARIAT AT THE PREAKNESS, 1973.

THE HORSE AND THE TIGER

> " *Whether Neil was telling me a story because it made everything sound better, or whether he actually did get Ron Turcotte to turn around and look at the camera, it's the most wonderful photograph. All you see is the blue-and-white-checked silks, Turcotte looking, and you have a sense of just the mane of the horse.*
>
> —**PAT RYAN**, former *Sports Illustrated* editor and *People* and *Life* managing editor

The Triple Crown races of 1973 turned out to be my own Triple Crown. Secretariat won the first two legs and set track records in each. Some people say that my Kentucky Derby picture of Secretariat, with his four hooves off the ground, was one of the great horse-racing pictures ever. At the Preakness, shooting at the far turn, I played the light right and got the picture I had hoped for. And the *SI* cover.

With the final race, the Belmont, I decided to gamble. And here pure luck played a big role again.

Two or three days before the race, I went to Belmont to check out possible positions for shooting. The finish line was not a great position. A small photo stand would be erected and twenty guys would be squeezed onto it. Everyone would get pretty much the same picture. The idea is to do something that's not only different but also better. One of the things a good sports photographer does is try to separate from the pack.

Like everyone else, I figured it would be a one-horse race—Secretariat went off at 1-to-10—with the odds-on favorite far ahead. I never expected him to win it by fifty-six lengths or some ungodly margin. (It was thirty-one lengths.) This was before the advent of auto-focus, and I was pretty good with eye-hand coordination. I wanted to try to fill the frame with a profile of the horse from the knees up and the jockey, Ron Turcotte. I thought that would make a dramatic photo. My biggest worry, quite honestly, was making sure I had it in focus. I would also be in a terrible place if it became a two-horse finish; the horse in the foreground would have blocked the horse in the background. But I was convinced that no horse would be close to Secretariat.

I decided to set up about one hundred feet back from the rail—on the turf course, that's just inside the main track. It would be roughly the same as shooting the pitcher from the photo box at Yankee Stadium. I had a 300mm lens, which would give me the image I wanted and make an exciting picture even in a one-horse race.

I'm sure the other photographers must have looked over at me like I'd lost my mind. Instead of shooting at the finish line, I positioned myself about thirty yards before the wire. I expected Ron Turcotte would be looking straight ahead, holding the reins, and concentrating on the finish line.

Turcotte built a commanding lead early. He was way ahead when they came around the turn for home, and he kept opening up a bigger and bigger lead. He went from twenty lengths ahead to thirty lengths and then he was coming down the straightaway. I waited until he was perpendicular to me, where I would get the profile of the horse and of Turcotte, exactly what I'd hoped for. So it all came down to getting the thing in focus. As Secretariat neared, I panned across. Then, when he was right in front of me, Turcotte suddenly turned his head and looked straight at me. Actually, he looked straight over my shoulder.

I honestly never saw him turn his head because I was so wrapped up in getting him and the horse in focus. It wasn't until I saw the photograph that I realized he had looked at me. The stories started immediately. How the hell did Leifer arrange that? Turcotte would have laughed at me if I had suggested such a thing. Later, when Turcotte was asked what he was looking at, he said the teletimer.

At first, I didn't understand why a jockey would look at the teletimer. It tells you how much time has elapsed in a race—two minutes and so many seconds. I realized later that Turcotte was wondering if he had a chance to break a record. If he did, he would keep the horse in full stride; if not,

SECRETARIAT AT THE KENTUCKY DERBY, 1973.

he would ease him in and still win. The timer, unnoticed by me, was about twenty yards straight behind me. Pure luck.

If he hadn't turned his head, it would have been a good picture, but nothing special. Luck is such an enormous factor in sports photography. In this case, I did get lucky, and when the opportunity presented itself, I didn't miss.

Speaking of four-legged animals, have I mentioned the tiger? He was central to the most embarrassing moment of my career. *Sports Illustrated* had assigned me a story about the King Charles Troupe, a team of unicyclists who played basketball. The team was a big act with the Ringling Bros. and Barnum & Bailey Circus. So I went to Houston to do the story.

FOLLOWING PAGES: RON TURCOTTE WINS WITH SECRETARIAT AT BELMONT PARK, 1973.

I photographed their act the way I would shoot a real basketball game, using strobe lights, and the picture quality was better than anything the circus people had seen. When they saw the *SI* spread, Ringling Bros. approached me about doing some freelance work. I said yes because I liked the circus and, let's be honest, it paid extremely well.

What Ringling wanted me to do was take pictures for their annual program. It was called "annual," but they would sell it for two years. There were two Ringling Bros. circuses that traveled the country and two major stars. One was an old, overweight German named Charlie Bowman who reminded me of Elvis near the end of his career in that both wore jumpsuits that were way too tight.

Bowman was the performance director of his unit, a tiger trainer, and a real showman. He popped up on Johnny Carson all the time. He also used to get his jollies by riding down L.A. freeways with a full-grown tiger in the back of his station wagon. He was gruff and tough, and he clearly didn't like me.

Irvin Feld, who owned Ringling Bros., and his son Kenneth, who now runs the show, let me know I could have anything I wanted, within reason. This proved to be an imposition on Charlie. I was always asking for special things: "Can I get this? Can I put a camera here? Can you hoist me up on a rig so I can photograph the trapeze artists from right in front of them?" And this meant more stuff for Charlie to do. But I think the real reason he didn't like me was that the star of Ringling's other show, Gunther Gebel-Williams, had become the biggest circus star in America.

Gunther had made such a name for himself in his native Germany that Irvin Feld had to buy a whole circus to get Gunther's act. Like Charlie Bowman, he worked with big cats, but also with horses and elephants. His wife and his daughter were in the act, too.

Gunther couldn't have been a more photogenic subject. He would end his act by wrapping a leopard around his neck like a woman wearing a fur. He'd walk out of the cage and stroll around the ring while the crowd went wild. I took pictures of Gunther with a leopard draped over his shoulders. He would put a bit of food on the leopard's lip so that when I shot my picture, the leopard would be licking his lips. It became a poster of Gunther that was used as a foldout in the program.

Gunther and Charlie were always trying to one-up each other, but clearly Gunther was the big star of the circus and had eclipsed Charlie's act. And I'm sure Charlie thought that in some small way my pictures had added to Gunther's popularity.

One night, I was shooting Charlie's act in St. Petersburg. During intermission, they set up the tiger cage in the center of the arena. It was a full house, ten or twelve thousand people. After intermission, they would turn off the lights so that the arena was pitch-black. They would take the tigers out of the transporting cage and direct each one to a stool inside the big cage. The tigers would sit. As the spotlights came on, Charlie would majestically enter the ring, waving to the crowd. One by one, he would point to a tiger and call it by name. The tiger would growl. The audience by now would be going crazy. Charlie would go through his act, which would end with each tiger moving through a hoop of fire. Part of his act was that he never smiled.

I thought Charlie wanted to get rid of me, especially when he suggested that I shoot from inside the cage with him. These were Bengal tigers, mind you, so there was no way I going to get into the ring, let alone in the tigers' cage. Charlie urged me, saying, "Believe me, you'll be okay." I said, "Yeah, I will, because I'm not going in that cage."

Instead, I had set up right outside the mesh that enclosed the ring. I was using a medium telephoto lens and shooting maybe five feet from the cage. My assistant, Anthony Donna, was about fifteen feet behind me, loading the Hasselblad backs. The arena was dead silent, mesmerized by Charlie's act. I was looking through the lens when suddenly I nearly got knocked over. It felt like I was being hit with water from a fire hose—until I realized, to my horror, that one of the tigers was—how shall I put it?—relieving himself on me!

I froze. And believe me, the tiger didn't miss. It was as though he had aimed at my face, and I was soaked from head to toe. I was so stunned and frightened that I couldn't move. But I will never forget three things happening at once. Charlie Bowman, who never smiled, was rolling with laughter. Anthony was doubled over. And there was a roar from the thousands of people in the seats, who obviously thought this was part of the act and that I was a clown. They were laughing their asses off.

Improbably, something good resulted from this. I had photographed Charlie's unit two or three times, and he had never concealed his dislike for me. After the incident, I spotted him walking out of the arena, still laughing and pointing at me. I walked over to him and said: "Charlie, I was wrong about you. You're a great animal trainer, the best in the world. Only you could've got your tiger to pee all over me."

From then on I never had any trouble with Charlie—or a damn tiger!

TOPEKA CAPITAL-JOURNAL

"

When Neil really wants to do something, there's this kind of internal conviction that he can do it. It's a combination of determination, instinct, and planning. Neil knows he has to plan more than a lot of people do and, in a sense, he works harder at it. I don't think even he understands that fully.

—RAY CAVE, former *Time* managing editor

Neil and I shared many Sports Illustrated *assignments over the years and it was always fun—for Neil was both very competitive (he was after the cover or the opening spread always) but he understood the term, "shared." We could work out what each was trying and the other often "covered" a piece of the assignment to make the innovative try happen. We were always a good team.*

—RICH CLARKSON, former director of photography, *Topeka Capital-Journal*

I always like challenges. I particularly like it when someone tells me I can't do something and I know for sure that I can.

One of the differences between a newspaper photographer and a magazine photographer is that the newspaper guy often does two or three assignments a day. After a typical—in those days—2½-hour baseball

game, it wasn't unusual for him to cover the mayor's press conference. I had never worked for a daily newspaper. Rich Clarkson, still an amazing photographer and perhaps one of the best basketball photographers who ever lived, shot for *Sports Illustrated* for many years. A Kansas native, Rich freelanced for *SI*, but his day job was director of photography for the *Topeka Capital-Journal*.

It was a small newspaper, but truly one of the great photography newspapers in the country. Rich cultivated two or three Pulitzer Prize winners, and two or three of *National Geographic*'s best photographers began their careers working for him. We were competitors, friendly competitors, and still are.

One night in 1969, Rich and I were sitting at a bar. I think he was on his second or third martini when he said, "You may be established, Leifer, but I'm not sure you could ever produce the way we newspaper photographers do. You always have time to think about your pictures. But if you're working five days a week, shooting two or three assignments, you don't have time. I'd love to see how you'd handle work on a daily newspaper." He laughed.

I decided to call Rich's bluff. I told him that I could produce just as well on a newspaper. He said he wasn't so sure. "Then invite me to Topeka," I said. "Pick a week when I can get away and I'll come out and work for the *Topeka Capital-Journal*."

He stuck out his hand and we shook. "Deal," he said.

"On one condition," I added. "You've got to promise me you'll treat me exactly the way you treat your staff."

He agreed. In fact, the first thing he did was remind me that photographers were required to process their own film. I hadn't been in a darkroom in years. I had been a lousy darkroom technician when I was a kid, and I wasn't much better in Topeka. As a result, the others probably helped me more than they helped anyone else so I wouldn't ruin the film. On that level, Rich probably bent the rules slightly on the promise he made to me. But on assignments he did not.

One was a ribbon-cutting ceremony. How do you make an exciting picture of that? Yet, that's what small-city newspaper shooters must try to do. I also spent a day covering two candidates in a contentious governor's race, which was exciting and fun. Then Rich gave me an assignment that was the highlight of my week.

Catherine, Kansas, a small farming town with maybe a couple of hundred families, had recently welcomed a new priest. Most of the people

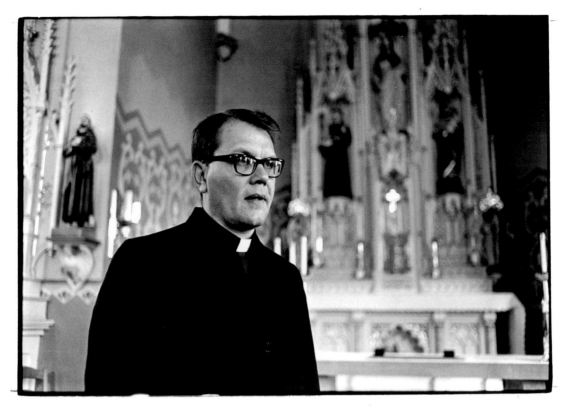

FATHER HOWARD BICH, 1969.

in town attended St. Catherine's Church; families grew up going there. The town was spread out over a large area because everyone had huge acreage, but what made this place, and its church, special was that the steeple was one of the two or three oldest in Kansas. The people loved their steeple. The land was so flat, you could see it for a good twenty miles in any direction.

Sadly, the steeple was corroding and infested with termites. The former priest, knowing how important the steeple was, never touched it. But the new priest, a young man, must have been the original bean counter. He looked at the expense of saving the steeple, fixing it, refurbishing it, and he decided that it was not going to happen. All of Kansas was interested in the fate of this steeple, and since Topeka was the capital, Rich wanted to do a piece on it. He planned to play the story big.

A young writer and I flew out to this farming community in a single-engine Piper Cub. After we landed, I started photographing people—always

being sure the steeple was visible in the background—and the writer started interviewing. It was apparent that the townspeople felt the old priest would never have chopped down their beloved steeple. Surely, he would have found a way to finance it. But nobody would actually say this.

I told the reporter, "These people aren't going to tell us the truth because you don't speak badly about your priest." Then I had an idea. It didn't even involve cameras, but it did involve knowing my two young children.

"Forget the adults," I told the writer. "Let's talk to kids." I figured that in this kind of town families ate dinner together, and I was certain the conversation would be about the steeple.

I would spot a kid on a bike at a farm. We would interview the parents and I would ask if we could talk to their child. I would photograph the kid, maybe on his bike or standing against a picket fence or a plow, and I would say, "What do you think about the steeple?"

Nine out of ten kids launched into exactly what their parents had said at the dinner table the night before. We would ask, "Do you think the old priest would have done this?" And the kid would say, "No, no, no. My mother said he would never have allowed this to happen. He would have found the money."

Later, we went to interview the priest, who explained at great length the church's finances. "Where are we going to get the money?"

For everyone I photographed, I was able to capture the church steeple in the background. The writer did a good job and we got a great story. One of my pictures took up half of page 1. The story continued inside with my pictures of the kids.

But the real story here is that once the article ran, the donations started to pour in. So much money was donated that they were able to save the steeple. To me, that was very satisfying. And on top of that, I proved I could work successfully on a newspaper. I knew that kids don't lie when asked about things like the steeple, and I don't think the young writer's story would have made the impact it did by simply quoting the parents.

HENRY LUCE AND HEDLEY DONOVAN

> " *Neil has a great eye, and he is relentless, calculated, and strategic.*
>
> —**TERRY MCDONELL**, former
> managing editor, *Sports Illustrated*

enry Luce was a legend. This was drummed into me from the moment I started working for Time Inc. publications. Luce had cofounded *Time* magazine in 1923 with his Yale classmate, Briton Hadden. Luce had been the publisher and Hadden the top editor, but after Hadden died six years later, Luce took over as editor-in-chief. By the time I arrived, the company had grown to four publications—*Time, Fortune, Life,* and *Sports Illustrated*—and Luce, the editor-in-chief of all of them, was God. At a certain point, although not wanting to retire, he did want to appoint somebody to run the company when he was ready to leave. That person was Hedley Donovan, the managing editor of *Fortune.* Hedley was 6'1" and looked like the Hollywood version of a CEO.

Somewhere I had read a piece, titled "Lunches with Luce," about monthly get-togethers with the magazine editors and a writer or two. The lunches, held in the executive dining room, would start off innocently enough with cocktails followed by a sit-down meal. Luce was fascinated by good ideas, and out of those lunches came special single-topic issues of magazines. Luce would say, "Wait a minute. We should really do a special issue on Japan." Or China. Long after lunch was over, the session would

continue, everyone having more cocktails. More ideas would flow, along with the liquor, but out of this would come important stories. Often, the sessions wouldn't end until six or seven o'clock, by which time everyone was very drunk.

One day in 1974, I was summoned by Roy Terrell, the new managing editor of *SI*. Hedley was having a lunch for young *SI* staffers, and Roy thought it would be nice if I went. I'd seen Hedley many times in the elevators, and he always seemed like a nice man. He was a Rhodes Scholar, had been a successful editor at *Fortune,* and now edited four weekly magazines and, I believe, a couple of monthlies. I had no idea if he was a sports fan. He lived on Long Island and took the train to work, so I figured he'd read all of his publications.

I put on my jacket and tie and combed my hair. I think there were seven of us invited, plus Hedley. He was quite socially adept and made a point of talking to everybody. But after a while, I began to wonder.

It was a big news week—the Watergate hearings dominated the news— so I was willing to give him the benefit of the doubt when not a word was mentioned about *SI*. The cocktail part of the lunch was going well, but it seemed odd that when he came over to talk to me, he didn't say something like, "Neil, that cover you did two weeks ago was fabulous," or any comment that pertained to my work. Not a word. It was apparent he had a crib sheet and knew who was coming to the lunch. By then, I had done a hundred covers for *Sports Illustrated*, so he must have known I was a prolific shooter. But all he said of a personal nature was, "You live on Long Island. Well, so do I."

At the table, I was seated next to him. This posed a problem. I am a funny eater. I don't eat salads and I don't eat fish and worse, when it comes to food, I'm incapable of politely hiding my strong preferences. So first came the appetizer, which was a shrimp cocktail. No way could I eat it and say how wonderful it was. I moved the shrimp plate around, but I didn't touch the shrimp, which, as I might've mentioned, disgust me. Hedley looked over at me but didn't say anything. Next came the salad, which I wasn't touching either. And finally the entrée, which was salmon.

Hedley said, "You haven't eaten anything."

I apologized and said I was a little funny about my eating habits.

"Are you allergic?"

I told him no, then followed up with the usual conversation I have when I try to explain my lunacy over what I eat.

"Well, what would you like?" he asked.

"I don't want to cause any . . ."

"No," he said and summoned the head waiter. I ended up with a steak and everyone was staring at me . . . I think with envy.

The conversation around the table, meanwhile, finally turned to *Sports Illustrated*, and it was apparent he hadn't read the magazine in weeks—if ever! I won't say he asked stupid questions; they were just extremely general questions, nothing about a particular story or picture. This startled me. One thing I had always enjoyed reading was *New York* magazine's annual list of salaries, and Hedley's was always on there: six figures, which was a fortune back then. And even though I'm a slow reader, I think that for six figures I would have read each of my magazines. Then again, a part of me was thinking that with all the Watergate stuff going on—and John Dean testifying—maybe his mind was elsewhere.

A couple of years later, there was another lunch, this one at the Olympics in Montreal. Right in the middle of the track and field events, Hedley decided he'd like to have lunch with the *Sports Illustrated* team. Gil Rogin, who was the assistant managing editor, invited Anita Verschoth, a reporter; Jerry Kirshenbaum, an associate editor who had done a big series on the East German athletes; Frank Deford, our star writer; and me. All of us were speechless because we were there to cover the Games; I still remember thinking this meal was going to make me miss the 200-meter final. But when the editor-in-chief invites you to lunch, you go.

Hedley cleared his throat and said, "Gilbert, my wife and I have been to a bunch of events. Maybe we should do something on the East Germans." Anita nearly swallowed her fork. But Gil, who had designs on the top job at *SI*, did a tap dance that was amazing. He said, "I know that we didn't quite cover everything in our piece, and I'm sure you're looking at other aspects of the story. We did try to get into the East German thing in the pieces that Jerry wrote."

Hedley turned to Anita. "Have you been to the Olympics before?"

That very week, the first piece in the magazine was a publisher's note about Anita, whose specialty was the Games and who was attending perhaps her fourth or fifth Olympics. Anita said, "Yeah, as a matter of fact, I have."

It was a pleasant lunch, and Hedley was such a nice guy, but it was clear to me that he did not read the magazine and that no great ideas would be forthcoming, just amiable chitchat. A couple of years later, I was again invited upstairs for a lunch with Hedley, but by then I did not expect anything like those legendary lunches with Luce.

TIME — Hollywood's Honchos — Burt Reynolds, Clint Eastwood

TIME — A Born Winner — Jockey Steve Cauthen

TIME — Women In Sports

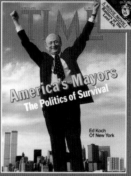
TIME — JOHN PAUL, SUPERSTAR

TIME — Good as Gold — U.S. Dazzlers: Eric and Beth Heiden

TIME — GETTING IT TOGETHER

TIME — Running Tough — "A Choice Between Two Futures"

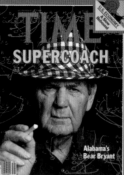
TIME — SUPERCOACH — Alabama's Bear Bryant

TIME — America's Mayors — The Politics of Survival — Ed Koch Of New York

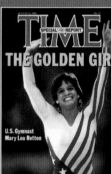
TIME — CATS — LOVE 'EM! HATE 'EM!

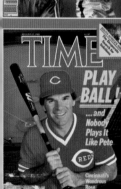
TIME — HEAVYWEIGHT HITS! — Boxing scores one-two punch at the box office — COONEY STALLONE

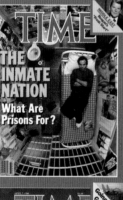
TIME — THE INMATE NATION — What Are Prisons For?

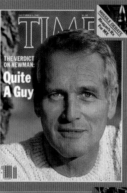
TIME — THE VERDICT ON NEWMAN: Quite A Guy

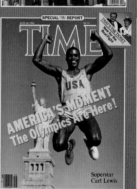
TIME — AMERICA'S MOMENT — The Olympics Are Here! — Superstar Carl Lewis

TIME — THE GOLDEN GIRL — U.S. Gymnast Mary Lou Retton

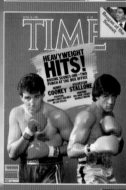
TIME — PLAY BALL! ...and Nobody Plays It Like Pete — Cincinnati's Wondrous Rose

TIME — Doctor K — Baseball's Hottest Pitcher — Dwight Gooden Of the Mets

TIME — Fixing NASA

TIME — Hail, Liberty! — A Birthday Party Album

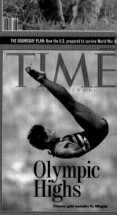
TIME — Africa — An Essay

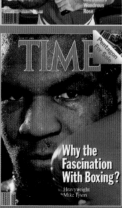
TIME — Why the Fascination With Boxing? — Heavyweight Mike Tyson

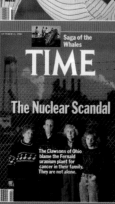
TIME — The Nuclear Scandal — The Clawsons of Ohio blame the Fernald uranium plant for cancer in their family. They are not alone.

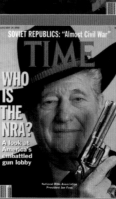
Saga of the Whales — **TIME** — WHO IS THE NRA? A look at America's embattled gun lobby — National Rifle Association President Joe Foss

SOVIET REPUBLICS: "Almost Civil War" — **TIME** — SCALING DOWN DEFENSE — How to REALLY cut military costs

THE DOOMSDAY PLAN: How the U.S. prepared to survive World War
TIME — Olympic Highs — Chinese gold medalist Fu Mingxia

FROM *SI* TO *TIME*

" *I'd used Neil as a photographer for years at* Sports Illustrated. *When I moved to* Time, *I asked Neil to come with me.* Time *had half a dozen very good photographers, but our style was formulaic. I wanted to shake up the photo editor and the photo department and I figured Neil was perfectly capable of that. I knew he would bring the same characteristics to photojournalism that he brought to sports photography. And that's what he did. Still, I'm astonished at the covers he did for* Time. *They were remarkable.*

—**RAY CAVE**, former *Time* managing editor

Neil told me, "I got this idea. I'd love to have you with a cigar in your mouth." My first reaction was "Whoa!" But I had a feeling about this guy, that he knew what he was doing—and that it might not be a bad idea.

—**STEVE CAUTHEN**, Triple Crown–winning jockey

By the end of 1977, I was terribly unhappy at *Sports Illustrated.* When Roy Terrell became the new managing editor, I talked him into hiring Jerry Cooke as photo editor. It was a horrible mistake. Jerry was not only one of my closest friends, but was also my rabbi, teaching me all the niceties I had ever learned about the world—how to be comfortable in a beautiful restaurant, how to order

wine, how to travel. None of this was part of my upbringing. Jerry, on the other hand, spoke five languages and was a fascinating man. He was a great guy—until he became photo editor.

I don't know if he was jealous of Walter Iooss and me because we were treated like stars. He was, too. But he was absolutely intent on getting rid of Walter, who he thought was overrated and not worth what he was being paid. I thought Walter was the best photographer he had—okay, besides maybe me. I would defend Walter to Jerry; then suddenly he began messing with *my* assignments. A heavyweight fight would come up and he wouldn't tell me until the last minute if he was going to assign me to it. He would say things like, "I want you to do other things." Once he assigned me to a women's drag race, a sport I knew nothing about. When Ali fought Ken Norton at Yankee Stadium in 1976, Jerry assigned himself ringside even though he had never covered a fight from that position. Assigning himself to shoot the Kentucky Derby was perfectly reasonable; he was a great racing photographer. Likewise with the Olympics, which he was very good at shooting. But assigning himself ringside at a heavyweight title fight or to the biggest football game of the year meant somebody else wasn't getting the assignment. He would say, "Listen, I want you to shoot the fight from upstairs," knowing full well that ringside was the place to be. I really felt that Jerry was going to get rid of Walter and me. Many years later, Jerry and I would again be friends, but at the time, he was making my life very difficult.

This went on for a year. I grew more despondent. I began speaking out about it, and Ray Cave had somehow heard about my situation at *SI*. Ray and I had grown up together at the magazine and had become good friends, even though he was my boss. When Ray moved to *Time* magazine, he entered a hostile environment. *Time* had always promoted from within, and everyone had been rooting for the heir apparent, Jason McManus, to get the job as managing editor. But Ray got it. He would go on to become, in my opinion, the most successful managing editor in the history of the magazine. But for a long time, he didn't have many friends there.

One night shortly after Ray became the managing editor of *Time*, we were having dinner when, to my surprise, he offered me a staff job. He said he wanted me to shake things up, to really show what *Time* magazine's photography could be. It was becoming an all-color magazine, publishing full-page art. I wanted the job, but I was concerned. At *SI*, I'd had more than one hundred and fifty covers. At *Time*, I was afraid I'd never see a cover. They still used art a majority of the time. Ray said, "Neil, *Time*

magazine has a tradition of art on the cover, and as long as I'm managing editor, we're going to continue that tradition. But I definitely intend to run a number of photographic covers in the course of a year, and you'll get your fair share of them."

Ray promised me that I was not coming onboard to be a sports photographer. He said that when *Time* did an important sports cover—the Olympics, maybe the World Series, or a heavyweight title fight—I would still, of course, be assigned to those events.

I said okay. Actually, I would have said okay no matter what Ray had told me.

There were no staff photographers at *Time*, so my position was a first. They had some top-notch photographers: Eddie Adams, who had won a Pulitzer Prize for his famous photo of the South Vietnamese police chief shooting the Viet Cong officer; David Hume Kennerly, another Pulitzer Prize winner; Dirck Halstead; and other outstanding photographers in cities around the world. Every one of them was under contract.

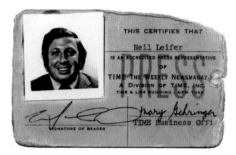

The difference between being on staff and being under contract was this: staffers got benefits, such as health insurance, a pension, and an allowance to purchase new equipment. The photo editor, John Durniak, had wanted to put other photographers on staff, but Henry Grunwald, the previous managing editor, had always turned him down. Suddenly, the new boss comes in and the first thing he does is hire a sports photographer and put him on staff. It created some bad feelings, but, much to my surprise,

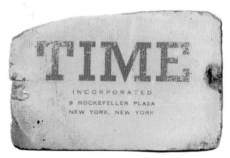

PRESS CREDENTIAL, *TIME*, 1978.

most of the photographers greeted me warmly, as if my hiring meant that maybe they could now get on staff, too.

That was 1978. My dream was to get a *Time* cover—and then many more.

- -

My first assignment at *Time*, my very first as a staffer, was a cover story on lawyers. The headline was going to be "Those Blankety-Blank Lawyers." I was looking for something thematic to do and I came up with what I thought were some pretty good ideas. But they ended up

running an illustration on the cover instead of a photo, and in this case, I think they made the right choice.

The following week, believe it or not, I was again assigned a cover. This was of the artist Saul Steinberg who, among zillions of drawings, did the famous *New Yorker* cover, *View of the World from 9th Avenue*, which became a classic poster. He was a fascinating man, but he didn't like to have his face photographed. So I took a portrait of him and had him hold the photo in front of his face. I also took a macro shot of just his hand holding a pen and signing his name. Either one would have made a strong, novel cover. There were others. At least six of my pictures were laid out as possible covers, but, once again, I was competing with a painting. *Time* spent a lot of money in those days, and it wasn't unusual for the art director to assign two artists and a photographer to come up with and execute cover ideas. In this case, they ended up using one of Steinberg's own drawings. It depicted New York City with the Empire State Building and the Chrysler Building. Of course, I'm a little bit biased, but frankly, I thought it made a lousy cover and that one of my pictures would have been much stronger.

I was now 0-for-2 and already becoming paranoid about *Time*. At *Sports Illustrated*, I had never been close with the art director, Dick Gangel. Early on, I had learned the three words that all art directors must learn their first week in art director school: "It doesn't work." Remember, art directors work for editors; their boss is the managing editor. But those three words will stop dead even the toughest managing editors, and that included Ray Cave and, before him, Andre Laguerre at *Sports Illustrated*. When the art director looks at the managing editor and says, "It doesn't work," the managing editor has no idea what to say. He probably has no idea why it doesn't work (if indeed it doesn't), but he seldom questions this unequivocal statement when it is uttered by the art director. Dick Gangel would not only use those three words regularly, but he also stacked the deck. By that, I mean he totally controlled the presentation of the layouts and covers and thereby had enormous influence over the editor's final decision.

I remember once doing a cover photo of Muhammad Ali and Sonny Liston for a preview of their second fight. I thought it made a spectacular cover, but Dick had also assigned a top artist. Here's the way the mock-ups of the cover were presented: the painting was a color print with the *SI* logo and actual type on it. It was beautiful. The photograph was presented as a black-and-white photostat of a color picture with dummy type. The type might even have been a little crooked. So the managing editor looked at both and, of course, the beautiful color picture with the actual words in

real type looked much nicer than the dummy type on a xeroxed black-and-white photo. So, the deck was stacked.

After almost twenty years in the business, I can say without question that the art director can always put in the fix.

At *Time*, the art director I was going to have to deal with was Walter Bernard. I had never met him, but I knew his reputation. He was the protégé of Milton Glaser, the legendary graphic designer, and had become art director under Glaser's guidance when Clay Felker started *New York* magazine. He had also worked at *Esquire* and had been hired by *Time*, just before Ray Cave arrived, to redesign the magazine. Walter invented the famous corner flap to headline a second story on the cover. But as far as I knew, he was merely the second coming—a younger version—of Dick Gangel. This was evident after my first year, when out of fifty-one *Time* covers—the "Man of the Year" issue was always a double issue—thirty-four were artwork, leaving half that many for photos. When I didn't get the Saul Steinberg cover, I assumed Walter was my natural enemy. I was beginning to think I would never get a *Time* cover.

--

The 1978 Kentucky Derby was a spectacular race. Affirmed, ridden by a jockey named Steve Cauthen, beat Alydar by a nose. Cauthen was eighteen, a phenom whom I had already shot in a posed cover picture for *Sports Illustrated*. Ray was a huge racing aficionado and he was determined to put horse racing on the cover of *Time* someday. Now here were two great horses possibly vying for the Triple Crown. And here was this kid who had captivated the whole country. Yes, Cauthen was going to be his guy.

Only there were problems.

The first one was *Time*'s chief competitor, *Newsweek*. Pete Axthelm would be writing their story. Not only was Pete a great sports writer, but he had also been hired to write Steve Cauthen's biography, which gave him total access to the jockey and the inside scoop on anything really important. We all assumed *Newsweek* would put Cauthen on their cover. The logical time to do this was after the next race, the Preakness, which, like all Triple Crown races, was run late on a Saturday afternoon. Both magazines went to press on Saturday night. This was the second problem. To close a story on Saturday night was expensive; to close a cover that late was huge. I mean, you didn't close a cover on Saturday night unless the president was assassinated or a new pope was elected. In the case of a

Triple Crown race, if you closed at the normal time—Friday night—and Affirmed lost on Saturday, you had a very embarrassing cover on the newsstand Monday morning. Neither *Time* nor *Newsweek* would risk that. Since there were three weeks between the Preakness and the final Triple Crown race, the Belmont Stakes, the obvious thing to do was to wait until after the Preakness, see if Cauthen won, then run the cover the Monday before the Belmont.

I would be competing against one of my best friends, Ken Regan, a very good photographer who was shooting the cover for *Newsweek*. Given all this, I'd bet that *Newsweek* was confident that its whole package would be better than *Time*'s.

Ray called me into his office. "Listen," he said, "we're going to close this cover tight on the night of the Preakness," and he told me his plan. *Time* would close two cover stories. One would be Cauthen, which would run if Affirmed won; the second would be political cartoonists. The idea was that I could take one black-and-white picture of the finish at the Preakness. The Associated Press would process the film, and I would pick a horizontal picture of the finish (to open the story inside the magazine) and wire to it to *Time* right after the race. If they didn't like my picture, they could use a wire service photo. But everything else—the Cauthen cover and four pages of color—would be ready to go as soon as Affirmed crossed the finish line. Post time was 5:35 p.m. By 6:30, *Time* would go to press. If Affirmed didn't win, the cover would be the political cartoonists.

Now I had to come up with an appropriate cover shot of Cauthen that I could do in advance. I went to see Walter Bernard.

- -

I knew the odds were stacked against me because *Time* still had a tradition of paintings on the cover, and Walter had assigned one of his favorite artists, Jim McMullan, to do a portrait of Cauthen. But I came up with an idea for the cover that I hoped would swing the odds back in my favor. Walter was a cigar smoker, so I knew he'd like my idea. I told him I wanted to photograph little Stevie Cauthen with a cigar. Cauthen has a baby face and could pass for a fourteen-year-old, I said, and it would be fun to have this kid smoking a cigar, which is synonymous with victory.

Walter did indeed like the idea, so I went out to Aqueduct, where Cauthen was working with Affirmed. Of course, Ken Regan was shadowing every move I made. Also, Pete Bonventre, my closest friend, was working with Axthelm on the story, so I was competing with my two best friends.

Still, my goal was to make a cover for *Time* that was so good that no one would pass it up on the newsstand and buy *Newsweek*.

And yet . . .

I knew there was no possibility that *Newsweek* was going to close a Preakness cover on a Saturday night. Why would they? They already had a big edge with Axthelm, and there was no reason to suspect what Ray had planned. Ray was going to have to eat one of the two covers (it would, of course, be the Cauthen cover, if Affirmed lost the race). But he was very competitive, and the idea of beating *Newsweek* on this one was irresistible to him.

Even before I got to the track the first day, I knew where I wanted to shoot the cover. There's a room at every track where all the jockeys' silks hang, all the colors and patterns that represent all the owners whose horses run there. It looks like a rainbow, a real spectacle of color. This is where I had shot my *SI* cover of Cauthen the year before, but this time I would shoot it in a way that made the background look like a blur of color, the silks out of focus. I could close the door to the room and no one would see what I was doing. Ken Regan was always lurking, and I didn't want him to walk in on me.

When the time came to shoot my portrait of Cauthen, I set up my camera and sat him down. "Now Steve," I said, "what I want you to do is smoke a cigar."

He looked at me and said, "I can't do that. I don't smoke. And it's a bad image, smoking."

I tried sweet-talking him, but he wasn't buying it. He might have been young, but there was nothing dumb or gullible about him. I explained that the cigar was synonymous with joy and victory—new fathers handing out cigars, Red Auerbach lighting one up after another Celtics victory. But Steve was still hesitant. "It's just a bad image. I have to ask my agent."

"Steve," I said, "trust me, please. Let me show you a Polaroid."

He held the unlit cigar and I shot the Polaroid. I used a Sharpie to draw the *Time* logo on it and I handed him my instant dummy cover. "Here's what you're going to look like on the cover of *Time*."

I could see his face light up. "Okay," he said, "as long as you shoot some without the cigar, too."

I promised I would. He put the cigar in his mouth, I lit it for him, and he clutched his teeth and posed his little heart out. He was terrific. He had a winning smile and it was a wonderful portrait. I knew right away I had a great cover shot.

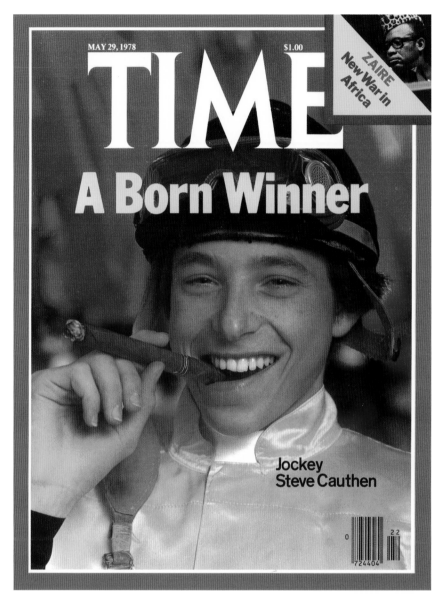

TIME, MAY 29, 1978.

But would Walter Bernard pick it as his favorite and then push it hard? Or would he say, simply and decisively, "It doesn't work"?

Walter was the most respected art director at Time Inc., so I knew Ray would ask, "Walter, what do you think?" as they considered my picture and Jim McMullan's drawing. I wasn't in the meeting, of course, but I later

heard that Walter said he "preferred the photograph." And, sure enough, they sent it out to be engraved. All I needed now was for Cauthen and Affirmed to win the Preakness.

Ken Regan and I flew together to Baltimore for the race, and along the way he was talking trash, telling me what a great piece Axthelm was writing. Somehow I kept my mouth shut.

The race turned out to be one of the most exciting I've ever seen. My heart was in my mouth as Affirmed and Alydar came down the home stretch neck-and-neck. I was on a photo stand just beyond the finish line and was shooting black-and-white film. Affirmed won by a nose, just as he had in the Derby. I picked out the best frame of the finish when the negative was still wet, and the AP wired it to New York. All the writer had to do was send in the lead paragraph and *Time* magazine would go to bed that night with Cauthen on the cover.

On the plane ride back, Ken was sounding confident because he was now sure he'd have a *Newsweek* cover the following week. I had my camera case under my seat with a photostat of the cover in it. As Ken went on and on, I could barely contain my excitement. I finally had my first *Time* cover since joining the staff. And I had come through for Ray.

Ken kept carrying on, and because he was such a good friend, I was trying my best not to burst his bubble. But when he started boasting about how great *Newsweek* was going to look a week later with Cauthen on the cover and how their package would blow *Time* out of the water, I could no longer help myself. I said, "I'm sure your Cauthen cover is going to look great, but I wouldn't bet on it ever running."

I pulled the photostat out of my bag and handed it to Ken. I could tell that he knew it was a damn good cover, but he said with pride, "We're going out with our cover and Pete Axthelm's story."

"I doubt it," I said.

Ken looked at me quizzically. "What are you talking about?"

"You didn't look at the date," I said.

Ken took a very close look at the photostat. "You've got to be kidding me."

"No," I said, "We closed this cover a couple hours ago. It's on press right now and it'll be on newsstands Monday."

If I remember correctly, Ken didn't say another word the rest of the way home.

I should also mention that Walter Bernard and I went on to become the best of friends. And, oh yes. Affirmed went on to win the Belmont, and the Triple Crown, and *Newsweek* never did run Steve Cauthen on the cover.

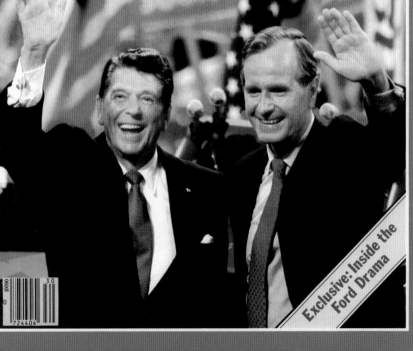

July 28, 1980

$1.25

TIME

GETTING IT TOGETHER

Exclusive: Inside the Ford Drama

THE 1980 CONVENTIONS

> " *It was true Neil could get in to see me anytime. There was a presumption that he was a friend and had an inside track. This was true. But the interesting thing about Neil is he would use the inside track—not in a pushy way—but more as a pest. If he had an idea and you told him, "No, that's a bad idea, don't do it," you hadn't heard the last of it. God knows you hadn't heard the last of it. Meanwhile, the other photographers never walked into my office. They could have, but they never did.*
>
> —RAY CAVE, former *Time* managing editor

In summer of 1980, I was thrilled to be added to *Time*'s team of photographers assigned to the national political conventions. When I say "team," I mean twelve. The magazine had to cover the candidates, the convention floor, and the social events. I had never shot a political convention and most of our team had. I began to do my homework.

First up was the Republican convention in Detroit. I knew from studying previous covers that the picture would be of the presidential and vice-presidential candidates—in this case, Ronald Reagan and George Herbert Walker Bush. In the convention hall, the main photo stand would be set up in front of the stage. We would have at least one photographer on it, maybe two. There were also two side positions. As background where the candidates would stand, they put up light blue walls—good for TV maybe, but it made for a very dull print picture.

As always, I was determined to get the cover. But as I continued to look at the old photos, I kept wondering, "How am I going to get something nobody else gets?"

In contrast to the dull blue backdrop, nothing was more colorful than the delegations on the convention floor. They had balloons and banners and signs. The whole audience was alive with color. I couldn't help thinking how much better the cover would look if I could use the audience as the background. But how? There was no reason for the candidates to face the wall with their backs to the delegates. They would come out on stage, stop in the middle, face the main camera position, and raise their arms. Everyone would get that picture. Then they would face the camera position to the right of the speaker's platform, then face the left. Next the wives would come out and the kids.

I went to see Walter Isaacson, the *Time* writer who had been covering Reagan for months. "Is there any way you could get the candidates to turn around?" I asked. I explained that I would stand on a platform behind the rostrum. I would be the only one up there except for the Secret Service agents. I would have to get permission to be there, but I didn't think that would be difficult. All I needed was for the candidates to turn around for five or ten seconds. The background would be a sea of color and slightly out of focus, people going wild, cheering. Walter was dubious, but he agreed to talk to Michael Deaver, Reagan's close aide.

Remember, this was 1980 and the cover of *Time* was damn important to the candidates. They not only wanted the cover to be great, they also gave the *Time* editors an exclusive interview—and one to *Newsweek* as well. These things mattered.

So Reagan was approached. Considering all that must have been going through his mind, I was amazed that he agreed and hoped that, in the excitement of the moment, he wouldn't forget to turn around. With the permissions granted, I climbed up to my post hours ahead of time. No assistant. Just me and a Secret Service agent.

I waited with the cameras in my hands. Finally, out they came. As expected, the first thing they did was face the battery of cameras stationed straight ahead. They were waving. Reagan had his right hand up and Bush his left hand. They were smiling and it was a fine picture, but it had a dull background. Then, sure enough, they turned around and looked straight up at me, standing maybe fifteen or twenty feet above them. It couldn't have been more than five seconds, but it was the easiest shot I ever took

because I had already framed it. I knew which lens to use, knew where they would be standing. Reagan and Bush also knew exactly what to do: wave for a few seconds. That was it.

Time chose my cover. Ray was happy. He liked being proven right. He had taken a risk by hiring me, and now I was competing against the best of *Time*'s photographers and I had shot a unique convention cover for him.

A month later, the Democrats held their convention at Madison Square Garden. Although President Jimmy Carter would likely get the nomination, there was still a chance Teddy Kennedy could pull off an upset. It's almost unheard of for a candidate to challenge a sitting president, but Kennedy was polling very well against Reagan, and many people still believe that if it hadn't been for Chappaquiddick, Teddy would have been the nominee.

Ray Cave called me into his office. "The candidate is almost surely going to be the president," he said. "I want a very presidential-looking cover. I want a portrait of him and I want him to look strong. I don't want him sweating. He must look like he's in charge, ready to take on the challenges that are in front of him. This is not the time for a smile."

At the moment, Carter was in rough waters. Not only did he have to repair the damage done by Teddy's challenge, there was also still the ongoing hostage crisis in Iran, plus inflation, the oil embargo, and gas shortages at home. But I knew Ray would be fair to both candidates. He wanted to show a strong presidential candidate. (In fact, the headline that ultimately ran on the cover was "Running Tough.")

This posed a huge dilemma for me. I had such a dislike for Jimmy Carter that I wished I had been a political cartoonist. Nothing would have pleased me more that to make him look terrible. I would have made him look like the donkey that his party uses as a symbol.

But I also knew there would be eleven other photographers shooting for *Time* and one of them was going to get a strong-looking Jimmy Carter. I knew the importance of *Time* magazine. I thought, if I give Ray what he wants, I might actually be helping to elect Carter! A lot of people would look at the picture and say, "Wow, he really does look up to the task."

Still, I wanted the cover. But how would I get it? Once again, I did my homework. One of the advantages I had was my experience covering sports, in which you have to be adept with long lenses. I knew the picture I

wanted would have to be made during the president's speech. There would be a few American flags behind him, and using a long lens, I could make those flags work as colorful background.

I got to the convention and began scouting locations. I decided on a place to the left of where the speaker's rostrum would be. I set up sixty feet back in either the Kentucky or the North Carolina delegation, I don't remember which. I brought a little ladder with me and my unipod. I arrived early and chatted up the delegates, told them a couple of Muhammad Ali stories, and, of course, that I was from *Time* magazine, so they carved out a little space for me. I stood on the ladder only when the president made his speech. I lined up Carter's face with the flags in the background. I think it's fair to say that no other *Time* photographer would have used a 600mm lens on the convention floor.

The speech took roughly forty-five minutes, and I shot umpteen rolls of film—different expressions, some with him looking straight at me. One of the two teleprompters was slightly to Carter's left, so he spent a good amount of time looking in my direction.

Ray had told me what he wanted. Maybe he was playing favorites, I honestly don't know. But when the managing editor chooses the cover, he never asks who took the pictures. With Jimmy Carter, he didn't know what I was going to do. He didn't know about the flags. But he chose my shot for the cover. On my first attempt, I had nailed both convention covers.

My picture of Carter made him look strong and very much in charge. I spent the next few months worried sick that I'd helped reelect him.

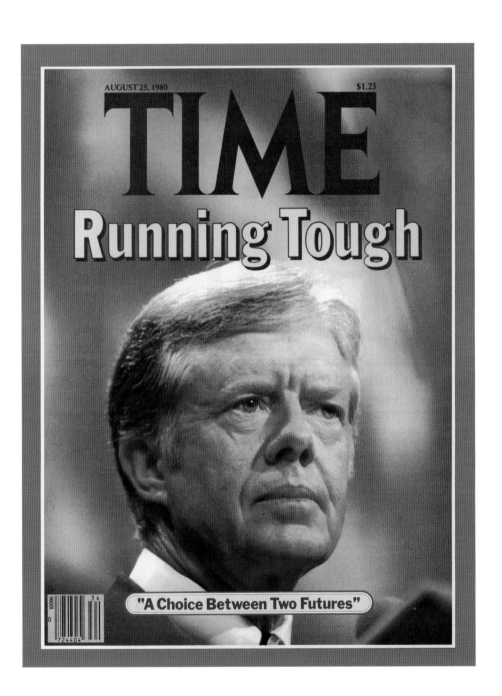

TIME, AUGUST 25, 1980.

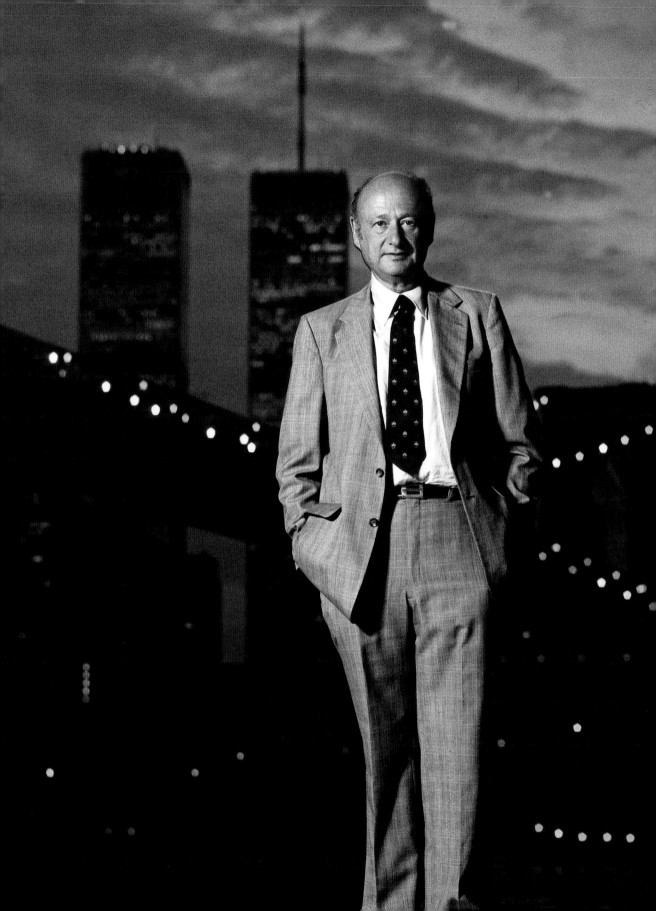

ED KOCH, AMERICA'S MAYOR

> " *When I posed for Neil I can tell you—it was sheer terror. I have a fear of heights that few people know about, and I didn't tell Neil. On this particular shoot, I had to be not just standing near a parapet, but boards were laid across it so that I felt I could slide right off the building. I was not going to interfere with his shoot so I said to a member of my security detail, "If you see me fall, grab my leg so I don't go over."*
>
> —**ED KOCH**, former New York City mayor

I had been trying for months to meet Ed Koch before I photographed him for the first time. I wanted to sit down with him in a relaxed setting, someplace away from City Hall, so he could get to know and trust me. I turned to my friend, Peter Aschkenasy, who owned several restaurants and was close to the mayor. I told Peter I hoped to do a *Time* cover on Koch and asked if he could set up a dinner for me and the mayor. Koch must have thought I was crazy to even suggest a dinner. His secretary called and asked me to come down to City Hall where he would meet with me. I was insistent; it had to be dinner. Eventually, Koch agreed to the dinner as long as Peter was there. We chose Peter's restaurant, American Charcuterie, at Black Rock, the CBS building in midtown Manhattan.

This was summer 1980 and *Time* wanted to do a preview of the upcoming Democratic convention in New York. My idea was to shoot the mayor below the Brooklyn Bridge with the bridge and his city in the background. He agreed and, though the photo wasn't used as a cover, he was so pleased by it that he asked me if he could make it his official picture.

The following year, I pitched Ray Cave on the idea of putting Koch on the cover of *Time*. Ray didn't bite. "Why would I put Mayor Koch on the cover?" he said.

"Because," I said, "if you don't, you'll be the first managing editor in the history of *Time* magazine not to put the New York mayor on the cover."

Ray looked surprised. He said he'd think about it. When he finally gave me the go-ahead, I knew exactly what I wanted to do. Ed was a New York boy, born and raised here. He'd been a congressman, and now he was mayor of the greatest city in the world. What a wonderful picture it would be to have him posed above his city. And other than Ali and Casey Stengel, there's never been a subject who liked the camera more than Ed Koch.

I knew exactly where I wanted to photograph him—on the 67th floor of 30 Rockefeller Center. The office I wanted to use was being leased to Don King. I went to see King in this spectacular office, and it truly felt like he was on top of the world. There were two huge terraces, the kind you can use for a party of two hundred people. One faced uptown, the other downtown. The one facing downtown looked straight out at the Empire State Building and the whole city was below and beyond.

I scouted the location carefully, figured what time it would be dusk, when you might get a beautiful sky and the buildings all lit up but still have enough daylight to shoot. Photographers and filmmakers call it the "magic hour." The terrace was as safe as you would be on the ground floor. There was absolutely nothing to fear. I told Ed that I would build a platform up there and pose him standing over the city—his city. He said he loved the idea although, as it turned out, he hadn't given it any thought. All he said was, "What time do you want me there?"

I had the platform built. I positioned it five feet from the edge of the terrace but it was six feet high so nothing would be blocking my view of the city in the background. Koch arrived right on time and in high spirits. As he gazed out over the city, he said, "Isn't it beautiful? Who'd want to live anywhere else?"

I explained my plan. "I'm going to put you up here and as the sun sets, the light will change. I want to take a bit of time, but all I want you to do is to look great."

RAY CAVE, ED KOCH, ME, AND MY MOTHER, BETTY LEIFER, 1985.

He could not have been safer. He had no chance of falling off the build-
ing—zero. But unbeknownst to me, he was terrified of heights. He never
said a word. He was in his late fifties, with a wonderful smile and very
good skin color, but when I looked through my viewfinder, he looked dead.
He was obviously having a hard time smiling. I took a couple of Polaroids
and, as he stood there, he aged twenty years right before my very eyes.
I said, "Ed, are you okay?"

"I'm fine," he said.

He sure as hell didn't look fine, but I shot some pictures knowing there
was no chance we'd put Ed Koch on the cover looking like this. "Okay,"
I said, "we've got it."

He stepped down, shaking like a leaf.

Now I had to come up with another idea. I still wanted to have Ed's
city as a background. I scouted a lot of locations and I thought about pos-
ing him on Governor's Island with the city behind him, but that didn't

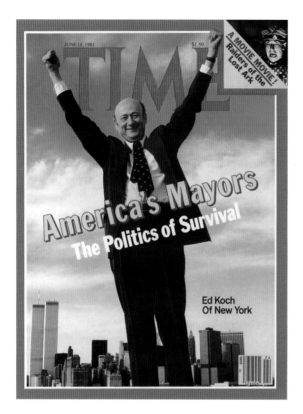

TIME, JUNE 15, 1981.

work. Finally, I rented a tugboat, thinking I would pose him on the boat's deck below the World Trade Center, at a point where the East River and Hudson River converge.

Ed couldn't have been a better subject that day. Once again, he was standing on a platform—only this time, the platform was at ground level. It was a beautiful day and the whole city shone behind him. His hands were raised above his head like a fighter who had just scored a knockout. "That picture of me with my hands in the air," he would say, "that's my signature pose."

It was also a very good cover.

Newsweek, learning of our project, decided to counterpunch. They tried to put out their own Koch cover before ours, but the mayor refused to give them an interview, telling them that *Time* had approached him first. Instead, they did a story about U.S. cities and put Felix Rohatyn, the man credited with saving New York City from bankruptcy, on the cover. It came out a week or two before *Time*'s planned cover on Koch. Ray waited a couple of months, then ran our Koch cover under the headline "America's Mayors."

That week our newsstand sales plummeted.

Years later, Ray was giving a talk. He was a very modest man who never blew his own horn. "You want to know how good of a managing editor I am?" he asked. "Thanks to my good friend Neil Leifer, who talked me into it, I put Mayor Koch on the cover of *Time* and it turned out to be our worst-selling cover of the year. But it forced *Newsweek* to beat us to the newsstands with its story on cities, featuring Felix Rohatyn on the cover. This shows you what a great managing editor I am because Rohatyn was their worst-selling cover in a decade."

Ray Cave

Neil —

The Koch take was a classic —
perhaps your best ever. More than
that, the story concept was yours,
which is photo journalism at its
best. Congratulations, my friend

R

Edward I. Koch, Mayor
City of New York
City Hall
New York 10007

August 12, 1980

Dear Neil:

 Your picture of me in Time Magazine is
the best I have ever seen. It is like a
portrait, and I am very grateful.

 With your permission, I would like to
use that picture as the official photograph
that I send out when requests for them are made.
If that can be arranged, I would appreciate
your providing me with the negative or print
needed to make the copies.

 Again, my thanks.

 Sincerely,

 Edward I. Koch
 Mayor

Mr. Neil Leifer
Time Magazine
Time & Life Building
Rockefeller Center
New York, N.Y. 10020

LETTERS FROM RAY CAVE, 1981, AND ED KOCH, 1980.

OLYMPIC GOLD

> **"** *Neil approached me and asked if he could take a picture of me with five gold medals—before I won the fifth. I was reluctant about doing that. I didn't really look at the Olympics as something I wanted to capitalize off of. What's a guy going to do with a photo of [himself] standing there with the fifth gold medal when it never happens?*
>
> —ERIC HEIDEN, speed skater, winner of five gold medals, 1980 Olympics, Lake Placid

The biggest story going into the 1980 Winter Olympics was the possibility that U.S speed skater Eric Heiden could sweep all five speed skating gold medals. His sister Beth, also a speed skater, was favored to win two. As a result, *Time* decided to put Eric and Beth on the cover of the preview issue for the Lake Placid Games, and I was assigned to shoot them—hardly a tough gig as they were training in Davos, Switzerland.

The cover shoot went well and when we were finished, I invited the Heidens to have dinner with me. Over a fine French meal, I told Eric I believed he would win the five gold medals and that *Time* magazine would love to have an exclusive picture of him wearing all five. I could see that he was definitely interested so now was time to tell him that there was one potential problem. I had already checked the speed skating schedule and he would not be racing for the fifth gold medal until noon on Saturday. To make matters worse, the medals would not be awarded for speed skating until Saturday night, long after the magazine's closing deadline.

But, I told Eric, there was a way to get the picture of him with five gold

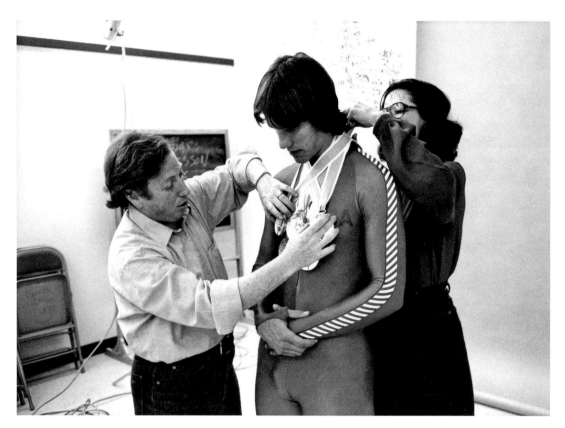

AFFIXING MEDALS ON HEIDEN, 1980.

medals into the magazine before its deadline. I then related the story about Billy Kidd and his 1970 Val Gardena gold medal, which Billy had posed with three days before he'd actually won it. I asked Eric if he would pose with five golds right after he'd won his third.

"But where would you get the other two medals?" Eric asked.

I would borrow them from the Olympic Committee, I said. I would explain I was doing a still life and wanted to show both the front and the back of the medal in one frame. Eric agreed to do it as long as his agent/lawyer Art Kaminsky agreed. Back in New York, I met with Kaminsky, who loved the idea. He had only one concern: that the medal picture was never exploited the way Mark Spitz's seven gold medals picture had been after the Munich Games.

Kaminsky also demanded that Eric own the copyright, which I was more than happy to give him (and, more to the point, so was Ray Cave,

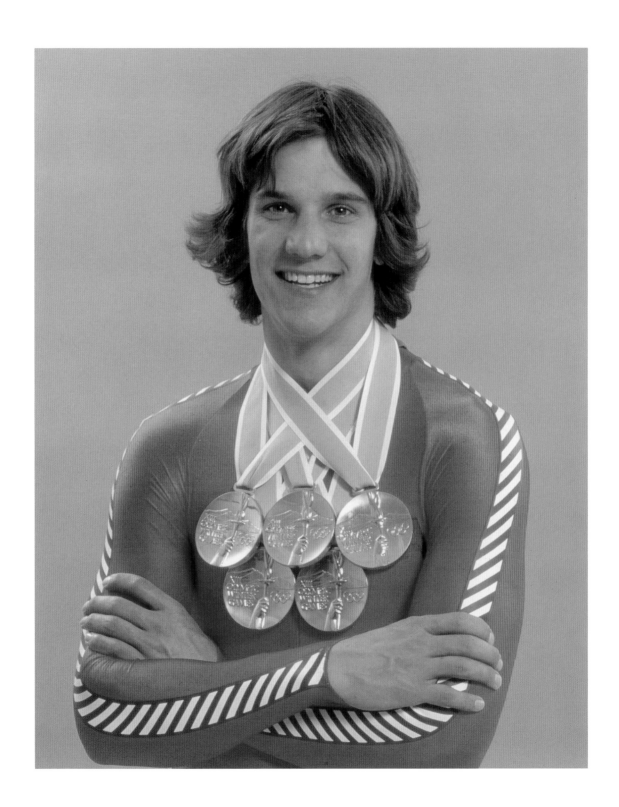

ERIC HEIDEN, 1980.

Time's managing editor). We had a deal. *Time* put it in writing that if Eric did not win the fourth and fifth medals, we would kill the picture and destroy it. Nobody would ever know he had posed with four or five medals unless he actually won them.

Eric did win his first three golds, and I was able to borrow the other two from the Olympic Committee. Eric kept his word and I had my picture. It ran for a full page.

One reason this isn't one of my best-known pictures is that the American hockey team beat the Soviets. I didn't think it was that big a deal. After all, they had done it before in 1960 at Squaw Valley, but no speed skater had ever won five golds. In fact, Eric Heiden had won every single speed skating event there was. I thought then and I still do that Eric Heiden was the story of the Olympics. And I am right!

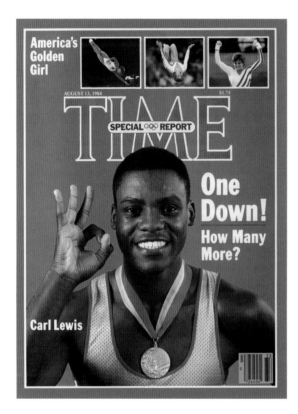

TIME, AUGUST 13, 1984.

But never mind that. I want to talk about the 1984 Summer Games. Because, once again, I planned to revert to my old trick of photographing an athlete with medals before he or she actually won them.

The big star at the '84 Games in Los Angeles figured to be Carl Lewis, who had a very real chance to win four gold medals, the same four that Jesse Owens had won in the 1936 Berlin Games. I had already photographed Carl twice, once posing him at the Statue of Liberty, a shot that became *Time* magazine's preview cover for the L.A. Games. So I called him and made my pitch: Would he consider posing with four gold medals before the Games? Carl quickly said yes.

Only this time, I was too clever for my own good.

It was obvious that both *Time* and *Newsweek* would have Olympic covers after the first week of the Games and, with the track and field events leading off, that Carl would clearly be the choice for both covers. Ray Cave

liked nothing more than to beat *Newsweek*. So a month before the opening ceremonies, we worked the same deal with Carl as we had with Eric, one that would give Carl the copyright to the medal pictures. The credit line would read: "Photograph by Neil Leifer, Copyright Carl Lewis."

The Games were beginning in July, so in June, I set up a studio at the Beverly Hills Hotel and went to the Olympic Committee and asked if I could borrow five gold medals for a still life I wanted to create using the medals as the five Olympic rings. The idea sounded good to them, so they agreed.

I would shoot Carl with one, two, three, and four medals. Carl arrived with a very short, cropped haircut. Since we had a month to go, I said, "You're not going to change your look, right? You're not going to grow a mustache or change your hair?" Definitely not, he said.

So I shot the four pictures, knowing we would run whichever one showed the actual number of medals he won.

Back in New York, Ray Cave decided to forget the four medals. Instead, he would put Carl on the cover with only one. The magazine closed on a Saturday night, and the *Time* cover would appear twenty-four hours after Carl had won his first race, assuming he did. There was no way *Newsweek* could beat us.

Carl won his first race—the 100 meters.

Meanwhile, I had no idea that Ray planned to use my one medal picture right away. And it was a disaster! Carl had changed his look—big time. He showed up

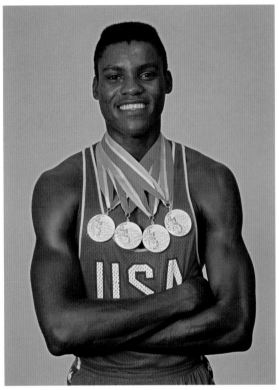

CARL LEWIS, 1984.

at the Games with a tall, distinctive flattop. Clearly, he did not have very short hair. Not even close. When I saw the magazine on the newsstand Monday, my heart stopped.

So much for my clever plan.

In the end, I reshot Carl with four medals—and the new flattop and gave *Time* the four-medal exclusive. It just wasn't a cover.

FOLLOWING PAGES: LEWIS WINNING RELAY, 1984.

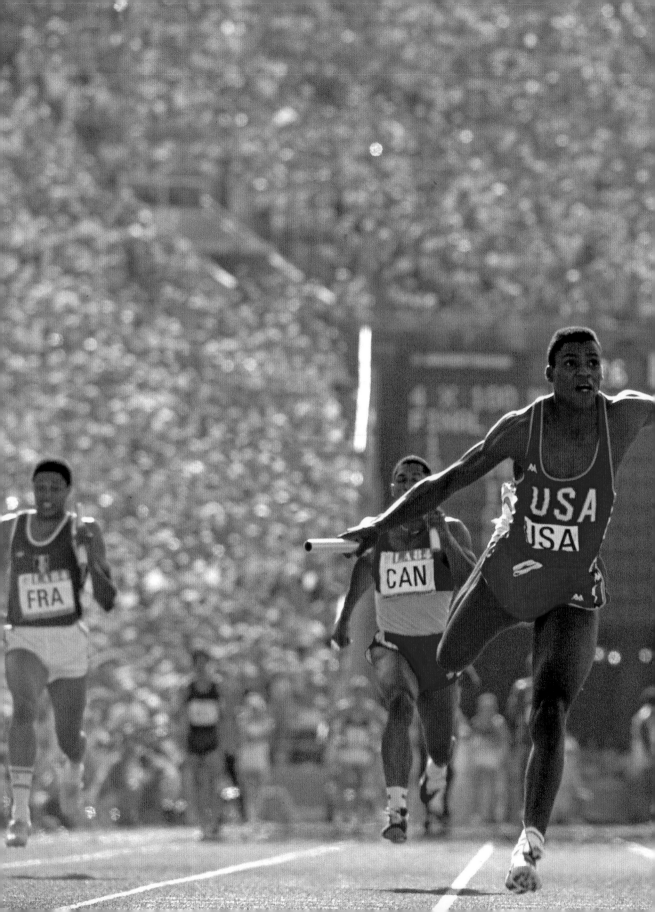

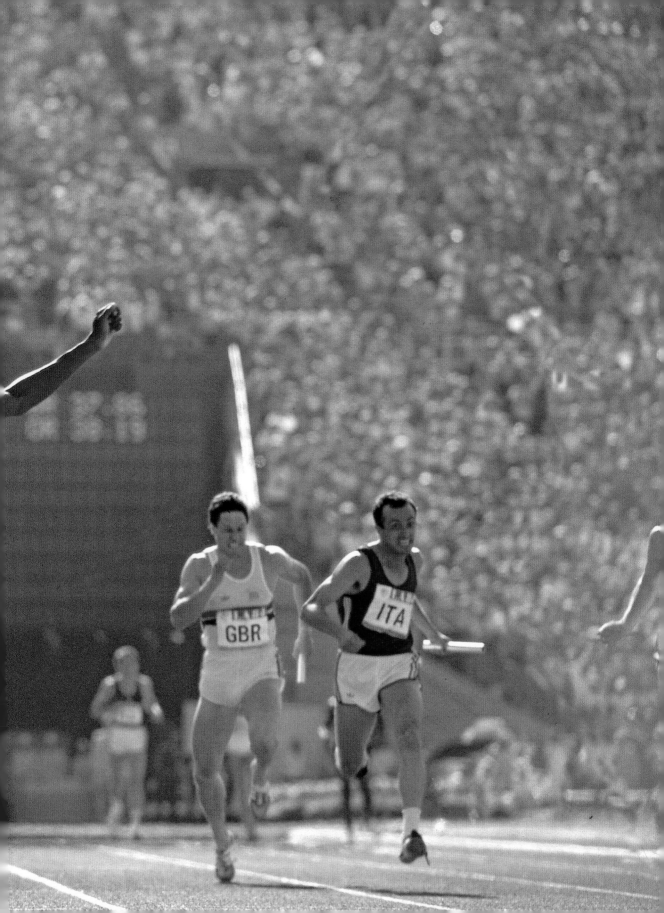

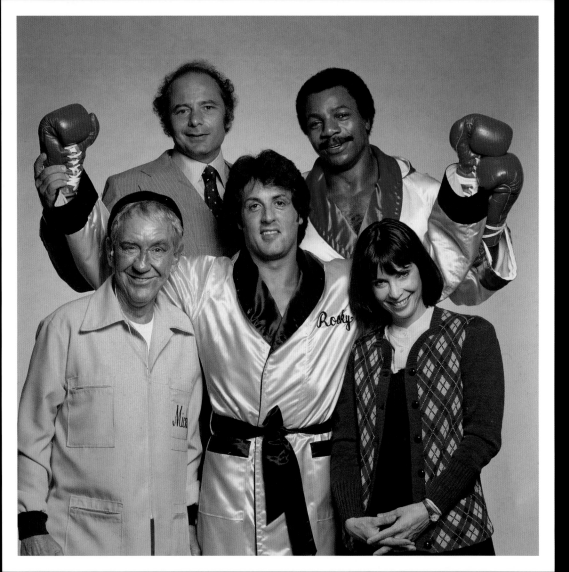

STALLONE AND REDFORD

> **"** *Neil is a good old-fashioned drummer, as we used to call them. He would have made a fabulous salesman. If Neil had sold ladies' skirts or hats or shoes—or tractors—he would have been great at it. And he's absolutely indefatigable. He will not take no for an answer. Sometimes he won't take yes. It's like, "Okay, Neil. We've settled it. Stop!" You know? I don't want to diminish his talent in any way whatsoever, but a large part of his success has been his ability to sell that talent.*
>
> —FRANK DEFORD, *Sports Illustrated* writer

Between magazine assignments, I would carve out time to shoot stills on movie sets for publicity and advertising purposes. Hollywood films would typically use an on-set unit photographer who stands next to the A camera and shoots every scene as it will appear in the movie. That's where I came in. I would be hired as what they called a "special" to shoot the photos for "one-sheets"—the posters used in movie theaters—and other PR pictures that would run in national magazines. Usually they would bring me in only for the big scenes. For instance, I shot all the stills for the Olympic scenes in *Chariots of Fire*.

One of the first movies I worked on was Norman Jewison's *Rollerball*. I spent five weeks in Munich in 1974, shooting the game sequences, and Norman was pleased. His next movie was the 1978 *F.I.S.T.*, starring Sylvester Stallone in his first film after *Rocky*. Norman was a great teacher. He could think out loud, and by just hanging around him, you could learn a lot because he'd have his cameraman on one side and his editor on the

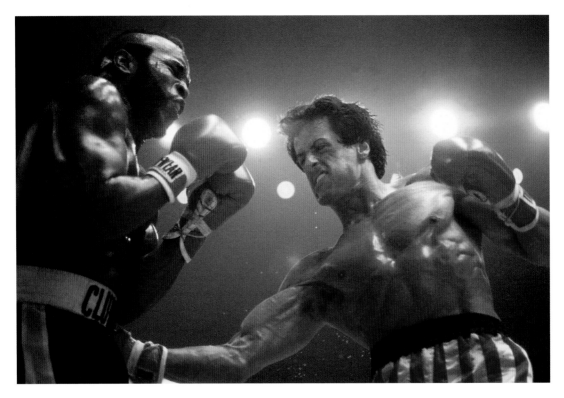

STALLONE FIGHTS CLUBBER LANG (PLAYED BY MR. T) IN *ROCKY III*, 1982.

other, discussing how a scene was going to be shot and how it would be cut later. I told him I would like to work on *F.I.S.T.*, even though it wasn't a sports film. It was more like a fictionalized version of the Jimmy Hoffa story. I said I would work for a week at the same rate I usually charged for a day. Norman hired me.

Rocky had come out by then and I had already met Stallone. My pal Pete Bonventre and I had been invited to an early screening of the movie, maybe three months before the film opened. This was at a time when Sly was very approachable and all you had to do was call up and say, "Are you free for dinner?" He would laugh. "Are you buying?" And I always knew we were in for a great night of fight talk if we got together with Sly.

Naturally, Sly and I hit it off, talking boxing whenever there was downtime on the shoot. He realized right away that I would be the perfect photographer for his fight movies. Even though the movie boxers don't really hit each other—at least, not intentionally—and use makeup to mimic

bruises and blood, he wanted the fight scenes to look real, as if they had been shot by *Sports Illustrated*. Sly got me the assignment, and I shot the stills of the fight scenes for *Rocky II* and *Rocky III*.

In 1982, Sly was directing *Staying Alive*, the sequel to *Saturday Night Fever*, and he hired me to shoot the dance sequences. Meantime, Pat Ryan, who had left her *SI* editing job to become managing editor of *People* magazine, wanted a cover story on Stallone and John Travolta during the making of the film, and a shoot was scheduled. As the director, Sly surely had a lot on his mind, but he agreed to pose with Travolta and showed up dressed perfectly for the cover photograph. He always seemed to know exactly what I wanted, and when he agreed to do a photo session or an interview, he did it 100 percent. I think that was a big factor in how successful he's been over the years.

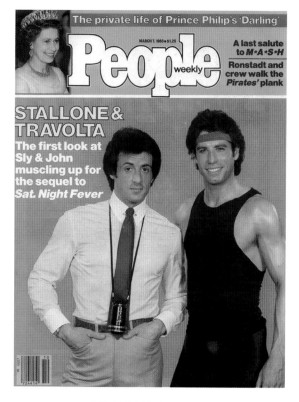

I had twenty minutes to shoot this cover, so I made sure everything was set up. Because Sly is shorter than Travolta, I arranged apple boxes for Sly to stand on so he would be the same height as John. I knew that was what Sly would want.

Travolta looked fantastic. He had trained with Stallone for months, and he was in the best shape of his life. So I got them together and took my first Polaroid. They both liked it. Sly looked magnificent, and neither of us noticed that he was still about an inch shorter than Travolta.

PEOPLE, MARCH 7, 1983.

When the cover came out, however, Sly let me know that he wasn't very happy about it. He thought they should have appeared to be the same height, as I said they would. This was, after all, his livelihood.

The next time I was in L.A., I went to see Stallone. He put his arm around me and said he forgave me.

"What changed your mind?" I asked.

He grinned. "I can't tell you how many compliments I had from that cover. Everyone told me how good I looked."

Travolta was another story altogether.

On stills shot for movies, unlike photos shot for magazines, A-list actors have kill rights—the power to eliminate any pictures they don't like. In *Staying Alive*, both Stallone and Travolta had kill rights. Since Stallone had hired me and was directing the film, I was obliged to show him the pictures first. The film I shot was processed in Los Angeles, and I edited it in my hotel room. I had a little light-box and I would put together a group of selects. A couple of times a week, I would go to Stallone's house and show him the carousel of my selects. He would say, "No, I hate that one. Get rid of that one." But he was a very good and fair editor.

Twice a week, I would also show pictures to Travolta. He was staying at the Westwood Marquis, in a very nice suite. I would bring my carousel, projector, and slides. His publicist, Gary Culkin, would be there, too. I would set up my projector twenty feet from a white wall. We'd close the blinds and I'd project the slides onto the wall. Now, normally you would view it from ten or fifteen feet back. Not Travolta. He would pull up his chair to maybe one or two feet from the wall. I wasn't even sure the pictures were in focus so close up, and I kept saying, "John, do you want to move back a little?" And he'd say, "No, I like to see them from right here."

Travolta looked fantastic, and he danced beautifully. The pictures I chose made him look like Baryshnikov or Nureyev. But he vetoed some spectacular ones. He'd see a little spot under his arm or, he thought, a little bump somewhere on his skin. In one photo, I caught him at the top of a leap; it was a magnificent picture. And he would point to something and say, "Look at this!" And out would go that one. John was a pleasure to deal with in every other way, but those teeny-weeny blemishes he saw, or imagined—to this day I still can't see.

Then there was "The Fix." It was an expression I always used to sum up how outside photographers are hired to shoot stills on movie sets. The studio would hire a photographer from the very magazine it wanted the pictures to appear in. Every publicist with a sports movie obviously wanted to get into *Sports Illustrated*. Many contacted me.

If there was a film I wanted to work on, I had to get the magazine's permission. I would use vacation time or an occasional leave of absence to do a movie shoot because that work was very lucrative.

Here's where The Fix came in.

Stallone would call me a month or two before they were to start shooting the *Rocky* sequels and give me a heads-up. Then, sure enough, the call would come. The studio person would say, "Neil, we're wondering if you'd be available to shoot the new *Rocky*." Then we would negotiate, but the first offer was never what I thought it should be. I would say, "I want to do this, but the money you're offering is not right." They would object. I would say, "That's my price," knowing they couldn't hire anyone else because Stallone wouldn't approve. They would call back to tell me they were working to hire another photographer—a bluff. A week later, they would call again, saying, "Maybe we could split the difference?" I would say, "I don't want to do that. I do this work on my vacation time, and I only have so many weeks of vacation. If you want me, this is my price." I always got it because The Fix was in: I knew Stallone wasn't going to approve anyone but me.

Which is why I tell people that Sylvester Stallone put both my kids through college.

- -

I should also mention that I had bit parts in three films. I will spare you most of the details of my on-screen career, but I do want to tell you about my biggest Hollywood moment: when Robert Redford "discovered" me.

I first met Redford in Grenoble, France, during the 1968 Winter Olympics. He was a friend and neighbor of writer Dan Jenkins who, at that time, covered skiing for *Sports Illustrated*. Redford was prepping for *Downhill Racer*, and he wanted to study the ski racing scene up close. *SI* hosted dinners almost every night during the Games, and Redford joined us more often than not.

Over the years, I would run into him from time to time, and in 1992, I got a call from a friend of mine, casting director Bonnie Timmerman, who was filling roles for *Quiz Show*, which Redford was directing. She asked if she could get my reel to show him, saying, "There's a part I think you would be perfect for."

"Reel?" I said. "I don't have a reel."

What I did have, I explained, was a tape of interviews I had done on *Good Morning America* and the *Today Show*, so I sent them over. Two days later, Bonnie called back. "Bob loved it. You've got the part. You're going to play a psychoanalyst."

She sent me one page—the dialogue for my only scene. It would involve Rob Morrow, who played an investigator for the congressional committee

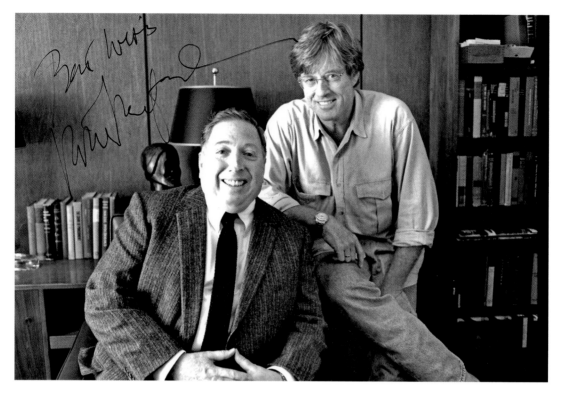

WITH ROBERT REDFORD, 1994.

looking into the game show scandal. In the scene, he would be interviewing previous contestants—I would be one of them—trying to learn if the shows were fixed. It would be a montage of contestants, but I knew enough about filmmaking to know that all of us wouldn't make it into the final cut.

My scene was to be shot at night in an office at the Fordham University Law School in New York. For my part, I had a ridiculous '50s haircut and was wearing an itchy wool suit. During makeup, I was seated next to Morrow, but I'd never seen *Northern Exposure*, his big TV show, and had no idea who he was. I assumed he was an extra like me.

Redford was waiting for us on the set—actually, I think he was waiting for Rob. It was about nine o'clock at night, and they had probably been shooting since seven that morning, but when I gave Redford two of my coffee-table picture books, he sat down to look at them. He had thirty people waiting to shoot the scene and go home for the night, but Redford was the director and he went through every page of both books.

Finally, we went to the set, where I was introduced to the star of the

film, Rob Morrow. Redford sat me down at my desk. "I know you read your scene. You've got a couple of lines of dialogue. Let's run through it real quick."

I did my lines twice. Mind you, I had only two lines and one of them was, "I loved being on the show." The second one was to answer if I'd ever been given the answers ahead of time.

Redford said, "When he asks you did anyone ever give you the answers, you've got to look startled."

He thought about it a minute. "You know what? I don't like that line of dialogue. I want you to answer any way you want. Forget the script."

Morrow and I rehearsed the scene, but Redford still wasn't happy. "Here, let me show you what I'm looking for," he said and sat down at my desk. "Stand next to the camera," he instructed me, "and watch what I do. Action!"

Morrow asked him a couple of questions, but Redford wasn't making eye contact. He was looking at the venetian blinds to his right. When Morrow asked if anyone had given him the answers in advance, there was a kneejerk reaction. Redford's head snapped and he was looking right at Morrow because he wanted to appear as if he had obviously been caught off guard.

I applauded. "Terrific, Bob. You should be playing this part."

"Very funny. Now sit down. You're going to be great. Action!"

When Morrow started asking me questions, I looked at the venetian blinds. When he unloaded *the* question, I snapped my head to look at him. "Perfect," Redford said. "Print it."

They shot the scene once more in extreme close-up, which would fill the frame with my face. And that was it. Redford turned the camera around and did the scene facing Morrow. I couldn't help thinking that I must have been unbelievably bad and that Redford had realized nothing would make the scene work. After five or six takes on Morrow, it was a wrap.

"Was I really that bad?" I asked Redford. "One take?"

He grinned. "Neil, you were perfect. I would have shot more if you weren't."

Seven or eight months later, I ran into Redford at a Hollywood party. "How is *Quiz Show* looking?" I asked.

"It's great. I'm putting the final touches on it now."

"Tell me the truth," I said. "Am I in the film?"

"Of course you are. You were brilliant."

"Come on, I was terrible."

"Let me tell you something," Redford said. "You were terrible, but I knew if I had done another take or two, you would have been a little better. I wanted a nervous actor. I wanted somebody who was visibly uncomfortable. And your first take was perfect."

Five months later, *Quiz Show* came out and my daughter, Jodi, went to see the movie in Florida. Either she forgot I was in it or didn't care. But she and her date were sitting in the middle of a packed theater and up came the montage of previous contestants. All of a sudden, there's my close-up on the screen. After a loud gasp, Jodi screamed, "That's my father!"

Then, she later told me, she just wanted to crawl under her seat.

CLINT EASTWOOD

> *Working for Neil, I never know what each day will bring. He always has several projects— books, films, or photo shoots—that he's working on at the same time. When the phone rings, I have no idea who it might be—Ed Koch, Alec Baldwin, someone in the White House, or just another girlfriend.*
>
> —**JOAN FAZEKAS**, personal assistant to Neil Leifer

Clint Eastwood had me completely fooled the day I went to photograph him.

It was 1977, and he and Burt Reynolds were the two leading male actors in Hollywood. They were huge stars, number one at the box office. *Time* decided to put them on the cover. I was still at *Sports Illustrated*, but since I had worked with Burt on *The Longest Yard* and *Semi-Tough*, they assigned me. I'm not sure why because they had another photographer, John Bryson, who had done quite a lot of work with Clint. *Time* wanted me to pose the two of them together. I would also shoot the inside pictures of Reynolds, and Bryson would shoot Eastwood. At the time, Clint was living in Carmel and Burt was living in Bel Air. They liked each other and were friends, but it was sort of an ego thing as to which one would travel to the other's territory.

Bryson had tried to get them together but struck out. I knew that *Time* would use an illustration for the cover if they couldn't get a picture of them together, but I was told that they were really hoping for a photograph. I was in L.A. and I went to talk to Burt. Was there any way, I asked, that he could get Clint down here? Burt said, "Let me give him a call."

He was involved with Sally Field at the time, and when he called, he said, "We'd love to have you down for dinner." After Clint said yes, Burt added, "And while you're here, *Time* could shoot this cover."

Clint agreed. I was told the photo would be taken at Clint's studio, Malpaso Company, on the Warner Bros. lot. I had to smile. Even though Clint was making the trip to Burt's territory, the photo would be shot at his studio. Touché.

The day before the shoot, I was at Burt's house, and I told him I needed to coordinate the color of my background with what he and Eastwood were going to wear. Burt led me into his closet. Some clothing stores don't have as many sports jackets and suits. He had every color and every style. He picked out a couple of jackets. I said, "Whatever you wear has to match what Clint is going to wear."

"Not a problem," Burt said. "We'll pick a jacket that goes with brown."

"How do you know what he's going to wear?" I asked.

"Neil, Clint Eastwood owns only two sport jackets and they're both brown."

Clint's office at Malpaso reminded me of a doctor's office with an outer area where I was told to wait. The secretary said Clint was on his way, and she was also expecting someone to fix the water cooler. So I sat there, surrounded by posters of Clint Eastwood from many of his movies, all of them featuring close-ups of that look, the square jaw, the squint. No matter what direction I turned, Clint's face was staring down at me from one of his movie posters.

Finally, in came the guy to fix the water cooler. At least, I assumed that's who he was, because he didn't look anything like Clint Eastwood. The secretary said, "I want you to meet Mr. Eastwood," and this man, who couldn't have been Clint Eastwood, came over and shook my hand. We went into his office and chatted for a few minutes. Even up close, he didn't have the square-jawed look I was seeing on all those posters. But the minute I looked through the lens, he instantly became Clint Eastwood.

And, by the way, he was wearing a brown jacket for the shoot.

That photo became my first cover for *Time* magazine, a proud achievement for an *SI* photographer.

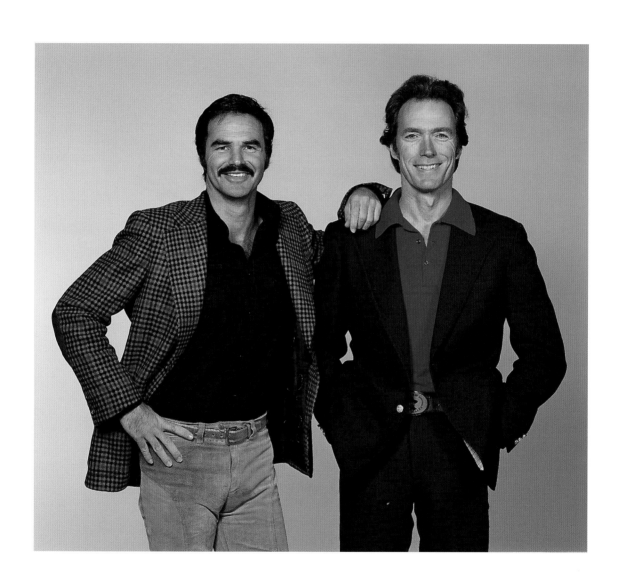

BURT REYNOLDS AND CLINT EASTWOOD, 1977.

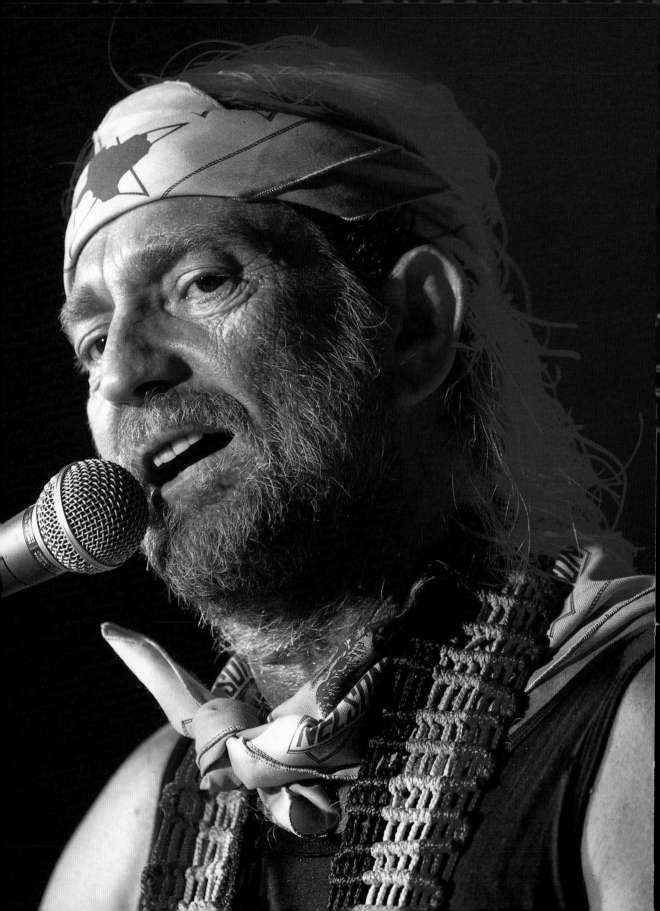

WILLIE NELSON

" *Photographers are my least favorite people. I don't really want to sit down and take time to get my picture taken. Neil shows up and he's about as aggressive one way as I am the other, so I decided I was either going to have to kill this guy or go ahead and smile for a couple of days.*

—**WILLIE NELSON**, multiple Grammy Award–winning singer-songwriter

Country-and-western music—what we used to call "shit-kicking" music—was something I had zero interest in and knew nothing about. But all that changed in 1978 when I was assigned to shoot Willie Nelson.

Ray Cave, the *Time* managing editor, had become a big Willie Nelson fan, and he wanted to put Willie on the cover. He was appearing at the Golden Nugget Hotel in Las Vegas, doing two shows a night, and I was going to shoot for five nights, ten shows in all. Willie let me set up my strobe lights above the stage, and he arranged for me to have a front-row table right below center stage. It was the perfect spot to shoot from; how could I go wrong?

Not really knowing Willie at that point, I couldn't have imagined how quickly we'd go from a can't-miss to a no-win situation.

It was no secret that Willie liked his weed: he smoked it nonstop all day. When I went to see him on his bus before the first night's show, he passed me a joint. I had never smoked pot, but I wanted to be polite. Now, Willie's pot was major-league stuff, so all it took was one little hit and my vision

was blurred. Back then, photographers still had to focus their lenses, and had I smoked even half of one of his joints, I doubt I would have been able to stand, let alone focus and shoot a camera.

As a result, the two shows I photographed on the first night were a bust. No great pictures, for sure. On the second day, I had no intention of making the same mistake, so I avoided going to the bus before the first show. (Willie, of course, knew exactly why and he was amused by it.) But once the first show was underway, his fans started sending shots of tequila to the stage (a tradition). He looked out at the audience and pointed down at me and said, "If you want to buy me a drink, you gotta buy one for my buddy from *Time* magazine." Another shot of tequila would quickly arrive at my table. Willie would raise his glass—so did I (what choice did I have?)—and say, "Down the hatch!"

This happened three, four, maybe five times during the early show, so before long, I could barely see Willie right there in front of me, much less take any pictures that were even close to being in focus.

I must admit, I thoroughly enjoyed those shots of tequila, but I had a job to do. So by the third night, I was totally concentrating on my pictures. With no weed or tequila fueling me, I was able to get really good shots of Willie's performance and truly loved every minute of the shoot.

Just before the *Time* story was to close, Willie was asked to perform at the White House for President and Mrs. Carter. I was assigned to shoot the concert, which took place on the south lawn. As it turned out, Jimmy Carter was unable to attend, but the First Lady and many prominent senators and congressmen were there on a beautiful September night. Still, the best was yet to come.

Willie and his group were staying at the Hay-Adams Hotel. Pete Axthelm, who was writing a *Newsweek* cover story on Willie and had a contract to write his memoir, was also staying there. Since the hotel is right across the street from the White House, we all headed there after the concert. By eleven o'clock, we were sitting at a table in the bar. A wonderful piano player was singing all the old standards, and at midnight, he asked Willie to join him for a couple of songs. The "couple" of songs must have gone on for at least an hour. They alternated between the standards and Willie's best-known songs. Around one in the morning, the waiters announced last call and the piano player said he had to leave. He told Willie to sit at the piano for as long as he liked. It quickly became obvious that Willie was going to be performing an impromptu concert for a long time.

Meantime, Axthelm and I ordered four rounds of drinks for everyone

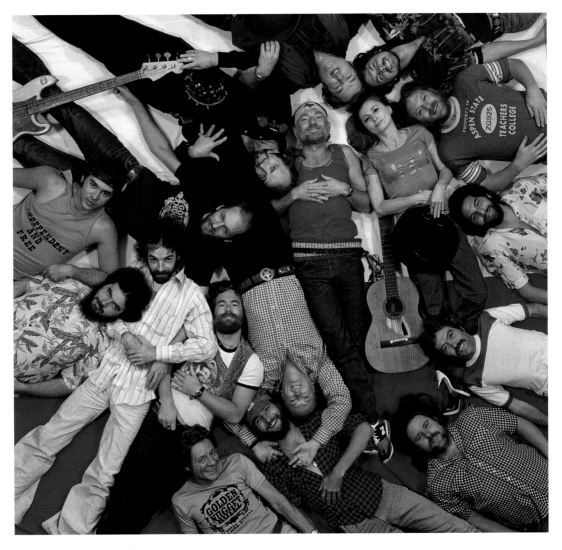

WILLIE NELSON & FAMILY, 1978.

at Willie's table. We lined up Willie's drinks on the piano top. Willie drank and sang until four in the morning. I doubt he has ever put on a better show, and only ten or twelve of us got to hear it.

Unfortunately for me, *Newsweek* beat *Time* to the newsstand, running its Willie Nelson cover one week before *Time* had scheduled its own cover story on Willie.

Because *Time* had been "beaten" on the story by our arch-competitor, we never put Willie Nelson on the cover.

DECEMBER 6, 1982 $1.50

TIME

THE VERDICT
ON NEWMAN:

Quite
A Guy

0 10690

49

0

724404

PAUL NEWMAN

" *I have long believed you can see greatness in the eyes of successful men and women. They have a level, steady, self-confident look in person and in their portraits. Look into the eyes of Neil Leifer subjects, and you will see greatness again and again. In the portraits, and, most importantly, in the eyes of the man behind the camera.*

—TOM BROKAW, former NBC News anchor, from the introduction, *Neil Leifer: Portraits*

When Paul Newman was making *The Verdict*, people thought it would be his Oscar-winning role. So I gladly took an assignment in 1982 to shoot Newman for the cover of *Time*. I was working in Los Angeles, shooting the stills for *Rocky III*, and Stallone could give me only one day off plus the weekend to photograph Newman. I mention this because it was fascinating to me to see how differently the two men handled their success. Stallone has long had an armed security detail watching his house and family and following him everywhere. Years before, when I was trying to persuade Ray Cave to put Stallone and heavyweight boxer Gerry Cooney on the cover of *Time*, I arranged a dinner with Ray and Sly. Sly insisted that his bodyguard, Tony Manofo, sit with us, saying it would be rude to put him at another table. I told him, "You just can't do that. Even Henry Kissinger's security guy sits at another table when he has dinner with Ray." Tony sat at another, nearby table.

Given my experience with Sly, I expected Paul Newman, who was an even bigger star, to have an even bigger security force. I went back to New York for the shoot. Newman wanted to meet me first. Also, I wanted to

figure out where to pose him. I was given Newman's address, in Westport, Connecticut, directions how to get there, and his telephone number. I had just come from Stallone's house, and I'm not sure the White House is as secure as that place. Anyway, as I approached Newman's house, I was expecting something on the order of that.

I was told to be there at 10 a.m., and I arrived five minutes early. Could this be the right place? There was a mailbox with the address on it, but no gate or fence, just a long, open driveway. I pulled up to a three-car garage and parked. There were no cars outside, and it appeared no one was home. I rang the doorbell a couple of times, but no answer.

I looked through a little window into the garage and saw three cars, but no one responded when I rang the bell again.

I stood by my car not sure what to do. At two minutes past ten, I noticed a lone jogger coming down the road. When he was maybe fifty feet away, he waved to me. He turned into the driveway and sure enough it was Paul Newman. "Hi, Neil, am I late? I didn't mean to be. I apologize," he said.

He led me into the house. I don't think the front door was even locked. "Come in," he said. "I've got to take a quick shower and change into something else. Then I'll show you around and we can talk about the shoot." But before he started upstairs he pointed to the refrigerator and said, "If you want something, there's some juice in there. You can have a beer, a soda. Just make yourself comfortable."

I stood there, dumbstruck. After a while, he came down and gave me a tour of the house and the rest of the property, which was beautiful. He also showed me a barn that he had converted into a theater. As we walked, I pointed out a couple of places I wanted to shoot. He had picked out a white sweater to wear, which I'm sure he knew would best show off his famous blue eyes.

And as soon as I spotted his full-grown calico cat, I knew what my picture would be. I remembered that one of the best-selling issues of *Time* had a puppy on the cover. I had actually done a cat cover for *Time* the year before, and that issue had sold very well. I said to myself, I've got Newman's eyes and a beautiful cat. I can't miss.

When I returned the next day for the shoot, I suggested we start with the cat. "Great," he said. Only, where was it? Newman spent a good fifteen minutes searching for the cat, even getting down on his hands and knees and looking under furniture, but no luck. Finally, I posed Paul, without the cat, at a little creek and it was beautiful. His famous eyes were impossibly blue.

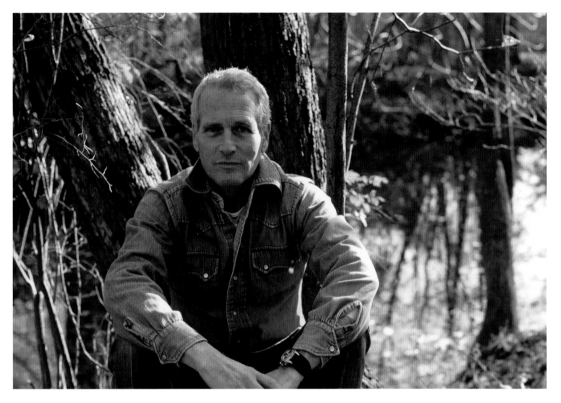

NEWMAN AT HOME, 1982.

The last picture I needed was with his wife Joanne Woodward. He said, "Nobody tells Joanne what to do. You're going to have to ask her yourself." He led me back into the house and introduced me. She really didn't want to pose. I appealed to her, saying, it was *Time* magazine, blah, blah, blah, and eventually she came outside for five minutes and they posed in front of their house. That picture ran, the cover ran, and I heard that Paul was very happy with it.

Although the two men couldn't have been more different, they did have one strange experience in common. Right after I shot Stallone for the cover of *People*, dressed as Rocky and holding his young son, the little boy was diagnosed with autism. Shortly thereafter, I got a call from a writer saying he was working on a piece about autism, and he told me he'd interviewed Stallone for the story. He offered me a lot of money to sell him my picture of Stallone holding his son and others I'd taken. I hesitated. I was a father with two young children and I had my doubts. I called Sly and he

said he'd really appreciate it if I didn't sell any of the photos of his son. As it turned out, the writer had lied to me. He had interviewed Stallone but not about autism.

After my Paul Newman cover ran in *Time*, I got a call from someone at *Playgirl*. Newman's son Scott had died of a drug overdose several years before. The person who called me said, "We're doing a piece on Paul Newman and we'd like to use your photographs." I'm thinking, Paul Newman agreed to a piece for *this* magazine? I said I hardly thought Mr. Newman would appreciate me selling these photos, and this person said, "He's cooperating. He's given our writer a very good interview."

I asked the name of the writer. He was a *Miami Herald* reporter to whom Paul Newman had indeed given an interview. I said I would think about it and get back to them.

I phoned Paul's office and explained the situation. "They pay a lot of money," I said, "but I won't do it if it's going to upset Paul."

His assistant said this didn't sound like something he would do, but she would get back to me. It didn't take long. "Paul said please, please don't do this. He said he gave an interview to that writer for a piece that had nothing to do with his son. He would never go along with something like this."

A week or two later, I got a note from Paul, thanking me for not selling the photos.

PAUL NEWMAN

September 16, 1983

Mr. Neil Leifer
One Lyric Place
Dix Hills
Long Island, N.Y. 11746

Dear Neil:

I understand you turned down a fee from Playgirl
Magazine as a matter of principle.

I know you did so out of consideration for my
feelings and I certainly appreciate it. Many
thanks.

Best personal regards,

Paul

LETTER FROM NEWMAN, 1983.

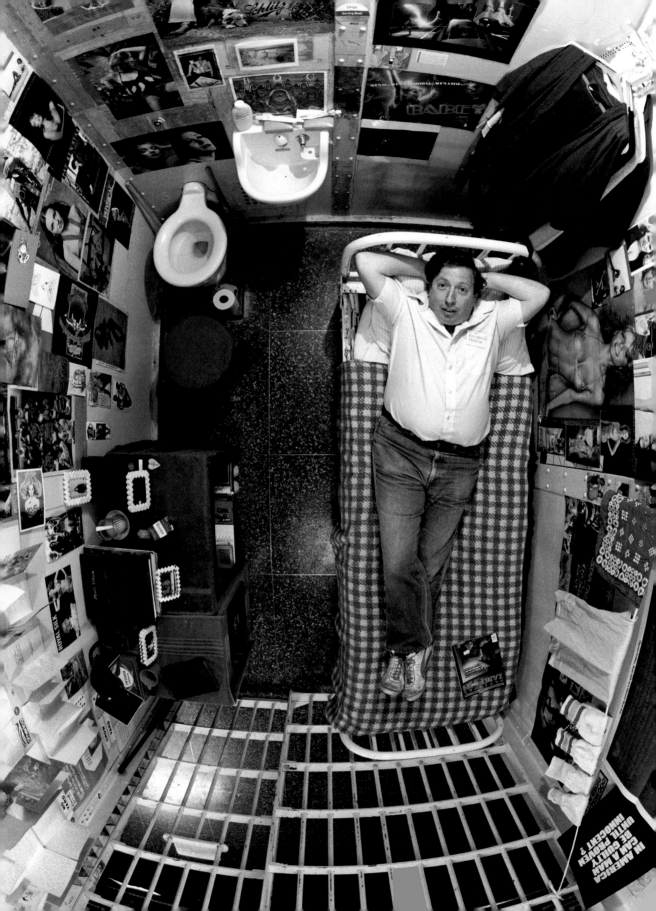

THE INMATE NATION

> **"** *Neil was a picture editor's dream. Not only did he always come up with some wonderful ideas, he executed them. He did a lot of research. So when he came to me with an idea, you know, "Let's do such and such," he would tell me where all the such and suchs were, how many he needed to shoot, how many plane tickets he would need so that I could budget the thing. I would know exactly what I was getting into, how long it would take. It was the total package. And I knew he was going to execute it.*
>
> —**ARNOLD DRAPKIN**, former director of photography, *Time*

N ow that I was at *Time*, I began to think of big projects—essays that I hoped would run for twelve or fourteen pages—on subjects that fascinated me. One was prisons. There is a whole world of inmates in this country, hundreds of thousands of people serving long sentences. Other than when we read about a parole hearing or hear a bit of news about an inmate, we have no idea how they live. I suggested to Ray Cave that we do a *National Geographic*-type story—like going into the Amazon to learn about a lost tribe, only we would be going into a number of prisons. Movies have been made about prison life, but they're never very accurate.

I told Ray we should do a piece on what it's like to be incarcerated. I wanted to shoot serious maximum-security inmates serving time in legendary penitentiaries. I wanted to shoot from inside a cell, not the clichéd outside shot of an inmate holding the bars. Ray said yes and approved my

IN AN INMATE'S BUNK AT ATTICA, 1982.

idea of shooting in black and white, even though *Time* was quickly becoming an all-color magazine.

The project took me almost a year. First, I made a list of five prisons, each one a household name: Attica, San Quentin, Huntsville in Texas, Leavenworth in Kansas, and Statesville in Illinois, where most of Chicago's worst criminals, many of them Mafia, were doing time. I also wanted to shoot an inmate whose name everyone knew. One candidate was Richard Speck, who had brutally murdered eight student nurses in Chicago. I tried to meet him when I was at Statesville, but he hid from me. I actually sat outside his cell for a while, but he didn't show up. He only came back after I had left.

Also on my list were Sirhan Sirhan, Mark David Chapman, James Earl Ray, and, of course, Charles Manson.

Next, I had to get permissions. Prison wardens always want to show you their model cellblocks. I wrote to each warden saying I had to be able to go wherever I wanted to, unless it was a particularly dangerous area. I knew they would send a guard with me, but I said he would have to stay back because inmates don't trust guards. And because inmates are notoriously litigious, I would have to get releases from each inmate before I photographed him.

I also wrote a letter to Charles Manson at Vacaville in California. I said I wanted to spend a day with him. I told him that my interest was not in his crime, but in an inmate who was famous but whom the public never sees. Manson would occasionally do a TV interview, but it always took place in a small interview room with the reporter on one side of a table and Manson on the other. I wrote that I wanted to see what his day was like, what his cell looked like. Did he have a job? Any friends?

To my surprise, he wrote back. It was a wild, crazy letter, but he said okay. It sounded convincing and I showed it to Ray. He said, "Let's do it."

I flew to San Francisco with my assistant, rented a car, and drove to Vacaville to the California Medical Facility, where they treat mentally ill felons, among others. When we arrived, I was brought to the warden's office.

"Charles Manson would like to meet you first without any cameras," the warden said. I thought, Oh, shit, he's going to want money, they always want money. The warden told me to leave my cameras and my assistant and to follow him. He took me to the prison chapel, where Manson worked, cleaning and sweeping. Before Manson came in, a young girl and a minister who worked at the prison both told me how nice Manson was, that he gave them no trouble, that I would be very impressed with him.

They brought Manson in. I shook his hand because he was a subject and

LETTER FROM CHARLES MANSON, 1982.

because I knew I'd need his cooperation. The first thing I checked out was the infamous swastika on his forehead. It was barely visible. I later realized that when he would come up for parole or was being photographed, he would color it in with a blue pen.

He said, "So what do you want?" Before I could answer, he said, "And how much are you gonna pay me?"

"Charlie," I said, "*Time* magazine doesn't pay. This is journalism. Paying is something we do not do. I wish I could. If you were outside, I could take you to dinner. I could do any number of things, but I can't pay you."

Manson said, "I have been paid before. I'm only allowed a certain number of interviews a year. German *Playboy* paid me." And he named several others. "Why would I do this for free?"

"We went over this in our letters. You told me to come out here. It cost *Time* magazine a lot of money."

"If you're not going to pay, I'm not going to do it," he declared.

I tried to change his mind, but he wasn't budging. Finally, he said, "You're not paying me. Have a good day." And he walked out.

I sat there thinking that this can't be happening. I was escorted back to the warden's office, and I told him what had happened. "Can you help me?" I said.

He was very nice, but said there wasn't anything he could do. I felt terrible for wasting so much of the magazine's money and having to return to New York with nothing, not even a bad picture. When I got back to New York and told Ray what had happened, he said, "Look, it was worth a try."

A month or so later, I was sitting at my desk, feet up, reading the paper, when the phone rang. A guy said, "Are you Neil Leifer, the photographer from *Time* who flew out to photograph Charles Manson?"

"Yes. Who are you?" I hadn't run around advertising my assignment.

"Charlie likes you," he said. "He asked me to call and find out if you wanted to come back and photograph him."

I was totally caught off guard. "Who are you?" I repeated.

"I'm Charles Manson's biographer." He gave me his name.

Wanting to make sure I wasn't being set up, I asked if I could call him back in half an hour. He gave me his phone number and I remember thinking for the first time this might be real because it was the Vacaville area code. Twenty minutes later, I called him back. Again I asked him who he was.

"I was in prison with Manson. We've been friends for a long time. I'm out now. I sort of help him with things, and I'm writing his biography. He asked me to call you."

As I was telling him that I didn't trust Manson, I was thinking about the turndowns I had received. I had tried James Earl Ray, Mark David Chapman, Richard Speck, and Sirhan Sirhan, but Manson had been the only one to respond.

I said, "I'd love to photograph Charles Manson, but he really screwed me the first time. I was embarrassed. I had to come back and tell my boss that I didn't get any pictures. I don't know if *Time* will want me to spend the money again. It's not my decision." I said I'd call him back.

I went downstairs and told Ray what had happened. "You want me to give it another go?" I asked. "Obviously, Manson can't be trusted to keep his word."

"You know what?" Ray said. "If we get it, it'll be worth it, and if we don't, what the hell? Go do it."

This time was different. This time, I—along with my assistant and my

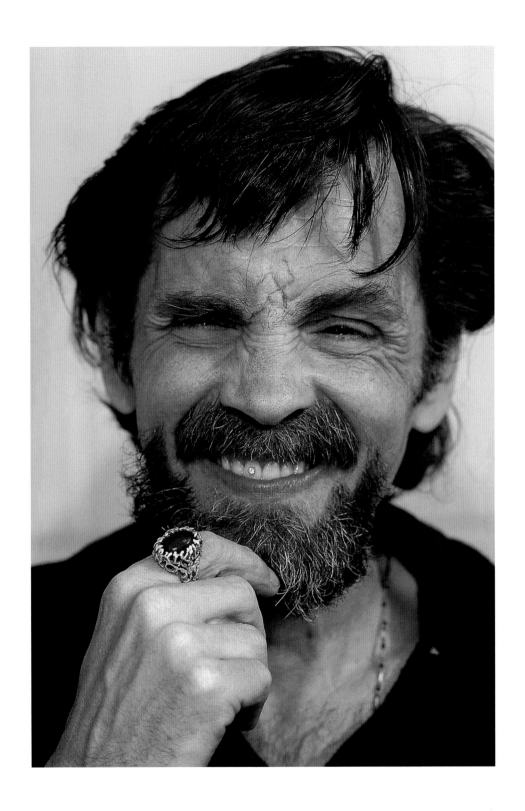

CHARLES MANSON, CALIFORNIA MEDICAL FACILITY, VACAVILLE, CA, 1982.

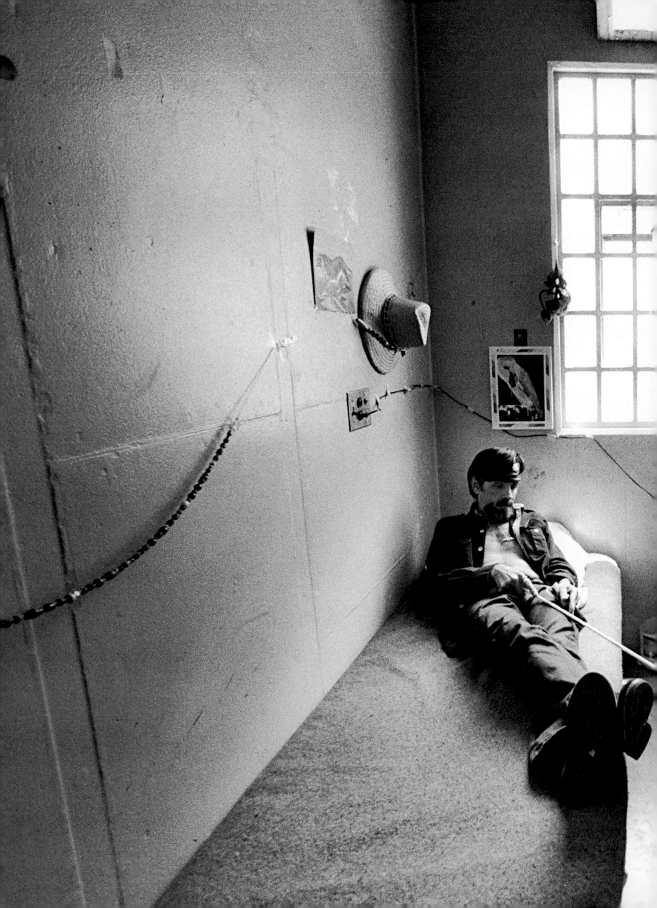

cameras—was led into the chapel right away. Manson was waiting for us, and I could tell he was serious now because he had darkened that swastika; it was now very blue, and you couldn't miss it. I spent almost the whole day with him. I photographed him in the chapel and with his friends, the younger inmates. I was in his cell with him for a good hour, maybe longer. He didn't have remote control so he used a long stick to change TV channels from his bed. That, by the way, is my favorite picture.

I shot everything in black and white, except the smiling—more like grinning—portrait of him with the swastika, which I couldn't resist shooting in color. I consider it one of my best portraits.

Oddly, he did not ask me to send him the magazine. What he wanted was something else. He said, "Am I gonna be on the cover of *Time*?" I told him I didn't know. He said, "I was never on the cover of *Time*, but Squeaky Fromme was when she tried to shoot President Ford. I never got to see that. Would you send it to me?"

I sent him a copy of the magazine and have to assume he got it, though I never got a thank-you note.

--

Meanwhile, I had other prisons to navigate. Arranging to visit each took a long time. None of the wardens liked the idea of a journalist poking around. I would say, "What are you hiding? Is there something to hide? It's *Time* magazine." And one by one, they reluctantly agreed. I didn't have any problems getting good pictures at Attica or Huntsville.

Statesville in Illinois was another matter. It is a spectacular-looking complex of round cellblocks, each a hundred years old, with a gun tower in the middle. Each cellblock almost looks like an opera house, a round theater with several floors, each with a balcony. The cells compose the outside ring. There is a wide walkway with a railing running along the inside of the cellblock. I thought it would make really great pictures. But before I could shoot anything, I had to get signed releases. Knowing how litigious inmates are, the *Time* lawyer summoned me to his office before my first prison shoot, went over the airtight release he had prepared, and gave me very strict instructions to get each one signed.

So, on a typical eight-hour day at a prison, I might spend four of those hours trying to talk prisoners into signing the release. They all want to plead their case to you and see if *Time* magazine could prove how innocent they are. I would tell them I was simply doing a piece on how they lived, not on what they did or didn't do to get themselves into prison. As I had told

PRECEDING
PAGES:
MANSON
USES A STICK
TO CHANGE
CHANNELS
ON HIS CELL'S
TELEVISION, 1982.

Charles Manson, this would be the one time they wouldn't be portrayed as monsters. I was only interested in showing how they spent their days.

The inmates would listen and some would say they couldn't sign. They had kids in school who didn't know they were incarcerated. Maybe they had been told that dad was in the army or was killed in action. In any case, I would spend forever trying to get inmates to sign. It was especially hard to get candid pictures because I had already taken away any spontaneity during the time it took to get the release signed.

Statesville may have been the fourth or fifth prison on my list, so I already had the system down pretty well. Now this prison was probably 90 to 95 percent African-American, heavily Black Muslim, Elijah Muhammad, Louis Farrakhan types. They really hated whites. I could feel it as I walked around. But I never felt in danger. If they didn't want to deal with me, they told me to get lost, usually a little more bluntly than that. I always kept the guard as far away from me as I could, and I think they respected that I'd come and that I wasn't afraid. Besides, the guard wasn't armed, so there wasn't a lot of help he could give me. He would be just as vulnerable if the inmates came after me. And in a cellblock where inmates are serving multiple life sentences, it doesn't mean a thing if one of them kills a *Time* photographer. Instead of serving three life terms, he'd now be serving four.

So there I was at Statesville, marveling at the sight of it, and I started walking around. Every time I spotted an inmate who interested me I'd go over and say, "I'm Neil Leifer with *Time* magazine." It quickly became obvious that the word had gotten out because before I could even finish introducing myself the guy would say, "Get the fuck outta here." I'd move on to the next inmate and it would be, "Get the fuck outta here." This went on for half of my first day and I was getting frustrated. When the word goes out in a prison like this one, nobody wants to be the guy who says yes.

For hours, I wasn't able to take a single picture. I was now up on the fourth level. Even if I got some releases, there would be another problem for *Time*: I wanted to shoot inside the cells and the artwork on the average cell wall made *Penthouse* look tame. This stuff was real pornography. So, among other things, I was looking for cells that weren't decorated with the hardcore stuff, but there weren't too many.

As I was walking around the fourth level, I noticed two tough-looking inmates leaning over the railing, gazing down at the center yard. One had a toothpick in his mouth and both were wearing do-rags. I was thinking, Wow, what a picture! Once again, I introduced myself. "Yeah," said one, "we know who you are. We're not interested."

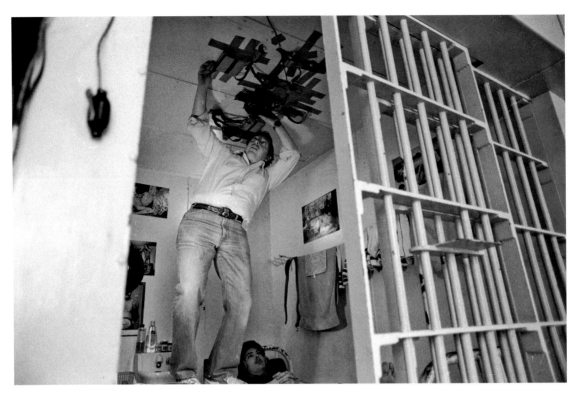

MOUNTING REMOTE CAMERA IN AN ATTICA PRISON CELL, 1982.

CLOSE-UP OF CAMERA AND GEAR ON CEILING OF CELL.

I looked down into the center court, which looked like a bullring. Then I looked into their cell and almost instantly knew what to say. "I would really like to take some pictures of you guys."

The inmate with the toothpick looked right at me. "Move on. We're not interested in your pictures."

"But you've got a whole bunch of them in your cell."

"What are you talking about, man?"

I said, "Those pictures of Muhammad Ali? I've probably taken more pictures of Ali than anybody."

"You're full of shit," the inmate said.

I looked into the cell again. It was practically wallpapered with tear sheets from *Sports Illustrated*, *Life*, and *Newsweek*. Probably a third of them were mine, including my "Sportsman of the Year" cover of Ali in a tuxedo.

"Actually," I said, pointing into his cell, "I took most of those."

"You're full of shit, man."

"Come on, I'll show you," I said.

The two skeptical inmates followed me into their cell. I walked over to one picture after another and pointed to the credit line: Photograph by Neil Leifer. Then I pointed to my visitor's badge, which had my name and publication printed on it. By the time I got to the tenth picture, I didn't have to point. "And I took that one."

One of them said, "You took that picture, man?"

TIME, SEPTEMBER 13, 1982.

I said I had. They called over to some other inmates, "Hey, this guy knows the Champ." One by one, inmates sauntered into the cell and were told I knew the Champ. And they'd say, "Bullshit," and then they'd look at the pictures, then check out my badge. I began regaling them with stories about the fights.

"You were in Manila?"

"Yeah, I was."

"And Zaire, too?"

As I talked, inmates began lining up, eager to sign the releases. Soon there was a long line of inmates waiting to sign. I shot for two days and not one inmate said no after that.

The prison essay ran fourteen pages. The cover was a picture of a Jewish bank robber from Queens.

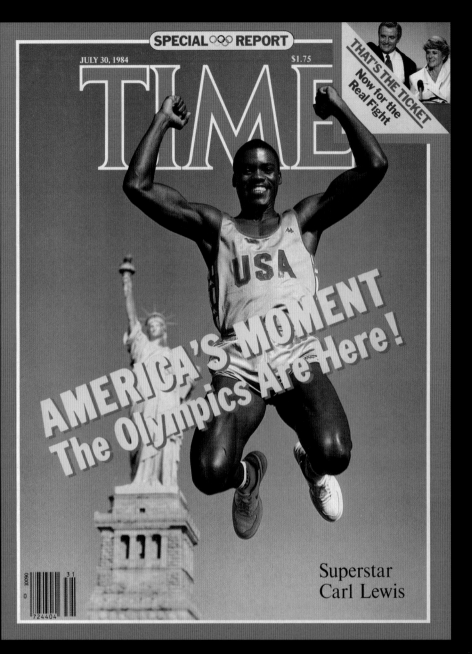

SPECIAL REPORT

JULY 30, 1984 $1.75

TIME

THAT'S THE TICKET
Now for the
Real Fight

USA

AMERICA'S MOMENT
The Olympics Are Here!

Superstar
Carl Lewis

'84 OLYMPICS PREVIEW

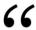 *Neil Leifer's work is the quintessence of great sports photography. It makes you hold your breath for a split second just as you do when you're experiencing a great sports moment.*

—**JERRY SEINFELD**, comedian, actor, writer, and producer

As the 1984 Los Angeles Olympics approached, I pitched Ray Cave an idea for *Time*'s Summer Olympics preview cover. I proposed to go around the world photographing likely medal winners posed in front of famous backdrops, each being the picture postcard of that Olympian's country. "Like Sebastian Coe," I told him. Coe, a Brit, had won the gold medal at the Moscow Olympics and was the world record holder for the mile. "I'll pose him running down the street past Big Ben."

Ray said nothing.

I continued, "I could photograph athletes around the world: the Indian field hockey team in front of the Taj Mahal, a Chinese gymnast on the Great Wall. I could shoot Koji Gushiken, the great Japanese gymnast, in front of Mt. Fuji, hanging from the rings. Russia? A weightlifter in Red Square with the Kremlin and St. Basil's Cathedral in the background."

Ray stroked his beard and said, "No, I'm not going to do it. Do you have any idea how much this would cost?" Such a project, he said, would be like making a hundred million-dollar Hollywood film. Ray was extremely cost-conscious, which was one of the reasons he was so successful. He didn't throw money away. I kept talking. "Mary Decker at Mount Rushmore, Carl Lewis at the Statue of Liberty . . . and you know we'll kick the shit out of Newsweek with this preview."

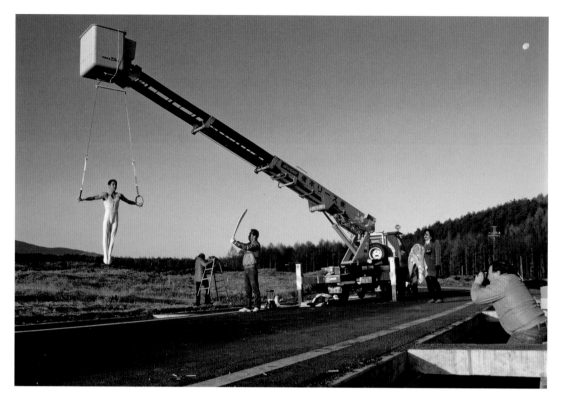

TAKING KOJI GUSHIKEN'S PHOTO, 1983.

I think that did it. Ray knew this was an alluring idea. Finally, he said, "Okay. But show me first." He told me to shoot athletes in three countries. Then he would decide if it was worth the money to do the rest.

I knew I had to stack the deck—all three pictures had to be great—so I chose England, Italy, and Greece. I would shoot an Italian athlete at the Colosseum in Rome. I would shoot a woman javelin thrower in front of the Parthenon and make her look like she was painted on a Greek urn. And then, of course, I would shoot Sebastian Coe and Big Ben. You couldn't beat these backgrounds.

London was my first stop. I checked into my hotel and immediately took a taxi to Big Ben to scout the scene. Only—my heart stopped—it was gone! I couldn't believe my eyes. Big Ben had completely disappeared inside scaffolding as part of a refurbishing project. I'd never seen anything uglier. Had I known I would never have picked London, which was one of the ideas that had sold Ray. I can't be having this kind of bad luck, I moaned.

KOJI GUSHIKEN AT MT. FUJI, 1983.

Quickly, I began to rethink my idea. Four years before, when I had been directing my first feature film, *Yesterday's Hero*, I had used Windsor Castle, the Queen's home away from London, as a location. I remembered it had a private road that ran directly from the castle to Ascot Racecourse. It was a beautiful setting. So I shot Sebastian Coe on that road with Windsor Castle in the background. It ended up making a stunning picture.

My other sample pictures, posed in front of the Colosseum in Rome and the Parthenon in Athens, turned out perfectly. Ray was so pleased that he gave me the go-ahead to keep shooting and, even better, he decided to put out a special Olympics issue of *Time*. Special issues were a rarity at that time in the news magazine business. Maybe they'd devote a whole issue to China or Russia or the economy. But to do the Olympics meant that every department—from culture to nation to business—would be connected to the Games. Ray's plan was to make my photo essay the centerpiece of the issue.

SOPHIA SAKORAFA AT THE PARTHENON, 1983.

INDIAN FIELD HOCKEY TEAM AT THE TAJ MAHAL, 1983.

ZHOU QIURUI ON THE GREAT WALL OF CHINA, 1983.

MOHAMED NAGUIB HAMED WITH THE PYRAMID OF KHUFU AND THE GREAT SPHINX AT GIZA, 1984.

So began a full year of hopscotching around the world. One of my favorite shoots involved Fidel Castro. I wanted to pose the Cuban president with the heavyweight boxer Teófilo Stevenson, and I wanted Castro to have a big Cuban cigar in his mouth. After all, he was known as a devoted cigar smoker. I knew it would make a wonderful picture. What I didn't know—the curse of Big Ben!—was that he was trying to cut back and had switched to cigarillos. They looked like cigarettes, and that wasn't going to work.

"Can I get you with a cigar?" I asked Castro.

Along with Stevenson, the Cubans had brought a number of other athletes, so my first photo was to pose Castro with the women's basketball team. "It's not polite to have a cigar with ladies," Castro said.

That was fine with me. So we did the picture of Castro and the women's basketball team, but no cigar. Then they began delivering all these other athletes, and I had no choice but to pose each of them with Castro. But the athlete I really wanted was Stevenson. When his turn came, I said to Castro, "Now, what I'd like is for you to be smoking a big cigar." Again, he took out the little cigarillo. "This isn't going to work," I said. "I need a big cigar."

"I'm sorry," he said. "I don't have any."

I don't think he expected my answer. "Well, I do. I brought a couple of Cohibas just in case." I handed him one.

He took the cigar. Then he did a funny thing: he tore off the Cohiba band. "Why did you do that?" I asked.

"Because," Castro said, "if I'm seen smoking a Cohiba, none of the other Cuban brands will sell."

So far our conversation had passed through an interpreter, but when I was finished and we were walking back across the field to his car, Castro put his arm around my shoulders and started speaking English. I wasn't really surprised. He had studied at Columbia University in New York, and I had been noticing that he answered my questions before the translator could speak. Before Castro left, he posed with me for a picture in which he'd be lighting my cigar. I've never been a smoker, and I couldn't get the cigar lit. A couple of the matches in Castro's hand nearly burned his fingers, but instead of getting mad, he was smiling and talking to me in Spanish through clenched teeth, much like a ventriloquist. I thought, "Isn't this nice? Fidel is trying to help me light my cigar," but I was also aware that everyone—including my assistant, Tony Suarez, who was shooting the picture and was fluent in Spanish—was laughing at us. It turned out that Castro was telling me to "suck on it." He must have said it three or four

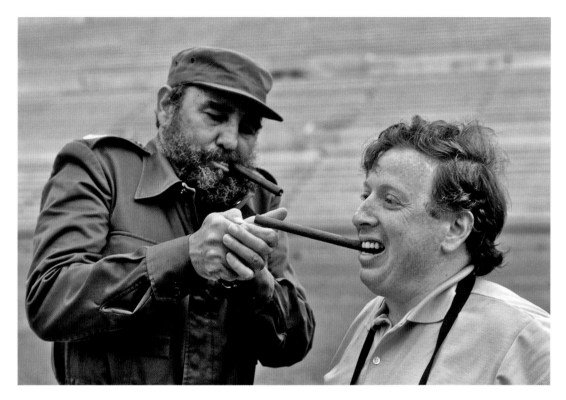

FIDEL CASTRO ATTEMPTS TO LIGHT MY CIGAR, 1984.

times and he had the assembled crowd roaring. I later learned that there are two ways to say, "suck on it" in Spanish. One is the way you tell your granddaughter to suck on a lollipop and the other way—the way Castro was saying it—is most commonly used in a bordello. I love the picture. A few years later, I got Castro a copy, which he signed for me.

I'll always remember one other picture from that Olympic issue. I wanted to shoot Kenyan long-distance runners. Twin brothers Kipkoech and Charles Cheruiyot were favorites to win medals in Los Angeles. I thought it would be wonderful to shoot them with animals in the background. I hadn't done anything like this before, so my first thought was a herd of elephants or maybe some giraffes. Obviously, I wasn't going to put them in the middle of a group of lions or cheetahs. But I wanted something visual and I finally decided on giraffes.

I had our Nairobi bureau get in touch with Don Hunt, who specialized in wrangling animals for Hollywood movies. He liked the giraffe idea

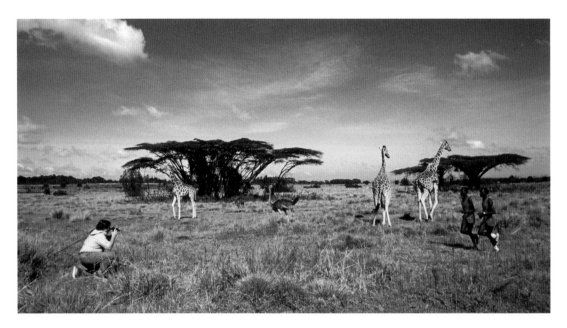

TAKING PHOTOS OF KIPKOECH CHERUIYOT AND CHARLES CHERUIYOT, 1984.

because they are very visual, and apparently, if you don't spook them, they'll stay put. Don took me out in his vehicle to scout locations. "Where do you want the giraffes?"

I said, "What do you mean where do I want them?"

"I need to know where the animals should be."

I said, "You must be kidding. We're talking about wild animals. We're not in a zoo." But I figured he must know what he was talking about, so I found a spot I liked. There was a beautiful acacia tree in the background that would work perfectly with the early morning light.

"So," he said, "where exactly do you want the giraffe?"

I laughed. "What are you talking about? Wherever they happen to go, we'll try to get the runners there."

"No, no," said Don. "Just tell me *exactly* where you want them."

"I'd like them right here, with the acacia tree in the background."

Don nodded. "Good. They'll be here in three, four days."

The trick, it turned out, was to place some sort of giraffe candy—it looked like bales of hay—where I wanted to shoot each day, and, sure enough, on the fourth day, four beautiful giraffes were right where Hunt said they'd be as the sun was coming up. They seemed to be having a most enjoyable morning eating this stuff.

Now it was time to start with the runners. The two Kenyans had grown up in the bush. The closest I had ever been to a giraffe was the Central Park Zoo or the Bronx Zoo. My assistant, Tony Suarez, was from Bolivia. Maybe he'd seen a goat or a llama, or whatever they have in Bolivia, but he certainly had never seen a giraffe. Tony and I were fine with the animals, but the two Kenyan runners were terrified. I wanted them to run in front of the giraffes. The brothers were shaking! It turned out they'd never been that close to animals in the wild.

I started with four giraffes and one armed guard. I was shooting very fast, using a medium telephoto lens, with the runners coming straight at the camera and the four giraffes behind them. As soon as I finished with one camera, Tony would hand me another and reload the first one. I had no idea how long the animals were going to stay there. Little by little, I moved closer because I wanted to use a wide-angle lens. In the meantime, other animals decided to drop in. One was a Cape buffalo, which can be a dangerous animal. We had our armed guard, but two of the giraffes immediately ran off. So now I had only two. I was using two motor drives and had already probably shot between twenty and twenty-five rolls of film.

By now, most of the giraffe candy was gone, but the giraffes looked calm and seemed sure that nobody was going to bother them. The runners, too, had relaxed, no longer worried they would be eaten by giraffes. I was getting really good pictures. Tony was busy loading the cameras and ten or fifteen feet away, my blue camera bag was on the ground. Tony would throw the exposed film into a side pocket. I was so focused on the runners that I didn't see one very large and obviously hungry ostrich heading for my camera bag. Tony glanced up and shouted, "Neil!"

I looked back. The ostrich's mouth was buried in the side pocket of my camera bag, and in the ostrich's neck, I could see rolls of film. I still don't know whether it was two or three. Luckily, I already had a great shot of two giraffes with their necks crossed. It might have been the best shot I took, but I will always wonder if I had an even better shot that ended up in the ostrich's belly!

As it turned out, the Communist countries boycotted the L.A. Olympics, and as a result, the special issue was shelved, but *Time* still ran my Olympic essay as a cover and fourteen pages inside the magazine. The picture of Castro lighting my cigar ran as the publisher's note, but without quoting Castro's instructions.

FOLLOWING PAGES: THE CHERUIYOT BROTHERS RUN WITH THE GIRAFFES, 1984.

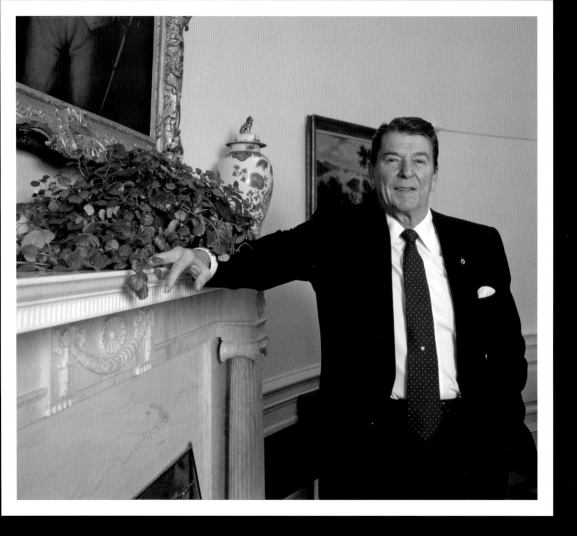

PRESIDENT RONALD REAGAN WITH THE PLANT, 1983.

THE WHITE HOUSE PLANT

> **"** *Luck has so much to do with great photography, and Neil seems to wear its mantle as if touched by a magician's wand.*
>
> —GEORGE PLIMPTON, journalist and author, from the introduction, *Best of Leifer*

Over dinner one night in 1982, Ray Cave said, "I have an idea I want you to shoot for the magazine." He had a big smile on his face as he continued. "I've been trying to get my editors to listen to me on this and all they do is laugh. Now we'll show 'em." This sounded good.

"You know how whenever a visiting dignitary goes to the White House to meet with the president, they have a photo op in the Oval Office?"

I did. I had attended the one with Gorbachev. It's always the same. There are two chairs in front of the fireplace, one for the president, one for the visiting dignitary. Maybe ten pool photographers are led in, two television cameramen, and four or five writers. It's not supposed to be a time for Q&A but Helen Thomas, Sam Donaldson, and the other reporters would always shout questions anyway. The photographers would form a semicircle in front of the two chairs and take the picture you see in every newspaper. Over the fireplace is a painting—usually one chosen from the National Portrait Gallery—and after a while, it might be replaced with a different painting. So the people change, the décor of the Oval Office changes, and the portraits change.

"But one thing that never changes," Ray said, "is the plant behind the two chairs. It's always Swedish ivy. Imagine if the plant could talk. It would be fascinating to do a piece on the plant. Who waters it? Who trims it? Why is it always Swedish ivy? I want you to go to the White House. I'll have the Washington bureau set it up. I know they'll laugh at me, but I want you to spend a

day and shoot the plant and the gardener who takes care of the plant. Maybe you could even get a picture of the president watering the plant."

After a bit of back-and-forth with the bureau, it was arranged. Since Ronald Reagan was preparing for re-election, Michael Deaver, the White House deputy chief of staff, was nervous about the president looking silly. Watering the plant was the last thing they would let him do. In fact, I was being given permission to do the shoot with the understanding that I wouldn't ask him to do that one thing. I knew if I asked Ronald Reagan to water the plant, he would have. But a deal is a deal.

The shoot was set for a Thursday after lunch. I was allowed to go into the Oval Office with my assistant and a Secret Service agent over the weekend, when the president was at Camp David, to test my shots. I can't begin to tell you how exciting it was. I spent a couple of hours in the Oval Office pretty much by myself. I checked everything out. I wanted to photograph a day in the Oval Office from the plant's eye view. I would look through a peephole in the door and shoot remotely.

This meant the camera could not be noisy, and it couldn't be an eyesore in the pictures other photographers took. So I had to take it down when the pool photographers came in. I was able to leave it set up there for everything else. Every time the president walked out, I would run in and change the film. First was a morning meeting with Deaver and, I think, Edwin Meese. They were seated at the far end of the room, so you saw an empty Oval Office in the foreground. Next came a National Security Council meeting, and after that, Egyptian president Hosni Mubarak was meeting with the president. As soon as the press was ushered out, and while the president was greeting people, I put the camera back in place. Then I left, too. I could look through a peephole in the door and shoot remotely. It was thrilling. It was an experience I thought I'd never have in my lifetime.

When the president left the Oval Office for lunch, I set up the strobe lights I had borrowed from White House photographer Michael Evans. I shot the gardener watering the plant. Ray Cave had made one request. He wanted me to ask for two clippings that he could put in his home and office. (He still has them.) The gardener gave me the clippings and then I waited for the president to return. When he did, I would have ten minutes to take my picture of him.

Aside from my assistant and Michael Evans, no one else was there when the president returned. I wanted an empty Oval Office so I could shoot with a wide-angle lens. It's possible President Reagan didn't know why I was shooting. His schedule probably said, "*Time* magazine photo shoot."

I was introduced and shook hands with the president. I immediately put him in position. He was now all mine for ten minutes. You can spend that ten minutes talking or shooting. I was there to shoot. The White House had provided me with a little ladder and I climbed down and walked over to him. I said, "Excuse me, sir," as I straightened his tie. You can't be intimidated, and his tie was not hanging quite the way it should be. I began shooting a couple of rolls. Clearly, this was a guy who liked the camera and knew how to pose. At about 8½ minutes, I could see people starting to look in. They wanted me out of there.

At nine minutes, people began walking in. I shook hands with Reagan again and asked if I could have my picture taken with him. Then I said, "And one more thing. The managing editor of *Time* magazine, Ray Cave, wanted me to give you this." It was a beautiful copper watering can with the presidential seal on it. Reagan got a big laugh. Then he looked at me and said, "Whose idea was this?" I told him it was Ray Cave's idea.

I said, "We're doing a piece on the plant because every president seems to have the same plant, Swedish ivy." Reagan stared at me. "Is that what the managing editor of *Time* magazine spends his time thinking about?" I laughed and we shook hands, and my shoot was over.

Much to my surprise, I hadn't been nervous at all during the ten-minute shoot. I was totally focused on photographing the president. After I took the last picture and gave him the watering pot, I was ushered out into the hall. Four Secret Service agents came in to carry out my equipment. And I remember that once I was in the hall, I started shaking, my hands and my legs. The only other time I remember having that experience was ringside at the 1961 Floyd Patterson-Ingemar Johansson fight in the first round when both fighters went down. It was only then that it hit me that I had just photographed and chatted with the president of the United States. And I couldn't stop shaking for five minutes.

Back at *Time*, they laid out the piece, four pages. Across the top and the bottom were strips of other presidents—Eisenhower, Kennedy, Johnson, Nixon, and Carter, all posing with dignitaries—and the plant. Weeks went by, but Ray couldn't get it in the magazine. His magazine. Then one night I was again having dinner with him and his wife, Pat Ryan, the managing editor of *People*. I asked when the piece would run. Ray said he was trying to find room for it.

Pat said, "Ray, I'll give you three weeks to get it in the magazine or I'll steal it. And I will run it."

Ray got it in the magazine. It's one of my favorite pieces.

FOLLOWING PAGES: REAGAN AND MUBARAK IN THE OVAL OFFICE, 1983.

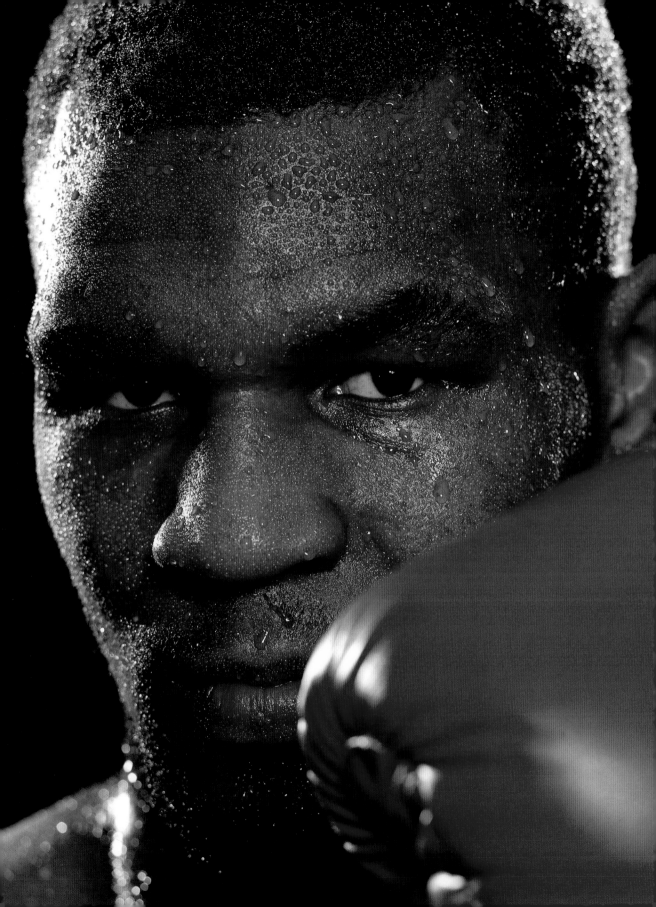

MIKE TYSON

> ❝ *It was a genuine thrill for me to have been photographed by Neil over the years. I was especially excited when he shot me for the June 27, 1988, cover of* Time. *Neil was a perfectionist in every way during that shoot. Having me pose with the glove and the sweat dripping off my face made for a great cover.*
>
> —**MIKE TYSON**, former undisputed heavyweight boxing champion

ime magazine rarely puts athletes on the cover, but, in 1988, Mike Tyson was irresistible.

He was scheduled to fight Michael Spinks for the heavyweight title in Atlantic City in June. Tyson was the undefeated heavyweight champion and the biggest sports name in the world—although Michael Jordan was gaining on him. Spinks, a former Olympic champion, was what they call a "blown-up" light heavyweight. Since little money can be made in the light heavyweight division, these fighters will bulk up from their previous 175-pound limit in order to earn the big heavyweight purses. For this match, Tyson was 218, Spinks 212. But the challenger was such a good fighter that he was considered a real test for Tyson. I was assigned to shoot the champ for *Time*'s preview cover.

I arrived in Atlantic City, having settled on a plan with Tyson's people. I set up a small studio near his training area, so all he had to do after his workout was walk over and let me take his picture. I had it all figured out. It was going to be a portrait for the cover, but I would also take supporting pictures of him preparing for the fight.

Tyson was scheduled to train between noon and 2:00 p.m. On the appointed day, noon came, but Tyson didn't. Twelve-fifteen, no Tyson. One-thirty, no Tyson. His guys kept saying, "Don't worry. We'll get him. We've got all his phone numbers." A half-hour later, when it was obvious that Tyson was not going to train, they started calling his numbers, including those of whatever ladies they knew he might be with. They didn't reach him. They said, "Don't worry. He'll be here tomorrow. Every once in a while he decides to skip training." Since it was two weeks before the magazine would close, I had plenty of time.

The next day was a repeat of the first. He didn't show up. On the third day, he did. He trained, he came over to my makeshift studio, and he was fabulous. I had given careful thought how to pose him. I put the glove partially in front of his face, knowing the cover billing would fit perfectly in the glove. When I looked at the Polaroid, I knew I had my cover. Now all I had to do was take supporting pictures.

We walked along the boardwalk and I photographed him talking to people. I also shot pictures of him on the beach, catching pigeons in his bare hands, something he seemed to really enjoy. Eventually, we came to the fancy condominium where he was staying, and there happened to be an expensive Italian clothing store on the ground floor. Mike stopped to look in the window. He was a sharp dresser, and I thought some photos of him trying on clothes might be good. Mike thought so, too. I went into the store and spoke with the owner, who was thrilled and closed the place so we'd be left alone. As I set up strobe lights, I was reminded of the stories I'd read about the queen of England going to Harrods and how the owner would close the store.

It turned out to be a smart business move because Tyson went on a tear. He bought some shirts, he bought a sport jacket, he bought a suit. At some point, I realized he wasn't going to stop until I told him I had enough pictures. I don't know how much he spent, but it was certainly a few thousand dollars.

I had theater tickets in New York that night, so I told Mike I had everything I needed and had to get back to the city.

He said, "What do you mean? You got a hot date?"

I told him I was taking my assistant to the theater. Tyson said, "Hey, why don't we go to the movies?"

It occurred to me then that he didn't have anybody to hang out with except the people who were hanging around, sucking up to him for a handout. I told him I really had to leave.

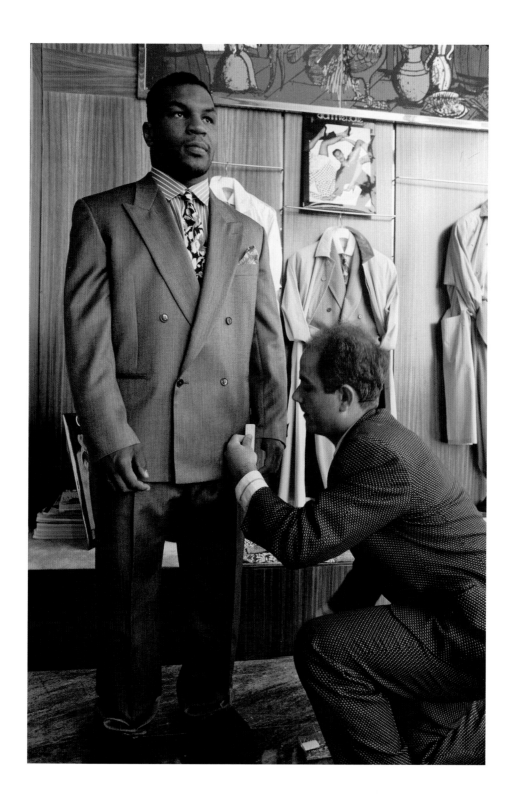

TYSON GETS FITTED FOR A SUIT BY AN ATLANTIC CITY TAILOR, 1988.

"Get her on the phone," he said. "I'll talk to her."

I said, "Mike, I can't do that. I promised I would take her to dinner and a show. I've got to get going." I finally left, but I couldn't help feeling bad for him.

A year later, I needed to photograph him again. Tony Hendra and Peter Elbling were writing a book called *The '90s*, a satirical history of that decade even though it was still 1989. For example, they spoofed the Palestinian-Israeli war. It was not uncommon for newspapers to show pictures of Palestinian kids throwing rocks at Israeli tanks; the accompanying story in the book would report that the kids had gotten so good—their arm speed so amazing—that all the Major League teams had rotations of nothing but Palestinians. I took a picture of a pretend Palestinian dressed in a baseball uniform. We even put his name on the back of his jersey—Sheik Alaram. There were a bunch of other crazy "historic" events, including one with Tyson. The idea was that he had beaten everybody he could possibly fight in the first round and there were no challengers left, so Don King had arranged for him to fight a grizzly bear. Of course, Tyson knocks the bear out in the first round. We secured a very expensive grizzly bear suit and the picture would be Tyson connecting with the person in the suit. Tyson agreed to do it.

I had sold *Life* magazine on the idea of running some of these pictures. The Tyson shoot would take place in Cleveland, where Tyson was then living and working out at Don King's training camp. I would have only two days because I had arranged with Paramount to shoot a picture of Whoopi Goldberg, also for *Life*, so I had to finish with Tyson in time to fly to L.A. for a 10:00 a.m. shoot.

In Cleveland, I set up my equipment and did my tests. All Mike had to do was show up. Which he did—in his new Mercedes convertible with his entourage. But first he wanted to hang out. So Don King, plus the mayor of Cleveland, two of Mike's people, and I went out to lunch. Then we went back to the mayor's office because the mayor wanted some pictures taken. After that, Mike decided he needed a dog. So he went out and bought a St. Bernard for eight or nine hundred dollars. Then we fooled around some more. Finally, I said, "Mike, I'm ready to shoot. When can I get you?"

He said, "I give you my word I'll be there tonight at seven."

At seven o'clock, Don King and I were there. Don was in a tuxedo ready to pose with Mike and a guy in a grizzly bear suit. The bear costume was there and so was the guy who'd wear it. The lights were set up. It would take me only fifteen minutes to shoot. Eight o'clock came and went and

so did nine. It became a replay of the Spinks assignment. Don was calling all of Tyson's numbers and getting nowhere. "Don't worry," he said. "He'll come. Sometimes he does this."

We ordered Kentucky Fried Chicken and sat there until eleven. It was a beautiful night, with one of those rare eclipses of the moon. Don, in black tie, though by now a little disheveled, and I watched the entire eclipse. At one in the morning, Don said, "I've got a feeling Mike's not gonna show up. Don't worry. I'll get him here tomorrow." Meaning today.

Only Mike did not show up. The following day, I was booked on a 4:00 p.m. flight to L.A. Mike had told Don he'd be at the shoot no later than noon. By ten o'clock, I was getting restless. "We've got to go find him," I said to Don.

Don located him at his girlfriend's house and off we went. We rang the bell and the girlfriend answered. Don said, "Is Mike here?" She said upstairs. Don said to me, "You're on your own."

I went up and found Mike sitting on the edge of the bed. I sat down next to him. I said, "Mike, you've got to come with me right now. I can't wait any longer."

Mike said, "I don't feel like going right now."

"But you gave me your word," I said.

He looked straight at me and said, "Well, Neil, I guess my word is no fucking good."

And that was that. I never got the picture of Tyson fighting the bear, and I must admit that when I left Cleveland that day, and for many years afterward, I was definitely not a fan of Mike Tyson. However, in the years since that day, I have watched him change into one of the nicest people I know, and I am proud to say that I consider him a good friend of mine.

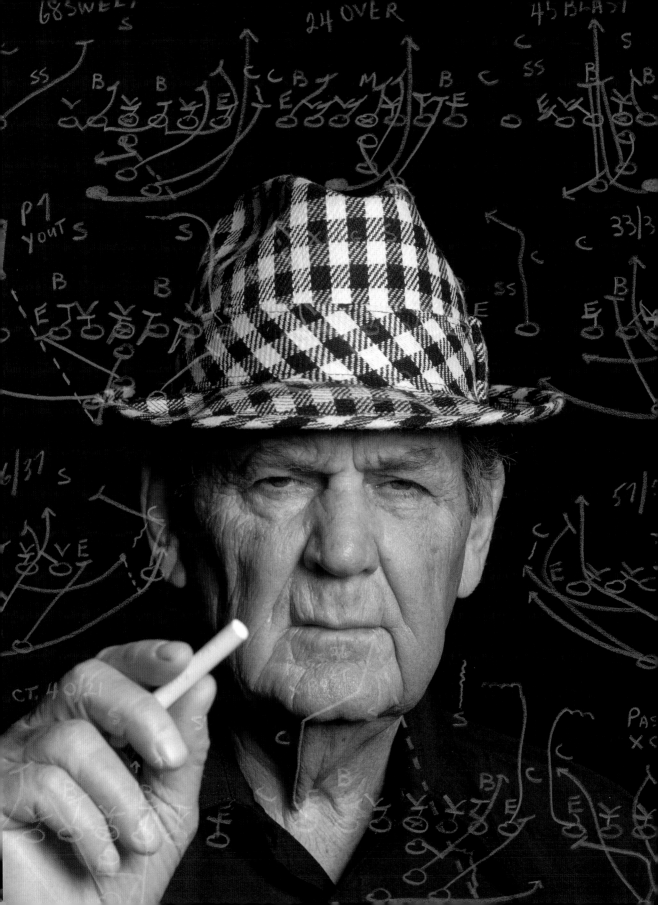

BEAR BRYANT

Possibly the best cover photo I ever shot was my *Time* picture of another bear—Bear Bryant. Certainly it is my best portrait. My picture of the legendary Alabama football coach is a perfect example of how I never give up on an idea. One picture that kept eluding me involved a coach diagramming a play on a chalkboard. If the chalkboard was glass and you could see through it as he wrote, it could make quite a dramatic picture. In 1964, I set out to try this for *Sports Illustrated*.

Little did I know it would take me sixteen years to get it right.

My first attempt was with Coach Don Shula of the Baltimore Colts, the best team in pro football that year. They were set to play the Cleveland Browns, the second-best team, for the NFL championship at Municipal Stadium in Cleveland. I took my idea to the picture editor; again, I wanted to give him a reason to assign me the cover. Our football writer, Tex Maule, had convinced the magazine that the Colts would win the title easily. *SI* even went to Don Shula to ask if he would write a piece that would run the week after the game—something like, "How We Won the Championship" by Don Shula. Tex did all the reporting, and the piece was written before the game, leaving only the final score and a few details to be added. I got the cover assignment.

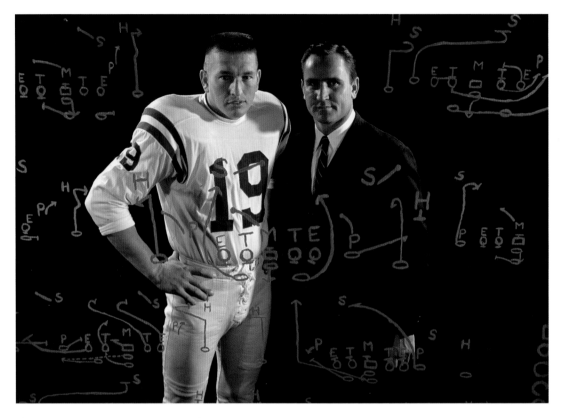

JOHNNY UNITAS AND DON SHULA, 1964.

I spent some time playing with my idea, using a piece of glass. We decided that both Shula and quarterback Johnny Unitas should stand on the other side of the see-through "blackboard," which would show plays diagrammed in red paint. The picture worked beautifully and would have made a great cover, except for one small problem. The Colts lost 27–0.

I decided to refine my idea a little more. One problem was getting the depth of field right so that both the diagram and the subjects were tack sharp. The Shula-Unitas picture was good enough, but I knew it wasn't perfect. The problem was lighting. If I lit the subject the way I wanted, there would be a very distracting glare from my lights on the glass. But if I lit the picture so there was no glare, the subjects would end up poorly lit. Neither was acceptable to me. It was a Catch-22.

One year later, I was ready to try it again, this time at UCLA. Lew Alcindor was causing a sensation, and I wanted to pose him with the great coach John Wooden. Like Shula, Wooden gave me actual plays, and this time

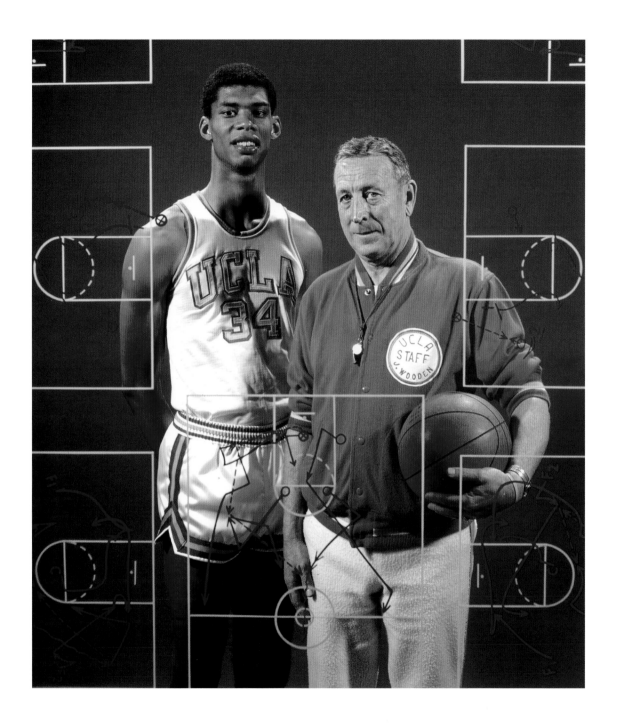

KAREEM ABDUL-JABBAR (THEN KNOWN AS LEW ALCINDOR) AND JOHN WOODEN, 1965.

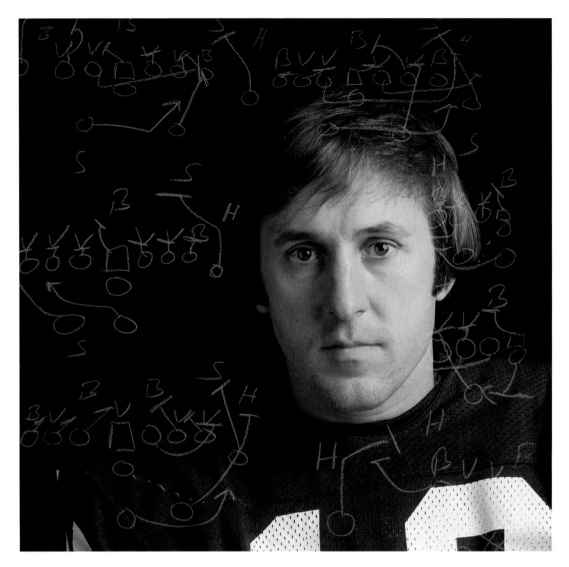

FRAN TARKENTON, 1975.

I had figured out how to solve the glare dilemma. The problem with that picture was that John Wooden was not comfortable in front of a camera. He looked stiff, and the picture was not published until many years later, on the cover of *Sports Illustrated*, when Wooden died.

Still determined to get it right, I tried it again in 1975, this time with Fran Tarkenton of the Minnesota Vikings. I thought Tarkenton, a cerebral guy, would be perfect. But the picture was only so-so.

Then, in 1980, I decided to try it again with Coach Bear Bryant. There are very few faces that you can't take a bad photograph of, and Bryant had one of them. With his houndstooth hat and stern look, he was perfect.

By now, I had figured out a better way to get the picture: rather than shoot it through a sheet of glass, I would do it as a double exposure. I would light Bryant's face exactly as I wanted it and I would also light the board with the plays as I wanted it. I had two Hasselblad cameras set up on tripods. First, I would shoot Bryant's face and not wind the film. Then, I put that same back on the other camera and I would shoot the plays on the blackboard, creating a double exposure of Bryant's face and the plays. All I had to do was convince the Bear to pose for the picture.

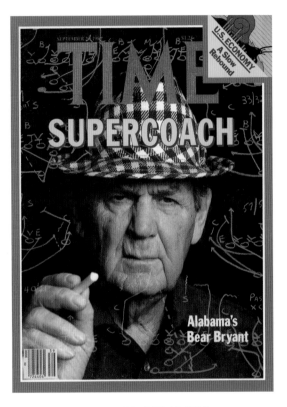

TIME, SEPTEMBER 29, 1980.

I went to Tuscaloosa to meet with him. I wore a jacket and tie and purposely did not bring a camera. After a few minutes of chit-chat, he asked me where my camera was and when I wanted to shoot. I told him I was there only to meet with him and explain my plan. This was something I often did. I wanted my subjects to feel comfortable with me because if they were, it made for a better picture. The Bear spent a good part of our meeting looking for my camera.

When I returned to Tuscaloosa a couple weeks later, ready to go, Bryant was ready to say yes to anything I asked for. He gave me all the time I needed. I kept moving back and forth between cameras, and each time it got better. I knew he had to wear something dark, so the plays would jump out, and with that houndstooth hat and his great face, you couldn't miss. The picture was technically perfect.

Time had wanted me to shoot Bryant on the sideline with his players. But the posed, double-exposure portrait was so much better than anything I shot at the game that they used it on the cover. In fact, the National Press Photographers that year awarded it first place not in the sports category, but for portraits.

And it only took sixteen years to get it right.

SEAN CONNERY AND ALEC BALDWIN, 1989.

ALEC BALDWIN AND MR. CONNERY

> " *I met Neil on the set at Paramount. The film was perhaps the most important event in my career up to that point. I was new to shooting "specials." But Neil is a very accomplished photographer and an unerringly professional man, not to mention a real gentleman. We struck up a friendship and we still eat together at the great joints in New York more than twenty years later.*
>
> —ALEC BALDWIN, actor and producer

Alec Baldwin and Sean Connery were up on a platform, exactly where I wanted them. Only, Sean Connery wouldn't listen to me.

It was 1989, and I was in Los Angeles shooting a photo for *Life* magazine on the set of *The Hunt for Red October*, a submarine movie. Paramount had built extraordinary sets to recreate the inside of a Russian sub, including a control room that could be tilted and rotated to simulate the feeling of a ship at sea.

I'd spent two days lighting both the submarine's interior and the background of the stage. In order for me to shoot the picture, they built a forty-foot scaffold in front of the main submarine set. They agreed to bring in the crew and the cast, including Connery and Baldwin, for twenty minutes during lunchtime. That would be all I'd need because I would have already tested everything with stand-ins.

At the appointed hour everyone arrived. I mean everyone. Because it was a *Life* magazine photo shoot, it became a command performance, or so I thought. All the top Paramount executives and Mace Neufeld, the film's producer, came to watch. And, of course, they positioned themselves right behind me on my platform. They all kept looking at their watches, which convinced me that their real purpose for being there was to make absolutely sure that I didn't go one minute over the twenty minutes I had been allotted for the shoot.

Last to arrive were Connery and Baldwin. I had met them briefly several days before, and both understood what I wanted to do. I had already positioned the crew at the back of the set, each man at his instrument or control panel. I brought the two stars to the front and showed them how I wanted them to stand. I had been testing for three days, so I knew that with the set tilted at a 30- or 40-degree angle, you couldn't comfortably stand straight. You had to tilt your body slightly. I showed them that. Then I climbed down the ladder and up to my platform, looking at my watch. Five minutes gone.

Oddly, Connery was the only actor I had worked with—ever—who was called "Mister." It was never "Sean." Newman, Redford, Stallone, Travolta were always called by their first names. But not James Bond.

My camera was probably thirty feet from them and, if I spoke loudly, they could hear me. I felt everyone's eyes on me, and I suspected the producers and the studio execs were thinking, "Okay, get this damn thing over with already!" They wanted to go to lunch.

"Okay," I said. "Ready to go." I shot a Polaroid.

I looked at it and saw that Connery was standing in a way that was very effeminate. He looked like a ballet dancer. "Mr. Connery," I said, "could you please stand the way I showed you?" Alec, by the way, was perfect.

Connery looked over at me and said, "It's not comfortable."

I said, "But the way you're standing doesn't look good."

He said, "I don't want to stand *your* way."

I took another Polaroid and this time he looked even worse. Meanwhile, everybody was looking at me like, "Okay, get going!"

I knew I needed five minutes to shoot. I would shoot a half-dozen frames and that would be it. I looked at the Polaroid and realized I had a choice. Sean Connery was telling me he was not going to stand the way I wanted him to. He was satisfied, but I definitely wasn't. So I grabbed my Polaroid and climbed down the ladder from my platform as everyone

stared at me. I showed Connery the picture and I said to him quietly, "You don't look good in this."

He studied it and said, "What's the problem? What's wrong with it?"

I said, "You look like a ballet dancer. You do not look anything like James Bond."

He took a closer look and laughed. "Neil, you're absolutely right."

I climbed back on my platform while everyone wondered what in the world I had said to Connery, but he was perfect for the next five minutes, and I got the picture I wanted. It ran as a double truck in *Life* magazine.

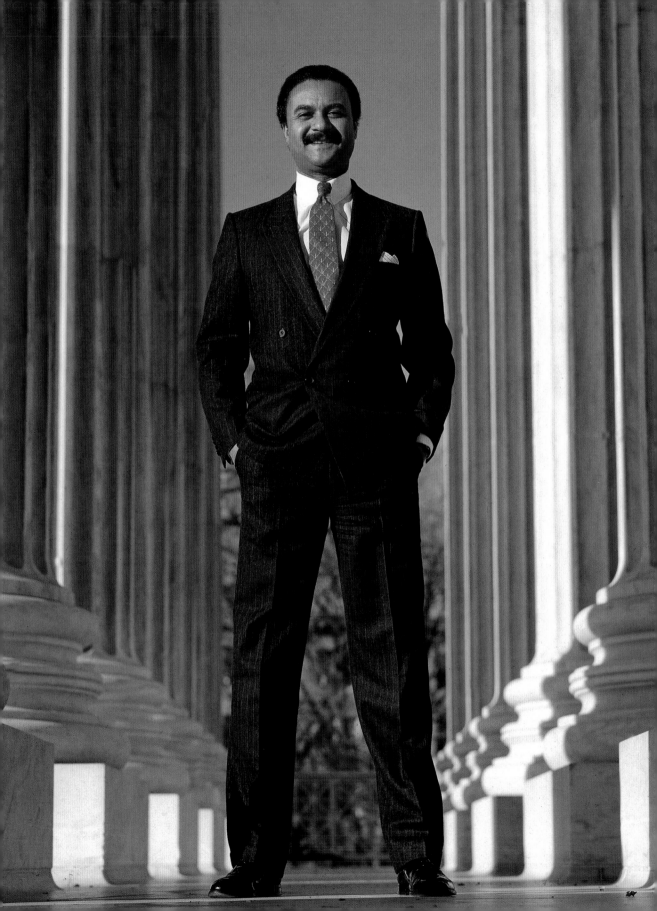

RON BROWN

> **"** *He is one of the best photographers of our time. Maybe, in fact, Neil is the very best. Certainly, he is the most creative, and his oeuvre deserves all the respect that we writers lavish on ourselves. Neil is an artist.*
>
> —FRANK DEFORD, *Sports Illustrated* writer

It was February 1989, and Ron Brown had just been named chairman of the Democratic National Committee. *Time* wanted to do a profile of him. Other than the cover, this was the best kind of assignment because a full-page picture accompanied the story, which, in this case, would be written by one of *Time*'s big stars, Walter Isaacson.

It was the kind of challenge I loved because the photos used in profiles had to be special. Ron Brown was a great-looking guy and a sharp dresser. His suits were perfectly tailored, his tie always neatly knotted, and he often wore a pocket square. So my brilliant idea was to take this handsome man and photograph him astride the symbol of the Democratic Party—a donkey. Surely, this was a shot that couldn't miss.

I would never in a million years have tried to poke fun at him. And even if that was my intention, *Time* would never have let me. I was simply trying to take a picture that would be fun to look at and memorable.

Brown was extremely busy, so I never got to talk to him directly before the shoot, but I did tell his people what I wanted to do and promised it would be a quick session. They said fine.

Finding a donkey didn't seem problematic. I assumed that, if worse came to worst, we could borrow one from a zoo. The *Time* Washington

bureau began calling around and discovered there were no donkeys for rent in Washington, or anywhere in the vicinity.

At last we located a rentable donkey somewhere in the wilds of Virginia, a good two-hour drive away. The donkey would be transported in an animal trailer to Rock Creek Park, the site I'd selected for the shoot. And because donkeys weren't the usual visitors, we were required to hire security. So far so good.

The trailer arrived about a half-hour before Brown was expected, and it turned out to be a pretty good-looking donkey. Had I been able to hold a casting session, I might have chosen one with better ears, but, hey, it was a donkey.

I walked over to the trainer. "He's not going to be a problem when Ron gets on him?" I asked.

"Oh, no," said the trainer. "He's ridden all the time."

Now all I needed was Brown. He was on a tight schedule, with meetings all day. But this was *Time* magazine, Walter Isaacson had already interviewed him, and we'd heard that Brown was pleased with how that went.

Ron arrived, beautifully dressed as always, and he walked over to shake my hand. "So," he said, "what are we doing?"

"As you know I spoke to your office about it," I said. "We've got this donkey."

At that point, the trainer led the donkey out of the trailer. The donkey stood still. Ron stood still. Skeptically, he said, "What exactly are you going to do?"

"I want you to ride the donkey, Ron. I'm going to put you on the donkey, and I will shoot a big, smiling portrait of you on the donkey."

Ron Brown looked at me like I was out of my mind. "You want me to get on a donkey? No. I'm not going to do that."

I can be pretty persuasive, and besides, he didn't say no that forcefully. Usually I can charm people into doing what I want them to do.

"It's going to make a fun picture," I said. "And it's symbolic." Which were the exact words I had used with Steve Cauthen.

"I am not going to get on that fucking donkey under any circumstances," Ron Brown said, obviously with more force than before.

"Let me put it this way," Brown continued. "You want me on that donkey, you show me a picture that you've taken of Lee Atwater squeezing an elephant's balls." He was referring, of course, to the chairman of the Republican National Committee. "And then I may get on that donkey."

"Would you pose just holding the donkey's reins?" I tried.

"I'm not getting near that donkey," Ron Brown said.

In fairness to him, he was the first black man to hold this post and he might have expected a more distinguished picture.

Unwilling to give up, I tried a few more approaches, none of which worked.

I said, "What can we do?"

He turned and spoke to his assistant. "Okay," he said, "we're free from three o'clock to four this afternoon. If you can come up with another idea, you can have that hour."

Then he drove off, leaving me standing there with the donkey.

Now what? I had only a few hours to come up with a Plan B, and it had to be good. I decided to photograph him in front of the stately white pillars that fronted many government buildings in Washington. One place I had previously shot was in front of the Supreme Court building; I remembered that the spot I had in mind faced west, so it would be beautifully lit in the late afternoon. And it wouldn't be obvious he was standing in front of the Supreme Court; he would simply be standing between white marble pillars.

Ron Brown showed up at the appointed hour. I photographed him from shoe level up, making him look very strong. It turned out to be a beautiful picture, but I still like the donkey idea. And, I might add, I wouldn't have hesitated to ask Lee Atwater to ride an elephant.

After Clinton won the election in 1992, he named Ron Brown as commerce secretary. Sadly, Brown was killed a few years later in a plane crash. Someone representing the family called me the day before the funeral and asked if they could put my picture in the program and also place a big print in front of the casket. I felt honored, of course, and said yes.

I'm sure they would have never used a picture of him on a donkey.

To Neil —
With thanks for years of fun And many more to come
R Jason

RAY CAVE (LEFT) AND JASON McMANUS, 1985.

AIRCRAFT CARRIERS AND AFRICA

> " *Great photographs have a mysterious life of their own. Neil's often amaze me with their drama, their powerful inner workings. Like Neil, they tend to burst with energy.*
>
> —**LANCE MORROW**, *Time* writer, from the foreword, *Sports*

I loved working at *Time* and continued to do well there, imagining myself like Alfred Eisenstaedt or Carl Mydans, who, in their nineties, still had little offices on the twenty-eighth floor of the Time & Life Building. I thought I too would grow old right there on the twenty-eighth floor, and watch and counsel the young photographers who surely would be coming along. I never intended to leave *Sports Illustrated*, nor did I foresee leaving *Time*. Sure, you got a bad boss for a few years, then you got a good boss, followed by a bad boss. But basically, back then, if you did good work, you could see happily spending your whole career at *Sports Illustrated*, or *Time*, or, like Eisenstaedt, at *Life*.

The masthead today at *SI* carries a list of photographers who have been there twenty-five, thirty years—or more. Walter Iooss is still on the masthead, though he has branched out. But, for most of us, there really was no better place to work, so we stayed. I certainly meant to.

Working for a magazine like *Time* and shooting plum assignments—the White House, the big fights, covers on Mike Tyson, Pete Rose, and Steve Cauthen—or doing essays like the one on Charles Manson and prisons was incomparable.

Then, in 1985, Ray Cave was moved upstairs and replaced as managing editor by Jason McManus. I hadn't grown up with Jason, and I was quite nervous. There was always a shadow of a doubt in some people's minds that I wasn't really that good, but was simply Ray's favorite. Nothing could have been further from the truth. In my heart of hearts, I believed that Ray was often twice as tough on me as on my colleagues. Several times I did not get the cover, and I believe it was because I had shot the photos and Ray didn't want to be accused of playing favorites. Other times, I knew from private conversations, when I showed Ray pictures, that he was expecting more from me. He was the toughest managing editor I had ever worked for—and the best—and he didn't hand out opportunities to shoot important assignments if he doubted that you could deliver. I am extremely competitive and proud of it, so when Jason took over, a part of me wanted to show everybody that my pictures, not my relationship with the boss, had made me a star at *Time*.

Right from the start, Jason let on how much he appreciated my work. He took me to the 21 Club for drinks. And, for the next two years, he couldn't have treated me better.

--

My first essay for Jason was on aircraft carriers. When he approved my idea on carrier power, it was another dream come true. As a kid, I had been fascinated with aircraft, and this interest extended, for obvious reasons, to carriers. I had also built models of those carriers, never imagining that one day I might actually land on one in an F-14. The carrier turned out to be the USS *Carl Vincent*, which, coincidentally, was the carrier that years later would carry the body of Osama bin Laden to a burial at sea. The piece would address the issue of whether the United States could afford to keep these supercarrier fleets operating.

What an experience it was! I had a helicopter at my disposal to shoot aerials. I hung a remote camera from the bow of the ship to capture the planes being catapulted off the side. I sat in the anchor room and watched them launch on a television monitor and pressed the remote button to shoot. At one point, we went into a swell and my 15mm lens, which was very expensive, got dunked and so badly damaged that I couldn't use it again. Luckily, I had already gotten my picture, and Jason would end up using it as the opening spread of the carrier piece.

Back in New York, I invited Jason to lunch. I wanted to offer some

other ideas, and I was pleased that the managing editor would find time to have lunch with me. For some reason, writers were always held in higher esteem than photographers. We were often made to feel like second-class professionals.

Jason asked what ideas I had. "I've always wanted to do something on animals," I said. "I'd like to do the animals of Africa." And, because I always did my homework, I added, "One of the best-selling covers in *Time*'s history was of a puppy, shot by Eddie Adams at Christmas time." I also mentioned I had once done a cats cover that had also sold well. I said this essay would take a lot of time because I would be shooting for the kind of quality essays *National Geographic* did. I knew the great Johnny Dominis had spent a year shooting the big cats in Africa for *Life* and that a *National Geographic* photographer had lived in the bush for eighteen months to shoot an essay on the Serengeti.

"And, Jason," I said, growing bolder, "I know exactly who should write this story." This is never done, a photographer suggesting a writer, but the one I had in mind was Lance Morrow, a big star at the magazine, a fabulous writer, and a close pal. "All the great writers have written about Africa," I said, as if I knew something about great writers. "Hemingway wrote about Africa. George Plimpton did, too." And I might even have thrown in Norman Mailer, though I had no idea if he had or not.

Jason approved both the idea and the writer. So off we went for seven weeks, first class all the way. Seven weeks sounds like a tremendous amount of time, and, for the writer, that might be true. But for the photographer, because the bar had been set so high and because people would compare my essay to those in *Life* and *National Geographic*, it wasn't much time at all. Not for what I had hoped to do, which was to capture the "big five": elephant, rhino, lion, Cape buffalo, and leopard.

I went with an assistant, Jimmy Kaiser, and four hundred rolls of Kodachrome's brand new 200 ASA film. It was about to be introduced to the public, and it was so new that the film they gave me was in little yellow boxes with no printing on them, not even the word "Kodak." For seven weeks, I got up every morning before dawn to look for animals to photograph. We did one trip to Maasai Mara and another to shoot in the Aberdare Mountains. Lance got very excited about spending a couple nights sleeping in a dung hut with the Maasai. Me, I got excited because I had a suite at the Norfolk Hotel in Nairobi, one of the great hotels in the world.

One day we were sitting at lunch at the hotel—Lance, me, and the Sgt.

WITH LANCE MORROW, 1986.

Bilko of the Maasai, a college-educated man named Moses. He had come to make a deal with us: he would get us out to one of their little dung hut villages, way out in the country. He began telling Lance stories about how they kill a lion with a spear. I can't remember his exact words, but he said something to the effect that the lion was left-handed and therefore if you circled to the right, you could spear it. I remember thinking to myself, Jesus, this guy is full of it! But Lance, with his Harvard degrees and a story to write, was eating up every bit of it.

Anyway, we went out there. One of the things they did—and I have no idea what we paid the Maasai for this privilege, but we certainly paid for it—was kill a goat for us, which in their world was a big honor. They asked us to drink some of the blood. When I said no way, Lance got really upset with me, saying I was insulting the chief. I said, "Sorry, but I'm not eating the goat and I'm not drinking the blood. Period."

I turned to Jimmy. "What if we shoot all night and all day tomorrow and then get out of here? Lance can stay." And that is exactly what we did. Lance thought I was a spoiled brat, though he was the one who grew up in a very wealthy family. (His dad was Nelson Rockefeller's chief of staff when Rockefeller was governor of New York and then vice president.) But I wasn't staying in that village any longer than necessary. We shot all night. I went out with the cows the next morning and with the little kids who herd the cows. I shot pictures of Moses showing us how he used his spear when hunting lions. Then Jimmy and I got out of there.

TIME, FEBRUARY 23, 1987.

But we delivered. My photos ran for twenty pages, followed by Lance's brilliant text for another eight or ten. The cover was a shot of a lion in the Aberdares.

WITH FRANK DEFORD, 1990.

FROM *TIME* TO THE *NATIONAL*

> " *At the Time-Life Photo Lab, I could always count on Neil to be at the end of one of the processing machines, waiting for his film or a print. One afternoon, while I was making prints for his layout on African animals, Neil asked me, "Carmin, why do you do all this for me?" I responded, "Because I love the passion you have for work." He said, "Passion?! Everyone says I'm a pain in the ass." I told him, "You are a pain in the ass, but you are a passionate pain in the ass." From that moment on, my relationship with Neil became a lifelong friendship.*
>
> —**CARMIN ROMANELLI**, former manager, Time-Life Color Lab, and former director of photography, *National Sports Daily*

For two years, all continued to go well, and nobody could accuse Jason McManus of playing favorites with me, as they had with Ray. I was still getting great assignments and doing some of the best work of my career. By now I had shot almost forty *Time* covers and a number of big photo essays. So I didn't think much about it when it was announced, in 1987, that Jason would move upstairs to become editor-in-chief of Time Inc. and Henry Muller, an assistant managing editor, would replace him as managing editor. I didn't know Muller,

but I assumed he was familiar with my work. Right away, I sent him a note congratulating him and saying I would love to get together—for lunch or dinner—so we could get to know each other a little bit.

I can't remember if he responded at all, but it soon became obvious that a shared meal wasn't going to happen. He didn't do anything blatant, but suddenly I wasn't getting the best assignments and my ideas for essays were being rejected. At the same time, there were staff layoffs at many of the magazines.

Michele Stephenson was the photo editor of *Time*. She had been Arnold Drapkin's deputy editor, and we had worked together on all my essays. When Arnold retired, I wrote Henry Muller a long letter praising Michele and saying what a mistake it would be if anyone else got the job. She got the job. Soon after, word spread that there would be staff reductions, including one photographer. There were three *Time* staff photographers: Tony Suarez, Teddy Thai, and me. Tony had once been my assistant and was a wonderful guy and a good photographer. Teddy was Vietnamese; his father had been *Time*'s photographer in Vietnam during the war, and Teddy had become a terrific photographer in his own right. He did whatever was asked of him, but he didn't produce a lot of work. He wasn't aggressive the way I was. I didn't think there was any comparison in terms of contributions to the magazine by the three of us. If I had been Henry Muller, I would have said, "You've got to get rid of one photographer, but it better not be Leifer!"

My heart broke when Michele called me into her office and said, "We have to let one photographer go, and I'm going to give each of you a choice. Would you like to be the one?"

I was speechless. I was so happy with my job, and Michele, of all people, knew it. I couldn't believe it. When I realized that she didn't care which one of the three of us went, it woke me up and paved the way for what eventually happened.

I had never been fired from a job, and I never expected that anyone would want to see me leave. From the days of delivering sandwiches, I always thought people appreciated how hard I worked. I was still a young guy, and I loved being at *Time* magazine. Since my arrival there, I had been offered the opportunity, more than once, to be the photo editor of *Sports Illustrated*, and I had turned it down each time. In any case, I was really hurt by the message I got from Michele. In the end, Tony Suarez took the package and left. But in my mind, it was only a matter of time for me, too.

My fears were not unfounded. Roger Rosenblatt, a major writer whom

Ray had hired, and Lance Morrow, another star, were soon to get the same message: Henry Muller didn't want any stars. He basically wanted a staff made up of interchangeable parts. Lance was beside himself and took a second job teaching at Boston University. Roger left.

I was convinced that when the next wave of layoffs came, I would not be given a choice. Still, I had no idea where I would go. The business was already changing dramatically. What would I do? I didn't have much savings. I needed to work and was worried about my future.

I went out to dinner with Pat Ryan, who at the time was the managing editor of *Life*. I told Pat I had grave concerns that Muller was going to get rid of me, and I asked if she could hire me. When I mentioned my salary, she said she could neither afford it nor justify it. But, she asked, how would I feel about her taking on half my salary if *Time* would pay the other half. I was thrilled because *Time*, a weekly magazine, would get far more value out of me than *Life*, which had gone monthly. Still, I was no longer getting great assignments, and I knew my days were numbered.

In 1989, Frank Deford had left *Sports Illustrated* to edit a new daily sports paper called the *National*. He had been one of three candidates competing for the job of *SI* managing editor. I was borrowed from *Time* for four weeks to act as the interim *SI* photo editor, working for Frank during his stint as acting managing editor. For a month, he got to see how I operated, the two of us worked very well together, and we put out a couple of really good magazines. As it turned out, Frank didn't get the job, so when the opportunity to be the editor-in-chief at the *National* came up, he jumped at the chance.

Over the years, we had become good friends, working together on movie projects and screenplays I was trying to peddle. In 1987, I had directed a second film, *Trading Hearts*, which Frank had written. Two weeks after the *National* started publishing, January 31, 1990, I had dinner with him at Rosemarie's, the same small Italian restaurant in lower Manhattan where Ray Cave offered me the job at *Time*. I assumed this would be a social occasion, a chance for us to catch up. The *National* had just begun publishing, and I'd read every issue and carefully studied all the photographs. I had also read the masthead, and noticed that Frank hadn't hired a photo editor.

Frank was a word man, a great writer with solid picture judgment, but never primarily a picture guy. Frank asked what I thought of the pictures in the paper, and I said I thought they had to be better. And I added, "Frank, you don't even have a photo editor."

He said he had a guy who had worked at *Newsday* setting up graphics and photographs, and he ran the picture department at the *National*.

"You need somebody with some imagination who can talk to photographers," I said. "A photo editor."

"Yeah," Frank said, "I'd love to have somebody like you."

"Well," I said jokingly, "why don't you offer me the job?"

Frank laughed. "You'd never want to work for a newspaper."

"I don't know about that. I might very well." And I started telling him about my troubles at *Time*. We were probably still on our first drink.

"Would you really consider coming to the paper?"

"If you're offering me a job, I'll take it," I said.

And that, basically, was that. After thirty years at Time Inc., I was about to leave the only place I had ever dreamed of working. A few weeks later, I started at the *National*, which was publishing in three cities—New York, L.A., and Chicago—and was rapidly expanding.

I had the time of my life. For a while.

Newspapers have a very different culture from magazines, especially successful and lucrative magazines like those at Time Inc. But for me, it felt like a natural transition. I had always edited my own pictures, and even though I wasn't editing photographers' takes, I was supervising all of it. I hired two deputies, Carmin Romanelli, who was fabulous, and Dan Cohen, a kid who had started assisting me right out of college. I was in charge of everything in the photography department—the editing of pictures, the assigning of photographers—to make sure we could get the best pictures at a price we could afford.

Luring talent to work for us was a big part of my job. I got Walter Iooss to shoot some photo essays, which *SI* was not happy about. But, given that Walter was no longer under contract, there was nothing they could do. I also gave Ken Regan a number of assignments, and he always came through with great pictures. I got William Coupon, one of the world's best portrait photographers, to shoot Muhammad Ali, and he produced some great shots. I also sent him to Las Vegas to shoot Buster Douglas for our preview of the Buster Douglas-Evander Holyfield fight. Douglas would not take off his shirt for anybody, probably because he was about thirty pounds overweight. Coupon, though, somehow got him to do this. The picture showed a roll of fat, and if you knew anything about boxing, you hurried to bet on Holyfield. I also got Nikon to let us borrow a prototype of the very first digital camera for that fight, and I sent Ken Regan to shoot with it. We were under intense deadline pressure. I think it was an 11:00

p.m. deadline in New York and the fight started at 10:50 eastern. When it ended at 10:58, Ken handed a digital card to Carmin Romanelli, and at eleven o'clock, I was in New York looking at a color picture of Holyfield's KO of Douglas, which we ran on Page 1. I was having a ball.

The hardest part for me was not taking pictures. But I had seen first-hand what happens when the photo editor won't give up shooting. It was Jerry Cooke's demise at *SI*. It's very hard to explain to a photographer that you've chosen yourself for a big assignment. You don't get guys busting their butt for you then, and you don't build love among your staffers. I did an occasional assignment, usually boxing. But otherwise, I stayed in New York and ran the department.

Sadly, the *National* had serious financial problems. It was hemorrhaging money. And one day Frank called me into his office and told me I had to get rid of three people in the department and it had to be done by seniority. "Wait a minute," I said. "I have two people who are terrible, and I've got two people who were hired later who are really good and who, by the way, are making a lot less money than the two disasters I am being asked to keep."

Frank said, "My hands are tied. This is not my decision."

"But what if I were to leave?" I said. "My salary could save two jobs."

I had signed a three-year guaranteed contract. The *National* agreed to pay me one year's salary plus one year of benefits. I figured this would give me enough time to plan my next move. So I left the *National* and, almost immediately, *Life* offered me a job covering the Gulf War in Saudi Arabia.

THE GULF WAR

> **"** *When we landed back on the ground, Neil turned to me and said, "Dan, that was the most incredible thing I have ever seen in my life." An overwhelming impression from the man who has seen it all, traveled around the world countless times, and photographed popes, presidents, living legends, and every wonder of the world. We went back to the hotel and I called my mother to tell her we spent the day hanging out of a plane, five thousand feet over burning oil fields. I'm not sure she believed me until she saw Neil's pictures.*
>
> —DAN COHEN, my former long-time assistant

In February 1991, *Life* magazine went from a monthly publication back to being a weekly so that it could best cover the first Gulf War. The war started when Iraq invaded Kuwait and tried to annex it. Jim Gaines, *Life*'s managing editor, and Dan Okrent, the assistant managing editor, asked me to be the director of photography in Saudi Arabia. I jumped at the offer. It was not only a great opportunity, but I would also be given combat pay.

The main U.S. air base was in Dhahran, Saudi Arabia, and it's from there that Tom Brokaw, Dan Rather, and the other broadcasters were reporting every night during the war. The sirens would go off every once in a while, whenever they thought a Scud missile was coming in. In fact, a Scud missile hit the U.S. military barracks a half-mile from our hotel and twenty-eight servicemen were killed. You had to carry a gas mask around

in the unlikely event of an Iraqi gas attack, so you certainly knew you were in a war zone.

I hired Dan Cohen to assist me and we moved to Dhahran, thinking we'd be there at least six months. The invasion of Kuwait by Iraq had actually occurred in August 1990, but it wasn't until January 17, 1991, that U.S. and United Nations forces started bombing. That's when Dan and I arrived.

Basically, I was there to edit pictures, not to shoot them. But a couple times I was pressed into action.

One that I'll never forget began the day after the war ended. I saw a press release from the Marines that said they were going to fly a victory formation over Kuwait. This apparently is something of a Marine tradition: when a war ends, they do this coordinated flyover and photograph it. I remembered seeing photographs of planes flying over the Champs-Élysées and the Arc de Triomphe after the liberation of Paris. There were great pictures of the Marines flying over Tokyo after the surrender. The press release said ten photographers could go, but you had to sign up. The planes were leaving out of Bahrain.

I immediately signed up and asked if I could take Dan along to assist me. As it turned out, we were the only ones who wanted to go because every other accredited photographer was now in Kuwait, where all members of the press had been forbidden to go until the final day of the war. So while the rest of the press corps stormed into Kuwait, the Marine plane was all mine.

Dan and I were bussed from Dhahran to Bahrain. When we got there, I asked if I could talk to the pilots. The pilot in command was a tough-looking Marine colonel who looked like he had stepped out of a John Wayne movie. He said that he and the other pilots would be flying F-18s, spectacular, state-of-the-art fighters. I was ecstatic! Dan and I would be in a KC-135, which would be refueling the F-18s in midair. They were going to fly from Bahrain over the main Kuwaiti airfield they had recaptured from the Iraqis.

The colonel asked, "What kind of picture do you have in mind?"

I said, "I've got a camera that takes a very wide-angle picture." I mapped out what I wanted to do and I asked if they could lower the loading ramp on my KC-135 while we were in flight. "I've got this 140-degree camera," I said, "and in a perfect world, I'd like to line up the seven F-18s, left to right, just behind the KC-135. Can we do that?"

The pilot of my KC-135 started talking about air speed because the F-18s were supersonic fighters and the KC-135 was not even close to supersonic. Moreover, when you lower the ramp in flight, it slows the plane even more.

I was told we'd be flying at 135–150 mph, which the F-18s don't handle very well. But the Marine colonel said, "Just show us what you want."

We'd be flying at five thousand feet. I was so excited because I had built plastic models of planes like these as a kid—okay, not the F-18, which hadn't been invented yet—and I had photographed a lot of planes in flight, but I'd never had a thrill like this.

We took off and they strapped Dan and me into harnesses and lowered the ramp. The harnesses allowed us to go to the edge of the ramp, and no farther. I stood at the edge with my camera looking down. I was worried that Dan would get frightened, but he stood right behind me and stayed calm. When we reached our altitude of five thousand feet, the pilot said, "Are you ready? They're coming in."

I looked out and there were the F-18s. I was in heaven. It was like looking at toys. One, then two, then three planes. Soon all seven were right there just off my ramp. As I watched these planes coming at me— and they were getting close—I began using my walkie-talkie, speaking directly to the colonel who was flying the F-18 in the middle of the formation.

The colonel said, "Okay, Mr. Leifer. Where do you want us?"

"I want you right where you are—in the middle."

He said, "Okay, here we come." And they started moving into formation.

KUWAITI AND SAUDI ARABIAN
CREDENTIALS, GULF WAR, 1991.

Now, years before this, John Zimmerman was shooting an ad using five jets in formation, with one of the most expensive prototype planes ever built, the XB-70 Valkyrie, a Mach 3 bomber. He was shooting from a Lear jet. The planes were in formation when something went wrong. Two of the planes clipped wings and this multi-gazillion-dollar plane crashed. Two pilots died. After that, the XB-70 wasn't built. I didn't want to be responsible for anything even remotely like that.

But here I was, watching these seven F-18s, which are built to do almost

U.S. MARINE F-18 HORNET FIGHTERS, 1991.

Mach 2, I think, nearly 1,200 mph. They were slowing down and lining up—just the way I wanted—and it looked to me like the planes weren't handling very well. The wings were jumping up and down. I told the colonel, "I'm a little nervous. I see it's hard . . ."

"Don't worry about us handling the planes," he replied. "You take your picture, we'll fly the planes."

All seven F-18s were fully bomb-laden, as if they were on a mission. They had bombs and missiles mounted under each wing. I was thinking they would have blown up if they'd touched wings. Meanwhile, the planes were coming closer. I was about fifty feet above them, and I was terrified they were going to collide. The colonel was saying, "Just line us up. Let me worry about where the guys are. How's the left side look?"

I said, "Okay, you can bring in the third plane a little." And suddenly, I'd see the third plane move in slightly. "Okay," I said, "The second plane is a little too high." And he'd go lower. Every time I got nervous about

something going wrong, the colonel would say, "Let me worry about the planes. You worry about the picture."

It was a fantastic sight. I got a magnificent picture. But what I didn't know was that my best shot was still to come.

Before we had taken off for Bahrain, I said that, if possible, I would love to fly over the oil fields, all of which the Iraqis had set on fire as they were leaving Kuwait. The colonel lit up with that idea. So off we went.

It was the most incredible sight I had ever seen. This was the day after the war ended and none of the fires had been extinguished. We had two F-18s in the background with a KC-135 about to line up to refuel. And I had an F-18 right in front of me, coming in to my KC-135 to refuel. Below all this were three or four burning oil rigs. It looked like a thousand Roman candles as far as the eye could see.

That picture ran as a double truck in what turned out to be the last of only four issues of the weekly *Life* magazine.

FOLLOWING PAGES:
F-18 HORNETS OVER BURNING OIL FIELDS, 1991.

THE GULF WAR 323

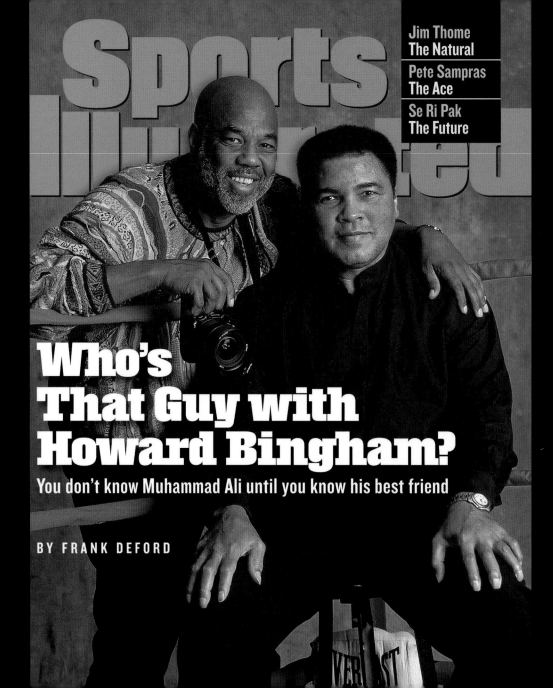

Sports Illustrated

Who's That Guy with Howard Bingham?

You don't know Muhammad Ali until you know his best friend

BY FRANK DEFORD

ALI, TAKE 2

> " *My favorite photo of Neil's is a photo of Muhammad sitting on the edge of the ring. There is just something about that look in his eyes that says I have it all. But then Neil was careful to study the subject. They trusted him to capture the photos that were going to be riveting, exciting, the ones that were going to turn heads . . . that people were going to look at for years to come.*

—**LONNIE ALI**, Muhammad Ali's wife

> *If one athlete is remembered one hundred years from now, two hundred years from now, I think it'll be Ali. And how are they going to remember him? Through Neil's fantastic, iconic pictures.*

—**PETER BONVENTRE**, former executive editor, *Entertainment Weekly*

In 1998, while he was still with *SI*, Frank Deford pitched a piece and suggested that I be assigned to shoot the accompanying pictures. He wanted to write about Ali's close friend—and photographer—Howard Bingham. Over the years, I had come to know Howard well. He was a very good photographer and a really nice, decent guy.

The first pictures I shot were at Ali's home in Berrien Springs, Michigan. One photo—of Ali photographing Howard with a large-format camera—became the lead picture of the piece. For the cover, I shot Ali in a

boxing ring sitting on his stool and Howard leaning over the ropes in the corner. When it was published, the cover line was "Who's That Guy with Howard Bingham?"

After the Michigan shoot, we headed to Washington, D.C., where Ali was being honored at a black-tie dinner. The next morning, we were all in Ali's suite—Howard, Frank, Ali, his wife Lonnie, and me. We were getting ready to fly back to Michigan when I asked if we could make a stop on the way to the airport.

What I was about to propose was taking a picture of Ali standing in

ALI, 1998.

front of the Vietnam War Memorial. Of course, he had refused induction into the army in 1967, in the thick of the Vietnam War. He had claimed conscientious objector status, based on his religious beliefs, and he had famously said, "I ain't got no quarrel with them Viet Cong. No Viet Cong ever called me a nigger." He was convicted of draft evasion, stripped of his titles, and forbidden to fight until the U.S. Supreme Court overturned the conviction in a unanimous 8–0 decision in 1971. He is arguably, to this day, the best-known conscientious objector to that war. I was at his draft board in Houston when he refused to step forward to be inducted. His lawyer, Hayden Covington, had held a press conference the previous day, and I remember his exact words. He explained that Ali still had his passport, and Coving-

ton had told him, "You could simply get in your Rolls Royce and drive to Canada and you'll be fine. You don't have to go into the army."

I always greatly admired Ali for his willingness to stand on principle, even though it cost him his livelihood, his reputation (in some circles, at least), and millions of dollars and the prime years of his boxing career. Once he refused induction, of course, he did lose his passport. But he had chosen to stay in this country and face the consequences of his actions. Those actions made him a pariah to some, but a hero to millions of others, including me.

In the hotel room, I said, "Howard, why don't you photograph Ali at

BINGHAM AND ALI AT THE VIETNAM MEMORIAL, 1998.

the Vietnam Memorial? And I will photograph you photographing him."
I thought it would be a spectacular picture and a very important one.

The only person to object to my plan was Frank. (I'm sure if we'd been sitting in a restaurant, he would have kicked me under the table.) Frank felt it would embarrass Ali.

I said, "I think it's gonna make a great picture."

"Well, to hell with the picture," Frank said. "Let's do the right thing for Ali."

Ali, meanwhile, said he had no problem with the picture, so off we went. When we arrived, Howard and I got out of the car to check out the location so I could decide exactly where I wanted him and Ali to stand. I needed to do this quickly because I knew we'd attract a crowd once people realized whom I was photographing. Once I photographed G. Gordon Liddy in front of the White House, and within thirty seconds, there were a dozen tourists jockeying with me for the shot.

After I found my spot, we went back to the car and began walking with

Ali. At that very moment, the light in the crosswalk turned green and a group of Girl Scouts crossed over. They were maybe twelve to fifteen years old and white, kids you'd think would have no clue who Ali was. But suddenly one of them said, "That's Muhammad Ali!" Then two of them were shouting, "Ali!" Soon they had him surrounded and were taking pictures with him. Eventually, we managed to get him out of this scrum and to the point on the wall I had selected. I put Howard and Ali in position. Ali asked about the names inscribed on the monument. I told him they were the names of the American soldiers who had died in Vietnam. He stared at the names for a long time. Softly, he said, "So many of them."

I probably had a minute without interruption and then someone who had been tracing a name on the wall walked over and said, "Muhammad Ali! Can I shake your hand?" Then a dozen people came over, and there wasn't a single negative comment; in fact, everyone greeted him warmly, saying, "How are you feeling, Champ?" Things like that.

It could not have been more obvious: the conscientious objector to a long-ago war was now a beloved man of the people.

- -

It is now January 3, 2012, and I am en route to Ali's house in Paradise Valley, Arizona. Impossible as it seems, Ali is about to turn seventy and *SI* has asked me to photograph him.

As I prepare for this shoot, I think back more than forty-six years to the night I shot Ali standing over the vanquished Sonny Liston. I had seen him many times over the years, growing frailer from Parkinson's disease, but he always had a twinkle in his eye and today turns out to be no exception. Now, when I arrive, he is relaxing in a chair in his den. He gets up and hugs me, and it is obvious to me that he is happy to see me. Ali is thinner than when I last saw him, but in truth, he looks pretty damn good to me. He listens intently as his wife Lonnie and I discuss the shoot that will start the next day. It's true that when you meet Ali these days, your first reaction is to feel sorry for him, but that impulse changes quickly because it's so obvious that he doesn't feel sorry for himself.

The next afternoon, I set up the first location under some palm trees. Ali arrives at 3:00 p.m. and needs some assistance walking, Lonnie on one side, her sister Marilyn on the other. But he never wavers or shows any sign of complaint. He is still the perfect subject.

Once he is settled into a chair beneath the palms, I start shooting. But he doesn't look good in this pose, sitting there in the chair. I try as hard as I

can to get something good, and I finally do, but the great Ali smile is never to be seen. I pose for my own picture with him, as we always do, and I'm surprised that he does not put up rabbit ears behind my head, like he did in every previous session we did together.

He's now into "bling." He loves big-faced watches, one of which he is wearing. He's also sporting two rings and a bracelet. I'm still worried about the pictures in the chair. I wish I could have him standing, but Lonnie is worried about Ali's equilibrium, afraid he might have difficulty standing by himself.

I finish the first shot, and Marilyn slowly walks Ali away to the next spot I've picked out. She stops and I shoot a few frames of him standing by himself. He is shaky, but he still looks much better than he did in the chair. My assistant, David Bergman, suggests we move the soft box strobe into position to shoot Ali standing with the mountains and the late afternoon sun in the background.

While we are setting up, Ali sits patiently by the pool. He walks slowly to the spot we have set up and he stands there for about five minutes. I know after the first frame that it is magic. No smile, but a boxing pose, and I can't believe how good he looks. I know that the assignment is already a success. That night Ali and Lonnie join me at a local restaurant for dinner. When we walk into the restaurant, he gets a standing ovation from the patrons who'd already been seated.

The second day, I shoot pictures of Ali in his home—some with a birthday cake I had ordered special for him and some while he's getting his physical therapy. I also shoot a picture of him with a beautiful LeRoy Neiman painting of Ali in gloves and trunks, looking every bit the champion he was, and still is to me.

The next day I return with the pictures I have selected. Lonnie looks through them and asks me to show them to Ali. I put the laptop on his lap and I show him every picture. He points to a couple and tries to say something, but his voice is low and I'm not sure what he's trying to say. As I get ready to leave, Lonnie asks him if he likes the pictures and he nods yes.

The picture that led off the *SI* essay was a two-page spread of Ali in a boxing pose. He looked strong. He looked great. He still looked like the Champ.

FOLLOWING
PAGES:
ALI IN
ARIZONA, 2012.

THEY'VE CAPTURED EVERY SUPER BOWL FOR 48 YEARS AND COUNTING

KEEPERS OF
THE STREAK

DIRECTED BY
NEIL LEIFER

AT THE MOVIES

> " *Neil is relentless, irrepressible, and irresistible. He has invited me twice to join him at Rao's, where he treated me to a fabulous evening filled with wonderful food, wine, and sparkling conversation. At each, I have committed to a documentary, leading me to question who is treating whom. But, in the end, the treat is Neil and the great work he creates.*
>
> —JOHN SKIPPER, president, ESPN

> *He just appeared on the scene. You gotta know how hard he worked and how he loves what he does.*
>
> —ELAINE KAUFMAN, owner, Elaine's

In the '70s and '80s, I had been spending a lot of time shooting stills on film sets. Basically, I did this to make money, but there's an old adage about being on a film set: you either fall in love or you fall asleep. I fell in love.

Early on, I thought the difference between still photography and filmmaking was that still photography is an individual thing. True, I had good assistants to help me, but basically, if you liked the picture or not, I was responsible. The credit or blame was mine. Filmmaking, however, is a collaborative effort. You need a cameraman, an editor, music, makeup, costume, and, of course, actors. You have to put together and lead a team that will make the film look good and make you look successful as its director. And, little by little, I began to realize that I could do this and that I wanted to.

I was already in my mid-thirties, so I was starting late by Hollywood standards. I began to develop screenplay ideas and to find writers who would work with me. Bill Johnson, a terrific writer at *Sports Illustrated*, wrote a script for me called *The Last Speed Graphic*, about an old photographer and a young photographer in New York. It was reminiscent of what I had encountered when I first started shooting pictures and had to deal with resistance from the New York press photographers.

I gave the script to David Hume Kennerly, a former White House photographer, and he put it in the hands of a wonderful, eccentric producer named Elliott Kastner. Elliott had made sixty or seventy feature films, including some of the early Clint Eastwood movies, *Harper* with Paul Newman, and *Missouri Breaks* with Marlon Brando and Jack Nicholson. At the time, I was in California shooting stills for *Rocky II*. My first book *Sports!* had just been published, and George Plimpton and I were going to be on the *Today Show*.

Elliott Kastner called and said he wanted to meet with me. I told him I was flying into New York for a Monday morning appearance on *Today* and I would be catching a plane back to L.A. that afternoon. Elliott said, "Come have breakfast with me at my apartment right after the *Today Show*."

I figured, God, he must love my script!

I arrived at Elliott's brownstone and rode an elevator to the third floor. A butler greeted me. He showed me into a room where Elliott was waiting for me in his bathrobe. He was on the phone. When he hung up, I asked if he had seen the *Today Show*.

"No, no," he said. "Sorry, but I didn't have time for that this morning." The next words out of his mouth were, "But I did read your screenplay. I don't like it. It's not for me."

My heart sank. Why then, I wondered, had he invited me here?

"But I like you," Elliott said. "You've got passion. I saw those pictures of yours. You've got real passion." Apparently, Kennerly had lured Kastner to an exhibition of my photos in Rockefeller Center. "I think you'd be a terrific director," Kastner said. "I've got a movie I want you to make." He handed me a screenplay. "The script needs work, but I know you'll make a good movie out of it."

It was called *Yesterday's Hero* and it was written by bestselling writer Jackie Collins.

"So read the script," Kastner said, "and get back to me."

I plunged into the script as soon I boarded the plane at JFK. Kastner was right. It was not a very good script. But true to his word, he hired me,

and though he paid me very little, I got first-class treatment, including a flat on Green Street in London, just off Hyde Park. Among my neighbors were Frank Sinatra; Cubby Broccoli, who produced the Bond movies; and some members of the Saudi royal family. Oh, and there was a Rolls Royce dealership right on the corner. Elliott fixed me up with a car—not a Rolls—and driver, plus four round-trip Concorde tickets.

Yesterday's Hero, which was released in 1979, was basically Rocky Balboa-turned-soccer player. Jackie Collins proved to be a delight to work with, and we made a pretty good movie. After six months in London, I was really hooked on filmmaking.

Naturally, I started trying to get another of my screenplays—all written by magazine writer friends—set up.
I would have loved to venture into filmmaking full time, but I was married, had two young kids, and was making good money as a still photographer. And nobody was hiring me as a filmmaker. It took seven more years before I saw another green light.

In 1986, Herb Jaffe, a producer, took a liking to a script called *Tweeners* that Frank Deford had written. Herb gave me a chance to direct Frank's script, which was now called, *Trading Hearts*. It starred Raul Julia and Beverly D'Angelo and was released in 1988.

By then, I was divorced and dating a Korean girl, and I became fascinated by the language. Listening to French or German or Italian, you might pick up a word or two, but you got nothing from hearing Korean. Many of the nail joints in New York are owned by Koreans, and while you're having a manicure or pedicure, they are blabbing away in Korean, usually talking about you.

This gave me an idea for a film set in a nail salon. I knew a young woman named Jane Read Martin, who had been Woody Allen's personal assistant for many years. I told her my idea for a short film, and she wrote a wonderful script called *Rosebud* about two women getting manicures and pedicures and gossiping about everything from work to politics to sex.

Rosebud was my first short, and it ended up making the short list for an Academy Award in 1992. (This meant it was on a list of ten films, five

RAUL JULIA BEVERLY D'ANGELO

TRADING HEARTS

A grand slam home run for the whole family!

ALEC BALDWIN BILL MURRAY

A Neil Leifer Film

SCOUTS HONOR

ALEC BALDWIN BILL MURRAY with ADRIANE LENOX FRANK PELLEGRINO ED SAXON

of which would get nominated.) This was easy! As far as I was concerned, I'd have two or three Oscars before I knew it. In fact, I've done seven more short live-action films and I haven't been on the short list again in that category. But still, I was hooked.

And so I started making short films, usually fewer than twenty minutes long. Although the cast and crew worked for free, I paid for everything else. It was what my father would have called a rich man's hobby.

I followed *Rosebud* with a 1996 short titled *The Great White Hype*. Ron Shelton produced it, and Bill Murray starred. Then I did *Scout's Honor* with Bill Murray and Alec Baldwin. A few years later, I made *Small Room Dancing* from a wonderful script written by Pete Bonventre.

Eventually I ran out of writers willing to work for free. So I wrote my own script called *Steamed Dumplings* and another called *God's Gift*. In 2008, I made what I think is my best live-action short, *What About Sal?*, about two die-hard Red Sox fans who make a pact: the survivor will spread the other's ashes in Fenway Park. It is my favorite of all my films, but sadly, it didn't get short-listed.

I also loved producing documentaries. My first one, made with Joe Levine in 2002 for HBO Sports, was called *Picture Perfect*. It was about the

iconic sports pictures of our time and the photographers who took them. I did another in 2004 for ESPN Sports about Frank Deford. The title, *You Write Basketball Better Than You Play It*, was a phrase he remembered his Princeton basketball coach saying to him.

Then came what is perhaps my best, *Portraits of a Lady*. Walter Bernard belongs to a group of twenty-five artists who have been meeting every week for fifty years to paint for fun. Walter's idea was to see how these artists would paint the same subject. Thanks again to David Hume Kennerly, we got former Supreme Court Justice Sandra Day O'Connor to pose. HBO bought the finished film and it was short-listed for the Academy Award, but it did not get a nomination.

Still, I was hooked on documentaries. My next one, also for HBO, *Dark Light*, profiled three talented blind photographers. My documentary *The ConVENTion* was filmed at a ventriloquist's convention. Sadly, neither rated the Academy's attention. I was sorely disappointed. I don't know if I'll ever win an Oscar, but I can't help myself. My most recent documentary, titled *Keepers of the Streak*, is an ESPN Films and NFL Films production about the four living photographers who have shot every Super Bowl. The film aired in prime time on ESPN and ESPN2, as well as on ABC, the weekend before Super Bowl XLIX.

SENIOR CITIZEN TOUR

> *There was a black-tie affair at Madison Square Garden in 1999, honoring the hundred greatest athletes of the century. My dad took me as his guest, and it was one of the best nights of my life. He introduced me to everyone, including Muhammad Ali, Jim Brown, Joe Montana, Magic Johnson, and Kareem Abdul Jabbar. It was fun to see how many of them remembered my dad and were able to recall some of the famous pictures he had taken of them. Not many sons are lucky enough to have a night like that with their father.*
>
> —COREY LEIFER

> *My dad never did anything on a small scale. For my sweet sixteen birthday present, while most girls were having a party, I was traveling into the city to meet Sylvester Stallone.*
>
> —JODI LEIFER SCHULEFAND

I am very proud of the years I spent shooting sports, but the time came when I really wanted to move on to other things. After all, I had already photographed fifteen Olympics, fifteen Kentucky Derbies, and the first twelve Super Bowls. I had done countless World Series games.

I still enjoyed shooting boxing, and I would occasionally go to a fight.

MANNY PACQUIAO VS. RICKY HATTON, 2009.

It was the one sport I'd kept my hand in, and at the Manny Pacquiao-Ricky Hatton fight in 2009, I even got one of my all-time best boxing pictures. I shot it from the catwalk seventy feet above the ring at the MGM Grand in Las Vegas, and I felt the same thrill I always had when *SI* ran that photo as a two-page "Leading Off"—the featured photos that open the magazine. And when Floyd Mayweather Jr. and Manny Pacquiao fought in May 2015, I knew I had to be there shooting, and I was.

At times, part of me missed sports. I'd watch the Derby on TV and notice many things that had changed, like what they'd done to hide the beautiful old twin spires at Churchill Downs. I'd watch the Super Bowl

FLOYD MAYWEATHER JR. AND MANNY PACQUIAO DURING WEIGH-IN, 2015.

and marvel at how big it had become. I have a picture on my wall of the coin toss in the first Super Bowl in 1967, held at the L.A. Coliseum. In the photo are the referee and two captains from each team; no one else was within fifty feet of them. Today, there are about a hundred people on the field for the coin toss. I began to wonder what it would be like to go back to the arenas and stadiums, the scenes of memorable pictures I'd taken, and see how the world had changed.

Meanwhile, Terry McDonell, the managing editor of *SI* at the time, kept encouraging me to shoot something for the magazine. But other than a big fight, nothing really inspired me. I had shot sports to the best of my ability for all those years—what else was there? I could think of nothing that would get me back on the sidelines.

Then one day in 2004, I found myself walking into Terry's office and saying, "On December 28th, I'll be sixty-two and that will officially make me a senior citizen. How about if I do a senior citizen's tour? I'll try to show how the big events have changed over the years. We could run some of my old pictures and play them against the new ones I'll take."

I put together a proposal, Terry approved it, and off I went. First on my list: the 2005 Rose Bowl on January 1 in Pasadena. I remembered a spectacular picture that John Zimmerman, one of my heroes, had taken from a helicopter. That's what I wanted to do. The Bowl is a perfect egg shape and almost every Rose Bowl has been played on a beautiful, sunny day.

The problem: getting permission to fly over a sporting event after 9/11—especially one with one hundred thousand people in the stands—wasn't easy. We were required to be at five thousand feet, which is a lot higher than I wanted to be shooting from. Worse, it turned out to be a God-awful day, not just overcast but threatening a downpour. Still, as I shot straight down on the Rose Bowl, I knew in the first five minutes I had exactly what I wanted.

My next stop was the BCS championship game to be played at the Orange Bowl in Miami. One of the reasons I wanted to do this project was my son Corey. A fanatical fan, he lives and breathes sports. But when I left *Sports Illustrated* in 1978, Corey was seven, and you can't take a seven-year-old to a World Series and put him in a photo position. You can't take him with you to the sidelines of a Super Bowl or the finish line at the Kentucky Derby. By the time he was twelve or fifteen years old and would have died to go, I wasn't shooting those events anymore. Now he was thirty-five, and he was able to take days off from his law practice to accompany me as my assistant.

In Miami, Corey was ecstatic to be on the sidelines of a championship game, and he worked very hard. But I had forgotten that when you have a sports fan as an assistant, he'll want to be watching the game much more than watching my cameras and the film. After a touchdown is scored, a net is raised behind the goalpost to keep the extra-point kick from sailing into the stands, and in the second or third quarter, we were standing right next to that net. I was using one of *Sports Illustrated*'s digital cameras, a very expensive piece of equipment. I handed that camera to Corey to hold while I was shooting the extra point, and out of the corner of my eye, I saw that it was stuck in the net, which was on its way up. He was so transfixed by the play that he somehow let the camera get caught in the webbing.

I nearly killed him!

But a second before the camera was out of reach, we rescued it. "Corey," I said, "this could be your first and last job as my assistant. Watch the game. But watch me first!"

WITH COREY AT ST. ANDREWS, 2005.

Other than that Orange Bowl mishap, I had nothing but fun. For the first time in my career, I didn't have to worry about how the game was going. In my *SI* days, I would be intense and focused on shooting the news: you've got to get the big touchdown or fumble or interception or capture the hero of the game in a great picture. For this assignment, I didn't have to do anything but take good pictures of whatever I wanted to shoot. If I was shooting the USC cheerleaders and missed a touchdown, so what? I never realized how much fun it could be when you take away all of the pressure. And it was a terrific start of a year of father-son bonding that we'd never had before.

Next I went to Super Bowl XXXIX between the Philadelphia Eagles and the New England Patriots. The Patriots won 24–21, but shooting the game wasn't the high point. In order to shoot anywhere on the field, instead of being limited to one sideline or end zone, a photographer must be wearing

VENUS WILLIAMS WINS WIMBLEDON, 2005.

a white vest, and very few are allocated. I wanted to be able to go anywhere in the stadium, so I went to see Steve Bornstein, the head of the NFL Network, and he managed to get a white vest for me. Before the game, Presidents Clinton and George H. W. Bush came onto the field and, with my white vest on, I was right there with them, standing only a few feet away.

But what surprised me most was the way the other photographers reacted to my being there. Many of the top shooters were in their thirties, and when I was shooting covers for *Sports Illustrated*, most of them were little kids, if they were even born. And suddenly, these photographers were coming over and wanting to meet me. They called me "Mister Leifer"! It was really funny, but also strange, and, at first, I didn't quite know how to react. Some wanted to know what other events I'd be shooting, then they'd show up with copies of my books for me to sign. It was really touching. Some said they had gone into sports photography because they had been such big fans of my work. Photographers would come over and say, "Excuse me, Mr. Leifer, but can I have my picture taken with you?" I thought way back to when I first met Hy Peskin, Marvin Newman, and John Zimmerman. I wish I had asked to take a picture with them back then. Truth is, I didn't have the nerve.

- -

For spring training, I decided to visit the Yankees, in part because Ozzie Sweet would be shooting there. He was another one of my heroes growing up and he was now close to ninety. Ozzie was known for his posed-action photos, some of which lined my bedroom walls as a kid. I had never met Ozzie, but I loved his pictures. I called him and asked if I could photograph him photographing the Yankees.

Posing star players these days is not easy, but Ozzie was given the kind of cooperation from the Yankees that is extremely rare. They gave us a separate field to set up our shots and, soon enough, out came Joe Torre and Derek Jeter on a golf cart, followed by Alex Rodriguez, Hideki Matsui, and Randy Johnson. Nobody gets that kind of treatment, and I knew I had Ozzie to thank for it. I shot Ozzie photographing them and also shooting Yogi Berra in the dugout. The two of them went back more than sixty years.

As it turned out, special treatment greeted me everywhere I went. At the Daytona 500, I was put in places they'd never allowed photographers before. As I was being driven to my shooting position in a golf cart, I realized I was being treated not as another photographer but as a celebrity. They let me shoot from the platform where the starter stands. The

honorary starter in 2005 happened to be Ashton Kutcher, whom, I'm embarrassed to say, I'd never heard of. People kept yelling up to him for autographs and pictures, but all I knew was that he would be in my way when the race started. Later, when I climbed down from the starter's stand, I said to my son, "This Ashton Kutcher—who is he?" Corey really enjoyed that one.

Among my other stops in 2005 were Wimbledon and the Tour de France, which, of course, Lance Armstrong won. Then I flew from the Alps to Scotland for the British Open. Corey loves golf, and we had already seen Tiger Woods win the Masters. He would go on to win at St. Andrews, too. I was able to get ABC credentials so Corey and I could shoot from inside the ropes. It was Jack Nicklaus's last British Open and his son was his caddy. Having my son with me made me understand how Jack must have felt. It was very touching.

We also went to the NBA playoffs and the Kentucky Derby. Lewiston, Maine, was also on my list. It was the fortieth anniversary of the Ali-Liston fight, the one at which I had captured Ali standing over Liston. I had not been back to Lewiston since that night in 1965, and the people there had recreated the scene for me. They put a boxing ring in the arena and added the ringside seats. I was able to photograph the spookily empty arena from the catwalk, getting the same overhead angle I had shot with a remote camera forty years before.

I went to Washington, D.C., to shoot Mike Tyson fighting Kevin McBride, whom I had never heard of. By chance, Laila Ali, Ali's daughter, was on the undercard, and Ali was sitting right behind me during the fight. She knocked out her opponent, and then, much to my surprise, Mike Tyson was knocked out cold, counted out on the canvas. It made great pictures, but to me, it was sad, seeing what had become of the once-great boxer. Before the fight, I got a picture of Mike in the dressing room with his arm around Corey, a huge Tyson fan.

I have always loved shooting aerial pictures, so I jumped at the chance to shoot the U.S. Open tennis from the Met Life blimp. That same weekend, I flew over Yankee Stadium in the Fuji blimp to shoot a big Yankees-Red Sox series. I shot one day game and one night game at dusk. I've lived in New York City my whole life, but it was only when I was taking that picture that I realized Yankee Stadium lines up perfectly with Fifth Avenue.

The World Series teams that year were the Houston Astros and the Chicago White Sox. I went to the Major League people in Houston—where Games 3, 4, and 5 (if necessary) would be played—and asked if I could have

UNC AND ILLINOIS TIP-OFF FOR THE NCAA FINAL, 2005.

THE KENTUCKY DERBY, 2005.

a third-base position. I was hoping to shoot a picture that matched the one I'd taken in 1963 of Sandy Koufax jumping up when the Dodgers swept the Yankees and the scoreboard was in the background. The third-base position in Houston was at exactly the same angle to the scoreboard in right field. And wouldn't you know, the White Sox swept the Astros and the pitcher, Bobby Jenks, just like Koufax, jumped up with his hands in the air and the scoreboard in the background. I had my picture.

Something else I want to mention about how times have changed. There were ten photo positions in that third-base box in Houston and four of them were taken by women. When I was shooting full time, there were no female sports photographers. Obviously, to be assigned to a World Series, these women had to be top shooters, and they were.

My Senior Citizen Tour would not have been complete without several other stops. I had shot stills for Sly Stallone when he was doing *Rocky II* and *Rocky III*, and as it turned out, he would be filming *Rocky Balboa* in December, and his new opponent would be Antonio Tarver, the real-life, reigning light heavyweight champion of the world. Sly agreed to let me shoot the fight scenes. By this time, I had switched to digital, having no choice. I ended up taking two of the best fight pictures of my life, shooting the made-for-the-big-screen event.

There were no Winter Olympics that year, but the 2005 U.S. Challenge in women's figure skating was being held in Boston in mid-December. I photographed Michelle Kwan and Sasha Cohen and the other great female skaters from the catwalk looking straight down, sort of like the young Neil Leifer would have done. I had no idea what the routines were going to be in advance, so imagine my surprise when Sasha Cohen, who would go on to win the women's title, ended her routine by sliding across the ice on her back, very gracefully, looking straight up at me. And I nailed it! The picture ended up as a double truck in the "Leading Off" section in *Sports Illustrated*.

Finally, for old times' sake, I went to see the New York Giants, who no longer played at Yankee Stadium but at the Meadowlands in New Jersey. As I was heading onto the field, the first person I ran into was Frank Gifford, the former Giants running back. We chatted for a few minutes, which brought back fond memories for both of us. I had photographed Frank in 1958 and '59, and for a *Sports Illustrated* cover in 1962. But now it was fifty years later, and it was Eli Manning I was shooting.

FOLLOWING PAGES: YANKEE STADIUM AND THE NEW YORK SKYLINE, 2005.

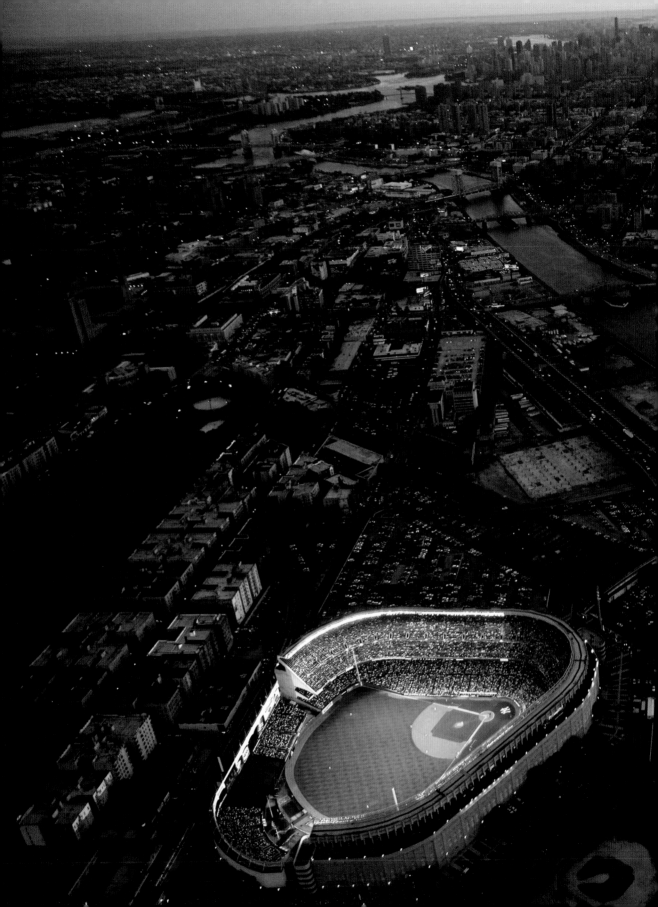

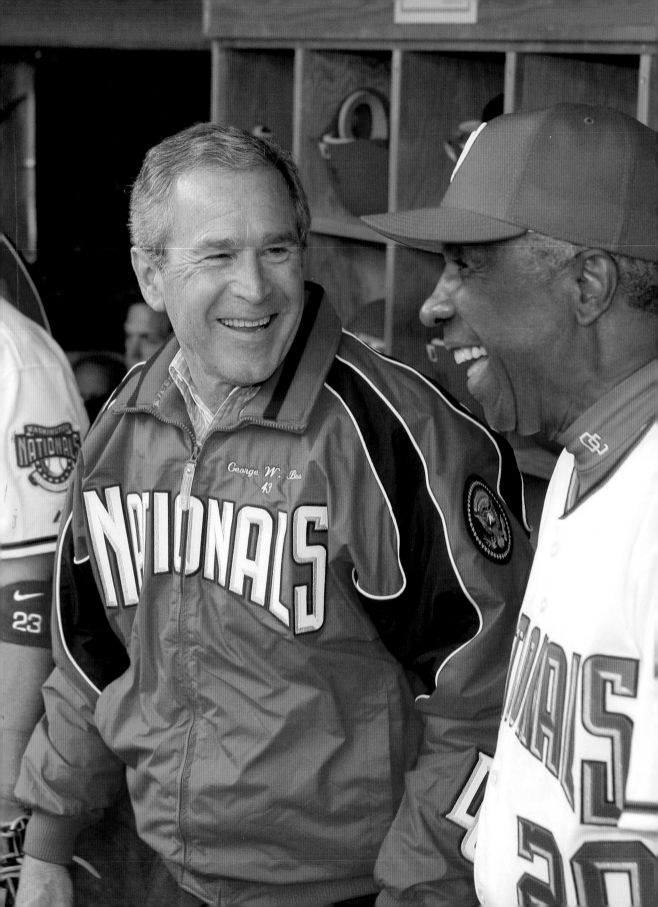

BASEBALL WITH BUSH

> " *With just a single still image, Neil Leifer captures and documents the essence of those heart stopping moments which have translated into a lifetime of my memories.*
>
> —**MATT LAUER**, The TODAY show

One more stop on my Senior Citizen Tour I must mention. When I was a young photographer, there was a team in the nation's capital, the Washington Senators, that played at Griffith Stadium. It was a tradition back then for the president to throw out the first ball on Opening Day, and in 1961, *SI* assigned me to photograph John F. Kennedy tossing the ball from his box. I was given a spot in the White House pool of photographers, all positioned fifteen to twenty feet in front of the box where the president and vice president were sitting. After the ceremonial pitch, I spent the whole game with my back to the field, hoping to snap a good picture of Kennedy. Maybe I'd get catch a break and he'd end up with a bit of mustard from a hot dog on his lip. No such luck. JFK did nothing that would make a great photo.

But I did get one of my best-known pictures. JFK was sitting beside Vice President Lyndon Johnson and a foul ball was headed their way. The president and other prominent Democrats seated around him, instinctively leaned to their left, away from the ball. I snapped away and knew I had a winner. JFK, LBJ, and most of the administration, all leaning to the left! How perfect was that?

But now it was 2005, and for the first time since 1971, a baseball team was back in Washington. The Nationals would be playing their

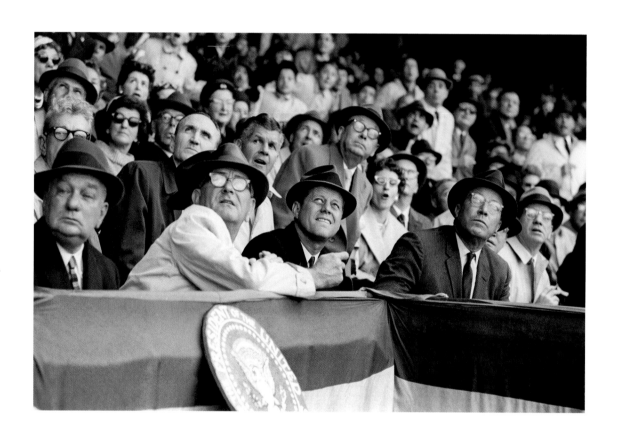

PRESIDENT JOHN F. KENNEDY WITH VICE PRESIDENT LYNDON JOHNSON AT GRIFFITH STADIUM, 1961.

home games at RFK Stadium, and they had yet to play their first game. I assumed that President George W. Bush would throw out the first pitch on Opening Day.

I had a pretty good in with Andy Card, the White House chief of staff, the man who controlled Bush's schedule. I wrote him a letter—and e-mailed him—telling him what I hoped to do. I also sent along copies of my Kennedy-Johnson pictures. What I wanted was to travel with Bush in the motorcade from the White House to the ballpark and sit with him in the box as he watched the game. Andy Card e-mailed back: "Let me see what I can do."

Two or three weeks later, my request was approved. This meant the president had personally okayed my idea. I knew what to expect at the ballpark: the president would warm up under the stands and throw the first pitch from the mound. The tradition had been for him to throw two or three pitches, but now the Secret Service was encouraging him to throw only one.

I had been told to come to the White House to meet the president's motorcade. Although I had been there before and photographed presidents for *Time*, I had never ridden in a motorcade. The White House photographer, Eric Draper, had the night off, so the No. 2 guy, Paul Morse, came out to get me. He led me to the driveway where the limousine and the other cars were lined up. I had been assigned to the third car and would ride with the president's surgeon and his physician. The head of the Secret Service detail introduced himself and gave me a pin that would identify me as a member of the White House party.

I was still standing in the driveway right in front of Bush's limo when the president and First Lady Laura Bush came out. Clearly, he had been briefed. He walked right over to me, shook my hand, and said, "Hi, Neil. It's great to have you. I'm so glad you could join us tonight."

And I said, "Mr. President, may I have a picture with you?"

He posed with me and said, "I was just upstairs looking at your book."

THE WHITE HOUSE
WASHINGTON

May 4, 2005

Mr. Neil Leifer
Apartment 21B
235 West 56th Street
New York, New York 10019

Dear Neil:

Thanks for the photographs you sent. The shots of President Kennedy and Vice President Johnson are great, and I really enjoyed seeing your pictures from the Nationals' Opening Day game. You are a talented photographer, and Laura and I were glad that you could join us at RFK Stadium to help capture the excitement of baseball's return to our Nation's capital.

Best wishes.

Sincerely,

George W. Bush

LETTER FROM PRESIDENT BUSH, 2005.

He was referring to *The Best of Leifer*, which I had sent him. "I loved your shot of my dad's inauguration," he said. "See you at the stadium."

It took exactly eight minutes to get there. Eight minutes from the driveway of the White House into the stadium, where the baseball commissioner, Bud Selig, met us. Bush went into the umpire's dressing room first. I was right behind him. One of the umps said, "Mr. President, I've got my grandson on the phone." Bush took the phone. I was shooting, but I was close enough to hear every word. Bush said, "No, it's really me." Then, "No, it really is the president. I'm here with your grandfather." Next they took him into the players' dressing rooms, and I have never seen baseball players better behaved. No one was partially dressed. They were all in uniform, sitting down, waiting for him. He addressed each team and posed for pictures. His next stop was a small room, below the stands, where I was not allowed to go. That's where they had him put on his bulletproof vest, the one thing they wouldn't let me photograph. When he came out, he stepped into one of the cages where pitchers warm up. For ten minutes, he threw to Nationals catcher Brian Schneider. It was just the two of them and me in the cage, something I will never forget.

"The reason I warm up," the president told me, "is because the vest is very restrictive and makes it hard to throw. There are fifty thousand people here, and I don't want to bounce the ball to home plate."

Waiting in the Nationals dugout, Bush chatted with manager Frank Robinson while I sat on the steps in front of them, snapping away. When the time came for Bush's big moment, I was allowed to trail him as far as third baseline. He was wearing a Nationals jacket over the vest, and after he threw the pitch, he jogged off the field and started to take off the jacket as we headed down the runway from the dugout. I was shooting, of course, but a Secret Service agent stopped me. No pictures of the vest.

Up in the president's box, I sat right in front of Bush for two or three innings, shooting. Between innings, the president and Mrs. Bush posed for me with the field in the background. By then I figured, hey, I've had my camera in his face all this time. So I walked out of the box to give him some time without me. Secret Service agents aren't known for small talk, but after a minute, the No. 2 agent said, "You've been with *Sports Illustrated* a long time. You ever shoot the swimsuit issue?"

I said, no, I hadn't, at which point he lost all interest in me.

When I went back into the box, the president leaned over to me and said, "Shoot whatever you want now." Then, about an inning later, he said, "Just so you know, we're leaving after the fifth inning."

"But you're a baseball fan," I said. "How can you leave?"

"Of course, I'd love to stay," Bush said. "But if I stay for the whole game, it ruins it for everybody else in the stadium getting out of here. They tie up all the exits. It's easier for me to leave now, and it won't destroy the evening for everyone else."

As we sped back along the Beltway, it suddenly occurred to me there was no traffic—none. There wasn't a car on the road in either direction. Then I noticed police cars at every exit. The Beltway had, of course, been completely blocked off.

- -

A year later, I was back at the White House. This time I had arranged to give the president my book, *A Year in Sports*, which included ten pages from my night at the ballpark with him. I was promised ten minutes alone with Bush.

I was shown into a small waiting room, and a few minutes later in came Tony Dungy, the coach of the Indianapolis Colts, who had won the Super Bowl, and Peyton Manning. Bush spent ten minutes talking to them before they went to join the rest of the team in the Rose Garden. Then the president spent ten minutes with me, signed my book, and posed for a picture with me.

As I walked out of the White House, I pulled out my cell phone and called my nine-year-old grandson, Joey. He had been very excited when I had told him I was going to visit the president at the White House. He asked me to call him afterward.

"Joey," I said, "I'm at the White House. I just met with the president."

"What was he doing?"

"He was honoring the Indianapolis Colts for winning the Super Bowl."

"Was Peyton Manning there?"

"Yes," I said, "I actually spent ten minutes with him."

"You talked to him?"

"Yes."

"Did you get his autograph?"

My heart stopped. "Uh, no."

It had never entered my mind. But I could hear it in Joey's voice; he was thinking, how could you be so stupid?

"I was with President Bush," I tried lamely.

"And you didn't ask Peyton Manning for his autograph?"

To this day, I'm pretty sure Joey has never forgiven me for that.

FOLLOWING PAGES: PRESIDENT BUSH WARMS UP BEFORE THROWING THE FIRST PITCH, 2005.

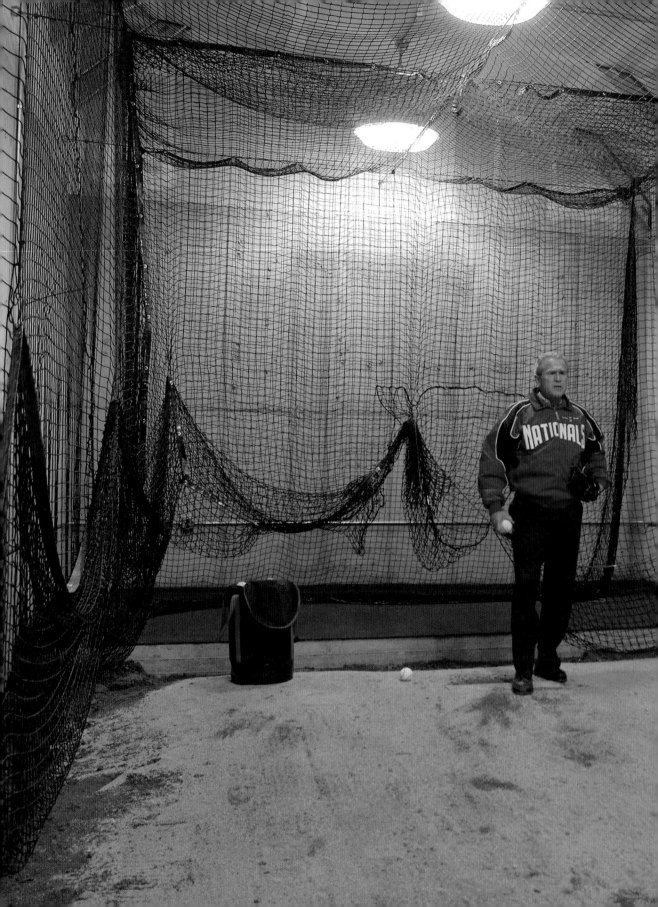

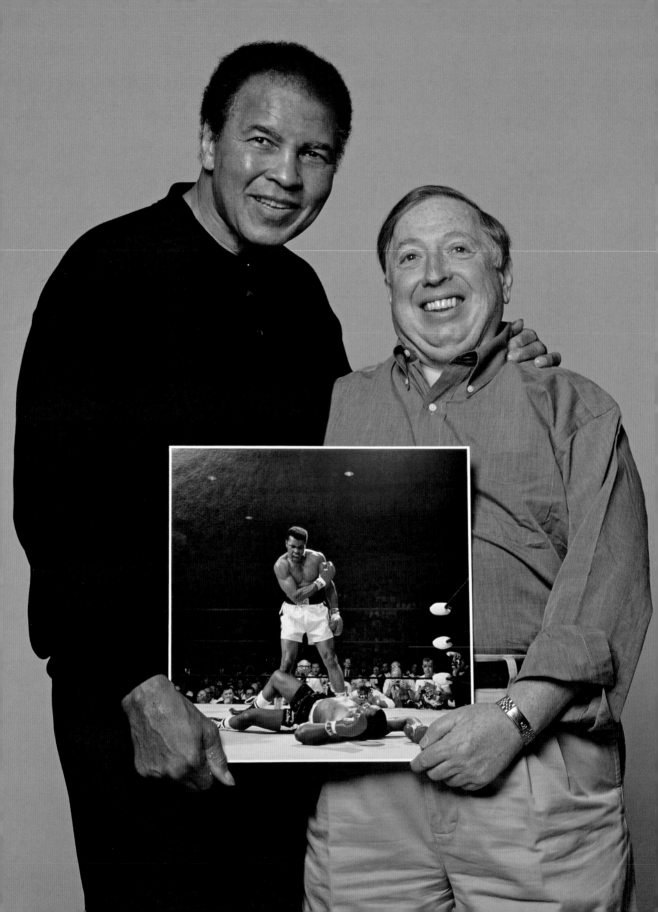

EPILOGUE

" *You can always recognize a Neil Leifer photo. It's easy. If the photo tells a story, makes you stare at it and lose your breath, and sometimes even makes your eyes sting, then you know it's a Leifer. There are thousands of those masterpieces . . . a skywalking Doctor J, Sam Huff in a Redskins uniform facing Unitas on a misty frozen field, JFK crossing the field at halftime of the Army-Navy game, Broadway Joe on the sidelines covered in mud. All those portraits of legends from sports, entertainment, and politics. All those shots of "The Greatest," Muhammad Ali. The list is endless, compelling, and enduring.*

—MICHAEL BUFFER, Boxing Hall
of Fame ring announcer

One of the greatest thrills of my career occurred in December 2013, when I learned I had been voted into the International Boxing Hall of Fame. For years, I had wondered why not a single photographer had ever been inducted into any of the major sports halls of fame. Writers had been, most of them deservedly so. Why were we held in lower esteem?

What made this honor even more special to me was that Oscar De La Hoya and Felix Trinidad, two of the greatest fighters I had photographed, would also be inducted at the ceremony in Canastota, New York, in June 2014.

Another happy event came my way in the summer of 2012, when I

was offered a dream assignment involving the Olympics. By then, I had covered fifteen Olympics (eight Summer and seven Winter), and I had no intention of covering another. The Games are a physical nightmare. You go nonstop for seventeen days and nights, racing from one event to another and getting very little sleep. At this point in my life, I had no desire to work that hard again. But Jim Bell, the executive producer of both the *Today Show* and the Olympic Games in London, made me an offer I simply could not refuse.

The idea was this: instead of me chasing after them, the American medal winners would be delivered to me. Since NBC was carrying the Games, the *Today Show* would be televised each morning from London. Their producers—not me—would be responsible for wrangling the athletes and bringing them to the set. After the athletes were put through the hair and makeup routine, they would be escorted a few steps into my little studio before walking another few steps to go on air with Matt Lauer, Savannah Guthrie, Al Roker, or Natalie Morales.

My whole day's work would take two hours—from noon to 2:00 p.m., London time, which meant 7:00 a.m. to 9:00 a.m. East Coast time in the States. All I had to do was get the medalists to smile and go along with any ideas I dreamed up. And they proved great to work with, all ninety-four medal winners whom I photographed. The only person who refused to pose was Venus Williams. Serena Williams didn't look too happy when it was her turn, but once I started to shoot, she broke into her lovely smile and produced one of my best photos. Michael Phelps did not bring any of his four gold medals, but NBC's sports commentator Jim Gray had brought the ticket from the night that Michael set the record for the most Olympic medals of all time: nineteen. (He finished with twenty-two.) Phelps holding up that ticket, which he had signed, made a good shot.

My plan for the entire series was to make the athletes look like the kids they were. And they all went along with whatever I suggested. Swimmer Ryan Lochte posed with that famous grill stuck in his mouth. He also posed wearing his blue-rimmed sunglasses, which ran with Lochte's name in one lens and an American flag in the other. Gabby Douglas, gold medal winner of the individual all-around event in gymnastics, had no problem doing a split on a stool, instead of a balance beam. I had Danell Leyva, who won a bronze in the all-around gymnastics, do a one-handed handstand, while holding his medal in the other hand.

But what to do with double silver medal-winning cyclist Sarah Hammer, who did not have her bike with her? Wait! Al Roker often rode from

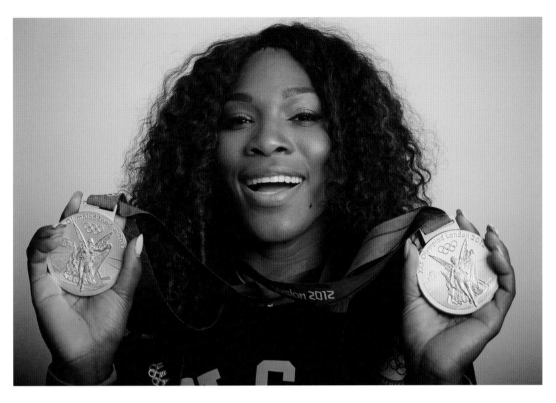

SERENA WILLIAMS, 2012.

MICHAEL PHELPS, 2012.

RYAN LOCHTE, 2012.

GABBY DOUGLAS, 2012.

the NBC Broadcast Center to the *Today Show* set on a portable, fold-up bike. I had noticed it sitting outside the makeup room. Let's just say I "borrowed" it for the five minutes it took me to shoot the picture.

In addition to photographing the medalists, I was given one more assignment. The week following the Olympics, when the *Today Show* was back in New York, they planned to run a series of pieces that would recreate iconic photographs starring *Today Show* regulars. They asked me if I could shoot the lead picture that would kick off the series on Monday. My job? Recreate the Abbey Road crossing, more accurately known as a "zebra crossing." But outside of London, it is always the Abbey Road crossing because of the famous Beatles album cover photo.

The *Today Show* went to incredible lengths to pull this off. They searched for and found the one guy still alive who was in the background, standing near an old VW, which they also found and placed in the exact same spot. They persuaded the London police to stop traffic for five minutes at a time—as if that mattered. As a New York-born, jay-walking pro, I wasn't going to be bothered by a little traffic, and certainly not by a few very loud horns.

The costumes were hilarious. Al Roker had fun with the fact that they chose a black man to portray Ringo. Somehow, Savannah and Natalie actually managed to look like John Lennon and George Harrison clones. And just before shooting began, Matt Lauer came over to me and said, "Neil, please, please take these quickly. I am very germophobic." He would be walking barefoot as Paul had in the original picture, and he was not happy about that. I ended up shooting seven or eight takes, all done very quickly. It was an experience I won't soon forget.

I had so much fun doing this and I can't help thinking: it might turn out to be the last photo assignment I ever do. Then again, who knows when I'll get the next offer I can't refuse?

THE END
(no, really)

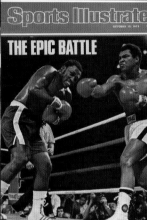
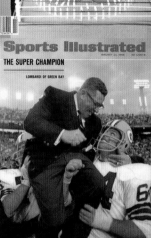
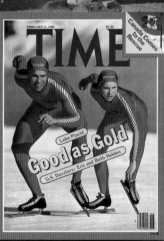
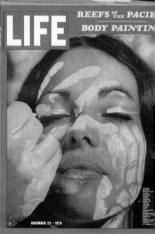
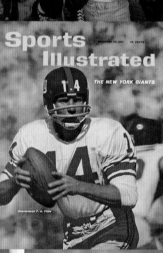

GIANTS vs. DODGERS · SUPER PATRIOTS

Sports Illustrated

IS NOTRE DAME FOR REAL?

The Best There Ever Was

JOHNNY UNITAS
1933–2002

Sports Illustrated

HOCKEY'S IMMORTALS
Bobby Hull of Chicago

Sports Illustrated
NOVEMBER 7, 1977 · ONE DOLLAR

SEMI-TOUGH GOES TO THE MOVIES

STRIKEO AND PSYCH-O

POST
WHAT WILL L.B.J. DO NOW?
A PILGRIMAGE THROUGH THE HAUNTED BATTLEFIELDS OF WORLD WAR II
$1,000,000 TREASURE FIND

Johnny Unitas of the Colts

ETY'S BEST-KEPT SECRET · DO WOMEN RUN THE U.S.?

Sports Illustrated
PALMER: Part 3

LATIN CONQUEST OF THE BIG LEAGUES

SAN FRANCISCO'S JUAN MARICHAL

TIME
JUNE 27, 1988 · $2.00

Pentagon For Sale

Why the Fascination With Boxing?

Heavyweight Mike Tyson

LOOK

Unique, dramatic pictures by the world's greatest photographers

THE GOLDEN GAMES
The definitive souvenir of the Los Angeles Olympics

CARL LEWIS

USA

BUSH VS. PEROT
Digging for Dirt

Newsweek

OLYMPIC PORTFOLIO

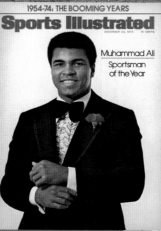

USA

eam Dream
By Frank Deford

1954–74: THE BOOMING YEARS

Sports Illustrated
DECEMBER 23, 1974 · 75 CENTS

Muhammad Ali
Sportsman of the Year

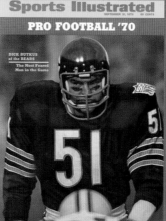

Sports Illustrated
SEPTEMBER 21, 1970 · 60 CENTS

PRO FOOTBALL '70

DICK BUTKUS of the Bears
The Most Feared Man in the Game

51

TIME

Hail, Liberty!

A Birthday Party Album

ports Illustrated
SEPTEMBER 15, 1975 · 75 CENTS

BOXING'S NEW BARNUM

Promoter Don King and the stars of the Thrilla in Manila

TIME
DECEMBER 7, 1981 · $2.50

Reagan's Risky Victory

LOVE 'EM! CATS HATE 'EM!

Sports Illustrated
AUGUST 2, 1976 · ONE DOLLAR

SHE STOLE THE SHOW

Nadia Comaneci

BUSH'S TAX PLAN
What It Means for You

Newsweek
February 10, 1992 · $2.95

OLYMPICS PREVIEW

JEWEL ON ICE
BY FRANK DEFORD

America's Kristi Yamaguchi

ACKNOWLEDGMENTS

I have dedicated this book to my mother, my father, and my brother Howie. I only wish that they were here to share this very special time with me. I miss them very much.

I think that I am much too young to be writing a memoir. But as I watch my five grandchildren—Joey, Taylor, Riley, Ryan, and Aiden—grow up, it's dawned on me that they have no idea that their grandfather once took some pretty good pictures that did not have them as their subjects. I hope that someday each of them will read this book and will be as proud of my accomplishments as I know my daughter Jodi and my son Corey already are.

There are so many people whom I'd like to thank for all they've done to help make my life so wonderful and my career as successful as it's been, but there's no way that I could get all of their names in the limited space that I have here. So I'll just say "thank you" from the bottom of my heart to all the editors who believed in me and gave me a chance to excel, the many great assistants who have worked with me over the years, the terrific writers who I was lucky enough to work with and get to know, and all my close friends, who have always encouraged me to do better.

Despite the limited space, there are a few people whom I must single out because, without them, this book could not have happened.

Diane Shah has been my partner on the book from the very beginning, about two and a half years ago. She is not only a great writer, she's also a very good friend.

I first pitched the idea of doing this book to Terry McDonell, who was

then the managing editor of *Sports Illustrated*. He loved it, and Terry is definitely the reason the manuscript got written. I am very grateful to Paul Fichtenbaum, editor, Time Inc. Sports Group; Chris Stone, *SI* managing editor; and Karen Carpenter, executive director of content management, for allowing me to use more than fifty years' worth of photographs taken for Time Inc. publications. I must also thank *Time*'s managing editor, Nancy Gibbs, and *Time*'s director of photography, Kira Pollack, for their support.

I consider Walter Bernard the best art director in the country. He did some dummy covers and a layout of two chapters of the book so that I'd have a strong presentation to pitch to publishers when the time came.

When we needed a fresh set of editing eyes to put the finishing touches on the manuscript, I turned to Rob Fleder, who did a great job getting it ready to be submitted.

I also needed a picture editor, and Joe Felice did a terrific job filling that role as well as serving as the manuscript's fact checker.

My personal assistant Joan Fazekas filled out my team.

Armed with a final draft of the manuscript and with Walter Bernard's layouts, I sent the project to my friend Don Carleton, the executive director of the Dolph Briscoe Center for American History at the University of Texas at Austin. He loved the whole presentation and passed it on to Dave Hamrick, the director of the University of Texas Press, who quickly agreed to publish it. The rest is history.

The UT Press staff took over, and they've been a real pleasure to work with: Allison Faust, assistant to the director; Lynne Chapman, manuscript editor; Sally Furgeson, copy editor; Derek George, designer; and Nancy Bryan, assistant marketing manager. I thank y'all!

In the end, I came to realize that there is no way that I could get all of my great stories and experiences into one volume. I also fully expect there to be many more great stories in the years ahead, since I have a few worlds still left to conquer. So I look forward to putting together volume 2 of *Relentless* sometime in the not-too-distant future.

Until then, I'll just continue to enjoy life. I'll keep cruising with my friends from Crystal Cruise Lines on their two great ships, and I'll continue looking forward to dinner at my monthly table (my proudest possession) at Frankie Pellegrino's Rao's restaurant.

Finally, I still love photography, so I will definitely continue taking pictures (just for fun) of my kids, grandkids, and my beautiful French ballerina Chantal Foret, who has brightened my life by sharing it with me.

INDEX

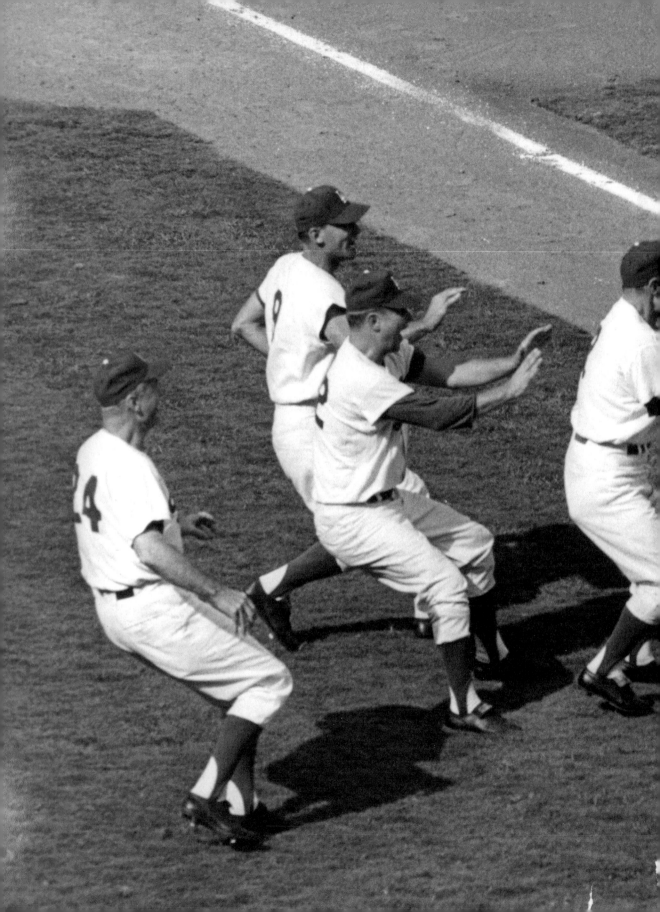